Rock Art of the Caribbean

CARIBBEAN ARCHAEOLOGY AND ETHNOHISTORY

Series Editor L. Antonio Curet

ROCK ART
OF THE CARIBBEAN

Edited by Michele H. Hayward,
Lesley-Gail Atkinson, and Michael A. Cinquino

THE UNIVERSITY OF ALABAMA PRESS
Tuscaloosa

Copyright © 2009
The University of Alabama Press
Tuscaloosa, Alabama 35487-0380
All rights reserved
Manufactured in the United States of America

Typeface: Bembo

∞
The paper on which this book is printed meets the minimum requirements of
American National Standard for Information Sciences-Permanence of Paper for
Printed Library Materials, ANSI Z39.48-1984.

Library of Congress Cataloging-in-Publication Data

Rock art of the Caribbean / edited by Michele H. Hayward, Lesley-Gail Atkinson, and
Michael A. Cinquino.
 p. cm. — (Caribbean archaeology and ethnohistory)
 Includes bibliographical references and index.
 ISBN 978-0-8173-1650-1 (cloth : alk. paper) — ISBN 978-0-8173-5530-2
(pbk. : alk. paper) — ISBN 978-0-8173-8159-2 (electronic) 1. Rock paintings—
Caribbean Area. 2. Petroglyphs—Caribbean Area. 3. Rock paintings—Social aspects—
Caribbean Area. 4. Petroglyphs—Social aspects—Caribbean Area. 5. Rock paintings—
Conservation and restoration—Caribbean Area. 6. Petroglyphs—Conservation
and restoration—Caribbean Area. 7. Caribbean Area—Antiquities. I. Hayward,
Michele H. II. Atkinson, Lesley-Gail. III. Cinquino, Michael A.
 F2172.R63 2009
 759.01'1309729—dc22

 2008051589

Contents

List of Illustrations vii

Acknowledgments xi

1. Introduction
Michele H. Hayward, Lesley-Gail Atkinson, and Michael A. Cinquino 1

2. Rock Art within the Bahamian Archipelago
John H. Winter 13

3. History, Survey, Conservation, and Interpretation of Cuban Rock Art
*Racso Fernández Ortega, José B. González Tendero,
and Divaldo A. Gutierrez Calvache* 22

4. Sacred Landscapes: Imagery, Iconography,
and Ideology in Jamaican Rock Art
Lesley-Gail Atkinson 41

5. Caring for the Spirit Helpers: Recording, Graffiti Removal, Interpretation,
and Management of the Warminster/Genus Rockshelter, Jamaica
Johannes H. N. Loubser and Philip Allsworth-Jones 58

6. The Rock Images of Haiti: A Living Heritage
Rachel Beauvoir-Dominique 78

7. Rock Art Studies in the Dominican Republic
José Gabriel Atiles Bidó 90

8. Rock Art of the Dominican Republic and Caribbean
Adolfo López Belando, with contributions by Michele H. Hayward 102

9. Rock Art of Puerto Rico and the Virgin Islands
*Michele H. Hayward, Peter G. Roe, Michael A. Cinquino, Pedro A. Alvarado Zayas,
and Kenneth S. Wild* 115

vi / Contents

10. The Rock Art of Guadeloupe, French West Indies
Gérard Richard 137

11. Contextual Analysis of the Lesser Antillean Windward Islands Petroglyphs:
Methods and Results
Sofia Jönsson Marquet 147

12. Prehistoric Rock Paintings of Bonaire, Netherlands Antilles
Jay B. Haviser 161

13. Rock Art of Aruba
Harold J. Kelly 175

14. A New Method for Recording Petroglyphs:
The Research Potential of Digitized Images
George V. Landon and W. Brent Seales 188

15. The Mute Stones Speak: The Past, Present,
and Future of Caribbean Rock Art Research
Peter G. Roe 198

References Cited 241

Contributors 271

Index 273

Illustrations

Figures

1.1. Map of the Caribbean 4

1.2. General cultural chronology of the Greater Antilles 7

1.3. General cultural chronology of the Lesser Antilles 8

2.1. Interior section of Hartford Cave, the Bahamas 16

2.2. Representative petroglyphs from the Bahamas 17

2.3. Representations of Taíno *cemís* 18

3.1. Distribution of pictographs by color for Cuba 28

3.2. Cueva Ambrosio, Matanzas Province, Cuba 30

3.3. Interconnected Lines pictograph style, Cueva Pluma, Cuba 31

3.4. Incised petroglyphs from Cueva de los Petroglifos, Cuba 33

4.1. Examples of Jamaican petroglyph designs 50

4.2. Birdmen pictographs at Mountain River Cave 51

4.3. Bird pictographs at Mountain River Cave 52

4.4. Geometric and abstract pictographs at Potoo Hole 53

4.5. Petroglyphs at Cuckold Point and Hull Cave 56

5.1. Sketch map of Warminster/Genus rockshelter, Jamaica 59

5.2. Panel 7 petroglyphs at Warminster/Genus rockshelter, Jamaica 68

5.3. Panel 2 petroglyphs at Warminster/Genus rockshelter, Jamaica 69

5.4. Panel 4 petroglyphs at Warminster/Genus rockshelter, Jamaica 71

5.5. Nychthemeral cycle of spirits 75

6.1. Voûte à Minguet petroglyph cave site 82

6.2. Bassin Zim petroglyph cave site 83

7.1. Dominican Chacuey petroglyph style 95

7.2. Dominican Hoyo de Sanabe pictograph style 99

7.3. Dominican Borbón pictograph tradition 100

8.1. Dominican José María pictograph school 104

8.2. Dominican Borbón pictograph school 106

8.3. Dominican Berna pictograph school 108

8.4. Dominican geometric petroglyphs 111

9.1. Selected anthropomorphic images, Puerto Rico 120

9.2. Selected zoomorphic and abstract images, Puerto Rico 121

9.3. Plan of Cueva Lucero, Galleries A–D 123

9.4. Petroglyph sequence, Caguana, Puerto Rico 129

9.5. Portion of Reef Bay, St. John, U.S. Virgin Islands 133

10.1. Enclosed-body petroglyph forms, Parc Archéologique
des Roches Gravées, Trois-Rivières 141

10.2. Mirrored anthropomorphic petroglyph, Trois-Rivières 142

10.3. Facial petroglyph, Plessis River, Baillif/
Vieux-Habitant Commune 143

10.4. Face and wrapped-body petroglyph/pictograph,
Marie Galante Island 145

11.1. Distribution of petroglyph sites, Lesser Antillean
Windward Islands 152

11.2. Representative images of petroglyphs, Lesser Antillean
Windward Islands 153

12.1. Upper-level prehistoric monochrome pictographs, Bonaire 165

12.2. Prehistoric and modern overlay pictographs, Bonaire 166

12.3. Original prehistoric pictographs, Bonaire 168

12.4. Modern 1927 design and reputed Mayan glyph
representation, Bonaire 173

13.1. Quadirikiri pictograph cave, Aruba 178

13.2. Anthropomorphic pictograph, Aruba 179

13.3. Polychrome anthropomorphic and geometric composite
pictograph, Aruba 180

13.4. Zoomorphic polychrome pictograph, Aruba 181

14.1. Equipment setup, Puerto Rico 191

14.2. Digitized 3-D image of a bird-form petroglyph at Caguana 192

14.3. Caguana anthropomorphic figure as drawn and in digitized form 196

15.1. Plan and rock art of Cueva la Catedral 223

15.2. Cueva la Catedral pictographs 224

15.3. Cueva la Catedral pictographs 225

15.4. Cueva la Catedral pictographs 226

Tables

3.1. Number and Type of Cuban Rock Art Sites by Province 27

3.2. Protection Status of Cuban Rock Art Sites by Province 36

7.1. Number and Percentage of Caves with Petroglyphs and
Pictographs by Province 91

9.1. Distribution of Rock Art Sites by Physical Location for
Puerto Rico and the Virgin Islands 118

11.1. Distribution of Petroglyph Sites and Images by Island 149

11.2. Windward Islands Petroglyph Tradition A Characteristics 154

11.3. Windward Islands Petroglyph Tradition B Characteristics 155

11.4. Windward Islands Petroglyph Tradition C Characteristics 156

11.5. Windward Islands Petroglyph Tradition D Characteristics 157

11.6. Chronological Periods, Ceramic Series, and Petroglyph Traditions
for the Windward Islands 159

15.1. Rock Art Survey and Documentation Status 200

15.2. Rock Art Site Densities 206

15.3. Rock Art Image Densities 208

15.4. Rock Art Site Locations 210

15.5. Rock Art Image Site and Type Data 212

15.6. Rock Art Chronological Indicators 215

15.7. Rock Art Legal and Conservation Status 234

Acknowledgments

The origin of this book was at the 2003 World Archaeological Congress (WAC-5), Washington, DC, for which the editors organized a session entitled "Caribbean Rock Art." This session provided the opportunity to promote Caribbean rock art to a wider global audience. The editors subsequently included additional Caribbean islands beyond those presented at the congress to widen the scope of the publication. The editors would first like to thank the authors who contributed to this volume: Philip Allsworth-Jones, Pedro A. Alvarado Zayas, José Gabriel Atiles Bidó, Rachel Beauvoir-Dominique, Racso Fernández Ortega, José B. González Tendero, Divaldo A. Gutierrez Calvache, Jay B. Haviser, Sofia Jönsson Marquet, Harold J. Kelly, George V. Landon, Adolfo López Belando, Johannes H. N. Loubser, Gérard Richard, Peter G. Roe, W. Brent Seales, Kenneth S. Wild, and John H. Winter.

We acknowledge the following institutions and individuals for their permission to reprint certain figures in the volume: Museo Arqueologico Aruba, The Institute of Jamaica, Evelyn Thompson, José Oliver, and Fred Olsen via the International Association for Caribbean Archaeology.

We are extremely grateful to the staff of Panamerican Consultants, Inc., who provided infrastructural support including communication services, editorial and research assistance by Mr. Carl W. Thiel and Ms. Sharon M. Jenkins, and graphic preparation by Mr. Alexander G. Schieppati and Ms. Lauren O'Meara.

The staff of The University of Alabama Press, with patience and forbearance, guided us through the submission process.

Rock Art of the Caribbean

I

Introduction

Michele H. Hayward, Lesley-Gail Atkinson, and Michael A. Cinquino

Rationale and Goals

The study of and interest in Caribbean rock art possess a long, though largely circumscribed history. Early European chroniclers, while excluding direct mention of the area's rock images, nonetheless provide a comprehensive context to aid in the understanding of this form of cultural expression. Later interested amateurs and professionals have continued to detail the varied and substantial body of pre-Hispanic-executed designs on rock surfaces.

This resource and its investigative potential remain little known. David Whitley's edited volume *Handbook of Rock Art Research* (2001) provides summaries of technical, interpretive, and regional advances in rock art research. The Caribbean is not included, although scattered references to the region can be found in the lowland South America section. Cornelius N. Dubelaar has undertaken two comprehensive surveys of rock art for part of the area. Information such as techniques of execution and site descriptions with line drawings can be found in his 1986 book, *South American and Caribbean Petroglyphs*. The focus is primarily on South American locations, with limited mention of Caribbean island sites. A similar effort for the Lesser Antillean islands is contained in Dubelaar's 1995 publication *The Petroglyphs of the Lesser Antilles, the Virgin Islands and Trinidad*.

The principal venue for publication of rock art research in the region is the biannual *Proceedings of the Congress of the International Association for Caribbean Archaeology*. The entire *Proceedings* from 1961 to 2005, or Volumes 1 through 21, are available on a DVD in PDF format from the website www. culturalresourcesolutions.com. More localized venues, such as the *Boletín del Museo del Hombre Dominicano* from the Dominican Republic and *El Caribe Arqueológico* from Cuba, regularly contain articles on the rock images of these or other islands.

Articles or information on Caribbean rock art can be found occasionally

in wider-distribution journals and books; in international conference pub-
lications; in cultural resource management contract reports for those islands
politically linked to the United States (Puerto Rico and the U.S. Virgin Is-
lands); and on electronic publishing or other informational sites through the
Internet.

Our goal is to add to the growing interest and research in the rock art of
the area through the following specific aims:

1. To provide an overview of Caribbean rock art from as many areas as pos-
 sible. Topics include the history of research, as well as the assessment of
 sites, and the application of methods, interpretive frameworks, and pro-
 tection strategies.
2. To collate these authors' and additional source data to more effectively di-
 rect and advance research and conservation efforts in the region.

Rock Art Categories and Terminology

The Caribbean contains three categories of rock art: painted images and
carved designs on rock surfaces and rock sculptures. The latter include carved
triangular objects and freestanding statues that are generally viewed as be-
longing to artifact classes of similar manufacture or function. For example,
triangular objects made from stone are analyzed along with those carved from
shell or bone. Other forms of rock art such as geoglyphs and large-scale rock
arrangements constructed in pre-Columbian times are unknown from the
region. Small-scale arrangements are possible. Gérard Richard (Chapter 10,
this volume) reports an apparent circular formation of boulders for one site
on Guadeloupe, while Maura Imbert (2007) suggests that rocks at one lo-
cation on Antigua may have been deliberately ordered for astronomical ob-
servations. Historically, however, rock art studies have been restricted to the
first two classes found on immovable or relatively stationary rock structures
(Dubelaar et al. 1999:1–2), although comparisons of designs across different
media are certainly incorporated.

Caribbean rock art researchers employ a range of terms and meanings in
their research. We follow a middle ground of editorship: reducing but not en-
tirely eliminating variability. The term *rock art,* normally found in the litera-
ture and this volume, refers to both carved and painted motifs on natural rock
surfaces. *Rock figures, images, designs,* and *motifs* serve as alternative vocabu-
lary. *Petroglyphs* refers to carved, pecked, ground, or other agency-produced
designs. *Pictographs* covers painted or drawn images that are also, though less
regularly, referred to as *rock paintings.*

The terms *type, style, school,* and *tradition* are utilized, frequently without

consideration of their technical meanings. The various elaborated types or typologies have been employed as a means to order rock art data. The categories are derived from identified attributes that then function as analytical units to examine intersite or intrasite similarities and differences (see, for instance, Cinquino et al. 2003 and Dubelaar 1995:27–31).

In common with other rock art areas (see Francis 2001), the use of *style*, with *school* and *tradition* as loose synonyms, remains problematical. These categories in the Caribbean have been differentiated on the basis of variously defined complexes of shared aesthetic and physical traits. Styles, schools, or traditions are intended to be higher-order classification units than types, as well as aids in the study of temporal and cultural differentiation. Yet, linkages of these visual proveniences or even types with particular geographical areas, cultures, or time periods have met with limited success.

Physical Setting

Definitions of the geographical and cultural extent of the Caribbean vary. They can include the entire island chain as well as the adjacent South and North American continental fringes, or they may exclude certain islands based on differences in the region's geological or cultural history. For this discussion of Caribbean rock art, we include only the island chain and certain islands immediately off the northern South American coast. Limited references are made to continental assemblages, whose culturally expressive principles the in-migrating populations would have brought with them.

The Caribbean or West Indian archipelago swings outward from the Venezuelan coast of South America to near Florida at the southeastern tip of North America and the Yucatan peninsula of Mexico in Central America (Figure 1.1). The islands lie close enough together that most can be seen from one another. Based on such factors as size and geologic development, they are divided into four primary physiographic subregions: the Greater Antilles and the Virgin Islands, the Lesser Antilles plus Trinidad and Tobago, the Bahamian archipelago, and the southern Caribbean Islands (Newsom and Wing 2004:10, 75).

The Greater Antilles is made up of Cuba, Jamaica, Hispaniola (with the modern countries of Haiti and the Dominican Republic), and Puerto Rico. These islands are the oldest, having formed by the mid-Cenozoic along the northern edge of the Caribbean tectonic plate. They also account for the largest landmasses in the region (Newsom and Wing 2004:10–11): Cuba with 110,860 km^2 (Climate Zone 2006), Hispaniola with 75,940 (Climate Zone 2006), Jamaica with 11,424, and Puerto Rico with 8,897. In general, mountains, intermontane valleys, and coastal plains provide topographic relief de-

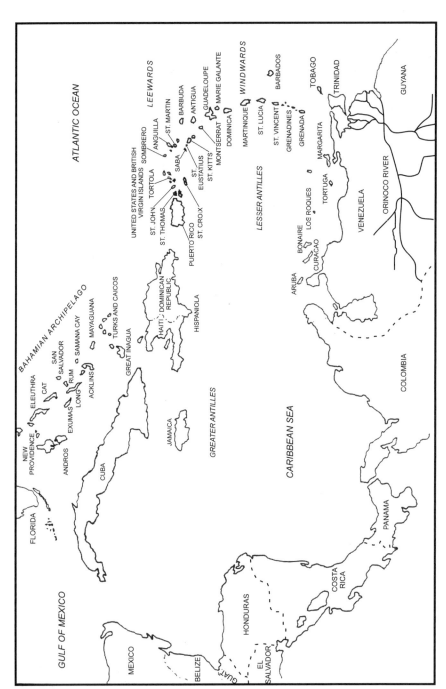

Figure 1.1. Map of the Caribbean.

rived from limestone, sedimentary, and metamorphic rocks (Newsom and Wing 2004:14 [Table 2.1]; Oldham 2007).

To the east of the Greater Antilles lies the Virgin Islands archipelago composed of numerous small islands politically divided between the United States and the United Kingdom. Volcanic rock predominates on most of the islands that together present a landmass of 502 km². The terrain is hilly with minimal level areas and relatively thin coasts that rise from a shallow island shelf attached to Puerto Rico (Climate Zone 2006; Davis 2002:15–16, 18–23; Newsom and Wing 2004:14, 114).

The Lesser Antilles extends from Sombrero and Anguilla in the north to Grenada off the coast of Venezuela. The islands formed during the Eocene and Miocene epochs at the eastern edge of the Caribbean tectonic plate and comprise coral limestone or volcanic landforms. This grouping is further divided into the Leeward Islands in the north (Sombrero/Anguilla to Guadeloupe) and the Windward Islands in the south (Dominica to Grenada) (Hofman et al. 2007:244; Newsom and Wing 2004:12, 14 [Table 2.1], 77; Rouse 1992:3). Landmasses are considerably smaller than those in the Greater Antilles, ranging from Saba with 13 km² to Guadeloupe with 1,702 km² (Newsom and Wing 2004:14 [Table 2.1], 77). Numerous smaller islands are also found throughout the Lesser, as well as the Greater, Antilles.

The next islands in line, Trinidad and Tobago, broke off at different times from the South American continent in the Quaternary. As continental rather than oceanic derived islands they bear close biological and physical relationships with the northeastern section of South America. Trinidad's 4,828 km² enclose mountain ranges, lowlands, and coasts resulting from sedimentary, limestone, and volcanic substrates. A central highland ridge, primarily made up of metamorphic and volcanic rocks, accounts for most of the 302 km² of Tobago, which is also bordered by a shoreline and to the southwest a broad coastal platform of coral limestone (Boomert 2000:17–19, 24–31).

The Bahamian archipelago comprises 35 small coral limestone islands with low, usually less than 30 m, relief. The Bahamas represent the most recently derived islands, stemming from banks on a slowly rising large limestone platform. The islands, along with more than 600 cays (smaller islands) stretching over 1,000 km, are divided between the governments of the Commonwealth of the Bahamas and of Turks and Caicos Islands (Newsom and Wing 2004:12, 14, 172, 174).

The southern Caribbean Islands generally lie within 50 km of Venezuela. Margarita and the Los Roques groupings belong to Venezuela, while Aruba, Bonaire, and Curaçao, being former Dutch colonies, are commonly referred to as the Netherlands Antilles (Newsom and Wing 2004:12). We focus on only the latter grouping of islands for this rock art survey. Their landmasses

in square kilometers are as follows: Aruba with 190, Bonaire with 288, and Curaçao with 443. Limestone and volcanic rocks predominate on these relatively low-lying islands (188 to 372 m high), where Aruba is attached to the continental shelf distinct from the oceanic islands of Bonaire and Curaçao (Newsom and Wing 2004:14 [Table 2.1], 60). Like Trinidad and Tobago, they all reflect the biotic and material cultures of the mainland (Boomert 2000; Newsom and Wing 2004), including rock art (see Haviser on Bonaire and Kelly on Aruba, Chapters 12 and 13, respectively, this volume).

Cultural Setting

Introduction

Populations initially entering the Caribbean island chain would have found more circumscribed landforms, less biotic diversity, and increased marine resources compared with their continental homelands. These factors, along with such physical conditions as the islands' divergent climatic, topographic, and resource bases, and in addition to varying local, interisland, and continental cultural ties, all affected subsequent cultural development.

We briefly outline this development and for chronological control rely on a 1992 framework by Rouse. Associations among principally ceramics and radiocarbon dates provide the basis for the sequence. Figures 1.2 and 1.3 present an updated version of Rouse's (1992:52–53, Figures 14 and 15) time/ space continuum with the nomenclature for major cultural periods, associated calendrical dates, general ceramic categories, and peoples.

Culturally, the Greater Antilles includes the Bahamian archipelago, Cuba, Hispaniola, Jamaica, Puerto Rico, the Virgin Islands, and, at times, parts of the northern Leeward Islands. The Lesser Antilles comprises the Leeward and Windward islands and, for our purposes, the near South American islands of Trinidad, Tobago, Aruba, Bonaire, and Curaçao.

The Preceramic Period: Lithic and Archaic Ages

An isolated spearhead from Trinidad marks the earliest evidence for Lithic Age hunter-foragers in the region, around 10,000 B.C. when the island was still connected to the mainland by a land bridge. The point bears similarities to the Canaiman subseries of the Joboid series of northern South America (Boomert 2000:49–51, 54). Much later, ca. 4000 B.C., groups from either northern South America or Central America moved into the Antillean islands of Cuba, Hispaniola, and Puerto Rico (Callaghan 2003; Newsom and Wing 2004:29–30; Rodríguez Ramos 2005:5; Rouse 1992:51, 54).

Even though the number of sites is limited, the material remains, as well as analogies to present-day hunter-gatherers, suggest that Lithic Age or Casi-

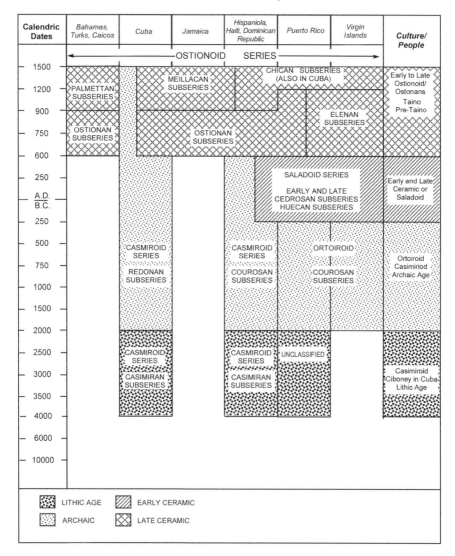

Calendric Dates	Bahamas, Turks, Caicos	Cuba	Jamaica	Hispaniola, Haiti, Dominican Republic	Puerto Rico	Virgin Islands	Culture/People

Figure 1.2. General cultural chronology of the Greater Antilles (Newsom and Wing 2004:176; Rodríguez Ramos 2005:5; Rouse 1992:Figure 14).

miroid people primarily manufactured flaked tools including blades and scrapers; were organized into small, mobile, egalitarian band-level societies; and engaged in varied subsistence practices from hunting on land to fishing for marine resources to manipulation of plant foods (Boomert 2000:51–52; Newsom and Wing 2004:29–30, 117; Rodríguez Ramos 2005:5–6).

Site density increases in the Archaic Age, with groups from northern South

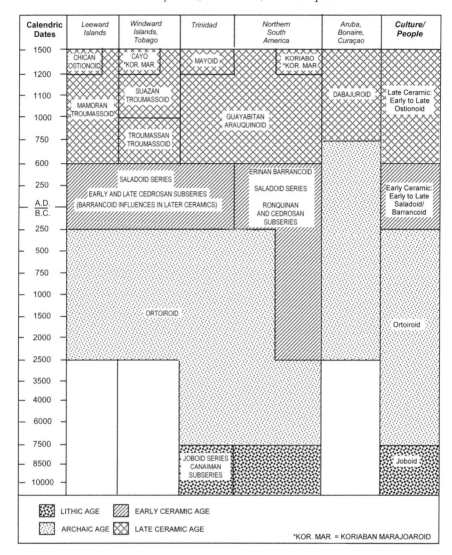

Figure 1.3. General cultural chronology of the Lesser Antilles (Boomert 2000:Figures 7 and 15, and personal communication 2007; Haviser 2001:118; Newsom and Wing 2004:61; Petersen et al. 2004:Figure 1; Rouse 1992:Figure 15).

America settling many of the islands beginning around 7500 B.C. in Trinidad and reaching the Greater Antilles by 2000 B.C. This interisland peopling also includes groups from the mainland that occupied the neighboring Netherlands Antillean islands for a restricted period between 1370 B.C. and A.D. 470. Cultural diversification is seen in the division of these societies

into the Ortoiroid series from northern South America to the Greater Antilles, with the Cuban and Hispaniolan populations maintaining their Casimiroid traditions in modified form (Newsom and Wing 2004:30, 61, 117–118; Rouse 1992:61).

Ground stone, bone, and shell artifacts, along with a general though not exclusive absence of pottery, characterize Archaic Age material cultural assemblages. Considerable local variation within overall shared subsistence and settlement patterns is evident. Subsistence appears to have been based on the exploitation of marine resources such as shellfish and reef fish, supplemented by the hunting or gathering of land animals and plant foods. More intensive utilization or manipulation of plant foods is indicated. Occupation of the sites, consisting mainly of shell middens on or near the coasts, was probably by small groups for short or recurrent periods. Sociopolitical organization likely remained at the band egalitarian level, albeit in a more complex form than in the previous Lithic Age (Boomert 2000:53–91; Newsom and Wing 2004:30–31, 78, 118; Rodríguez Ramos 2005:6–8; Rouse 1992:49–70).

Ceramic Period: Early and Late Phases

The Ceramic Age not only marks the widespread adaptation of pottery-making traditions, settled village life, and full-time horticulture throughout the region but, in addition, the settlement of all the major Antillean islands. People left the lowland tropical forest region of the Orinoco, as well as interior and coastal river basins of Venezuela and Guiana, to establish new settlements beginning around 400/500 B.C. Thin-walled ceramics with a variety of plastic elements and painted designs were manufactured, as were intricately carved and polished beads, amulets, and pendants from stone, shell, coral, and bone. The dietary base was widened to include cultivation of various plants, especially root crops including manioc. Settlements were permanent, located near the shoreline, coastal plain, and alluvial valleys. These diverse Early Ceramic or Saladoid people left little evidence of marked sociopolitical stratification and may have been organized into segmented "big man" local political units in which kinship ties served to integrate these polities into multicommunity groupings (Newsom and Wing 2004:31–32, 78–79, 118–119; Rouse 1992).

The Late Ceramic Period is marked by intensification of the sociopolitical system, increased economic activity, intensification of plant food production, and population growth, particularly in the Greater Antilles. The number of ceramic styles also multiplies, coupled with a simplification in design and manufacture. The latter trend carries over into the production of personal adornment items, including beads and pendants. The number and type of settlements diversify, combined with expansion into new interior locations.

Archaeological evidence points to a transition from tribal political organiza-
tion to incipient to complex chiefdoms by the end of the period. Social strati-
fication takes the form of a two-tiered division into elites and commoners
(Newsom and Wing 2004:33, 61, 73, 119; Rouse 1992).

Objects and structural features modified from Early Ceramic examples,
or newly introduced, suggest their use in private as well as, increasingly, in
public ritual and ceremonial contexts. Formal ball courts and plazas are now
constructed in the Greater Antilles on level, prepared earthen surfaces in
rectangular, square, or oval/circular shapes. They can be partially or com-
pletely lined with varying arrangements of stones and earthen embankments
or may be unmarked. The enclosures likely served as places for ball playing
and more secular activities such as public dances (Alegría 1983; Oliver 1998;
Rouse 1992).

Three-pointed objects, so called because of their triangular shape involv-
ing a flat base and a central point between two end points, were primarily
made of stone. Examples from the Early Ceramic tend to be small and un-
decorated, while those of the later period are larger and incised with a va-
riety of anthropomorphic, zoomorphic, and iconographic designs. Ethno-
historical accounts suggest their functions included the promotion of fertility
and, most important, being physical representations of *cemí* spiritual beings
(Alegría 1997).

The Late Ceramic Taíno or Ostionoid populations are the direct ances-
tors of the contact- or historic-period Taíno that Europeans encountered
in the northern Caribbean. Chroniclers reported that settlements were per-
manent, averaging from 1,000 to 2,000 people whose subsistence was pri-
marily based on agriculture. People were divided into two classes: the elite
nitaíno and the common *naboria.* Complex chiefdoms or *cacicazgos* were in
place whose leaders or *caciques* were responsible for a number of functions
including organizing daily activities and serving as religious functionaries
(Alegría 1997; Rouse 1992).

Caciques also planned *areytos* or ceremonies that involved local as well as
adjacent communities. Marriages or deaths of *caciques,* in addition to events
such as natural disasters, provided occasions for the *areytos.* Drinking, feast-
ing, singing, and dancing over several hours formed the core activities of an
areyto, which was held in a central or public location. Song topics included
chiefly, community, and religious histories. Ball games played by both sexes
and mock battles were also part of the festivities (Alegría 1997:21).

Native populations throughout the pre-Hispanic Caribbean believed the
invisible world was inhabited by supernatural beings or *cemís* that included
mystical or godlike forces, life-sustaining energies, beings, and spirits of the

dead. *Cemís* acted for or against individuals' and society's interests and could manifest themselves in a variety of ways or objects such as smells, rocks, and animals. Their manifestations might, though not always, require some form of more permanent representation made from a number of materials. Examples include the aforementioned three-pointers; small freestanding sculptures largely of anthropomorphic design made of wood, stone, or perishable materials; and specially preserved skeletal remains. These representations were considered to embody the powers of the spirits, and they were also called *cemís* (Alegría 1997:23; Oliver 2005:246–248; Stevens-Arroyo 1988).

Names and descriptions of *cemís* in the chronicler accounts further suggest belief in a supreme male god, Yúcahu Maórocoti, and the fertility goddess Attabeira, along with lesser gods related to natural forces. Alegría (1997:23) succinctly summarizes the importance of these named or manifested *cemís/zemis:* "They were kept in special shrines, set apart from the houses of the Taíno, and symbolized a cacique's power. Zemis were the most important objects in Taíno society, representing social status, political power, fertility, and productivity."

As noted above, *caciques* were involved in ritual and ceremonial activities, as were *behiques* or shamans. These latter religious specialists undertook a variety of curing and magico-religious rituals. *Behiques* were considered to be mediators between the everyday and spirit worlds and played a key role in the interpretation of native cosmology (Newsom and Wing 2004:34; Rouse 1992).

Rituals and ceremonies conducted by both *caciques* and *behiques* might include the use of *cohoba,* a strong New World hallucinogen made from the seeds of the *Anadenanthera peregrina* or *Piptadenia peregrina* tree. Ground seeds mixed with crushed shell and occasionally tobacco were inhaled into the nose through tubes made from animal bones, ceramics, or wood. Additional associated *cohoba* ritual items included carved sticks to induce vomiting to ensure a proper ritual state and spoons to relay the powder or snuff. *Cohoba* produced an altered state allowing the individual to communicate with supernatural spirits and dead ancestors (Alegría 1997:24).

Cultural diversity and increased complexity were also hallmarks of the Lesser Antilles in the Late Ceramic. The Leeward Islands in the north appear to have been developing along the lines of the sociopolitical systems of the Greater Antilles. In contrast, the Windward Islands, Trinidad, Tobago, Aruba, Bonaire, and Curaçao appear more oriented toward cultural developments from the northern South American continent as seen, for example, in mutual ceramic influences (see Figure 1.3). While population growth is noted for the Lesser Antilles, a decline nonetheless occurs around A.D. 1200 even leading

to possible abandonment of certain islands. A final northern South American migration occurs at the end of the period with Island Caribs moving into the Lesser Antilles (Newsom and Wing 2004:34, 79).

Volume Organization

Our review of Caribbean rock art is ordered by island from north to south: the Bahamas to Aruba. The information we solicited on the several topics noted above was received from authors for the following areas: John Winter on the Bahamas; Racso Fernández Ortega, José B. González Tendero, and Divaldo A. Gutierrez Calvache for Cuba; Lesley-Gail Atkinson, in addition to Johannes H. N. Loubser and Philip Allsworth-Jones, on Jamaica; Rachel Beauvoir-Dominique for Haiti; José Gabriel Atiles Bidó, as well as Adolfo López Belando, on the Dominican Republic; Michele H. Hayward, Michael A. Cinquino, Peter G. Roe, Pedro Alvarado Zayas, and Kenneth S. Wild for Puerto Rico and the U.S. Virgin Islands; Gérard Richard on Guadeloupe; Sofia Jönsson Marquet for the southern Windward Islands; Jay B. Haviser on Bonaire; and Harold Kelly for Aruba.

Two additional articles complement the specific-area presentations. George V. Landon and W. Brent Seales present a new method to document petroglyphs via three-dimensional laser scanning and discuss the research potential of the resulting digitized images. In the final chapter Peter G. Roe brings together these and other authors' data while assessing the current status of Caribbean rock art, suggesting additional research directions, and offering interpretive statements or views.

We have chosen to present the chapters in their regional context. The area's island setting and colonial legacy are evident in this volume's varied investigative approaches. Further, English for nearly half the authors is not their native language. The translations and editorship are designed to maintain the writing styles, spirit, and meaning of all of the initial submissions.

2

Rock Art within
the Bahamian Archipelago

John H. Winter

Introduction

The Bahamian archipelago, which consists of the Commonwealth of the Bahamas and the Turks and Caicos Islands, lies 97 km north of the Greater Antillean islands of Cuba and Hispaniola. The archipelago evolved from shallow-water carbonates beginning 200 million years ago. During the past two million years, the sea level first lowered then rose, causing the meltwater from the last ice age to flood these carbonate banks. These factors contributed to the current island formation, which developed about 4,000 to 5,000 years ago (Sealey 1994).

From A.D. 700 to European contact, the Bahamian archipelago flourished with Amerindian populations who migrated from the Greater Antilles (Granberry 1955; Keegan 1997; Winter et al. 1985). Upon arriving in the island chain, the migrants found primeval forests containing mastic (*Mastichodendron foetidissmum*) and mahogany (*Swietenia mahogany*) trees covering the relatively flat limestone islands (Winter 2001). Only Cat Island has an elevation exceeding 61 m above sea level (Sealey 1994). While these islands had no rivers or streams, freshwater ponds and subsurface freshwater lenses were alternatively present (Winter 2001). They were accessible by excavating through the nonlithified carbonate dunes or by climbing into lithified limestone solution holes.

These new environments of purely sedimentary-rock origin differed notably from the settlers' homelands, which contained sedimentary, igneous, and metamorphic rocks that formed coasts and mountains giving rise to freshwater streams and rivers (Winter et al. 1985). The disparity between these environments greatly influenced the migrants' survival strategies. Ceramics were now created using shell rather than quartz for temper. There was a greater reliance on the sea for food resources than on the land (Winter and Gilstrap 1991).

The northward frontier migration of settlers from the Greater Antilles began with Ostionan Ostionoid populations, ca. A.D. 600 (Keegan 1997; Figure 1.2, this volume). Eventually Meillacan and Chican Ostionoid (Taíno) populations, via migrations, trade networks, or both, spread into the archipelago (Rouse 1992; Winter et al. 1985). By the time of Christopher Columbus's entry into the New World in A.D. 1492, the adaptive strategies of resident and subsequent groups evolved into the Palmettan Ostionoid culture (Granberry and Winter 1995). The Europeans referred to them as Lucayans, derived from their native term *Lukku-cairi* (Granberry 1973). The Lucayans maintained many of the sociocultural customs of their homelands, reflected in language, geographic knowledge of the region, ceramic decoration, and religious ideology (Dunn and Kelley 1989; Keegan 1997).

A specific aspect of religious cultural expression that was transferred into the Bahamian archipelago involved the execution of images on rock surfaces. To date, Bahamian rock art has been found only in caves, where petroglyphs predominate over pictographs. While research on the images has been limited, Williams (1985) included a sample based on Hoffman's (1973) freehand sketches in his comparative study of prehistoric northern Amazonian and Antillean petroglyphs. Williams argued that most of the Antillean petroglyphs were of the Timehri type, named after anthropomorphic figures found on the Corartijn River, the Guianas, in northeast South America (Figure 1.1, this volume). These figures appear to illustrate a costume used as part of a masked fertility dance of horticultural groups on the Upper Vaupes, Colombia.

The Timehri type includes complete or masked anthropomorphic figures. The complete figures exhibit three components of the costume: a rayed lunate crest; a body displaying various design elements; and a basal arrangement of parallel verticals signifying a raffia skirt. These images resemble Antillean wrapped or enclosed motifs. The masked figures are often shown as faces with various forms: round, triangular, lunate with rays, and square. Williams maintains that this type is designed toward securing or maintaining objectives of subsistence horticulturalists—the kind of lifestyle that has been reconstructed for the Lucayan Taíno. The distribution of the Timehri type implies a northward diffusion from Amazonia. If Bahamian rock art is included in Williams's classification scheme, then the issue of context must be addressed, as certain of his assigned meanings may have been lost and new ones added en route to the Antilles from Amazonia.

A low frequency of geometric designs is also present. Anthropomorphic, as well as geometric, petroglyphs vary in design elements between islands of the archipelago and even within caves from the same island, suggesting that further typological classification will prove fruitful for research.

Lucayans, like their ancestors, incorporated features of the natural cave systems into their renderings of petroglyphs. Within the Bahamian archipelago, petroglyphs can be found in either solution caves or solution holes. The rising and falling of sea levels during the previous ice ages resulted in the formation of these elements within limestone rock. The solution caves, also known as wide-mouth or narrow-mouth flank-margin caves, form at the interface of the freshwater and saltwater mixing zone near the shoreline, while the solution holes form as the freshwater works its way to the groundwater table and the inland mixing zone (Mylroie 1988). The wide-mouth caves provide sufficient work area and ample smooth-surfaced limestone walls. These caves contain many petroglyphs. The solution holes or narrow-mouth caves have a limited work area. They can be found in the interior or facing inland and often possess only a single petroglyph. Limestone rock surfaces of whatever cave type were probably etched out with a conch (*Strombus spp.*) shell blade.

Description of Bahamian Rock Art Sites

Hartford Cave

The archipelago contains numerous large and small caves that have yet to be surveyed, leaving open the high likelihood of additional discoveries. The oldest and most renowned site is Hartford Cave at Rum Cay. Mallery (1893) published an early report of the cave and its contents, which was expanded upon by Núñez Jiménez (1997). The cave represents a wide-mouth flank-margin type that provides plentiful sunlight during the summer months. It lies 30 m from the sea and measures 13 m wide at the entrance and more than 30 m deep.

I visited this cave three times over a 10-year period (1980, 1982, and 1989). During my first visit, the limestone rock walls were very damp, with green algae covering the limestone surface making it difficult to identify the petroglyphs. A three-year period of reduced rainfall conditions preceded my second visit. Due to a lack of ground moisture, much of the green algae had died, revealing additional petroglyphs. These dry conditions were also apparent during my third visit, when even more petroglyphs were observed. Núñez Jiménez (1997), during his 1988 trip to the Bahamas, recorded 63 petroglyphs and one pictograph. Since then I have located two petroglyphs near the western entrance to the cave that were not reported by Núñez Jiménez. Within the archipelago, Hartford Cave possesses the largest assemblage of petroglyphs.

This large assemblage suggests the cave played a central role in the life of an individual community or of multiple populations. For instance, a major coastal Lucayan settlement designated RM 3 (Keegan 1985) lies about 1,000

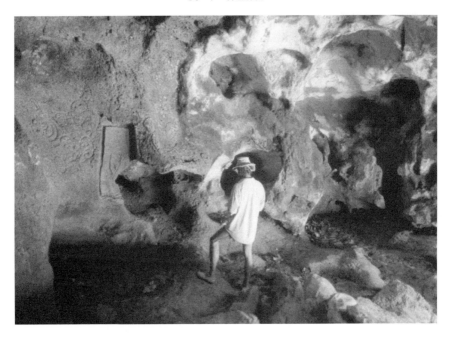

Figure 2.1. Interior section of petroglyphs in Hartford Cave, Rum Cay, the Bahamas (photograph by Winter, 1989).

m to the east of Hartford Cave. This archaeological site has not been excavated, hence its possible association with the rock art location remains undefined. Part of RM 3 has eroded away through storm action since its abandonment, providing evidence that the shoreline of the northern coast extended farther seaward. This would have made the cave more accessible to the Lucayans.

The easiest access into the cave is by the western edge. The entrance contains a large humanlike face 38 cm wide by 29 cm high. Below the face at ground level are two concentric circles measuring respectively 29 cm wide by 30 cm high and 18 cm wide by 20 cm high. Since my initial trip, sand has been filling the cave entrance so that the concentric circles are being covered. Perhaps the figures are guardians for the cave or signs of ownership.

Most of the petroglyphs occupy the rear of the cave (Figure 2.1). Although no cutoff line separating the images is readily apparent, I grouped individual figures into larger clusters after observing patterned marked and unmarked areas on the cave walls. Each area has at least 10 petroglyphs within a section of the rock wall, based on my original observations.

A majority of the petroglyphs of the archipelago depict simple circular or oval humanlike faces with two eyes and a mouth, as is the case for Hartford

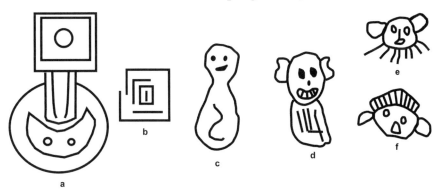

Figure 2.2. Representative petroglyphs from the Bahamas: a, representational masked face; b, geometric design; c and d, wrapped or enclosed anthropomorphic figures; e, humanlike face with rays and ears; f, humanlike face with ears and headdress (a–d, drawing by Winter, 1982; f, drawing by Winter, 1975).

Cave. One of the petroglyphs is decidedly different, illustrating as it does a pre-Columbian-style paddle for a canoe. This form of water transportation is well documented from ethnohistoric sources for the contact-period Taíno (Rouse 1992) and, it seems, Late Ceramic Period (A.D. 600–1500) populations as well. The petroglyph has been removed from the cave and was initially placed in the New World Museum and later at the Gerace Research Center, both on San Salvador Island.

This paddle image came from the first identified petroglyph cluster area. Above and to the left of where the paddle was removed, there appears to be a large masked figure measuring 69 cm high by 43 cm wide (Figure 2.2a). A squared geometric design, 20 by 20 cm, is located to the right (Figure 2.2b).

The second cluster area exhibits an intriguing set of figures. Figure 2.2c depicts a head and body outline enclosing minimal internal features and lacking or having infolded appendages. Enclosed figures may represent dead ancestors wrapped in hammocks as part of the preparations for their interment (Roe 1997a:154–155). To the right of this figure lies a facial image with a broad set of teeth, two large circular eyes, a triangular nose, two ears, and an enclosed body (Figure 2.2d).

The representation of teeth is singular and may relate to Taíno oral tradition. The teeth resemble some carved conch teeth that I excavated from LN 12 (East Stella Maris, Long Island, Bahamas; Winter 1990). LN 12 seems to be a late Lucayan site, as Spanish sherds were recovered. The excavated shell teeth were probably used as inserts in wooden *duhos* (carved, low seats used by *caciques* and shamans as emblems of power and prestige; see Alegría

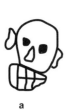

a b c d

Figure 2.3. Representations of Taíno *cemís:* a, Bahamian Yúcahu (drawing by Winter, 1982); b, Puerto Rican Yúcahu (Olsen 1973:Figure 3); c, Bahamian Attabeira (drawing by Winter, 1982); d, Puerto Rican Attabeira (Olsen 1973:Figure 11b) (Olsen figures used with permission).

1997) or three-pointed stone objects (see Alegría 1997; Hayward, Atkinson, and Cinquino, Introduction, this volume). This particular face resembles several carvings that are observed on *duhos,* stone objects, and shell ornaments from the Greater Antilles. In fact, the face in Figure 2.2d bears a striking resemblance to other Antillean representations of the Taíno *cemí* Yúcahu, a male deity identified as the giver of manioc (Olsen 1973) (compare Figures 2.3a and 2.3b).

The third cluster is located in the southeast corner of the cave. Again, many of the motifs consist of humanlike faces, either oval or circular, with two eyes and a mouth. Sometimes rayed lines projecting below or above the face are added (Figure 2.2e). One headless figure appears to be squatting and may, following Olsen's (1973) consideration of iconographic representation, depict another Taíno-named *cemí* spirit, Attabeira, the fertility goddess. Two enclosed images with faces and folded or absent limbs complete the third cluster.

On the eastern corner of the cave wall, isolated from the other petroglyphs, is a lone design that utilizes two natural holes in the rock that are enclosed in a large upright oval. I did not notice the pictograph described by Núñez Jiménez (1997).

McKay/John Winter and Kelly Caves, Crooked Island

The north-central coast of Crooked Island has two wide-mouth flank-margin caves within the same lithified dune ridge. McKay Cave, which Núñez Jiménez (1997) renamed John Winter Cave, faces north, while Kelly Cave faces a southwesterly direction. The entrances to both caves lie over lithified limestone rock.

McKay Cave stands at the edge of the sea, so that ocean spray enters the

cave at high tide. The cave measures more than 25 m deep and 30 m wide at the entrance. I explored this cave in 1974 and identified only five petroglyphs. Núñez Jiménez (1997), during his 1988 exploration, found additional petroglyphs, bringing the total to 10, all located on the rear wall. Two of the faces appear to wear crowns or perhaps feathers in their hair, one of which is illustrated in Figure 2.2f. The other is quite different in that the face is not as rounded and perhaps a neck is present attached to the face.

Kelly Cave represents a rock overhang covered in vines. Hoffman (1973) initially reported on the petroglyphs that lie along the northern wall. Two of the head motifs have headdresses or feathers. Kelly Cave yielded remains from the prehistoric period: ceramics and human bone. A definite dissimilarity between the shapes of the faces in the two caves is evident, with the McKay figures having more curves and the Kelly ones being more linear. These variations suggest that they were produced by different groups or during different time periods. One additional carving in Kelly Cave that is above and to the right of the other petroglyphs may be historic. This petroglyph reveals a human figure that is holding a cross. Early contact with the Spanish is possible since Christopher Columbus is reported to have landed on the western shore of Crooked Island.

Additional Locations

Hamilton Cave represents the only recorded site on Long Island with pictographs. Located south of Deadman's Cay, the location comprises a 1,000-m-long solution cave with several openings. Núñez Jiménez (1997) describes the figures as black-colored anthropomorphs and zoomorphs.

De Booy (1912) discovered six petroglyphs in the main chamber of the "New No. 1 cave" at Jacksonville, East Caicos Island. Although this island is not within the Bahamas political jurisdiction, its population in the prehistoric period was part of the Lucayan culture. The images appear to be anthropomorphic. The type of limestone cave formation is not described.

The remaining known petroglyphs are found in solution holes or narrow flank-margin caves. On the eastern edge of Rum Cay near the Salt Pond entrance is Goat Cave, a narrow flank-margin cave that faces inland. Near the entrance is a semicircular humanlike facial design that shows only a pair of eyes. It measures 30 cm wide by 17 cm high with the inner arc being 13 cm high. Each eye lies 5 cm above the base line and within the arc. Stacked in one corner of Goat Cave were more than 70 Queen conch (*Strombus gigas*) shells that had small circular holes at the apex, indicating processing prior to consumption within the cave. No excavations have been carried out in the cave.

Salt Pond Cave, also a narrow flank-margin cave, is found on Great Inagua

Island in the southwestern interior. Past the entrance of the cave, the central chamber divides into two sections. At the dividing point are two petroglyphs: a simple anthropomorphic face and another facial image with a rayed crest. On San Salvador, Sugar Loaf Sinkhole and Beach Cave each possess a facial petroglyph. The former cave is a solution hole that contains freshwater, while the latter represents a narrow flank-margin cave. Beach Cave also yielded ceramics and human skeletal material from the prehistoric period.

Interpretive Remarks and Future Research

This brief review of Bahamian rock art, along with the studies by Williams (1985) and Núñez Jiménez (1997), reveals similarities as well as differences with the rock art of the remaining Caribbean islands. Migrating populations from the Greater Antilles continued the tradition of producing rock art, as well as making allowances for the different rock surfaces they found in their new homeland. Motifs and design elements in the Bahamas highlight parallels with those in the Antilles yet exhibit differences that mark a new interplay between people, their culture, and their environment.

I have suggested, for example, that the toothed humanlike facial image from Hartford Cave closely resembles other Caribbean depictions identified by some (see Olsen 1973 and Figures 2.3a and 2.3b) as the Taíno-named *cemí* Yúcahu, while the squatting figure from the same cave may represent Attabeira (see Olsen 1973 and Figures 2.3c and 2.3d). The large array of petroglyphs in Hartford Cave and McKay Cave might indicate that these functioned as central ceremonial centers for the Lucayans. In terms of the arrangement of the petroglyphs, each occupies a distinct space and no overlapping of motifs occurs. The significance of this "rule" or "proscription" for the production of rock images remains unclear, as does the meaning of geometric designs. The enclosed forms and humanlike faces, as has been suggested elsewhere for the Caribbean (Roe 1997a), may relate to ancestor worship, a central component of Taíno religion (see Siegel 1997), or a fertility costume (Williams 1985). The rayed figures might be representations of Lucayan deities of sun or rain or may be masked fertility figures (Williams 1985).

An issue can be raised regarding the distribution of the rock art. While not all caves have been investigated, it is clear that certain ones were selected. One possibility is that the caves with one or two petroglyphs may indicate territorial markers from ancestral founders. Lone petroglyphs, such as in the freshwater well at Sugar Loaf on San Salvador Island, might indicate ownership of the water source by way of ancestral ties.

Although Núñez Jiménez (1997) and I (Winter 1993) have undertaken

studies concerning the nature and function of Bahamian rock art, much more research needs to be done. Surveys for additional rock art sites are of critical concern, despite the problems of accessibility to widely spaced islands of the archipelago. Detailed documentation of the images and physical surroundings, in addition to comparative intersite and intrasite studies, are among the essential types of investigations required for a systematized and comprehensive database. Linkages with known and dated habitation sites or other site types should be established to place rock art sites within broader cultural and physical contexts, as well as to develop a chronological framework. Since large-scale permanent settlement in the Bahamian chain did not occur until the Late Ceramic Period, image comparisons, especially with the Greater Antilles, will aid in the elaboration of both local and regional spatial-temporal models.

Summary

During the Bahamian historic period (1780s to 1830s) most of the caves were exploited for their guano and soil concentrations. After the excavation of the cave deposits, scattered cultural materials were exposed and many of the petroglyphs and pictographs were left intact. Whether the rock images functioned in fertility ceremonies, ancestor worship, or territorial ownership is unclear. What is apparent is that the Greater Antillean sociocultural traditions continued into the Bahamian frontier. The presence of rock art points to a common heritage that united the frontier Lucayan Taíno of the Bahamian archipelago and the homeland Taíno of the Greater Antilles.

Acknowledgments

I want to thank the following individuals for logistical or financial support during my research in the Bahamas: Dr. Don and Kathy Gerace of the Gerace Research Center (formerly the Bahamian Field Station); Mr. David Melville of the Rum Cay Club; The Foundation for Field Research; Mr. Georges Charlier; Mr. Basil Kelly; and Mr. Eugene Pyfrom. Ms. Lynne Quiroz helped with the computer imaging of the figures. Dr. A. Nicholas Fargnoli proofread the paper, while Mrs. Takako Winter assisted with the Photoshop applications.

3

History, Survey, Conservation, and Interpretation of Cuban Rock Art

Racso Fernández Ortega, José B. González Tendero, and
Divaldo A. Gutierrez Calvache

Translation by Michele H. Hayward

History of Cuban Rock Art Research

Nineteenth Century

We divide our review of Cuban rock art research into three stages based on chronology, in addition to theoretical and political currents. Nineteenth-century works concerning the island's rock art by both Cubans and non-Cubans primarily consist of straightforward descriptions and untested statements concerning the images. These early references begin with the 1839 article "Apuntes para la Historia de Puerto Príncipe" published in the *Memorias* of the Real Sociedad Patriótica de La Habana (Anon. 1839), which mentions figures on the walls of Cueva de María Teresa, in the mountains of Sierra de Cubitas, Camagüey Province (Núñez Jiménez 1975:154). Two years later, the noted poet Gertrudis Gómez de Avellaneda (1963 [1839]) referenced this same cave in her novel *Sab*.

The Censo de Población (census) of 1847 reported the existence of a cave with pictographs at Banes, Oriente, in the present Holguín Province (Comisión de Oficiales 1847:216). This information was later reprinted in the daily *Faro Industrial de La Habana* on April 10 of the same year (De la Torre 1847). The Spanish geographer Miguel Rodríguez Ferrer, who pioneered archaeological investigations in Cuba, did not consider the pictographs to be works of "art" nor the products of the island's pre-Hispanic people. He advanced this position in an 1876 publication, an opinion that later prevailed at the 1881 Madrid Congress of the Americanists.

Additional information on rock art sites during this period comes from the following sources: the work by D. Ramón Piña y Peñuela that lists some sites in the Sierra de Cubitas, Camagüey Province (Piña y Peñuela 1855:249); a group of young people who explored three of the caves in the Sierra de Cubitas in 1847, who also note, but without specifics, the presence of picto-

graphs and whose encounter was subsequently published under the title *Una gira cubana* as part of José Ramón Betancourt's 1887 compilation *Prosa de mis versos* (Betancourt 1887); the priest Antonio Perpiñá's references in his 1889 publication to a cave with red-colored linear pictographs in the same mountain range; meager mention of one petroglyph at the extreme east end of Cuba by the French archaeologist Alphonse Pinart (1979:82) as part of a larger study of Caribbean rock images; and a two-sentence mention in Brinton (1898:255) of a petroglyph site along a river in the center of the island.

Twentieth Century

Twentieth-century research into Cuban rock art reflects local political developments, as well as worldwide scientific discoveries and the replacement of chronicler-based information on New World cultures by archaeologically based reconstructions. Early works comprise the following: comments on petroglyphs (note that early investigators might be unsystematic in their application of rock art terms) by the American Jesse W. Fewkes (1904:590–591) of the Smithsonian Institution, including a reference to the Brinton-mentioned petroglyph site in the center of the island; mention of the Cueva No. 1 rock art site in a 1910 publication by the Frenchman Charles Berchon; and Cuban Juan Antonio Cosculluela's first use of the term *petroglyph* in a national publication to refer to carved images as opposed to painted designs (Cosculluela 1918:176–177). The latter represents an important distinction since it had yet to be accepted that the island possessed petroglyphs in addition to pictographs.

Mark R. Harrington in the mid-1910s began his investigations in the eastern portion of Cuba sponsored by the Heye Foundation of the Smithsonian Institution. In the Maisí area, Guantánamo Province, he located a petroglyph assemblage in the Cueva del Agua, also known as Cueva de los Bichos or Caverna de Patana, on a raised marine terrace. The grouping included three petroglyphs plus one sculpted into a stalagmite measuring 1.2 m high, called the Gran Cemí. Harrington published descriptions of this site initially in English (Harrington 1921) and only later in Spanish versions (Harrington 1935). The petroglyph itself currently resides at the Smithsonian. Based on his analysis of ceramics present in the cave, Harrington attributed the figures to the Taíno, although a possible association with the pre-Taíno ceramic people was left open.

Harrington's rock art discoveries alongside the noted Cuban Fernando Ortiz's revisit to the Punta del Este cave system in the early 1920s initiated an era of scientific study of the island's rock images. This new era is characterized by systematic examination of the figures paired with meticulous descriptions of attributes including their colors, forms, and line widths.

In particular, Ortiz's work at the Punta del Este Cueva No. 1 (alternative names: Cueva de Isla or Cueva del Humo) stimulated the interest of a group of investigators from the Museo Antropológico Montané of the Universidad de La Habana in addition to that of members of the Grupo Arqueológico Guamá. All belonged to the Junta Nacional de Arqueología y Etnología, including René Herrera Fritot, Fernando Royo Guardia, Luis Howel Rivero, Oswaldo Morales Patiño, Juan Antonio Cosculluela, and Carlos García Robiou, who began organized work at Cueva No. 1 in the second half of the 1930s. The rock images and their relationship to the island's pre-Columbian inhabitants formed the focus of these investigations, whose principal results were published by Herrera Fritot in 1938.

Press reports of rock art sites at the beginning of the century comprise the following: a cave with petroglyphs in the region of Sama, Holguín Province; the Punta del Este Cueva No. 1; the supposed discovery of petroglyphs and pictographs in caves of the Sierra de Tapaste in La Habana Province and in the hills of Gavilanes, Villa Clara Province; and petroglyphs at the Cueva de Waldo Mesa (García y Grave de Peralta 1939:29; Massip 1932, 1933). Mention should also be made of petroglyphs located in the Banao Hills of the Sancti Spíritus Province by members of the Grupo Guamá organization in the Farallones de la Virtud or del Garrote area (Morales 1949:144).

Ortiz continued his research at the Punta del Este Cueva No. 1, finally summarizing his investigations as a chapter within his broader-themed 1943 work. His detailed and comparative study of the cave's images stood for a long time as a research model, easily surpassing in substance the three previous articles by Herrera Fritot in 1938, 1939, and 1942 on the Grupo Guamá and Museo Antropológico Montané members' studies. Ortiz's notable investigative techniques involved the use of design element number and distribution patterns to define a pictograph type that he termed "curvilineal." This represents a first attempt at devising a classification scheme based on line widths, color, production techniques, and motifs. He also advanced possible meanings for the figures, including their function in astronomical observations, through rigorous contrast of the images.

The founding in 1940 of the Sociedad Espeleológica de Cuba (SEC) proved to be another invigorating force in Cuban rock art studies. SEC members brought about the increased exploration of caves, thereby expanding survey coverage throughout the island. Ortiz and Herrera Fritot again figure as particularly involved spelunkers, as were Antonio Núñez Jiménez, Manuel Rivero de la Calle, José M. Guarch del Monte, and Jorge Calvera Roses, among others.

The 1950s to the 1970s mark the most productive years in terms of publications on Cuban rock art. Articles appeared in such journals as *Carteles, Bohemia, Lux, Cuba,* and *INRA,* as well as sections of larger works by Tabio and

Rey Betancourt (1979) and Rivero de la Calle (1966). The successful revolutionary movement between 1960 and 1970 also resulted in the establishment of government institutions that supported new and ongoing research into the country's pre-Columbian past, including its rock art.

A singular research effort from this period concerns Núñez Jiménez's 1975 book *Cuba: Dibujos rupestres,* which brings together his and others' investigative results on rock art sites. His personal knowledge of known sites at the time makes this an especially informed compendium. Núñez Jiménez also compiled a useful sample of photographs and tracings of pictographs and petroglyphs, many of which for the first time were made available to researchers in addition to the general public.

Guarch del Monte represents another dedicated later twentieth-century student of Cuban rock images, who brought a theoretical bent to the discipline. Although he was not as prolific as Núñez Jiménez, his publications nonetheless provide fertile ideas for interpretation. His 1987 monograph includes much of his work regarding rock art. Other articles worth noting are those by Rivero de la Calle (1961), Mosquera (1984), Matos (1985), Escobar Guío and Guarch Rodríguez (1991), La Rosa Corzo (1994), and Arrazcaeta Delgado and García (1994).

End of the Twentieth and Beginning of the Twenty-First Century

Despite a smaller number of researchers being involved in island rock art studies in the past 20 years, investigations have continued and there have been improvements in the documentation and understanding of the rock images. Local internal communication, in addition to organizing and attending national and international conferences, has kept individuals informed of the broader movements in rock art studies. Particular recent publications include those by Romero (1997), García (2004), Pereira (2004), Alonso et al. (2004), and Guerrero and Pérez (2004).

We also identify in the emerging literature by Cuban rock art investigators a theoretical framework that we term "archaeo-anthropological," which views rock art as an integral part of the archaeological record. Representative authors include Calvera and Funes (1991), Fernández Ortega and González Tendero (2001c), and Gutiérrez Calvache (2004).

As for publication sources, we estimate that 80 percent of the information on rock art is disseminated through the *Boletines* series, produced in mimeograph form through the support of individual speleological groups, and in reports appearing in *Libros Resúmenes* from different local, national, and international meetings primarily sponsored by the SEC. Another important source comprises *Cartas Informativas,* which are unbound yet keep the national and international academic communities informed of archaeological work on the island.

Publications that seek to broaden circulation include the *Boletín Casimba,* the official bulletin of the Grupo Espeleológico Pedro Borras of the SEC; the compendium *Arqueología de Cuba y de otras áreas antillanas* of the Academia de Ciencias de Cuba; the yearly *El Caribe Arqueológico,* from the Casa del Caribe de Santiago de Cuba, with the support of the Fundación Taraxacum S.A.; and finally the *Boletín del Gabinete de Arqueología* from the Oficina del Historiador de La Habana, which featured articles on rock art in 1996 and 2001.

We end our review with a short list of what we consider to be critical sources on Cuban rock art from any period: *Las cuatro culturas indias de Cuba* (Ortiz 1943); *Cuevas y pictografías, Caguanes pictográfico,* and *Cuba: Dibujos rupestres* (Núñez Jiménez 1967, 1970, 1975); *Arqueología de Cuba: Métodos y sistemas* (Guarch del Monte 1987); *Arte rupestre: Petroglifos Cubanos* (Guarch Rodríguez and Pérez 1994); *El arte rupestre de Rodas* (Rodríguez and Borges 2001); and *El enigma de los petroglifos aborígenes de Cuba y el Caribe Insular* (Fernández Ortega and González Tendero 2001a).

Rock Art Site Particulars

Rock Art Site Distribution

The beginning in 1999 of the Proyecto Cuba: Dibujos Rupestre, in the Sección de Antropología y Arqueología of the SEC, has greatly aided the systematic survey and registry of rock art sites throughout the island. Many individuals, especially members of the SEC, have contributed to the development of a Mapa Rupestrológico Nacional and Catálogo del Dibujo Rupestre Cubano that updates and complements Núñez Jiménez's 1975 listing (for an English version of the latter see Linville 2005: Table 5.1).

To date, some 65 percent of the island's karst topography has been explored, with a tally of 192 cave locations with rock images. Table 3.1 presents the distribution by province and type. Currently, those provinces with the greatest number of sites in descending order are Matanzas (45), Guantánamo (35), Pinar del Río (28), Sancti Spíritus (22), and La Habana (19). Pictograph and petroglyph sites tend to occur separately, with the former outnumbering the latter two to one. A small percentage of sites contain both carved and painted images.

Most Cuban rock art sites are located in caves or cavelike settings, a not unsurprising number given that 66 percent of the country consists of karst topography. Thus far only three sites, all petroglyph ones, have been documented in open-air locales. The La Loma de la Chicharra and El Dolmen de Taguasco sites are located in the Sancti Spíritus Province in the center of the country. The third site, Maffo Petroglyph, is found on a boulder along the Contramaestre River in the eastern province of Santiago de Cuba.

Table 3.1.
Number and Type of Cuban Rock Art Sites by Province

Province	Number of Sites	Number of Pictograph Sites	Number of Petroglyph Sites	Sites with Both Types
Camagüey	8	8		
Ciego de Ávila	1	1		
Cienfuegos	5		3	2
Ciudad de la Habana	2	1		1
Granma	3	1	2	
Guantánamo	35	1	33	1
Holguín	10	4	6	
Isla de la Juventud	12	12		
La Habana	19	14	4	1
Las Tunas				
Matanzas	45	43	2	
Pinar del Río	28	22	5	1
Sancti Spíritus	22	15	3	4
Santiago de Cuba	1		1	
Villa Clara	1		1	
Total	192	122	60	10

Even though petroglyph sites are located throughout the country, most are concentrated in the eastern region in the provinces of Guantánamo, Holguín, Santiago de Cuba, and Granma. Execution via pecking or abrading characterizes these petroglyphs, which are largely sculpted on secondary formations at the entrances to or on the walls of caves. Simple anthropomorphic designs predominate, and some have been interpreted as representations of deities associated with Ceramic Period agricultural groups that are known from these areas (Fernández Ortega and González Tendero 2001a:47).

Incised petroglyphs, in contrast, are concentrated in the western portion of the country, from the Sancti Spíritus Province westward but especially between the provinces of Matanzas and Pinar del Río. Two locations are known from the eastern Holguín Province. Here the image-makers employed cave walls as well as ceilings for their compositions, leaving aside secondary formations. Images are found in natural and semilit salons and connecting chambers of caves. Forms are varied, although geometric, intersecting line, and rectilinear designs figure prominently. A particularly notable site involves Cueva de los Petroglifos, Pinar del Río Province, where the image-maker incised a series of thin lines in soot or carbonized wall section (see below).

Pictograph distributional patterns differ significantly from those of petro-

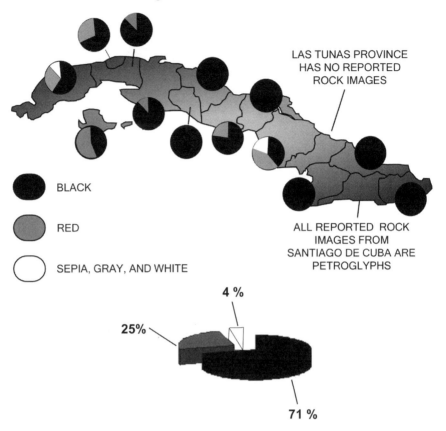

Figure 3.1. Distribution of pictographs by color for Cuba (map by Fernández, González, Gutierrez, 2006).

glyphs. Circumscription by color does not appear to be a particularly defining characteristic as are petroglyph execution techniques (Figure 3.1). A further difference involves location within caves where pictographs normally, if not exclusively, are only found on the walls, not on ceilings or secondary formations. Black is the most frequently used color, found at 122 locations in all parts of the island. Red-colored pictographs are found at 33 sites with a wide distribution; white and gray colors are minimally used for images with an associated limited distribution, followed by sepia-hued designs at a scant three locations in the eastern half of the country.

Color frequencies for particular types of caves can be noted for those that contain evidence of funerary activities. Of 16 locations, 69 percent of the pictographs were black, 12.5 percent red, and 12.5 percent indistinct red or black, leaving some 6 percent with a bicolor combination (Fernández Ortega 1994:6).

Rock Art Classification

Núñez Jiménez (1975), Mosquera (1984), Dacal Moure and Rivero de la Calle (1986), Maciques Sánchez (1988, 2004), and Alonso Lorea (2003) have attempted to categorize Cuban rock art as belonging to different styles, types, or schools. Their efforts at devising useful comparative or analytical units have proved of limited success beyond the study of images at particular or specific locales (Gutiérrez Calvache and Fernández Ortega 2005). These schemes also tend to treat rock art as homogeneous and as having functions, uses, and meanings that have changed little through the millennia. They omit the influence that such factors as different environments and adaptive strategies would have had on the psychology of rock art–producing groups.

We provide three classifications, two pictograph styles and one petroglyph style, in addition to reviewing particular sites that provide further details on Cuba's rock art.

Geometric-Figurative Pictograph Style

The Geometric-Figurative motif grouping represents a simple means of depicting surrounding reality in the cognitive world or context of the native image-maker. The style is characterized by geometric designs including circles (some images contain concentric forms), rectangles, triangles, and straight lines often crossing or forming designs suggestive of limited ideograms, as seen in Figure 3.2 (González Colón and Fernández Ortega 2001).

Images of this style are produced using red and black colors, with a marked preference for black, as was noted above for all pictographs (see Figure 3.1). No mixing of hues within individual designs is noted, although occasionally red and black figures are found close together on rock walls, but without any readily apparent association. In general, mural groups or isolated figures have been placed in interior cave locations that receive natural light for all or a good part of the day.

Gutiérrez Calvache and Fernández Ortega (2005) recognize variants of this grouping that contain anthropomorphs and zoomorphs elaborated with geometric forms in such caves as Ambrosio, Pluma, Mural, and María Teresa.

Interconnected Lines Pictograph Style

The Interconnected Lines style (Gutiérrez Calvache and Crespo 1991; Maciques Sánchez 1988) can encompass abstract figures, although it is geometric in its use of elements. Open-ended groupings of interconnected, labyrinth-like lines that leave off distinct segments are typical of this style.

Alternate terms for this style are "Random Lines" (Gutiérrez Calvache and Crespo 1991; Maciques Sánchez 1988) or "Chaotic Lines" (González Colón and Fernández Ortega 2002) (see Figure 3.3). Frequent forms in-

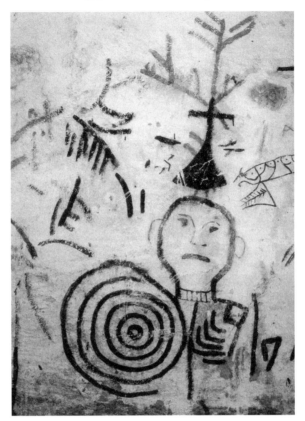

Figure 3.2. Cueva Ambrosio, Matanzas Province, Cuba.
Variant of Geometric-Figurative pictograph style. Human
figure possibly of African slave origin (photograph by
Fernández, González, Gutierrez, 2003).

clude grouped rectilinear lines, curves, dots, entangled lines, and free-form
(Gutiérrez Calvache and Crespo 1991; Maciques Sánchez 1988). In our opin-
ion, these images reflect minimal image-making rules where individual ex-
pression predominated and where our understanding of the rock image pro-
duction process remains at its initial stages.

In general the forms of the Interconnected Lines style are found in sec-
tions of caves that are narrow or difficult to access and without natural light,
in addition to side galleries that are practically perpendicular to the whole
cave system. Vegetable-based carbon applied directly to the walls accounts
for the black coloring used for the images. The figures sometimes leave the
impression that the image-maker deliberately incorporated irregularities in
the rock surface into the design (González Colón and Fernández Ortega
1998, 2001).

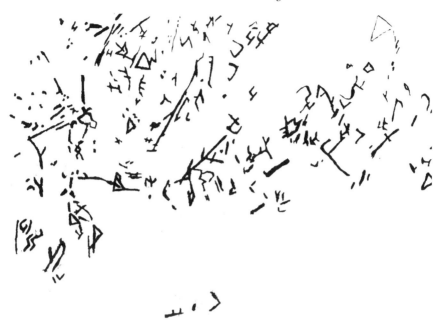

Figure 3.3. Interconnected Lines pictograph style, Cueva Pluma, Matanzas Province, Cuba (redrawn by Alexander G. Schieppati from photograph by Fernández, González, Gutierrez, 1987).

Patana Petroglyph Style

We prefer not to employ Western art terms and concepts such as those for styles (naturalist, abstract, figurative) in discussions on pre-Columbian rock image production. Our investigations suggest that at least Cuban rock art can be more profitably viewed as part of the process of change from schematic and geometric forms associated with hunting and gathering groups to forms associated with agricultural societies (Calvera et al. 1991; Gutiérrez Calvache et al. 2003; Izquierdo Díaz and Rives Pantoja 1991). This position will re-quire new and different lenses to view premodern people.

In this vein, we have recently defined the Patana style located in the Maisí area within the Guantánamo Province. The Cueva de los Bichos serves as the type-site for this classification, which is associated with the area's pre-Hispanic horticultural populations. The caves of this grouping demonstrate similarities in various attributes from the use of space to production methods and overall themes (Gutiérrez Calvache et al. 2003).

The Patana style represents a point in the mental development of agri-cultural groups that were confronted with the problem of how to physically characterize certain individual and group ideological conditions. In the Maisí context, petroglyphs proved to be one solution executed through pecking

and abrading, employing stone knives, axes, and chisels, typical tools of agricultural economies. The images contain what we see as narrative, anecdotal, and magical scenes that would have reinforced proper social conduct, as well as solicited aid in performing daily tasks. We also suggest that the petroglyphs functioned outside the religious system as topographic markers, specifically locating water resources, critical for subsistence and a scarce commodity in this area. The images can be found incised and engraved into the stalactites and stalagmites of the caves that receive natural light or in penumbral spaces.

Recent Discoveries

Even with 167 years of rock art research within Cuba, certain recently discovered sites remain little known to researchers. These include the Cueva de los Petroglifos and the Cueva de la Iguana, both in Viñales, Pinar del Río Province, and the province of Matanzas sites of Cueva del Mural in Carbonera and Cueva de la Cachimba in Cumbre Alta.

The Cueva de los Petroglifos is located in the Sierra de Galeras mountains, in Viñales Municipio (a local administrative division), Pinar del Río Province. The petroglyphs and pictographs at this location (Figure 3.4) were produced using four different techniques: soot applied, incised, incised over soot, and direct application of carbon. The Cueva de los Petroglifos represents thus far the only location in Cuba with these four application techniques and perhaps the only one in all of the Caribbean (Gutiérrez Calvache 2004).

The Cueva de la Iguana is located in another mountain system, the Sierra de Pan de Azúcar, of Viñales Municipio, at an altitude of more than 300 m. The cave contains nine petroglyph groupings elaborated with fine incised lines into a surface of decomposed limestone on the walls and roof. The rock images were discovered in 1998 by the Spanish spelunker Gaizka Carretero during Expedición Espeleológica Cubano-Vazca Mogote '98 (Les Jabier et al. 1998).

Entering through the cave's mouth, known as the Boca de la Iguana, and advancing through a tubular chamber for some 60 m from the entrance, one finds the majority of the petroglyphs in numerous overhead solution vaults. A small spring is also present whose waters disappear into a siphon, which has yet to be explored. Most of the images are finely incised with lines 1½ mm wide and scarcely 2 mm deep, a characteristic that is becoming more common as the rock images of the western region are increasingly investigated (Gutiérrez Calvache and Fernández Ortega 2006).

The Cueva de la Cachimba images are among those that display complex iconography. The cave is located in Matanzas Province, 2 km from the coast and 63 m above sea level in an emerging marine terrace zone (Arrazcaeta

Figure 3.4. Incised petroglyphs from Cueva de los Petroglifos, Pinar del Río Province, Cuba (an inverted and desaturated photograph from Fernández, González, Gutierrez, 1989).

Delgado and Navarrete Quiñones 2003) containing numerous caves with archaeological sites.

This particular rock art assemblage exhibits a minor number of pictographs along with some 174 petroglyphs that are complex and abstract in design. The large panel currently represents the most extensive assemblage in Cuba. The assemblage is also unique among the sites of the terrace zone in having a mix of the pictograph styles discussed above.

The Cueva del Mural is known for its pictographs executed exclusively in red, which sets this site apart from the rest of the rock art locations on the north coast of the Matanzas Province and, in particular, the Carbonera area (González Colón and Fernández Ortega 2002).

The images are found in an interconnecting gallery, approximately 10 m long, that partially adjoins the large entrance hall of the cave. The pictographs initially appear as isolated figures, but as one takes in the setting, groupings

become evident and finally a mural composition measuring 1.5 by 1.3 m is apparent at the end of the gallery.

While the development of a systematic temporal and spatial framework for Cuban rock art is just beginning, we can nonetheless divide the island's rock images into three broad time periods: pre-Hispanic, early Hispanic occupation, and African slave. The Cueva Ceremonial No. 1 of the Guafe area in Granma Province serves as an additional example of pre-Hispanic images, while the Cueva de los Generales in the Sierra de Cubitas, Camagüey Province, is representative of native rock art designs under the influence of Spanish occupation. The Cueva del Agua in the town of San José de las Lajas, La Habana Province, depicts images made by African slaves escaping from nearby sugar plantations during the eighteenth and nineteenth centuries.

Conservation and Management Status

While vandalism, natural processes (time, climatic conditions, natural or introduced microorganisms), and inappropriate investigative techniques have all adversely affected the rock art of Cuba, the single most destructive problem is graffiti. People have used pencils, crayons, and different types of sprays and acrylic or oil-based paints to leave "their mark" in the form of letters, dates, and designs alongside the original rock images.

In part, the graffiti problem prompted the new revolutionary government, as early as its founding in 1959, to recognize the necessity for protecting the island's cultural heritage. The elaboration of a legal protective system took shape with Cuba's Parliament in 1976 with the approval of two laws, the Protección al Patrimonio Cultural y Natural and, second, Monumentos Nacionales y Locales. These laid the legal basis for the conservation of both cultural and natural resources through the establishment of the Registro de Bienes Culturales (a registry of cultural properties) and also defined the criteria for determining which sites would be protected under the law.

The Comisiones Nacional y Provincial de Monumentos attached to the Ministerio de Cultura and the provincial governments were subsequently charged with furthering conservation efforts. Among these organizations' functions is the granting of permits for explorations and archaeological excavations. They also approve the Monumentos Nacionales y Locales's list of sites that have been nominated by municipal delegations for protection.

More recently, the Comision Nacional de Monumentos issued Resolución No. 11, which established the special designation of a Zona de Protección (protection zone) that could be given to all archaeological sites, including those with rock art. This new designation parallels but is not equivalent to a

protected site or monument identification under Law No. 2. Unfortunately, the existing legal structure does not always prevent harm or destructive effects to sites from approved and unapproved visits (Fernández Ortega and González Tendero 2001c).

Conservation efforts have nevertheless been strengthened, especially in cases involving various rock art locations that have been designated as both protected monuments and protected zones. Examples include Cuevas Nos. 1, 2, 3, and 4, Punta del Este, in Isla de la Juventud Municipio; Caverna de Patana and Cueva Perla del Agua in Guantánamo Province; Cuevas Ambrosio and Santa Catalina in Matanzas Province; Grutas or Cuevas de las Mercedes and Pichardo in Camagüey Province; Cuevas el Cura, Mesa, and Paredones in Pinar del Río Province; and finally Cuevas la Virgen and García Robiou in La Habana Province.

To the list should be added those sites within national parks or natural reserves that have their own police or guards that have also managed to significantly reduce damage to the rock images. Examples are Cuevas de María Teresa and Matías in Camagüey Province; Cuevas el Fustete and Ceremonial Nos. 1 and 2 in Granma Province; and Cuevas Ambrosio and Los Musulmanes Nos. 1 and 2 in Matanzas Province. Table 3.2 summarizes the official protection status of Cuban rock art locations by province.

Guides are available for a limited number of sites due to their location within national parks or natural reserves. These include the caves Ambrosio and Los Musulmanes Nos. 1 and 2 in Matanzas; María Teresa, Matías, El Indio, and Los Portales in Camagüey; Ceremonial Nos. 1 and 2 and Fustete in Granma; and the four caves of Punta del Este.

Intellectual Currents in the Study of Cuban Rock Art

Nineteenth Century: Reports and Comments

Since the first half of the nineteenth century, reports on the existence of pre-Columbian petroglyphs and pictographs in Cuba have been found in literary, historical, and archaeological works. These examples, as detailed above, represent simple or low-level empirical statements, an unclear understanding of their origin, and a disinterest in actual field investigation or confirmation. We allow that the authors of these works likely were more concerned with reporting the existence of rock images than in their serious, scientific study. Many may not have even been to the sites they were reporting on (we do not refer here to any efforts by avocational archaeologists). For these reasons, we cannot characterize this period as belonging to any intellectual current or theoretical position, except to note that these works did bring public and eventually professional attention to the study of these cultural resources.

Table 3.2.
Protection Status of Cuban Rock Art Sites by Province

Province	Number of Sites	Local Monument	National Monument	National Park/ Preserve	Percent Monument
Camagüey	8	7			88
Ciego de Ávila	1			1	
Cienfuegos	5	2			40
Ciudad de la Habana	2	1			50
Granma	3	2		3	67
Guantánamo	35	4			11
Holguín	10	3			30
Isla de la Juventud	12	8	4	3	100
La Habana	19	11			58
Las Tunas					
Matanzas	45	5	5	4	22
Pinar del Río	28	6	1	13	25
Sancti Spíritus	22	14		17	64
Santiago de Cuba	1				
Villa Clara	1				
Total	192	63	10	41	38

Twentieth Century: Beginning of Systematic Investigations

In contrast to nineteenth-century reporters of rock images, twentieth-century investigators focused on the systematic survey and study of rock art, a perspective we term "cultural-morphological." This is evident in the publications of the century's leading figures, including Ortiz, Herrera Fritot, Núñez Jiménez, Rivero de la Calle, and Guarch del Monte.

While we have already noted the rigorous approach Ortiz employed in his rock art investigations (see above), it was Herrera Fritot who first championed this approach beginning in 1938 with his multiple visits to Cueva No. 1 of Punta del Este. His efforts resulted in the first detailed registry of the pictographs via drawings and photographs, as well as the first plan locating the principal images (Herrera Fritot 1939, 1942).

The systemization of efforts to locate additional caves with images throughout the country is linked to members of the SEC and, in particular, one of its promoters and presidents, Núñez Jiménez. Under his direction in the 1960s, emphasis was placed not only on site discoveries but also on obtaining different types of observations. For example, data were collected on the images under day and night conditions for possible correlations with astronomical

events, an area of investigation that has yet to be fully examined in the Cuban context.

Rivero de la Calle further promoted the new discoveries by serving as editor of four texts describing a number of locations including the Cuevas Ambrosio and Victoria in Matanzas Province, the important archaeological Caguanes zone in Sancti Spíritus Province with more than four pictograph caves, and the Cueva García Robiou in La Habana Province (Rivero de la Calle 1961, 1966, 1987; Rivero de la Calle and Núñez Jiménez 1958). Núñez Jiménez's substantive contributions to Cuban rock art (in addition to studies in other Caribbean and South American locations) are numerous (8 books and some 30 articles and conference presentations) and remain influential. In addition to his major 1975 work, *Cuba: Dibujos rupestres,* which contains a wealth of data on rock art sites known at the time (discussed above), he proposed a nonchronological morphologically based classification system with such terms as "step- or stair-like" forms and "eye-glass" shapes (Núñez Jiménez 1970:34, 1975:506, cf. 26–41). His site documentation system, however, was not widely adopted despite its simplicity and ease of application (Núñez Jiménez 1970:10).

Formal frameworks for understanding rock art took form in this century. Guarch del Monte (1987), even though his works maintain a descriptive tendency at the moment, established new concepts that have facilitated subsequent analysis, interpretation, and classification of pictographs into motifs and simple or complex design forms.

While we consider useful such divisions of pictographs into open and closed compositions, we also consider them limiting in obtaining a fuller understanding of the designs. Guarch del Monte appears to favor analysis of the image aesthetics, without attempts to elicit their meaning or function. For instance, in one study (Guarch del Monte 1987:59) his division of pictographs into motif and design categories results in the separation of adjacent or nearby images that might as a whole have formed a meaningful grouping. In other instances, motifs that by their design and morphology do not appear to have been produced at the same time (Guarch del Monte 1987:60) are grouped together when the only reason for the association that we can surmise lies in the attempt to relate the rock images to different cultural groups.

For most of the twentieth century, Cuban rock art investigations were focused on locating and documenting the island's past carved and painted images. The development of methods and theoretical frameworks to advance beyond the necessary, though limiting, descriptive level of investigation were lacking.

Our own characterization of this period as cultural-morphological captures the fundamental preoccupation of researchers with the aesthetics of the rock images and their forms (anthropomorphic, zoomorphic, and others; Guarch del Monte 1987; Núñez Jiménez 1975; Romero 1997); color sources (vegetable-based carbon, manganese, ochre); types (pictographs, petroglyphs); and dimensions (length, width, height, interfigure). Finally, we add that the effort to document rock art sites was driven by the aim or desire to link these images with particular cultural groups.

End of the Twentieth Century and New Attitudes

By the end of the twentieth century, researchers began to advance beyond the descriptive level of analysis by employing new techniques and approaches that have led to a fuller comprehension of the nature and meaning of Cuban rock art. We, along with such investigators as Jorge Calvera and Roberto Funes, can be said to subscribe to the "archaeo-anthropological" intellectual current within the broader theoretical orientation known as Latin American social archaeology that views native societies from Marxist perspectives.

Proponents of the archaeo-anthropological viewpoint consider rock art to be a class of material culture, equivalent to ceramics or lithics. Just like any other artifact category, rock art needs to be related to its cultural and ideological context in order to extract as much information as possible. Further, the rock image's symbolic content is dependent upon the structure of a society and that society's perception of the surrounding environment. Although rock images were likely produced at and for special occasions, they nonetheless informed everyday life and so were conditioned by the functioning as well as the structure of a society.

Jorge Calvera is a leader in the application and definition of the archaeo-anthropological approach. In his 1990 doctoral dissertation, he proposed comparing rock images with ceramic designs from surrounding archaeological sites as a basis for associating rock images and particular cultural groups. This method has also met with success in the United States since the 1950s and more recently in Argentina. Two later publications by Gutiérrez Calvache (1994, 2004) have expanded the range of analytic techniques. In the first publication, computerized statistical measures (cluster analyses) were used to define typological patterns within a grouping of bird-form pictographs. The later article concerns mathematical methods to explore relationships between numerical representations and the native cosmological and natural order.

Work on the rock art of the Matanzas Province also falls under this approach, where stylistic provinces have been proposed for more than six locations based on the comparative study of the similarities and differences among the assemblages (see, for example, González Colón and Fernández

Ortega 2001, 2002). The practitioners of this movement owe an intellectual debt to Fernando Ortiz, who earlier recognized that discovery and categorization of rock images forms the initial step in the desired goal of their interpretation.

Today's Cuban researchers, in attempting to understand the meaning and function of rock images, start from the premise that pre-Columbian agricultural populations practiced sympathetic magic. Rituals, involving such substances as *cohoba* (a hallucinogen) and activities like *areytos* (performances with dance and song) (see Hayward, Atkinson, and Cinquino, Introduction, this volume), were intended to control or influence the spirit world and natural forces through the manipulation of symbols. Rock imagery is considered fundamentally narrative and anecdotal, as well as serving other functions including having a role in propitiatory demands and denoting topographic features.

Contemporary studies of native South American societies (considered close cultural analogs to Antillean pre-Columbian populations) indicate that shamans possessed objects (sticks, spines, quartz pieces) through which their power flowed, rather than flowing directly from their bodies. Similarly, a shaman, or *behique,* through ritual actions could increase the magical value of objects or places, so that their spiritual importance derived from use as well as the physical representations or locations.

Objects employed in ritual contexts, whether they pointed to spiritual beings or served as instruments of spiritual power, derived their intrinsic significance from the symbolism assigned to them. The shamans manipulated these symbols to obtain the desired effect, wherein the perceived success depended upon the shamans' magical powers and the strength of their faith in the powers being represented. We consider that the examination of South American ritual and religious systems has already led to a more integrative and realistic appraisal of the role and function of rock images within past Cuban tribal and chiefdom societies.

One of the fundamental issues, and perhaps the most difficult task that the archaeo-anthropological framework needs to address, involves determining the meaning of the rock figures, especially the so-called abstract images. Despite problems in eliciting the significance of rock images that were produced within past premodern cultures, researchers need to go forward with the application of existing or the development of new explanatory methods and concepts, realizing that they are always subject to revision as new data are supplied.

New conceptual frameworks should recognize the interconnected relationships between a society's social and symbolic systems. The process of executing rock images operated within wider subsistence, settlement, and

sociopolitical contexts, which, among other uses, gave meaning to the lives of people. All too often investigations under the cultural-morphological approach divorced rock images from their cultural setting, resulting in insufficient attention to the cultural constraints on the production of rock figures, including their topographic location, execution techniques, and specific location at a particular setting. The island's pre-Columbian tribal and chiefdom societies, we submit, viewed their cosmological world through selective, culturally conditioned lenses. Not all sites would be appropriate for rock images, not all techniques would be employed, and not all design forms would be used.

Finally, we note that symbolic, linguistic, and myth analyses are among the Cuban researcher's investigative tool kit. Early chronicler reports on contact-period native cosmology and ideology, especially that of Fray Ramón Pané (1974), are being employed, for instance, to aid in iconographic decipherment, as Oliver (1998, 2005) did for his interpretation of the petroglyphs at the Puerto Rican ceremonial ball court site of Caguana (summarized in Hayward, Roe, et al., Chapter 9, this volume). Fernández Ortega and González Tendero (2001a) have proposed specific meanings for certain abstract petroglyphs of Caverna de Patana. They also argue for the depiction of the sun and moon myth in various pictographs of Cueva de las Mercedes, Cueva Ramos, and Cueva Ambrosio, found in the Camagüey, Sancti Spíritus, and Matanzas provinces, respectively (Fernández Ortega and González Tendero 2001b).

4

Sacred Landscapes

Imagery, Iconography, and Ideology in Jamaican Rock Art

Lesley-Gail Atkinson

Introduction

Rock art scholarship in the Caribbean has traditionally been descriptive, mainly a narrative of the discovery of sites and the aesthetic elements observed. This trend is also noted for Jamaica, where the earliest rock art discovery involved the 1820 reporting of the Dryland petroglyph, later published by Duerden (1897). Since then, 45 rock art sites have been reported island wide. However, only 39 are recorded, and the remaining sites have yet to be relocated. The most notable finding recently was the discovery of the Potoo Hole pictographs in 1993 (Atkinson and Brooks 2006). Rock art in Jamaica, as elsewhere in the Antilles, is dominated by petroglyphs (see Dubelaar 1995; Dubelaar et al. 1999). On the island, 89 percent of the rock art sites contain petroglyphs exclusively. There are only three pictograph sites (7 percent) and two locations (4 percent) that have both petroglyphs and pictographs.

Over the years, numerous discourses have been found in the literature on whether "rock art" is really an "art in the Western sense of the word" (Whitley 2001). Some scholars prefer to use terminology such as "rock-art" (Chippindale and Taçon 1998) and "rock imagery" (Loubser 2001). Henry Petitjean Roget (1997:101) argues that ceramics, tools, ornaments, rock carvings, and paintings are "all genuine works of art." Petitjean Roget (1997:101) adds, in reference to the art of the Antillean Amerindians: "We simultaneously refer to its practice, to technological skills, to rules and processes that were followed to produce such manifestations as are qualified as aesthetic. Sculptures, decorated pottery, all objects of 'primitive art' immobilize the dialogue established between raw materials and those who have gone beyond these contingencies in order to communicate a message."

Petroglyphs and pictographs embody the technological applications, expressiveness, and creativity that define "art." These "art" forms are considered to be more open ended when viewed in a premodern non-Western context. In addition to positing a multifunctional nature for these images in the

prehistoric Caribbean, their study must include understandings of imagery, iconography, and ideology (Hays-Gilpin 2004). Iconography is interpreted as "images with shared meanings, and the presumption of their power in particular cultural contexts" (Hays-Gilpin 2004:10). Ideology is perceived as an ideal representation of the world that seeks to "explain" the way things are. As Hays-Gilpin (2004:10) notes, "Ideology often obscures, hides, or contradicts the changes, conflicts, and tensions inherent in social, political and even economic process."

Petitjean Roget (1997) suggests that "primitive art" seeks to "communicate a message," thus rock art is more than just visual imagery; it is a reflection of the artist's worldview. This perspective is reinforced by Emmanuel Anati (1994:9), who perceives rock art as a reflection of "human capacities of abstraction, synthesis and idealization." Anati (1994:9) expounds that it illustrates the economic, social, and ideational activities, beliefs, and practices unique to the intellectual life and cultural patterns of man. Prior to the invention of writing, rock art was the means in which the most ancient testimony of human imaginative and artistic creativity was recorded (Anati 1994:9).

Distribution of Rock Art Sites within the Physical Landscape

Anati (1994) argues that the physical characteristics of a particular site greatly influenced its selection for the production of rock art. This view is also shared by Hays-Gilpin (2004:3): "Rock art is one way of marking the landscape, shaping the landscape, and encoding it with meaning. Long after the people who made it have gone, we can still study the spatial and formal relationships among rock art sites and other loci of human activity."

The distribution of rock art sites within the physical environment is an important analytical tool. Some sites have been classified according to their physical locale, as in, for instance, Fewkes's (1903) discussion of Puerto Rican rock art based on river, ball court, and cave locations. David Whitley (1998:11) emphasizes the importance of rock art sites as "sacred places in the landscape." This is reflected in conscious efforts made by the creators in determining the location of the sites and the distribution of the various motifs. Thus the physical locations of these sites within the geographic and cultural landscape are critical factors (Atkinson and Brooks 2006). In the following sections the distribution of Jamaican rock art sites is assessed in relation to geographic factors such as topography, elevation, and the proximity to a water source. The selections of these geographic locales reflect issues of accessibility and symbolism.

Physical Location

In Jamaica, half of the rock art sites are on the southern coast. James Lee (1990, 2006:180–181) suggests that climate is a likely critical factor in the

rock art site distributional pattern: "The very dry south-coast climate may be responsible for the better survival of petroglyphs in that belt, as the geologic processes of solution and re-deposition limestone are less active. The wetter north-coast zone probably has lost some aboriginal sculptures in limestone because of either more rapid solution by freshwater or faster build up of the dripstone, which tends to mask earlier features."

The distribution of sites in the western and northern portions of the island is 24 percent and 22 percent, respectively. There is a virtual absence (4 percent) in the eastern section. These low numbers may be due to the aforementioned geologic processes since this region experiences more rainfall and has a moister climate than the other sections.

Topography

Jamaica's topography is divided into three main areas. The interior mountain range makes up the core of the island, encompassing the central and western interior, with elevations generally exceeding 900 m. The Blue Mountain Range is located in the east and contains peaks exceeding 1,800 m (Clarke 1974). Limestone hills and plateaus border the interior mountain range extending over much of central and western Jamaica (Porter 1990), with altitudes ranging between 300 and 900 m.

The interior valleys represent basins or depressions, in which the surface is either level or gently undulating and is covered by alluvium or clay or both. The flatter coastal plains are composed largely of thick deposits of alluvial sand, silt, gravel, and clay (Porter 1990). A majority (72 percent) of the rock art sites are located in the interior valleys and coastal plains, followed by the limestone hills and plateaus (24 percent), with the balance unknown. To date, none have been found in the interior mountain range. The preference for the interior valley and coastal plains could be a result of several factors, including greater accessibility and proximity to settlements. This topographical area would also have provided access to a variety of soil-derived pigments such as kaolin and red and yellow ochre. Another attraction might have been the vegetation, which in this region consisted of areas of Great Morass, Herbaceous Swamp and Marsh Forest, Dry Limestone Forest, and Mangrove Woodlands (Atkinson 2005). These ecosystems would have provided not only vegetable sources for dyes or paints such as the mangrove extracts but also the animals that could have served as inspirations for the artist, including frogs, crocodiles, turtles, and birds. All are popular motifs in Jamaican rock art.

Elevation

Seventy-six percent of the rock art sites have recorded elevations. The Chesterfield site possesses the highest altitude at 550 m vs. the Canoe Valley caves

with the lowest elevations at 7 m. The data reveal a relationship between the topographic site distribution and sites located at elevations below 300 m. In the north a preference is apparent for sites found above 300 m and the opposite is true for locations in the south. These associations for rock art sites at the various elevations could result from the preferences of different prehistoric periods (Atkinson 2005). Despite these correlations most of the rock art sites are located below 100 m.

The distribution of rock art sites by elevation illustrates that petroglyphs are found at various altitudes throughout the limestone hills to the coastal plains. Pictographs, however, are usually located at elevations above 290 m. The only exception is the Potoo Hole site, which is found at 30 m.

Proximity to Water

The close proximity of rock art sites and water sources has been observed across the Caribbean, for example, at Hinche–Bassin Zim (Haiti), Anse des Galets (Guadeloupe), and Reef Bay (St. Croix). This preference is also observed in Jamaica, where 49 percent of the sites are located near a water source, whether a river or the sea. This percentage could have been higher in the past as rivers or streams that may have run nearby may have changed their course or dried up in postcontact times.

This may also apply to rock art sites located in the interior valley and coastal plains that are well drained with a variety of seasonal streams. In the limestone hills and plateaus, rainwater disappears into the fissures, cavities, and sinkholes of the limestone and flows underground through subterranean limestone areas (Porter 1990), contributing to the numerous caves with pools utilized by the Taíno such as the Jackson Bay Cave-1 site. The water sources associated with rock art sites can be subdivided into five main categories: river, cenote, caves with pools, morass, and sea. The majority of sites are situated close to rivers (42 percent), such as the Dryland and Pantrepant petroglyphs (Atkinson and Brooks 2006).

Distribution of Rock Art Sites within the Cultural Landscape

Occupational and Burial Sites

Jamaican prehistory is associated with two Late Ceramic Ostionoid peoples, the Ostionans, who colonized Jamaica ca. A.D. 650, and the Meillacans, ca. A.D. 900 (Hayward, Atkinson, and Cinquino, Introduction, this volume; Rouse 1992). The Ostionan or Redware culture primarily settled along the southern coast of the island, concentrating in the modern parishes of St. Elizabeth, Manchester, and Clarendon. Although the Ostionans were dependent on the sea and its resources, they also advanced into the interior valleys as evidenced

by their settlements in the parish of St. Ann (Atkinson 2003a). According to Rouse (1992), the Ostionoid culture utilized caves for burials and these are associated with Redware sites. Other artifacts and features associated with the Ostionan subseries (A.D. 600–1200) include petaloid stone celts; *cemí* objects of stone, shell, and clay; and the introduction of petroglyphs and ball courts. The large number of petroglyph sites could indicate that production of carved images on Jamaica began with the Ostionoid period, as Rouse inferred. Canoe Valley rock art sites in Manchester, for example, are located within prime Ostionan areas and Redware pottery sherds were recovered from these sites (Atkinson 2005).

The Meillacans also settled along the coast as evidenced by the Hellshire Hills and the Old Harbour Bay sites in St. Catherine. The majority of their sites, however, were further inland, generally situated upon hills overlooking the environs and within reach of a water source (Atkinson 2003a). Lee believes that only the Meillacans executed Jamaica's petroglyphs and pictographs on the basis of associations of Meillacan White Marl ceramics with rock art sites and existing special distributions (Allsworth-Jones 2008).

The island's most prominent pictograph site, the Mountain River Cave, St. Catherine, is said to be associated with the Meillacan settlement of White Marl. According to Aarons (1988), pottery sherds of the Meillacan series were found near the pictograph location. Aarons also highlights the Two Sisters Cave petroglyph site and its association with the Meillacan settlements in the Hellshire Hills such as Half Moon Bay and Rodney's House (Atkinson 2003a).

Lee and the Archaeological Society of Jamaica (ASJ) have mapped 25 petroglyph and pictograph sites (1965–1985) and claim that the spatial distribution of these sites reveals that "White Marl type villages" were the "nearest occupation sites in every case" (Allsworth-Jones 2008:105). According to Lee, the rock art sites were located an average of 3.8 km from an occupational site, with the closest being the Pantrepant East rock art site and Pantrepant Village with a distance of 200 m. The farthest involved the Worthy Park #2 site and the East Mount Rosser settlement, separated by 9.45 km (Lee 1990, 2006:Table 13.3).

The Meillacan culture also used caves for burials, for example, the White Marl Burial Cave in St. Catherine. Many of their burials, however, to date have been found in open-air locations (Atkinson 2003a). Nonetheless, a number of rock art sites are located close to burial locations such as Gut River #1, Manchester. A few rock art sites that also contain burials are associated with the Meillacan period. These include such petroglyph sites as Duff House, St. Elizabeth, and Jackson Bay Cave-1, Clarendon. Jackson Bay is very significant as it is one of only two rock art sites at which radiocarbon dating has

been conducted. A human bone fragment yielded a date of 710 ± 60 B.P. (cal A.D. 1240 ± 60), along with a marine shell dating to 795 ± 70 B.P. (cal A.D. 1155 ± 70) from deposits associated with White Marl ceramics (Fincham 1997).

Pictograph sites with associated burials include Potoo Hole, Clarendon, where "surface fossil guano" was dated to 950 ± 50 B.P. (A.D. 1000 ± 50). The Spot Valley site, St. James, also contained the remains of eight individuals (Allsworth-Jones 2008). This combination of sites reveals an association between rock art and burials, as well as emphasizing a spiritual and religious relationship between the images and Late Ceramic or Taíno burial practices (Atkinson 2005).

The dating of Jamaican rock art sites has proved difficult. The use of associated artifacts such as pottery can be useful, but various individuals or groups could have visited a rock art site over centuries. Thus the presence of pottery may just be evidence of one or a few groups using the location for ceremonial or ritual purposes, not a representation of the total number. Another dating problem involves possible cases of secondary deposition, where the artifact was brought to the site. For instance, in Jamaica there is evidence of both cultures occupying sites, as seen at the Warminster site, St. Elizabeth, where pottery sherds from both the Ostionan and Meillacan periods were recovered (Atkinson 2005). What is clear is that rock art is associated with both the Ostionan and Meillacan cultures and the distribution of rock art sites correlates with the general distribution of Ostionan and Meillacan sites (Atkinson and Brooks 2006).

Caves: Portals into the Sacred Realm

Anati (1994:45) emphasizes that "every assemblage of rock art appears to reflect choices of the artists concerning the place, the inclination of support and the selection of the surface to decorate." On Jamaica this selection process was restrictive in that all the known rock art is found in or near caves. This fascination with caves is understandable as caves have always been viewed with a certain apprehension and held a certain allure. Karl Watson (1988) highlights the mystique of caves, stating that these closed-in dark spaces could serve as shelters for man but were also places to be feared since both good and evil spirits could live there as well or could use the locations to harm man. The early chroniclers indicate a similar understanding of the power and symbolism of caves among the contact-period Taíno societies. Caves or rockshelters in particular stood in for their conception of the cosmos divided into the underworld, the present world, and the sky domain, in addition to serving as portals or points of interchange between these worlds (see Loubser and Allsworth-Jones, Chapter 5, this volume).

Cave Type Preference

While the Jamaican Taíno only chose caves or nearby boulders to produce petroglyphs and pictographs, not all cave locations were considered equal. Certain caves appear to have been preferred over others, although any patterns at present remain preliminary since a limited number of caves (34 percent) have been classified according to type. The 10 types in the literature are these: cave to shaft, cave with pool, complex cave, complex shaft, chamber cave, dry passage, river passage, shaft to pool, shelter cave, and sinkhole.

The shelter cave type was the most popular (41 percent). According to Robert Howard (1950:108), the rock art sites "are nearly always located under a rock ledge or in a shallow cave and may have served as shrine caves." This type of cave consists of a chamber, open on one side, or of an overhang providing shelter from rain. Examples of shelter caves include the Pantrepant East (Trelawny) and the Mountain River caves. The complex cave type (27 percent) is second in popularity and is one that contains interconnected shafts, passages, and chambers (Fincham 1997), such as the Dryland and the Jackson Bay caves.

It is interesting to note that the shelter and complex cave types are not the most common ones found in the island. Fincham (1997) reveals that shelter caves make up only 7 percent of the total, while complex caves fall into a broader category that accounts for 26 percent.

Distribution within the Cave

Anati (1994) highlights that the artists took into account various factors in selecting a particular location within a cave setting. Those factors included surface orientation (horizontal, oblique, vertical, floor, or ceiling) and the natural shape and color of the background to be decorated. In Jamaica, both petroglyphs and pictographs are usually located at the entrance of caves. Lee (1990, 2006) observes that few petroglyphs are actually inside the caves but rather they are found at entrances or on the surface of massive blocks of limestone broken from sinkholes or cave walls. Rouse (1992) adds that the Taíno carved or painted outlines of the natural spirits in places where they believed them to live, especially in caves and on rocks along streams or coasts.

Jamaican petroglyphs were frequently carved into pronounced features such as boulders, stalagmites, stalactites, and rock faces at the entrance of the cave (Atkinson and Brooks 2006). Loubser and Allsworth-Jones (Chapter 5, this volume) report that at Warminster, St. Elizabeth, 95 percent of the figures were carved on flowstone and dripstone calcite surfaces. In many cases the centering of the petroglyphs on such protrusions as stalagmites and sta-

lactites creates a symmetrical effect whereby natural surfaces enhance the carved images.

Lee (1990, 2006) notes that these pillars or other vertical cave formations are often adapted to create a three-dimensional appearance for the carvings. These factors contribute to the presence and allure of the rock art (Atkinson and Brooks 2006). This has been observed at sites such as Kempshot (St. James), Mountain River Cave (St. Catherine), Warminster (St. Elizabeth), and Windsor Great Cave (Trelawny). At Windsor, the image is carved on a stalagmite that stands in a "sentinel-like" position at the entrance (Allsworth-Jones 2008).

Another perspective on the location of carvings at cave entrances concerns the central role caves have played in religious rites and practices. Caves have been seen as "portals into the sacred realm" (Whitley 1998:16). Caves are thought to facilitate the shaman's entry into the spirit world. Thus, the location of the carving at the entrance of the cave can be seen as representing the transportation from one world to the next. In addition, shamans produce rock art to depict the altered state of consciousness experiences of their vision quests and rituals.

Pictographs are generally located on the ceilings or walls of the cave. At Potoo Hole, the pictographs cover the surface of two adjacent rock faces at the base of the pit entrance (Fincham and Fincham 1998). The depth of the Potoo Hole and the location of the pictographs add to the elements of transcending into a sacred realm (Atkinson and Brooks 2006).

Image Types in Jamaican Rock Art

Imagery or visual symbolism refers to pictures, ones meant to represent something in the physical or nonphysical world (Hays-Gilpin 2004). The creator's environment and belief system have a profound impact on the generation of design motifs and themes. In the previous paragraphs it has been emphasized that artists followed certain rules or preferences for where the rock art sites should be located, in addition to where the images should be located within the caves. Prescriptive rules of design and composition are also seen in the use of individual design elements and motifs.

Petitjean Roget (1997) introduces the importance of the "elementary motif," which he defines as the smallest unit that can be derived from an art or expressive form. He explains: "A motif may be modulated, transposed, or reversed without losing its identity . . . The study of elementary motifs shows there are patterns constituted by particular motif configurations that are repeated through the interplay of symmetry on a single vessel or from one vessel to another. These are *themes*. Although these are primarily seen in ceramic

art, sculptures and petroglyphs also reflect similar networks of expression that intersect each other" (Petitjean Roget 1997:102).

Anati (1994) is not surprised that many rock art sites contain zoomorphic images of animals in their natural environment, as images on rock surfaces were often attempts to interpret nature. Petitjean Roget (1997) adds that each culture selects from among the infinite themes offered by its natural environment. Anati (1994:20) expounds further: "The artist did not represent everything he saw or knew, but instead made specific choices. Although the subject matter varies consistently from one age to another, it is always rather circumscribed within each age. Thus the frequency and assemblage of subjects allow us to construct a rudimentary hierarchy of the artist's values. The gamut of subject matter is always well defined and consistent within specific cultural and tribal patterns."

The classification of engraved and painted images according to their design motifs has been a preoccupation in rock art studies across the globe. These design motifs can be generally subdivided into three major categories: anthropomorphic, zoomorphic, and abstract or geometric. The distributions within these categories vary according to the geographic region, cultural period, sites, and type of rock art.

Jamaican petroglyph designs are broadly classified according to anthropomorphic, zoomorphic, and geometric or abstract designs (Atkinson and Brooks 2006). Howard (1950:108) early on observed that "human and animal rock carvings appear to be the chief motifs in Jamaican rock carvings." However, it is clear that anthropomorphic images predominate. Petroglyph sites with solely zoomorphic or geometric/abstract designs are not known; rather, these motifs appear in clusters along with anthropomorphic images.

Lee (1990, 2006) classified Jamaican petroglyph sites into four types: (1) single anthropomorphic, (2) double anthropomorphic, (3) principal petroglyph with smaller glyphs, and (4) cluster. Within this scheme, the single most numerous types consist of sites with a single anthropomorph, accounting for 38 percent of the total. Examples are Byndloss Mountain and God's Well. Clusters of petroglyphs with anthropomorphic, zoomorphic, and geometric motifs are also numerous (33 percent), such as those at the Canoe Valley caves and Warminster/Genus sites. Locations consisting of a principal anthropomorphic design with smaller glyphs make up 17 percent, exemplified by the Coventry and Pantrepant East caves. Windsor Great Cave is the only site that contains double anthropomorphic petroglyphs (2 percent). Ten percent of the total remain unclassified.

The anthropomorphic images can be further subdivided according to the following fivefold system (Atkinson and Brooks 2006): (1) full body, (2) in-

Figure 4.1. Examples of Jamaican petroglyph designs: simple (a), complex (b), and developed (c) humanlike facial images; d–e, geometric motifs (a–d, Lee 2006; e, illustrated by Edward Coore, 2006; all retraced by Alexander G. Schieppati).

complete body, (3) simple faces, (4) developed faces, and (5) complex faces. Definitions of the three facial categories follow those of Rodríguez Álvarez (1993) for Puerto Rican rock art, where simple faces possess eyes or mouths; developed faces have additional elements including noses, ears, hair, or rays; and complex faces exhibit headdresses or headgear. In Jamaica, the majority of the carvings comprise simple faces that possess eyes or mouths. Lee (1990, 2006:179) states, "by far the most common Petroglyph motif is a simple oval face, incised by a continuous line, with three circular or oval depressions to represent eyes and mouth." Examples of the three humanlike facial designs are illustrated in Figure 4.1a, b, and c. These facial designs paired with a fully executed or partial body form account for the first two categories.

Zoomorphic representations refer to animalistic or naturalistic forms. In Jamaica, very few zoomorphic petroglyph images have been found. The images that have been reproduced comprise *jujo* (snakes), as seen at Farquhar's Beach, Clarendon, and birds, in particular *múcaro* (owl), as discussed by Loubser and Allsworth-Jones (Chapter 5, this volume) at the Warminster rockshelter, St. Elizabeth.

Geometric or abstract petroglyph designs are rare. Lee (1974) notes the presence of geometric designs at Warminster and Mountain River Cave.

Figure 4.2. Birdmen pictographs at Mountain River Cave (Evelyn Thompson; used with permission).

Other sites with geometric motifs include Milk River, Clarendon (Figure 4.1d), and Hull Cave, Manchester (Figure 4.1e).

As previously stated, only five pictograph sites have been found on the island. Among these sites anthropomorphic and zoomorphic motifs constitute the most popular designs. The anthropomorphic images tend to depict men squatting or dancing and reflect a ritualistic theme as demonstrated by the birdmen at Mountain River Cave (Figure 4.2). Nonetheless, zoomorphic images seem to have been the favorite design type, as these sites are filled with representations of the turtle (*Carey*), frogs (*Coki'* and *Tona*), crocodiles (*Iguana, Caimáin*), fish, spiders (*Guabá*), and birds such as ducks (*Yaguasa*) and egrets (Figure 4.3). These animals represent abundant features in Jamaica's natural environment. The geometric and abstract images encountered are mostly linear designs, stars, and spirals as observed at Potoo Hole (Figure 4.4).

Motifs, Themes, and Taíno Ideology

The interpretation of rock art is always challenging, but it is vital in comprehending the worldview of the creators. Anati (1994) makes clear that rock art

Figure 4.3. Bird pictographs at Mountain River Cave (Evelyn Thompson; used with permission).

is conditioned by the natural and cultural contexts that shape the production of rock images. As such, researchers can legitimately expect the art to reflect aspects of past human behavior, including technologies (weapons and tools), subsistence (hunting scenes), and religious or intellectual concepts (depictions of myths, physical locations of sites). The analysis of the design motifs and themes of Jamaican rock art demonstrates that this form of Taíno expression has been strongly influenced by their folklore, religious beliefs, social constructs such as gender, and perceptions of nature.

Taíno Mythology

José Oliver (1997:141) emphasizes that "the Taíno had definite ideas about how the universe, the cosmos, was created—and therefore they had not only an explanation of the roles that humans play in it but also a moral blueprint to guide their conduct in it." He argues that "[t]he Taíno's cosmological views

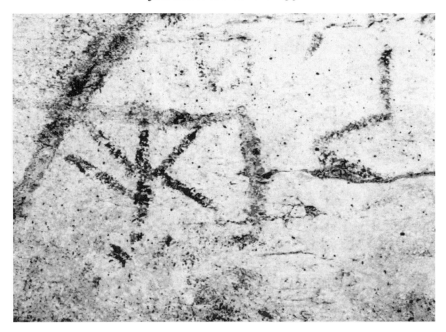

Figure 4.4. Geometric and abstract pictographs at Potoo Hole, Clarendon Parish (Fincham and Fincham 1998; used with permission).

are paramount in understanding their religious beliefs and practices" (Oliver 1997:140). Thus decoding an artwork first involves bringing forward the hidden message, then discovering the means to decipher this message (Petitjean Roget 1997). Fray Ramón Pané (1999), the early Spanish chronicler, provides a critical key to the understanding of Taíno religion. Roe (1993a) has argued that certain myth themes have been symbolically represented in ritual material items such as wooden sculptures and, of import here, petroglyphs and pictographs.

The Pané narratives include descriptions of the creation story; the transformation of humans into other entities such as stone, birds, and frogs; and how the sea was formed. As Petitjean Roget (1997:103) states, "parts of them tell of events that exist only outside the common world: the sun transforms a man into stone, others into trees or birds; bones are transformed into fish; a man is given birth from the back of a turtle." Oliver (1997:142) holds a similar viewpoint:

> The myths of the Taíno are presented in terms of a kind of "narrative" where the events and actors belong to the past, to a remote primordial cosmos. The events are presented not in a historical (chronological),

linear sequence but rather in sacred time and space, and therefore the normal rules of the passage of time and of the movement from one place to another do not apply. In this primordial world rocks, plants, and animals can "speak" to each other—but in sacred, nonhuman language. Moreover the actors can suffer transformations from one state (for example, "human") to another (for example, plants, rocks, or animals), usually after a specific behavioral act that changes their role.

Pané (1999) reveals that caves played a critical role in Taíno religion and oral tradition, as they believed that mankind originated from two caves called Cacibajagua and Amayaúna in the province of Caonao. This belief is reflected in their reverence for caves and perhaps in rock art intended to illustrate the creation story, as has been argued for the figures at the Cuban site Caverna de Patana (Dacal Moure and Rivero de la Calle 1996).

The creation story highlights the unfortunate character Mácocael, who was subsequently turned into stone:

> When they were living in those caves, those people stood watch at night, and they entrusted this task to a man by the name of Mácocael. Because one day he was late in returning to the door, they say, the Sun carried him off. Because the Sun carried away this man for his lack of vigilance they closed the door against him. Thus it was that he was turned into stone near the door . . . the reason why Mácocael was keeping watch and standing guard was in order to see where he would send or distribute the people, and it seems that he tarried to his great misfortune [Pané 1999:5–6].

I believe that the "sentinel" presence of rock figures, especially petroglyphs at the entrance of caves, could be a depiction of Mácocael. The execution of these stone figures made sure that the caves were always guarded and served as a reminder of his folly.

Birds were valued beyond being a food source and a trade item (Carlson et al. 2006). Yahubabayael (nightingale) and Inriri (woodpecker) were central components in Taíno mythology. Pané (1999) narrates how Yahubaba was transformed by the Sun into a nightingale and how sexless bodies were carved by the woodpecker into women. Avian imagery has been reflected in *cemís* (representations of supernatural spirits) associated with the *cohoba* ritual, as seen by the *cemí* recovered from the Aboukir Cave, St. Ann. The platform at the top of the bird's head would have held a narcotic snuff that the *cacique* ingested in order to communicate with the spirits in a hallucinogenic trance (Carlson et al. 2006; see also Hayward, Atkinson, and Cinquino, Introduc-

tion, this volume). Zoomorphic images of birds are also depicted as petroglyphs and pictographs (see Figure 4.3).

Saunders (2005:31) notes that the Amerindian peoples who inhabited the Caribbean islands "saw birds as spirit beings, the natural avatars of shamans or *behiques*, able to break the bonds of earth and fly up to the spirit realm." This is especially the case with Múcaro, the owl or bird of the night. García Arévalo (1997:122) reports that "by following the cosmic flight of the owl, the *behiques* could see and talk to the spirits and enter the region of the dead to rescue the soul of an ailing person, who had been captured by evil spirits, and return the soul to its body, thus healing the patient."

Petroglyph owl motifs have been found at Little Miller's Bay Cave, Manchester (Lee 1990, 2006) and Warminster Cave, St. Elizabeth (Allsworth-Jones 2008; Loubser and Allsworth-Jones, Chapter 5, this volume). At Warminster, petroglyphs representing owl imagery are present probably depicting both the Jamaican brown owl (*Pseudoscops grammicus*) and the white barn owl (*Tyto alba*). They are described as having sentinel-like positions at the outer portals of the cave.

Oliver (1997:142) notes that some characters portrayed were neither human nor animal, "but rather [were] simultaneously human-animals (anthropozoomorphic personages)." A prime example of this is "Birdman," a bird-faced figure that was recovered from a cave in Carpenter's Mountain, Manchester. Birdman was found with his face toward the east (Duerden 1897; Lovén 1935). This human bird-headed motif has also been observed at the Mountain River Cave site.

According to Allsworth-Jones (2008:107), "one of the striking scenes at Mountain River Cave shows two men in bird masks facing each other and holding spears or throwing sticks" (Figure 4.2). Lee considered that this represented a hunting scene for aquatic birds, but in Aarons's (1988) view, "it had a wider religious or ceremonial significance." I believe that the interpretation of the images' having a ceremonial significance seems more plausible. The spear or throwing sticks could also be ceremonial staffs. In close proximity to the birdmen is another anthropomorphic image, which is seated or squatting as if he is watching the interaction of the birdmen (see Figure 4.3).

Rouse (1992) considered that petroglyphs were another means of picturing *cemís*. In Jamaica, petroglyph representations have been identified for Boínayel, the Gray Serpent—a metaphor for rain-bearing clouds (Pané 1999). The rain deity is usually depicted with tears descending his face, as are the petroglyphs at the Canoe Valley, Cuckold Point, and Hull caves in Manchester (Figure 4.5) (Atkinson and Brooks 2006; Lee 1990, 2006). The petroglyph sites are in very close proximity to each other and the location where the non-petroglyph Boínayel *cemí* was recovered. Apparently the Taíno believed

Figure 4.5. Petroglyphs at (a) Cuckold Point and (b–c) Hull Cave, both in Manchester Parish, that may be representations of the Taíno rain deity Boínayel (a, Lee 2006; b–c illustrated by Edward Coore, 2006; retraced by Alexander G. Schieppati).

that visiting or supplicating *cemís* of Boínayel would result in near-immediate rainfall (Pané 1999).

Gender

Gender refers to relationships between the concepts of male and female, masculine and feminine, men and women (Hays-Gilpin 2004). Kelley Hays-Gilpin posits that gender represents an abstract concept, but the enactment of gender arrangements often has material and behavioral correlates that we can study, and this is reflected in rock art. According to Hays-Gilpin (2004:2), "rock art often plays in the active construction of human gender arrangements, through initiation rituals, by signaling ethnic and territorial identities, by manipulating a gendered spirit world, and by picturing a gendered cosmos." Thus, studying "gender arrangements is one way to begin because gender actively structures not only social relationships but also belief systems, ritual practice, and the way people think about the natural world" (Hays-Gilpin 2004:2).

Whitley emphasizes that rock art sites were more than entry points to the supernatural. He argues that "sites had different meanings, and different levels of meaning, beyond this fundamental symbolic attribute. One constellation of such meaning pertains to the gender symbolism associated with these sites which was ultimately a determinant of rock-art site location" (Whitley 1998:18).

Gendered constructs are very dominant in Taíno material culture in which their *cemís* and effigy vessels display masculine and feminine attributes. I consider that gender is also reflected in the location of rock art sites and the motifs utilized. For instance, the preference of caves for rock art sites is crucial. Caves represent a form of shelter and can provide a sense of warmth and se-

curity. In addition, as noted above, in the Taíno creation story the first people came from a cave, as if emerging from the womb. The cave could be seen as a symbol of femininity. We also see masculine representations within caves: for instance, the stalagmite at Windsor Great Cave is very phallic. Whitley (1998:19) notes that "male shamans used feminine-gendered rock art sites, because on one level their entry into the supernatural was conceived as a kind of ritual intercourse."

With regard to the design motifs, Petitjean Roget (1997:105) notes the recurrent themes of the fruit-eating bat and the tree frog in Taíno art:

> The theme of the frog has also appeared in the myth . . . Frogs belong to a lower level, that of moisture. They symbolize femininity. The connotations of the frog (which comes from beneath the surface of the water) define the character of the animal that must occupy the inverse, meaning masculine, position, which is a dry animal that lives out of water. Thus, art helps to reveal who this being ought to be. It is the fruit-eating bat, *Artibeus jamaicencis,* modeled or painted in Saladoid or Taíno art. In the primeval world as depicted in the myths, women were frogs and men were bats.

In Jamaica, sites, namely Potoo Hole, Spot Valley, and Mountain River Cave, are filled with representations of Coki' (frog). Yet, there are no frog petroglyphs. There are no bat representations of the masculine figure, despite the fruit-eating bat's being a common species found on the island.

Whitley (1998) highlights the symbolism of the rock art site (as opposed to motif) as a ritual location placed in the landscape. According to Whitley (1998:16), "their physical location in the landscape, geomorphological attributes (rock outcrop, cliff face, rock-shelter walls and ceilings) and the rock-panel faces themselves—were, in fact, important symbols in their own right."

Rock art in the Jamaican context reflects this tradition, as evidenced by the Taíno creators' preferences in the location of rock art sites in specific topographic areas, elevations, closeness to water, and proximity to occupational and burial sites, and in their preference for shelter and complex caves. The fact that these sites are separated from the occupational sites also emphasizes the Taíno's veneration toward these "shrine caves." The distribution of images on prominent features such as stalagmites and stalactites at the entrances of these caves and the created imagery reflect Taíno mythology and how they engendered the world. These "sacred landscapes" are vital components in understanding Taíno iconography and ideology.

5

Caring for the Spirit Helpers

Recording, Graffiti Removal, Interpretation, and Management of the Warminster/ Genus Rockshelter, Jamaica

Johannes H. N. Loubser and Philip Allsworth-Jones

Introduction

In this chapter, we will argue that observations placed within relevant physical and ethnographic contexts greatly improve our understanding of rock art expression. While a variety of observations at a site are critical for detecting details, only knowledge of physical and ethnographic processes is sufficient to realize the importance of those details. We further suggest that certain details would not have been detectable, in the first instance, without the awareness of the relevant chemical, physical, and cultural phenomena.

An illustration of this two-way interaction between observation and theory involves the recordation, conservation, and interpretive exercise completed in June and July of 2005 at the Warminster/Genus rockshelter (Site #EC-15), in the parish of St. Elizabeth, southwestern Jamaica. Observations made during the condition assessment and graffiti removal of the shelter's petroglyphs supplemented those made during the tracing of the images. More important, these observations when placed within the context of the Taíno religious experiences, beliefs, and practices provided an understanding of the identity and distribution of the petroglyphs within the shelter.

Description of the Warminster/Genus Rockshelter

The shelter occurs near the base of a limestone outcrop, roughly 20 m south of an asphalt road that Alumina Partners of Jamaica, Inc. (Alpart) constructed in 2003. The shelter measures ca. 10 m from west to east and 6 m from south to north (Figure 5.1). The shelter has three entrances, two from the downslope side to the north and east and one from upslope to the south.

A large boulder occupies the northern end of the shelter that presumably once was part of the shelter's overhang or ceiling. After it broke from the

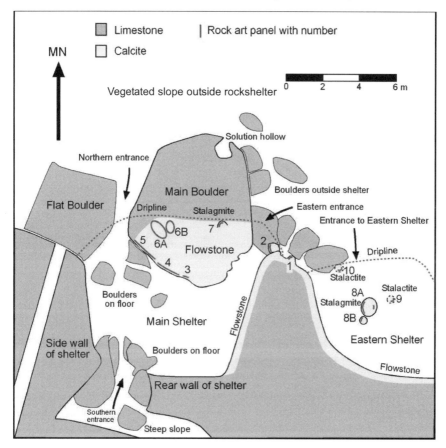

Figure 5.1. Sketch map of Warminster/Genus rockshelter, Jamaica.

parent rock, the boulder was wedged between the current ceiling and the floor of the shelter, creating the northern (right) and eastern (left) entrances. Smaller boulders scattered on the surface within and in front of the shelter also represent spall from the roof. Like the main shelter, a secondary one directly to the east also appears to have been formed by roof spalling.

Limestone comprises carbonate rock that typically consists of the minerals calcite and dolomite (Flint and Skinner 1974:167). The carbonate minerals are soluble in the carbonic acids found in most groundwater. The main shelter was formed by roof spall, thus it is not a solution hollow or cavern. However, solution has created a small cavern in the front face of the main boulder. When exposed to the atmosphere, water droplets emanating from fissures within the parent rock lose tiny amounts of dissolved carbon dioxide gas and precipitate particles of calcium carbonate, or calcite, against the

ceiling, walls, and floor of the shelter. The gradual accumulation of calcite forms flowstone (travertine) against the walls, dripstone from the ceiling (stalactites), and dripstone on the floor (stalagmites).

Within the Warminster/Genus shelter, the formation of curtainlike flowstone occurred mainly on the interior side of the main boulder (see Figure 5.1). Bands of flowstone also occur on the eastern wall of the main shelter and on the walls of the eastern shelter. Stalactites hang from the ceilings of both the main and eastern shelters. A stalagmite is present on the eastern side of the east entrance to the main shelter, as well as on the floor of the eastern shelter.

Background to the Recording and Conservation Exercise

James Lee, a local geologist and amateur archaeologist, reported the Warminster/Genus site in the literature. He visited the cave in 1969 and later in 1981 (Lee 1969, 1981:7), followed by Philip Allsworth-Jones's inspection in April 2003. During this visit, Allsworth-Jones found a Meillacan, locally known as White Marl, type sherd eroding from the deposits within the shelter. Similar sherds elsewhere in Jamaica have been dated to the Late Ceramic Period, A.D. 1000–1500. Based on the close association between rock art and White Marl ceramics in Jamaica, Lee (1990, 2006) has proposed that most Jamaican rock art probably dates to this final phase of the Ceramic Period.

Allsworth-Jones also noticed red paint graffiti on many of the petroglyphs and recognized the need for their removal, particularly in view of the construction of the new road close to the shelter in 2003. Members of the local community became involved in the review process and actively supported the removal of the graffiti, especially with the possibility of increased visitation by passing motorists. Not only do graffiti beget more graffiti, but they also cover, distract from, and damage the original images. Before the graffiti were removed, a consensus was reached that the shelter should be assessed and the rock art recorded. The mapping, condition assessment, recording, and cleaning of the site were completed with the assistance of second-year archaeology students from the Mona campus of the University of the West Indies during June and July of 2005.

To help discourage the recurrence of graffiti within the shelter, proper management procedures were elaborated, which are detailed below. A likely deterrent in any context involves the proper study and interpretation of the rock art. Sound interpretation allows for the informed presentation of the motifs. When people are aware of this type of cultural heritage, they are less likely to damage it and more likely to protect the resource from damage by other people. We hope the neighboring population will continue their protective role in the case of this rock art site.

Condition Assessment

Ten panels with rock engravings were identified during the project. Of these, six occurred within the main shelter, Panels 2–7; three occurred in the eastern shelter, Panels 8–10; and the last one, Panel 1, was located between these two shelters. Crudely painted red lines of graffiti occurred on Panels 4, 5, 6, 7, and 8, where the lines either fully or partially encircled the images. Since most engravings occurred on slight protrusions of the flowstone, the graffiti typically were found around the protrusions and occasionally around projections without any petroglyphs. A few short paint strokes were also applied against the plain western wall of the main shelter. Judging from the powdery texture of the red lines, together with the solubility of the pigment in ethanol and acetone, the paint is most likely acrylic. Where liquid paint ran across the limestone surfaces of Panels 4 and 5, solution of the underlying rock created tiny ruts and rills.

Green algae covered many of the carved motifs on Panels 4 and 5 of the main boulder within the main shelter. Algae also grew on the lower portions of the Panel 8 stalagmite in the eastern shelter. Subdued light and dripping water appear to facilitate the growth of algae within the shelters. Algae can be a conservation problem as it possibly releases weak acids. Dust from the floor of the main shelter has settled on the backward-facing surfaces of Panels 3–5. This is problematic as dust can abrade the underlying rock and eventually form a physical bond that is difficult to remove.

Additional factors affecting the conservation of the shelter involved a thinly incised set of initials, numbers, and a drawing of a girl's dress attached to a female-indicated petroglyph in Panel 5. Also, a minor accumulation of salt encrustation or efflorescence at the site was found on one side of a flowstone in Panel 5. The presence of goats, the possible source of abrasion marks on the lower surfaces of Panels 2 and 3, has caused an increase in the amount of dust.

In July 2005, Hurricane Dennis provided an ideal opportunity to observe the hydrology and water flow within the main shelter. On the first day of the storm, the extreme western side of Panel 5, closest to the northern entrance, became wet due to the heavy rains. The next day, a natural receptacle, hidden from full view between the ceiling and the apex of the main rock behind Panel 7, overflowed and caused water to flow across Panel 5 for about three days. This water source conceivably resulted in the formation of the flowstone on top of the main boulders many years ago. Interestingly, during a previous downpour a week earlier, water flowed across Panel 4. The central portion of Panel 5 remained wet the longest after Hurricane Dennis. Considering that this is also the only part of the shelter with salt efflorescence, there may be a possible link between prolonged drying of water and salt formation.

Panel 2's images on the stalagmite at the eastern entrance were covered by water coming through the adjacent wall. Those of Panel 8's stalagmite were kept wet by water dripping from the ceiling in the eastern shelter.

The condition of the rock support varied considerably throughout the shelters. The sections exposed to full sunlight, namely Panels 6 and 7, were the best preserved, probably due to the sun-baked crust. The far-western edge of Panel 5 was friable, most likely resulting from the fluctuating water flow in this part of the shelter that is close to the northern entrance. Even different sides of the same vertical travertine flow exhibited disparate hardness. This disparity may have derived from differential water flow and salt-formation processes.

Graffiti Removal

Prior to graffiti removal, loose dust was flicked away with horsehair brushes. Dust accumulation was particularly severe on the main boulder in and around Panels 3 and 4. Panels 4–7 contained red paint, whereas incised graffiti were limited to Panel 5. Testing showed that most of the acrylic graffiti could be removed with the aid of water, ethanol, and acetone. Applied as paper poultices, these solvents at first had limited effect. After adding a further step involving scrubbing with nylon, copper, and steel brushes, the poultices finally proved effective in absorbing the red pigment. These results strongly suggest that a thin layer of calcite must have covered the acrylic paint, creating a barrier between the solvents and the pigment. Once brushing removed the thin calcite skin, solvents could directly touch and interact with the red acrylic paint.

As mentioned above, rock surfaces exhibited varying degrees of hardness, even within the same panel. This variation was most likely the result of vertically oriented microzones with different aspects that favored varied salt-formation processes. Various techniques of graffiti removal were applied depending on the hardness and accessibility of the rock surface. In robust areas, such as the upper portion of Panel 4 and most of Panel 6, use of the electric rotating copper brush was the most useful removal technique coupled with ethanol as the most valuable solvent. The steel-wire brush was used where the acrylic paint was thickly applied. Detail work, such as within hard-to-reach hollow surfaces, was done with steel scalpels. On the more friable western side of Panel 5, the naturally flowing and dripping water on the main boulder turned out to be an effective solvent in conjunction with vigorous brushing.

Removal of the acrylic paint layer from the rock exposed the whitish flowstone surface directly below. A thin layer of algae covered most of the

flowstone, but it did not grow beneath the graffiti. Thus when the acrylic was removed lines of white flowstone within a sea of green algae remained. To correct the visual distraction caused by the white lines, we also removed the surrounding algae layer. The algae were carefully removed to avoid damaging the underlying rock and engraved areas, exposing virtually the entire flowstone surface of Panel 5.

Bearing in mind that the main purpose of the graffiti-removal exercise was to minimize the visually distractive effects of the red paint lines, removal efforts focused on red paint that obscured the petroglyphs, compromised their visual integrity, or resulted in both situations. Not every single speckle of acrylic paint was removed due to the recognition that overcleaning could produce its own scars. Moreover, when inspecting the rock surface closely, future archaeologists and conservators should be able to notice traces of the graffiti.

Differences in the highlighting of various rock surfaces additionally modified the extent of graffiti removal. In the comparatively dark Panels 4 and 5, red paint was removed from within engraved areas too, since leaving patches of paint within these engraved areas would have been visually distracting. Red paint was left alone within the engraved surfaces of the far left-hand figure (a well-defined owl-like motif with zigzag legs) of the well-lit Panel 6. A half circle of red acrylic paint around the sentinel-like owl motif in Panel 7 was left untouched because the graffiti blended with the natural red color of the rock crust.

Except at its western end, close to the northern entrance, the main body of flowstone was surprisingly hard. The laminated texture of the flowstone and its translucent appearance close to protruding edges resembled the appearance of carved ivory. In the fading light of Hurricane Dennis and during rainstorms in general, vigorous brushing occasionally produced faint bursts of light immediately behind the surface of the calcite. This brief internal flash is very likely a physical phenomenon known as pressure-induced luminescence, or triboluminescence, a property of some minerals including calcite that causes rock surfaces to glow when they are struck, scratched, or rubbed vigorously (Chapman 1982). Significantly, the original image-makers most likely witnessed the same phenomenon while carving and pecking motifs into the rock faces.

Recording and Redrawing

Tracings were done on plastic sheets as part of the condition assessment and baseline documentation prior to removal of the graffiti. The tracings were checked and updated after graffiti removal. With most of the graffiti gone,

numerous details were observed for the first time, most memorably a rayed arc near the bottom of Panel 4 and a vertical grouping of three faces within Panel 5. The discovery of new motifs was attributed to the removal of the thick paint, algae layers, and distracting graffiti shapes, which leveled and covered some of the engraved depressions and furrows. In addition, working on the rock surface at different angles allowed cleaners to notice lines of shadows that defined engraved edges.

A proper rendition of details captured on the field tracings, for interpretive display and research purposes, is typically scaled-down redrawn copies of the originals. Sturdy Mylar sheets were placed over the plastic field tracings on a drawing table in order to make one-to-one scale redrawn copies. After tracing from the originals, the Mylar sheets were taken for reduction at a graphics company with specialized roller-fed equipment. Final redrawings were done on 8.5-by-11-inch sheets, using the Freehand computer graphics program to draw clear lines and to render shading. Three-centimeter scales appear on all copies so as to keep track of size reduction. Standardized lines and colors were employed to distinguish between marks made by people and natural folds, edges, and cracks.

The redrawings represent three-dimensional rock and worked surfaces on two-dimensional paper. For this reason, some redrawn motifs, particularly those done on stalagmites or Panels 2, 7, and 8A, appear wider than they do when viewed directly in the field or on photographs. In spite of this distortion, the choice of a "flat view" is an elegant way to present information, very much in the way a Sumerian cylindrical seal is rolled out on a flat strip of clay.

Placement of Recorded Panels

Observations made during condition assessment, graffiti removal, and tracing strongly suggest that certain surfaces were selected for petroglyph production. Of the 62 motifs identified at the site, 59 motifs (95 percent) were executed on flowstone and dripstone calcite surfaces. Many petroglyphs were centered on the protrusions created by travertine folds, stalagmites, and stalactites, a positioning that produces a symmetrical effect. In many instances the shapes of the natural surfaces accentuate the carved images.

Virtually all the surfaces with petroglyphs have images on calcite instead of on parent limestone. Interestingly, the calcite was often less weathered, more uneven, and harder than the adjacent limestone parent rock; the calcite was not necessarily easier to carve or peck. Instead of condition, texture, or hardness, we propose that calcite was selected, at least in part, for its suggestive shapes and its luminescent properties. Bulbous protrusions, "curtain

ridges," and other natural contours were preferred, often to symmetrically frame the petroglyphs.

Considering that calcite surfaces face various directions, including due east, it is significant that 64 percent of the motifs face in a westerly direction, generally toward the Santa Cruz mountain range. When walking through the shelter it is not easy to immediately see many of the petroglyphs. Indeed, a few are done at upward-facing angles that make them difficult to spot while standing or walking on ground level. Instead of carving the motifs to face the viewer, such as exhibitors would do within an art gallery, the motifs seem to gaze toward the mountains behind the shelter.

The placement of the petroglyphs also seems to be related to the hydrology within the shelter. Following the two big rainstorms experienced during fieldwork, most of the rock art was covered in water trickling down from the ceiling. Significantly, the now permanently dry calcite walls on the eastern side of the main shelter and at the back of the eastern shelter showed no traces of rock art.

The Ethnographic Context of the Petroglyphs

The selective placement of the petroglyphs, together with the prevailing aspect of the panels, the luminescent properties of calcite, and the hydrology of the shelter, is best understood within a reconstructed ethnographic context. The Taíno were the immediate predecessors of precontact Jamaican societies (Rouse 1992:107). Although instructive, the available ethnohistoric descriptions of the Taíno are limited due to these people's relatively early demise in the sixteenth century. To fill lacunae in the record, ethnographers and archaeologists have successfully employed the more recent historic-period ethnographies of Indians from the Guianas and Upper Amazon in South America to interpret Taíno religion.

We do the same here, suggesting that certain widely shared beliefs among these people most likely account for the placement, mode of execution, and selection of Warminster/Genus's carved images. Our analysis also takes into account that Taíno beliefs were intertwined with their religious experiences and rituals, which involved altered states. Perhaps more pertinent for the purposes of rock art conservation, ethnographically grounded interpretation assists in the formulation of preservation strategies.

Taíno Religion and Lithic Image Expression

The observations of Father Pané and Bishop Las Casas on Taíno religion reveal that the Taíno believed in a layered cosmos characterized by the sky,

the earth, and the lower world. The Taíno informed Pané that "during the day they [the dead] hide away [below the ground], and at night they go out to walk about" (Pané 1999:18). Moreover, the Taíno believed that the sun and moon emerged from the lower world, at openings in the ground, such as Iguanaboína Cave in Hispaniola (Pané 1999:17). Similarly, they believed that at sunset spirits of the dead emerged from two mouths of Jagua Cave (Pané in Griswold 1997:172). The traveling between the lower world and this world via caves enabled the spirit beings to partake in various nocturnal activities, including fishing and flying around in the form of birds. Worrisome to the average Taíno was that these nocturnal spirits sometimes "got into bed among the living" and appeared "on the roads and public ways" (Pané in Griswold 1997:173). We suggest that such accounts may be references to nightmares and other encounters with imaginary beings.

In Pané's account (in Griswold 1997:173), Taíno people stated that the spirits of the nocturnal beings particularly favored sweet things. The concept of *cemí* has been described as a "life force" that had an impact on everyday people in the everyday world (see Oliver 2005:245–246). According to Oliver (personal communication 2006), the term *cemí* is cognate with several Northern Caribbean, or Arawakan, languages and a high degree of probability exists that the word *cemí* actually translates as "sweet" (both as an adjective and as a noun). Hence the term might be expanded to include an aspect of "sweetness" and help explain other chronicler-recorded native behaviors discussed below.

Whereas *cemís* were expected to move among the living at nighttime, their comparatively rare appearances during the day were viewed with some trepidation. Based partly on Pané's observations, Oliver (2005:247) succinctly illustrates this point: a potential encounter with a *cemí* may occur to any ordinary Taíno walking through a forest, who may sense an unusual movement of a branch, an unexpected stench from a rotten fruit, the sudden appearance of a rare bird, the presence of an oddly shaped river boulder that was not there before, or any other sensorial experience that was unusual for that particular environment or that specific time.

Not knowing how to properly communicate with an unusual plant, animal, or rock, the ordinary Taíno required a *behique,* or shaman, to address the anomalous behavior. The *behique* ritual specialist would fast, vomit, and then snuff hallucinogenic *cohoba* powder through his nostrils via an ornately carved inhaler (for descriptions see Columbus in Griswold 1997:171, 178; also Hayward, Atkinson, and Cinquino, Introduction, this volume). Being in an altered state of consciousness the *behique* was able to hear and understand the instructions of an unusual plant, rock, or animal to "make from it a statue" (Las Casas quoting Pané in Griswold 1997:176). Of interest for rock

art production, Pané (in Griswold 1997:174) wrote that if *behiques* happened to obtain answers from a *cemí* among the rocks, they carved an image from the rocks. According to Pané (in Griswold 1997:174), only once the *behiques* controlled a *cemí* would that *cemí* "listen to their wishes." Understanding and control of supernatural forces as sometimes embodied in carved *cemís* helped the *behiques* to complete a variety of tasks critical for the survival and well-being of communities, ranging from curing the sick to predicting the future to controlling the weather.

Assuming that rock carvings most embodied a *behique's* control over his visions experienced during altered states, hallucinations probably informed the petroglyphs within the Warminster/Genus rockshelter. The placement, execution, and identity of motifs within the rockshelter tend to support this proposition. The first motif noticeable upon approaching the rockshelter from the north concerns the incised and partly sculpted stalagmite, or Panel 7, that is perched on the main boulder, roughly 9 m above ground surface (Figure 5.2). Arguably the most impressive carving at the site, this motif resembles a three-dimensional sculpture, especially considering that the grinding away of surfaces near the natural edges has enhanced its rounded appearance (Figure 5.2a). When one enters the Warminster/Genus rockshelter through its eastern entrance, another carving can be seen on a prominent stalagmite to the left, or Panel 2 (Figure 5.3a).

The prominent locations of these carved stalagmites at the entrance to the rockshelter recall the placement of two *cemís* described in the ethnohistoric literature as Boínayel and Márohu, who stood at the entrance of Iguanaboína Cave in Hispaniola (Pané 1999:17). Boínayel or the Rain Giver is portrayed in other surviving sculpted figures with tears or lines running down the cheeks from the eyes (Arrom 1997:73–75). According to Pané (in Griswold 1997:173), the Indians revered and venerated this cave "more piously than the Greeks did Corinth" and could not enter to see the "thousand kinds of paintings" deeper within. Although the Warminster/Genus rockshelter has no signs of paintings, like Iguanaboína Cave it too is marked by elaborately carved and sculpted effigies at and near its entrance.

The concentric eyes and tufted ears of the Panels 2 and 7 motifs resemble those of the Jamaican owl (*Pseudoscops grammicus;* Figure 5.2b) (Downer and Sutton 1990). Stylized concentric-ring eyes are present on many owl-like effigies recovered from prehistoric archaeological contexts in the Caribbean (see Beeker et al. 2002:17; García Arévalo 1997:114, 120–122). The mouth and square jaw line below the owl-like eyes of the Panel 7 motif (Figure 5.2a) nonetheless remain distinctively human. A similar combination of owl and human facial features is present on a Taíno ceramic flask from the Dominican Republic described by García Arévalo (1997:123). The unusually elongated

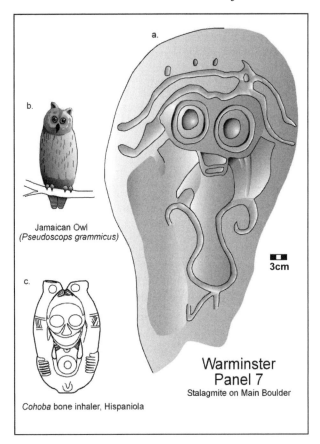

Figure 5.2. Panel 7 petroglyphs at Warminster/Genus rock-shelter, Jamaica.

and curving body of the Panel 7 motif resembles that of a snake or fishlike creature. Viewed in its entirety, then, we suggest that the Panel 7 motif combines the features of a sky creature (owl), land creature (human), and underground or aquatic creature (snake or fish).

The conflation of different species within one artifact or motif is common in Taíno expressive forms (see Bercht et al. 1997), as is employing orbital eyes and grimacing mouths to help accentuate the cadaverous cheekbones and jaw of a dead person. Yet other anatomical features of the same entities suggest movement, such as the wings in the Panel 2 motif or the meandering body of the Panel 7 motif.

Such a fusion of life and death attributes within the same motif is also apparent in a bone carving of a "contortionist" skeleton from the Dominican Republic reported on by Roe (1997a:140, 146) and illustrated here as Fig-

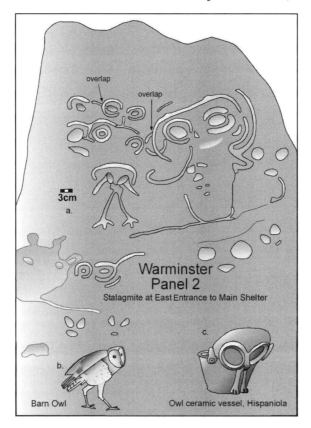

Figure 5.3. Panel 2 petroglyphs at Warminster/Genus rockshelter, Jamaica.

ure 5.2c. Carved from manatee bone, this hollow figurine represents a human skull with the ears of a bat and a clearly delineated rib cage. Were it not for its obvious maleness and fleshy arms, hands, and legs, the otherwise skeletal figure could easily be misidentified as a corpse. Las Casas's (in Griswold 1997:178) eyewitness account of the use of a similar artifact by the Taíno provides the key to its use as a *cohoba* inhaler. A hollowed-out, small flute–sized, three-sectioned instrument was placed with one section on a plate holding the *cohoba* powder, which was inhaled into the nostrils via the other two sections.

The physical resemblance between *cohoba* inhaler as artifact and *cohoba* inhaler as transformed human *behique* is all the more striking considering that *cohoba* powder physically moved through the body of both artifact and human to achieve its effect.

Left of the Panel 2 owl (Figure 5.3a) lies a carving of a smaller owl-like

creature. Unlike the Jamaican owls discussed thus far, this owl has inward slanting eyes and no ears. The rounded top of the head together with the eyes appears to be a stylized depiction of a barn owl (Figure 5.3b). A remarkably similar stylization of a barn owl (most probably the barn owl *Tyto alba* that inhabits Jamaica and neighboring islands; Downer and Sutton 1990) occurs on a ceramic vessel from the Dominican Republic (Figure 5.3c) (Garcia Arévalo 1997:122). Curiously, both the stylized rock image and the ceramic depictions of the barn owl emphasize the heads and legs but seem to lack bodies, as the legs are directly attached to the head.

Although the owl-like images at the entrances to Warminster/Genus do not necessarily represent Boínayel and Márohu, the same underlying beliefs and sense of awe were very likely associated with the prominent placement of petroglyphs at the gateways to both this rockshelter and Iguanaboína Cave. Indeed, it is conceivable that conspicuous and elaborate imagery at the entrances to such venerated places signifies points of transformation from the everyday world to the lower world. A general parallel to the situation at the Warminster/Genus rockshelter and Iguanaboína Cave is provided by the Cueva de Mora in Puerto Rico, investigated by Roe and his colleagues (Roe et al. 1999). Here too the owl played a key role, with a comparable deliberate placing of petroglyphs at the outer portals of the cave system that receive daylight.

Perhaps because the Warminster/Genus rockshelter has no dark zone, petroglyphs have also been executed behind the main boulder farther within the shelter. These panels too contain elaborate carvings. Indeed, Panel 4 with its considerable variety of motifs is arguably the most complicated panel within the site. On the left-hand side of Panel 4 a carver deftly transformed a sunken calcite pillar into a barn owl by skillfully adding a rounded head line and inwardly slanting eyes (Figure 5.4a and b).

Although the eyes of both owl species are emphasized in Jamaican and Caribbean rock art on numerous artifacts, both species actually locate and catch their prey through their acute hearing instead of their eyesight (Trapp 2006). The Taíno *behique*'s emphasis on carving the owl eyes was probably to portray the notion that spirit beings from the dark lower world and nighttime can see things invisible to everyday people.

Diagonally above and to the right of this owl-like motif is another depiction of a head with inwardly slanting eyes. In this motif the head has a discoid shape and the mouth looks human. The floppy legs of this motif resemble those of an owlet (Figure 5.4c). Moreover, the inverted triangular shapes on the sides of the lower head resemble the undeveloped wings of an owlet. The fact that this carving is bigger than the nearby depiction of an adult owl suggests that scale did not matter to the carver(s). With the excep-

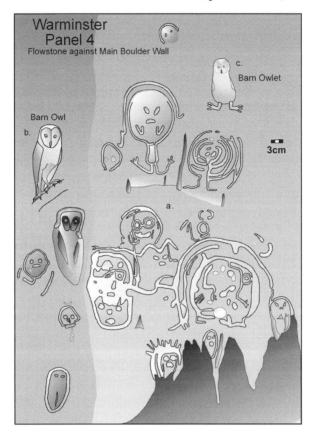

Figure 5.4. Panel 4 petroglyphs at Warminster/Genus rock-shelter, Jamaica.

tion of the prominent sentinel owl motif in Panel 7, this owlet is the most carefully executed. The lines encircling the owlet have an even width and the forehead has been carefully excised from the rock, creating a smooth convex surface. Overall, the careful execution, central placement, and relatively big size of this owlet suggest that it had special significance to its creator. The owlet may actually represent a particularly powerful spirit helper, inasmuch as infants and dwarves are potent spirit helpers among the Indians of Amazonia (see Crocker 1985:291–292).

Slightly below and to the right of this owlet within Panel 4 is a motif that comprises nested concentric rings. Judging from the legs at the bottom of the rings and a suggestive beak near its center, this motif possibly represents another owlet. The definite lines and fairly good preservation of this petroglyph suggest that its appearance is intentional and not due to bad or sloppy tech-

nique. Near the bottom central portion of the same Panel 4, another carefully executed concentric-ring design is even less recognizable; only clawlike feet and a concentric-ring eye are apparent (Figure 5.4a).

We consider that the two juxtaposed ringed motifs, comprising the encircled claws with eyes motif and the concentric rings and beak motif, together with the owlet motif within Panel 4, can be explained in terms of altered-states visions. Of relevance here is the claim of Amazonian Indians that *cohoba* powder "produced overwhelming kaleidoscopic visions—first of ever-shifting geometric designs, then of transforming animal, bird, and human forms" (Roe 1997a:146). Taken together, the series of three related motifs could portray the incubation and hatching of an owlet, very much like entoptics are known to change into iconic forms during a deepening trance (see Lewis-Williams 2002; Siegel 1992).

Near the center of Panel 4, to the left and slightly below the owlet motifs, lies a badly weathered line that encircles three vertically stacked faces. Within this overall motif, the jaw of the central face seems to define the upper head line of the lower face. The replication of shamanic visions (see Roe 1997a:149) could account for motifs that include such vertically stacked faces.

Extending outwards from the middle face is an armlike appendage with a clawlike hand. This and similar face motifs within the Warminster/Genus shelter with arms summon to mind a story told of a *cemí* called Vaybrama (also known as Baibrama: Alégria 1997:23; Pané 1999:27 n. 112; said to have been found in Jamaica: Senior 2003). Las Casas (in Griswold 1997:178–179) documented a Taíno story about an enemy group trying to burn and destroy Vaybrama, whom they stole from its owners. After the concerned owners managed to recapture Vaybrama, "they washed him with the juice of the root . . . called yuca [cassava] . . . he grew arms and his eyes reappeared and his body grew" (Las Casas in Griswold 1997:179).

It is interesting to note that the juice of cassava plants (*Manihot esculenta*) contains high levels of toxic and hallucinogenic hydrocyanic acid, a colorless liquid with a distinctively sweet aroma (Webster's Online Dictionary 2006). Being bathed in this sweet but dangerous and hallucinogenic liquid, it is perhaps understandable why the *cemí* was revitalized in the treacherous spiritual world of altered states. Viewed in terms of this ethno-pharmacological information, the numerous faces within the Warminster/Genus shelter that have arms, legs, and branches or roots probably represent emerging or growing plant *cemís*. This emergence and actualization of plantlike forms on the rock face echos depictions of the emerging owlet in the same shelter; the concept of "becoming" seems to be portrayed again and again.

Immediately above the three-in-one face motif is a stylized zigzag depiction of a snake, complete with forked tongue. Snake designs are rare in Taíno

art or expressive forms. Nonetheless, like owls, snakes in this part of the world are essentially nocturnal creatures, spending daylight hours in dark locations (Senior 2003). As with the owl-like motifs within the rockshelter, the portrayal of the snake suggests that the engravers favored nocturnal creatures. Of importance is that Pané (1999:24–25) collected the following account that unambiguously identifies snakes as the spirit helpers, and not ancestors, of *behiques:* "And they say that at night many snakes come, of various kinds, white, black, and green, and of many other colors, and they lick the face and the whole body of the said physician [*behique*] whom they left for dead, as we have said. He is in this state for two or three days, and while he is thus, the bones of his legs and arms join once again and mend, they say, and he stands up and walks a little and goes back to his house. And those who see him inquire, asking: 'Were you not dead?' But he answers that the zemis went to his aid in the shape of serpents."

This quote is important as it suggests that like nocturnal snakes, owls depicted in the Warminster/Genus rockshelter probably represent spirit helpers instead of ancestral spirits. According to early chroniclers' accounts, spirits of specific ancestors were associated with the political and religious elite living in the major settlements (Columbus in Griswold 1997:170–171), most of these settlements being associated with ball courts and carved depictions of *cemís* on boundary stones. The elite would have included the *cacique* (chief) and a few *behique* collaborators. Actually, *caciques* were accomplished *behiques,* who looked after the collective welfare of their followers. Lesser *behiques* were more involved in the health and welfare of individual families (Oliver 2005:245). The ancestral connotations of the *cacique's cemís* were expressed in the fact that skulls and other body parts of deceased ancestors were actually incorporated in the *cemís* of the elite (Siegel 1997:106–108).

Viewed from the perspective of everyday consciousness, the *behiques'* entering the world of spirit helpers was by all accounts a disorienting and counterintuitive experience. This can, for example, be seen in Pané's (in Griswold 1997:174) observation that "with which *cohoba* the *boítios* [*behiques*] also suddenly begin to rave, and at once they begin to see that the house is moving, turning things upside down, and that men are walking backwards." Although no explicit documented accounts of underground travel or so-called soul flights of *behiques* are known, mythical tales of *behique*-like beings living underground, traveling underwater, and flying around have been recorded (Pané in Griswold 1997:172).

Insights Gained from Ethnographic Information

The Warminster/Genus rockshelter can certainly be considered a place that reflects an overarching cosmological unity. We consider that the tendency of

motifs within the rockshelter to face the mountains west of the Warminster/ Genus rockshelter is an important expression of this unity. As among so many other Amerindian groups, in Taíno cosmology the West was the land where dead spirits went to dwell (Columbus in Griswold 1997:171; Roe 2005:333). The prevailing westward aspect of motifs within the Warminster/Genus rockshelter probably amplified the link that the owl and skull-like motifs had with the world of the dead.

In the tiered cosmos of the Indians who inhabited the Amazonian lowlands and Caribbean, the dead spirits emerged from the dark lower world mainly at night, a time during which some spirits took on the appearance of stars in the Milky Way (Roe 2005:296, 333). The quick internal bursts of glowing light within the calcite surface of the rockshelter that would have been visible during image production might have resembled twinkling stars in the night sky. This physical resemblance could have resonated with the beliefs of the Taíno engravers. Perhaps more important, such light resembled the entoptics that *behiques* would most likely have seen during at least some altered-state experiences.

We propose that the landscape was a convenient natural model to reflect levels of consciousness; the ground surface separated normal everyday problem-solving mental states from the more uncontrollable altered mental states associated with the lower world. In this sense the landscape was an apt physical metaphor to represent the mindscape; mental transitions were associated with visible openings in the surrounding natural and cultural setting.

To better understand Taíno cosmology, then, it is useful to know some basic geomorphology. The highly permeable karst topography of southwestern Jamaica limestone favors the underground flow of water. Very likely related to this predominantly submerged drainage pattern was the Taíno belief that the lower world was basically aquatic (Roe 2005:334). In the essentially concentric, or domed, universe of the Taíno (Siegel 1997:108), the spirits of the dead lived hidden within the wet cavernous limestone during the day only to emerge in the equally dark night sky after the sun had descended into its cave (Roe 2005:296, 297, 332).

The day–night, or nychthemeral, cycle of "wet" spirits being spat out and swallowed by caves resembles the movement of owls and other nocturnal creatures, such as snakes (Figure 5.5). Knowing that in the reversed world of spirits "men are walking backwards" (Pané in Griswold 1997:174), depictions of spirit beings will likely have them moving backwards too. In terms of the water trickling through the cavernous and porous ceiling of the Warminster/Genus rockshelter and downwards across the rock walls, it is then conceivable that the emerging petroglyph *cemís* are moving upwards, against the direction of flow. Nonetheless, these spirit figures always have

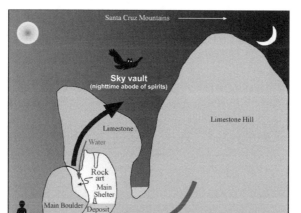

Figure 5.5. Nychthemeral cycle of spirits as expressed at
Warminster/Genus rockshelter, Jamaica.

their eyes directed at the land of the dead in the west where they really be-
long and from which they ultimately derived their wisdom.

Overall then, the dynamic setting of *cemís* within the rockshelter suggests
that more than just reflecting Taíno cosmology the rockshelter and rock art
embodied imagery and processes that were important in Taíno spiritual life.

Summary and Management Recommendations

So far the fate of the Warminster/Genus shelter's rock art has been dependent
on its being privately held. According to available information, access to the
shelter was open to goat herders, people processing vegetable matter, church
groups, adventurous children from the area, and the occasional hermit. We re-
ceived numerous visitors from the Genus community while working in the
shelter. This was advantageous, not only considering the useful background
information that they shared with us but also because our labors at the shel-
ter visibly impressed upon them the importance of the petroglyphs and their
preservation.

Details concerning the future management of the site depend on what
happens once the land is fully transferred from private ownership to the Al-
part firm. Whatever transpires, we recommend that a community meeting

be organized to inform the local people about the rockshelter and what precautionary measures are being adopted for its preservation. The public image of Alpart can benefit from cooperating with the Genus community and involving members from various levels of the local community. An unobtrusive barbed-wire fence, paid for by Alpart, might act as a temporary measure to reduce goat access to the shelter. It might behoove Alpart to involve a local conservation body or environmental tourist agency to manage the site for the purposes of public visitation. This effort should involve the training and salaried employment of a guard, or site interpreter, from the local area. Visitors from abroad can be charged a fee for the privilege to visit the site and view the petroglyphs.

Since not all the petroglyphs within the shelter are automatically recognizable, a site interpreter might be of great value to point these out to visitors. Copies of redrawings made from the tracings can be used on interpretive brochures or signs installed at the site. In addition to helping visitors identify the rock motifs, redrawn copies can help interpret their age, archaeological association, ethnic affiliation, and meaning. Since prehistorically carved, pecked, and incised motifs are not immediately apparent to the average person visiting the site, it is vital that a properly recorded rendition of the motifs be included in some form of interpretive display or brochure.

In spite of the somewhat lengthy ethnographically informed exegesis presented above, we consider that interpretation should be kept minimal and straightforward, so as not to create unnecessary boredom or confusion. Nonetheless, interpretation should at least state that available Taíno accounts suggest the motifs within the shelter are most likely representations of spirit beings.

Given the possible significance that the water flowing across the petroglyphs has in terms of ethnographically informed interpretation, it is best not to curb its flow, such as by installing an artificial drip line. Additionally, no evidence is present to suggest that the surface water damages the images.

To reduce the level of dust generation within the shelter, loose slabs of stone could be used to create a pavement on the current deposits. The installation of a pedestal with a box containing a visitors' book at a strategic point within the rockshelter would create a psychological barrier beyond which the visitor would stand to sign his or her name and to obtain information for viewing and identifying the rock motif panels. Other than their educational purpose, visitors' books record names, dates of visitation, comments, and approximate numbers of visitors.

These recommendations, of course, depend on the goodwill and agreement of members of the local community. Without their involvement, co-

operation, and input, future management of the site and its motifs is on an uncertain course.

Continual monitoring at the site is highly recommended to check for signs of vandalism, natural deterioration, and the success of graffiti removal. Ongoing maintenance is important to remove trash, to fix signs, and even to remove any new graffiti. The success or failure of these recommendations can be assessed every year or so. In the event of some unexpected negative effects due to the new infrastructure at the site, the signs or proposed pavement could be removed without any harm to the rockshelter or its deposits.

The restoration and recording of the rock carvings at Warminster/Genus have been successfully carried out. So far as we are concerned, during the two-week period of activity and observation in and around the shelter, it became curiously dynamic: the suggestive shapes of the natural calcite flows, the trickling surface water running across the rock face, the triboluminescent properties of the calcite, and the westward-facing petroglyphs made the site come alive. The mental experiences, beliefs, and rituals of the image-makers, so far as we have been able to reconstruct them, have allowed us to gain a fuller and more reliable appreciation of this animated site. It will now be up to all interested parties to maintain it.

Acknowledgments

The following individuals and institutions supported this project in a variety of ways: The Reed Foundation, New York, and the University of the West Indies (UWI), Mona Campus (financial support); The Jamaica National Heritage Trust (JNHT) (site permission); Shalane Nembhard (site information); Franklin Ross, manager of the Lands Department at Alumina Partners of Jamaica (Alpart) Mining Venture (site access); the UWI second-year archaeology students (field crew); and Mr. Lance Neita, Mr. Mike Blackwood, Mrs. J. Senior, Mr. Elvis Bellinfante, Mrs. Karen Spence, and Mr. G. Dixon (local help and assistance). Thanks go to Joe Joseph, Tom Quinn, Joe Ivanowski, and Peter Siegel for information and technical assistance. Philip Allsworth-Jones directed the UWI side of the project. Johannes Loubser was in charge of all aspects concerned with the removal of the graffiti and the recording of the images.

6

The Rock Images of Haiti

A Living Heritage

Rachel Beauvoir-Dominique

Prehistoric Culture Overview

Two major cultural periods mark the prehistory of Haiti. The first roughly spans the six millennia of the Lithic and Archaic ages. On Haiti, these hunting and gathering cultures are known from habitation and cave sites; coastal shell middens; stone, shell, and flint collections; and funerary sites (Veloz Maggiolo 1972).

Jacques Roumain, the father of Haitian archaeology, published a seminal paper entitled "Lithic Workshop of the Ciboney of Haiti" (Roumain 1943), based on his work at the towns of Cabaret and Merger in the southern region of Port-au-Prince. His work is complemented by the research of Froelich Rainey (1941) and Irving Rouse (1941), mostly in the northeastern Fort Liberté region, which led to the characterization of each of the two cultural phases.

The later Archaic Courian Casimiroid populations were increasingly associated with fishing and the sea, as well as the production of shell ornaments, conch tools, and the like. The earliest dates for Lithic cultures generally come from sites in the Cabaret-Arcahaie area (Duclos VII, 4160 B.C., and Vignier III, 3630 B.C.), with later phase occupation indicated from the Fort Liberté and Port-de-Paix regions, dated to 2660 B.C. and 2470 B.C. (still within the Lithic Age), respectively (Moore 1992).

Archaic cultures, of the early, middle, and late periods, extend from 2780 B.C. (Matelas site) to A.D. 390 (Philippe, La Gonave). While these sites are generally concentrated in the Ile à Vache and southern part of Haiti, they are also found, contrary to previous belief, throughout the country, including the center and north (for example, Gonaïves, Anse Rouge, Ferrier, Limonade, Port-de-Paix, and La Tortue). Since Archaic sites are normally located near the sea, they are under the constant threat of erosion (Moore 1992).

The Ceramic Period marks the second major Haitian prehistoric division,

incorporating the Ostionan, Meillacan, and Chican Ostionoid ceramic series that are associated with pre-Taíno and Taíno peoples (see Figure 1.2, this volume). Both Puerto Rico and Hispaniola, including Haiti, as Wilson (1999) has argued, represent the areas with the highest expression of Taíno artistic, social, and political development.

Ostionan artifacts (A.D. 650–960) are located primarily around Fort Liberté, particularly at the sites of Ile à Cabrits and Ile à Boucanier. Red-colored pottery predominates within the assemblages. It should be noted that the lack of recent archaeological research in the country means that we still possess a limited and likely biased sample from the earliest phase of the Ceramic Period (Moore 1998).

The few Ostionoid artifacts rapidly give way to two major Meillacan ceramic types. The Finca style from southwestern Haiti is closely linked to Jamaican ceramics, while the Meillac style finds its most classical expression in the north, including sites in the Fort Liberté region. Finally, the Chican ceramic style of the Classic Taíno culture (A.D. 1200–1500) is largely distributed throughout the Haitian territory, though much more scarce in the southern Guacayarima province (Moore 1998).

A third period of rock art production appears to have taken place in the early historic period with the introduction of African populations to Haiti.

Rock Art Sites

A thorough inventory of Haitian rock art has yet to be undertaken. Nevertheless, a number of locations have been identified throughout the years, most notably:

- The Roche à l'Inde (Camp-Coq, Limbé), Roche Tampée (Cerca Carvajal-Hinche), and Sainte-Suzanne riverbed sites in the north and Central Plateau region;
- The Voûte à Minguet of Dondon in northern Haiti and Bassin Zim in Hinche, Central Plateau, both deep cave sites;
- The Bohoc/Colladère (Pignon) and St. Francique (St. Michel de l'Attalaye) cave sites in the Central Plateau;
- The historically mentioned Dubedou cave site near the city of Gonaïves in the department of Artibonite.

Additional reported sites include the caves of Tortuga Island, Marmelade's Grotte Dufour, and the Morne Deux-Têtes Meillac site of Limbé in the north. As for the south, the literature mentions a major ball court in the hillsides of Merger, as well as the cave site where the famous *cacique*

Anacaona took refuge. Farther down the southwestern peninsula, following Haiti's major karst line, lie the grottos of Camp-Perrin, the Port-Salut Moreau Cave, the town of Pestel's Grotte aux Indes, Grande Grotte in Port à Piment (the largest in Haiti, estimated at 1,000 m long), and the Grotte nan Baryè of the Grande Anse Department. All contain rock art.

Riverbed Petroglyph Sites:
Roche à l'Inde, Roche Tampée, and Sainte-Suzanne

Three riverbed sites of the north are amongst Haiti's most ancient witnesses of the pre-Columbian past. The Roche à l'Inde site, near the village of Camp-Coq and close to the major town of Limbé, was the first of these sites to be explored, particularly by the late William Hodges (1979). Its proximity to a Limbé Meillac site, as well as the Morne Deux-Têtes petroglyph site in the same area, led Hodges (1984) to link the engraved images with the second-phase Ceramic Period Meillacan peoples, A.D. 900–1200.

One hundred small petroglyphs, mainly of spiral (possibly symbolizing life cycles) and wave motifs, measuring from 5 to 6 cm to a maximum of 25 cm are carved on three major and two secondary basalt stone formations. Complete human figures, some quite clearly representing males, adjoin simple and complex human faces, zoomorphic images, and various other abstract shapes. Arrazcaeta Delgado and Navarrete Quiñones's (2003) hypothesis regarding the abstract images from Cueva de la Cachimba in Cuba as a form of prehistoric writing, a "vocabulary of symbols and hieroglyphs," may be relevant here due to the presence and relative abundance of equally abstract designs. Regrettably, about half of the designs were destroyed during the American occupation of 1915–1934 in order to establish a weighing station for agricultural produce (Viré 1941).

Roche Tampée at the town of Cerca Carvajal represents the second major riverbed rock art site that was also studied by Hodges (1984). The images are found on one large rock at the confluence of the Samana River and a small mountain stream, the entirety forming a sort of amphitheater with the petroglyph-adorned boulder at the center. Surrounding it are seven other petroglyphs, some on flat stones at its base, apparently serving as stepping-stones. The main boulder possesses 24 engravings, whose principal images consist of (1) a very large head apparently wearing a pointed headdress with a horizontal line above it and oriented directly northward, (2) an owl figure, (3) various other anthropomorphic and zoomorphic designs, and (4) a high percentage of conceivably "pairs of eyes" motifs.

Contrary to the Roche à l'Inde assemblage, the Roche Tampée site contains very few spirals and waveforms. Both sites, however, feature petroglyphs

usually oriented toward the north and a central figure (possibly a *cacique*) with a "pointy hat" having a bar above it, in addition to simple and complex face and eye shapes.

Sainte-Suzanne's rock images were only recently discovered and are consequently still being investigated. The site features a large number of complex faces, as well as simple ones and spirals.

Petroglyph Cave Sites

Voûte à Minguet or Minguet Vault

From the French colonial period to the present, the Minguet Vault has been known as a significant rock art site (Figure 6.1). In 1871, Edgar La Selve wrote:

> The Minguet cave deserves its reputation . . . At the extremity of the nave, you see square stones on which other flat stones . . . have been placed . . . These rough-hewn tables are altars. Each year, according to the report of Moreau de Saint-Méry, the kacik and the nitaynos of Marien came here, at the head of their tribes, to hold sacrifices for the Zemi, titular gods, of which the butios, combination of doctors and priests, interpreted the oracles . . . At the time of the new moon, they went there to await the rising of the blond divinity of the nights, and as soon as she had arisen in the whiteness of the sky, they threw themselves outside, crying, according to the rites: Nonun! Nonun! The walls of the cave, that appeared whitewashed, retain . . . the dates, inscriptions, names, Spanish for the most part, in charcoal or engraved since the end of the sixteenth century by the Europeans who have visited. Courouille found a six-inch, crudely sculpted statue, but well conserved. This statue represents Zémès crouching, wild, ready to jump, threatening with his left hand and hurling his dagger with the other [La Selve 1871; translation by Brian D. Oakes].

According to Rouzier (1890), following Saint-Méry's (1984) compendium of information on the French colonial period of Haiti, the Taíno of Marien believed they originated from this cave and that the sun and the moon had pierced its vault in order to illuminate the world. This interpretation, echoing general Taíno cosmological beliefs, is linked to marking alignments in the cave during the summer and winter equinoxes. Recorded Taíno oral traditions also report that the first humans who imitated these heavenly bodies were changed by the sun into frogs, lizards, birds, and such, and the cave's guardians were turned into stone, thus explaining the two megaliths placed

Figure 6.1. Voûte à Minguet petroglyph cave site (photographs by Didier Dominique and Rachel Beauvoir-Dominique, 1995).

at the entrance of the grotto. Further within, the chamber is separated into three-by-two lateral rows of stalagmites; the sides are decorated with petroglyphs, primarily with facial features.

Additional caves, such as Marc-Antoine, Cadelia, and Voûte des Dames, surround Minguet Vault near the town of Dondon, several of which also contain abundant rock figures. In the past, a thick and spongy layer of guano covered Minguet Vault's floor.

The Dondon Cave System

The Dondon cave system is connected with important river rock art sites of the north, as well as the cave systems of the Central Plateau, through mountain passes later used by both Amerindian and African slaves in revolt.

Bassin Zim

Situated in a spectacular location, the Bassin Zim site is noted for its archaeological remains, as well as its physical beauty (Figure 6.2). The location

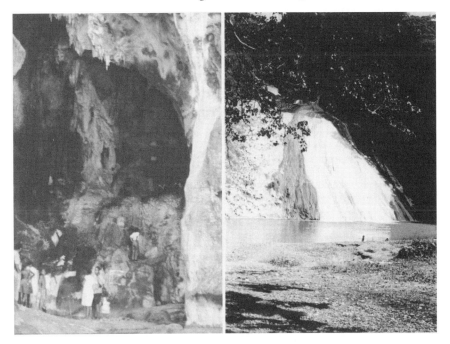

Figure 6.2. Bassin Zim petroglyph cave site (photographs by Didier Dominique and Rachel Beauvoir-Dominique, 1995).

consists of a 20-m-high waterfall complete with basin. Behind it are caves and a subterranean water system that feeds the waterfall. The local population has attached a cosmological-based explanation to the site including names for various locations and rocks, in addition to interpretations of the figures.

This remarkable location has been explored since the 1940s (Mangones and Maximilien 1941; Viré 1941). The modern use of ladders to reach the elevated petroglyphs suggests this place possibly served as a Taíno initiatory center. The petroglyphs might have formed a necessary part in the sequence of the rites or forms of traits leading to the teachings or knowledge of the spirit world.

The anthropomorphic figures, often rendered with upright arms perhaps indicating supplication of or interaction with the supernatural, alongside abstract symbols might suggest the depiction of entoptic phenomena associated with shamanistic trance experiences (Clottes 1998; Lewis-Williams 2002). Such a supposition is supported by the early contact period–documented ritual use of *cohoba,* a hallucinogen, in Classic Taíno culture (see Hayward, Atkinson, and Cinquino, Introduction, this volume).

Other Central Plateau Cave Locations

The neighboring Bohoc and Colladère sites, in the Pignon region, contain notable petroglyph assemblages. At Bohoc, a very large fish is carved on a 6-m-tall rock face, forcing the observer to step back about 10 m to appreciate the image. The fish is traced in relief and painted brownish-black (Salgado ca. 1980). The fish image is possibly an aspect of the Taíno cosmology in which creation proceeds from the primordial ancestors' bones (later changing into fish) spilling out of a water-filled calabash or gourd.

Most impressive, to the modern observer, is the nearby St. Francique cave, which, even more than the aforementioned locations, continues to be revered in Vodou religion. Rituals are conducted at an assortment of cave locations during the summer equinox. A current principal figure within the cave complex entails a stalagmite carved into a female image (possibly Attabeira, the mother of the Creator God, Yúcahu, in Taíno oral tradition) dressed with a skirt during present-day Vodou annual services. Since the St. Francique site is actually a set of caves, modern populations venerate each separate location for different spiritual and mythological reasons.

The naturalist Descourtilz (1935 [1809]) described the Gonaïves Dubedou site at the end of the French colonial era. Research has yet to be conducted at this site where, according to Descourtilz (1935 [1809]:2:18–19), "[t]he superstitious Indians worship their monstrous divinities in natural caverns, which are lit from the top to allow the first rays of the sun to enter . . . The interior of these natural vaults is lined with idols, encrusted and engraved in the rock, in bizarre and grotesque forms, which the caciques usually interpret in their favour."

The Descourtilz text is accompanied by a subjective drawing showing eight such forms: frogs with heads on their feet, human bodies with cone-shaped torsos and spherical knobs for heads, tortoises, and other animals including snakes. Unfortunately, no professional investigation has subsequently been undertaken.

Rock Art Characteristics

Petroglyphs, based on current data, outnumber pictographs, although the lack of systematic surveys renders this statement provisional. Petroglyphs at the principal Haitian rock art sites comprise two forms: chiseled/pecked and carved. The chiseled or pecked form, on rock walls and boulders, usually reveals triangular sections with profound grooves having dulled bottoms (blunted V shapes). The images at Bassin Zim are also generally deep and large, but a noteworthy particularity here involves the presence of relief. The

figures appear to be inscribed after the rock had been scraped, producing a bas-relief effect. Levels of sophistication vary—for instance, those of Sainte-Suzanne are quite rough, though figuratively complex; perhaps designs of African origin accompany the Taíno design backdrop.

The second major form consists of roughly carved (hacked or cut out) stalagmites or other naturally formed rock protuberances, with a posterior smoothing effect.

Interpretation and Ongoing Research—African Connections

Haitian interpretation of cave representations has recently been linked with national scholarship relating to territorial formation, culture, and resistance. Although apparently paradoxical, it is no coincidence that after the fierce war of independence waged by the slaves of African descent during the eighteenth century, people chose to reassume the former Taíno name, Haiti (meaning the mountainous land), for their country. In fact, the first Haitian constitutions entitled all people of native descent to Haitian nationality.

The deported people of Senegambia, the Gold Coast, and, later, the Congo basin who came to this half of Hispaniola managed to link their respective traditions of revolt with the insurgency of the island's natives who had been fleeing to the caves of the Central Plateau and Bahoruco regions since the Spanish conquest. This cultural innovation is attested by ceramic analyses (Smith 1995), particularly of the presence of Colonoware, a relatively crude earthenware initially believed to have been influenced by European and native pottery styles but later found to be a mix of African and native elements, at least in a Haitian context (Smith 1995). The oral history furthermore unequivocally points toward the formation of Haitian culture through the linking of these two groups in revolt (Beauvoir-Dominique 1995, 1997). This original cultural *metissage* has traditionally been overlooked in the literature, which instead has focused on separate European or African legacies, thereby neglecting the elements of continuity.

The Haitian people still continue to revere the places associated with this struggle, particularly the cave locations, possibly as a way of healing the trauma of the past (the subject of slavery being generally avoided in conscious memory). This veneration takes the form of a pilgrimage round held during the summer. The round begins with a journey to Perches in the north, a locality amidst hidden rock formations, followed by intermediate stations, such as the Saut d'Eau waterfall in the center on July 16, and ending at St. Jacques (La Plaine du Nord) and Ste. Anne (Limonade) in the north on July 25 and 26.

This linkage of past native ritual sites with present-day ceremonies rep-

resents an intricate cultural exchange that appears to have occurred between the native and newly introduced African populations during the first centuries of colonization and resistance and can be seen as an interplay that helps explain why and how the modern Haitian population exhibits many native cultural traits.

Rebels of African descent formed part of the native *Cacique* Henri's early 1500 rebellion. According to the Spanish colonial source Las Casas (1951: 3:275), 30,000 Africans were introduced to Hispaniola between 1516 and 1520. This was probably a clandestine commerce and as such would not appear in official census figures. Nonetheless, colonial documents report that many Africans escaped, going into revolt or maroonage, and joining the first Taíno rebels (see Fouchard 1981).

Escaped Africans and natives began to form a new understanding or utilization of the terrain. For the first time (both the natives and the Europeans had previously been attached to the coastal lines), networks were established that connected the northern and southern regions via mountain valleys. For instance, *Cacique* Henri, in the south, managed to link up with Tamayo, his first lieutenant, in the north. These connections, once in place, offered places of refuge or pockets of resistance from which those in revolt could coordinate their attacks on colonial settlements.

Given that a majority of the slaves in revolt were newly introduced, they needed this transmitted knowledge, including local topography (places to hide and how to escape), plant use (medicines, food), and belief system, to be able to successfully maroon or escape from slavery for short or long periods. Knowledge of effective attack strategies was also critical for survival since, lacking manufactured goods, they were forced to regularly obtain them from colonial settlements.

Investigations of the postcolonial Haitian defensive system (Collectif ISPAN 1990), which includes a semicircle of fortresses (Fort Crête-Rouge, Fort Rivière, Fort Bayonnais) around the Central Plateau conceived as an interior shelter zone, reveal that the semicircular defenses roughly correspond to the vital cave locations of both native and African-origin rebels. The Citadelle Laferrière, a World Heritage monument and part of the semicircular fortresses, is positioned directly above the Voûte à Minguet and Grand-Gouffre cave sites (Beauvoir-Dominique 1997; Dominique 1993).

Nothing short of such a highly structured constant linkage with the past explains these "just-come" slaves' mastery of skills necessary for survival outside slavery. This linkage is also evident in the modern Haitian Creole with its Spanish-Creole antecedents (Hilaire 1992). Frostin (1975) furthermore associates the rebellious permanence of St. Domingue, the French colo-

nial name for Haiti, to the legacies of previous peoples who felt "legitimately authorized to the land" and were often of mixed blood.

Assuredly, the strength of the Haitian culture, with its Creole language, territorial defense organization, and Vodou cosmology, indicates the deepest levels of intergenerational transmission, starting from the womb of the caves.

Legal Framework, Conservation, and Government Support

The 1941 law creating the Bureau of Ethnology (October 30, 1941) introduced the protection of archaeological remains in Haiti, declaring all artifacts "property of the Nation." All pre-Columbian vestiges having scientific or artistic importance are classified as archaeological objects (Article 3) and "eventual possessors, after having declared them at the Bureau of Ethnology, may be authorized to conserve them uniquely as guardians" (Article 2). Archaeological excavations are subject to authorization by the Department of the Interior, on the Bureau of Ethnology's recommendation (Article 7), the latter being entitled to the presence of a chosen representative at all excavations (Article 8). This law remains in effect today.

The 1987 Haitian Constitution additionally stipulates that "[a]rchaeological, historical, cultural, folklore and architectural treasures in the country, which bear witness to the grandeur of our past, are part of the national heritage. Consequently, monuments, ruins, sites of our ancestors' great feats of arms, famous centers of our African beliefs, and all remnants of the past are placed under the protection of the State."

The October 2005 Decree on the Environment states (Section IV, Article 49) the following: "The responsibility for classifying natural sites belongs to the Ministry of Environment, whereas the Ministry of Culture is charged with all matters that concern archaeological, cultural, historical, and folkloric resources." Article 50 further states that all such resources "are declared the natural patrimony of the nation, including all grottos, caves, and other natural underground cavities. All physical alterations of their natural and cultural characteristics are forbidden, including the removal of geologic, paleontological, archaeological, or other types of materials. Also forbidden is the introduction of foreign materials that are capable of changing the existing ecological equilibrium" (translation by author, revised by Michele H. Hayward).

Other pertinent legislation includes the 1968 decree on national parks and natural sites and those organizing the National Park and Natural Sites Administration (1983), the Bureau of Ethnology (1984), and the National Heri-

tage Commission (1989). Finally, Haiti remains a signatory of the UNESCO World Heritage Convention since 1980.

Despite this respectable amount of preservation legislation, the actual protection of Haiti's archaeological remains is largely dependent on its implementation. This, however, has been significantly lacking in recent years.

Threats to this heritage, as concerns Haiti's rock art locations, are of several types:

• Environmental: Deforestation and various other types of alteration of the natural setting obviously have a great impact on the preservation of sites in general and particularly on the preservation of rock art images, as they are visual expressions fundamentally linked to their milieu.
• Economic: The exploitation of guano over the past decades as well as the industrial logging throughout the nineteenth century have altered cave locations, putting them in peril.
• Political: A good number of rock formations on Tortuga Island were dynamited in 1982 by the dictator Duvalier during his siege of political opponents.
• Social: Graffiti and other forms of disrespect of this heritage have been inflicted by visitors throughout the years.

After several years of social and political turmoil, the 2006 national elections carry a hope of respite for Haiti. This opportunity, accompanied by the appointment of a pair of heritage specialists as cabinet ministers, marks a perceptible will to reverse the lack of concern for the conservation of the country's cultural resources. A Technical Commission, restructuring both the Bureau of Ethnology and the National Heritage Preservation Institution, has been set up within the Ministry of Culture to this effect, alongside immediate efforts of regional and international cooperation. These endeavors reflect a determination to overcome momentary political impulses by the establishment of a perennial body of protection of the national heritage, including recognized authorities in the public and private sectors, to defend this patrimony.

Conclusion

Haiti, with its archaeological past, remains the "sleeping giant" of the Caribbean, as can be seen in these preliminary notes concerning its rock images. A major effort is currently under way to inventory, study, and protect cultural resources including works executed on rock surfaces, to which the

Haitian nation invites regional cooperation. One example involves the country's participation in the World Heritage nomination for Caribbean transnational archaeological sites. It is hoped that this and other efforts will build and sustain a momentum for the preservation of our rich prehistoric and historic heritage.

7

Rock Art Studies in the Dominican Republic

José Gabriel Atiles Bidó

Translation by Michele H. Hayward

Cultural and Physical Contexts

Lithic and Archaic age people reached Hispaniola around 4000 and 2400 B.C., respectively, followed by Early Ceramic people around 100 to 200 B.C. or even several centuries earlier (Atiles Bidó and López Belando 2006; Rouse 1992). These new and resident pre-Columbian cultures on the island found themselves in a highly diversified geomorphological environment. Three mountain ranges, five peaks, three karst regions, four low-lying coasts, and more than 15 intermountain valleys provided a terrain rich with caves and other rock formations.

On the Dominican side of the island natives took advantage of rock surfaces, primarily in caves, to execute a variety of anthropomorphic, zoomorphic, and abstract designs. Petroglyphs and pictographs have been registered for 453 locations detailed in Table 7.1 by province.

This listing, although it represents sites personally known to me or referenced in scientific literature, is incomplete. I estimate that only some 30 percent of caves on the island have been explored with regard to the presence of rock art, a condition that likely accounts for the absence or minimal numbers of locations for several provinces in the inventory. Many more sites are expected to exist. The density of images for petroglyph sites in the present sample varies from 1 to 400, while the figure for pictograph locations ranges from 1 to 2,500.

A History of Dominican Rock Art Investigations

Contact-Period Chroniclers

Researchers of Dominican rock art have in particular relied upon the ethnohistorical works of Father Ramón Pané (1974) and Pedro Mártir de Anglería (1979) to assist in the interpretation of the images. Although the works con-

Table 7.1.
Number and Percentage of Caves with Petroglyphs and Pictographs by Province

Province	Number of Caves	Percentage of Caves
Azua	23	5.08
Bahoruco	11	2.43
Barahona	2	0.44
Dajabón	4	0.88
Distrito Nacional	39	8.61
Duarte	4	0.88
Elías Piña	3	0.66
El Seibo	5	1.10
Espaillat	0	0.00
Hato Mayor	1	0.22
Independencia	4	0.88
La Altagracia	66	14.57
La Romana	15	3.31
La Vega	16	3.53
María T. Sánchez	26	5.74
Monseñor Nouel	1	0.22
Monte Cristo	0	0.00
Monte Plata	0	0.00
Pedernales	26	5.74
Peravia	0	0.00
Puerto Plata	4	0.88
Salcedo	0	0.00
Samana	45	9.93
Sánchez Ramírez	72	15.89
San Cristóbal	57 (30)	12.58
San Juan	3	0.66
San Pedro de Macorís	17	3.75
Santiago	2	0.44
Santiago Rodríguez	2	0.44
Valverde	5	1.10
Total	453	99.96

Note: For the San Cristóbal Province 57 is the number of likely or reported caves, of which 30 have been confirmed.

tain little information directly related to the production and meaning of the figures, both authors make clear the ritual–religious and social importance of caves to native populations at contact.

The Pané document indicates that certain caves possessed names, specific locations, and special characteristics: "Hispaniola has a province named Caonao, in which there is a mountain, called Cauta, and in it are two caves

named Cacibajagua and Amayaúna. From Cacibajagua came forth the greater part of the people that populated the island" (Pané 1974:22, translation by Michele H. Hayward; see also Griswold in Pané 1999:5–6). Later on, Pané relates the following:

> And they also say that the Sun and the Moon emerged from a cave, which is located in the territory of one cacique called Mautiatihuel, this same cave is named Iguanaboína, which they highly venerate, and have painted after their fashion, without any figure whatsoever, but with many plants and other similar things. And in this cave were two cemís, made from stone, small, the size of half an arm, with hands tied, and with a sweating appearance. These cemís they highly esteemed; and when it did not rain, they say they entered there to petition them and suddenly it would begin to rain. And one of these cemís they called Boínayel and the other Márohu [Pané 1974:31, translation by Michele H. Hayward; adapted from Griswold in Pané 1999:17].

Pedro Mártir's reference to caves in Book VIII of his work adds the notion that caves with sociopolitical associations might also be named, in addition to ones with perceived religious or cosmological links:

> It is of interest to hear what from their ancestors' tradition the indigenous peoples believe concerning the mystery of the Cave, they judge that the island is possessed of a vital spirit, that it breathes, drinks, feeds and digests like a living, monstrous beast, of a feminine nature they believe that nature is a cave of that cavern and the anus through which it expels the excrements and frees itself of its wastes, proof of that is the name the region has due to the Cave, since *guaca* means "region" or "vicinity" and *larima,* "anus" or "place of filth" [Mártir de Anglería 1979:629; translation by Hugh Tosteson García].

Post-Chronicler Research

The medical doctor Narciso Alberti Bosch and the lawyer Cayetano Armando Rodríguez stand out among the early post-chronicler investigators of Dominican rock art. The former can be considered the father of Dominican rock art studies, as evidenced by his systematic approach to the discipline (Alberti Bosch 1979). Rodríguez (1976) provides one of the initial descriptions of images in caves and accompanying archaeological materials.

The engineer Emil Boyrie de Moya's (1955) monumental study of the open-air petroglyphs of Chacuey in the Dajabón Province is, in my estimation, the single most complete work on Dominican rock art. His precise

descriptions, even today, allow for the relocation and further study of these carved images.

Institutions have also played a leading role in the study and conservation of rock art sites. The Departamento de Investigaciones Antropológicas of the Universidad Autónima Dominicana, for example, has reported on new locations, in addition to investigation results.

The decade of the 1970s was one of the most important for the development of Dominican rock art studies. Dato Pagán Perdomo and Abelardo Jiménez Lambertus founded the Sociedad Espeleológica Dominicana, which led to the discovery of numerous caves with rock art. Various researchers including Fernando Morbán Laucer, Manuel García Arévalo, and Bernardo Vega stimulated interest in studying petroglyphs and pictographs. All were associated with reports of additional rock art sites, new investigative techniques, and diverse research interests.

Jiménez Lambertus undertook field investigations at rock art sites, as well as interpretations of the images (Jiménez Lambertus 1978b, 1987; Olmos Cordones and Jiménez Lambertus 1980). A prime focus for Pagán Perdomo involved the systematic ordering of known rock art sites and associated references, leading to an inventory of Dominican sites (Pagán Perdomo 1978a) and an associated bibliography (Pagán Perdomo 1978b). Seventy-two caves with images were listed, along with their geographic location and principal characteristics.

Pagán Perdomo's (1978c) work at Cueva de Borbón also remains a model for research. He developed a classification scheme for the cave's pictographs that serves as a basis for cross-site comparisons. His careful consideration of the theme and content of the images, in addition to excavations involving subsurface examination and analysis of materials, provided a context for the interpretation of the pictographs.

Many other researchers have subsequently enriched our understanding of the meaning and role of rock art in the pre-Columbian period. Veloz Maggiolo (1970, 1972; Veloz Maggiolo and García Galvan 1976) has advocated the utility of chemical analyses of the pigments and placing rock art sites within temporal-spatial frameworks. Morbán Laucer's (1979, 1982), Jiménez Lambertus's (1978a), and Luna Calderón's (1982, 1997) studies of human remains found within caves have shed light on the ritual significance of these locations. Rimoli's (1980a, 1980b) investigations of the fauna present in caves amplify the physical context of these types of rock art sites.

The 1990s was also a time of increased research and discovery. For instance, new speleological societies were formed that, unfortunately, have brought mixed results. Additional cave sites with figures were recorded, but since these organizations may also have undertaken exploration to increase

public access, other sites were negatively impacted with no scientific documentation undertaken.

Additional factors mitigating the progress in the documentation and preservation of Dominican sites involve the lack of a well-established sociopolitical support structure and scarce economic and human resources. Notwithstanding these limitations, Pagán Perdomo's (1978a) inventory of 72 caves with images executed on their rock walls has grown under the auspices of the Departamento de Arte Rupestre y Espeleología of the Museo del Hombre Dominicano, directed until recently by me. From 1996 to 2005, the increase from 72 to 453 recorded locations has resulted in a reassessment and an enhanced appreciation of the density, quality, and variety of the country's rock art. These trends are expected to continue.

Classification and Characteristics of Dominican Petroglyphs

Petroglyphs account for the majority of the relatively immovable rock art of the Dominican Republic. In addition to cave locations, figures carved in low or high relief can be found in rockshelters, on boulders along waterways, and on rock formations in karst regions or in slate-bearing strata. Pictographs are found in cave systems that almost always contain petroglyphs as well.

Production, design, and spatial dissimilarities between these two rock art types have long fostered the notion that they relate to different cultural groups and time periods. This conceptual framework accounts for some, but not all, empirical observations. Clearly more research is needed to establish relationships among pre-Columbian carved and painted images and their cultural and chronological contexts.

Our current understanding of the nature and distribution of petroglyphs suggests that these images can be grouped into four styles. Certain execution, design, and distribution criteria serve to differentiate the four categories. Yet within them enough variability is also present that it may be possible in the future to subdivide into finer classes.

Anamuya Petroglyph Style

The Anamuya style is characterized by large-scale designs; geometric motifs including circles, crosses, spirals, and linear designs; location in open-air sites or in rockshelters; polished or ground wide and deep lines; a tendency to mural compositions; and a lack of clear association with nearby sites or archaeological materials. Anamuya style sites are found in the La Altagracia, Monseñor Nouel, Sánchez Ramírez, Constanza, and Pico Duarte zones and provinces.

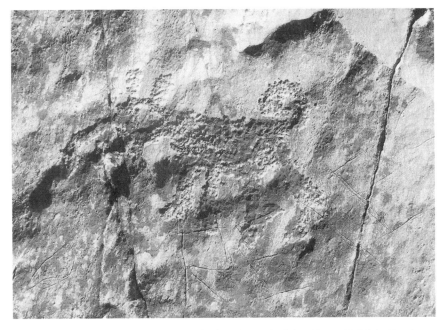

Figure 7.1. Dominican Chacuey petroglyph style, pecked dog figure, Dajabón Province (photograph by Atiles Bidó, 2000).

Chacuey Petroglyph Style

Medium to small-scale images; a predominance of zoomorphic figures; the presence of Grecian frets and linear designs in panels; production via pecking or incised pecking; location in open-air sites and near rivers or streams; execution of the designs to show movement and sexual activity; and certain designs also produced as pictographs typify the Chacuey style (Figure 7.1). Chacuey, Dajabón, Sánchez Ramírez, and Constanza account for areas with this type of petroglyphic renderings.

Mixed Type Style

The third petroglyph style is the most numerous and can be found throughout the Dominican Republic. Its principal attributes consist of the predominant use of the circle as a design element; the presence of anthropomorphic, zoomorphic, and anthrozoomorphic images; circular humanlike faces with gesturing appendages; location in caves at the entrances and toward the interior in lighted and semiobscure zones; placement of the figures normally from the center of a rock face to the left and less frequently to the right; the composi-

tion of humanlike figures with arms, legs, ears, visible sexual organs, head-dresses, and masked eyes; execution in high relief; and a tendency toward mural compositions.

Fine-Line Incised Petroglyph Style

The fourth petroglyph style forms a series of finely incised images found at the entrances to caves. Motifs include crossed lines giving the appearance of woven fabric or cloth, simple crossed lines, and certain anthropomorphic figures. Bone or wood, among other types of tools, may have been used to produce the designs. I have located this tradition in the Tru Nicolas caves in the Fronteriza region and in the Gato Cave of San Pedro de Macorís Province.

Classification and Characteristics of Dominican Pictographs

While painted petroglyphs have been reported from the Parque Nacional del Este area of La Altagracia Province and the Sánchez Ramírez Province, the majority of Dominican painted rock surfaces occur as pictographs. Image types include natural, abstract, geometric, and astral or cosmological, as well as lined, anthropomorphic, and zoomorphic designs. Other types or categories have also been advanced.

Almost 98 percent of the pictographs, based on investigations that I have been involved in, are executed in black, with ochre, red, white, orange, and gray making up the remaining colors. Sources for the colors include finely ground carbon, the *jagua* (or custard-apple, a local fruit), the *bija* (a local red-colored seed), mangrove trees, animal grease, hematite, clay, kaolin-type clay, and soot.

Color application techniques vary. The existence of positive and negative handprints in some caves points to these body elements as application devices. The thick outlines of the images in the caves of the Parque Nacional del Este suggest use of fingers, as well as small bundles or brushes of cotton or other material. The use of sharp wooden tools is indicated by the thinner design outlines found in the San Cristól, Borbón, and La Cidra caves. Multiple applications of the same color were used to create the white pictographs within Cueva de la Cidra.

Usually, pictographs, either individually or in groups, are monochrome. A noteworthy example of multiple colors involves a panel within the Cueva José María of the Parque Nacional del Este with black, white, ochre, and gray figures. The painted petroglyphs within the Parque Nacional del Este and the Fantino region in the Sánchez Ramírez Province are also multicolored.

Pictographs are currently concentrated in the south and east portions of the Dominican Republic. Caves in the east possess especially high concen-

trations of painted images and compositionally developed panels. Those in the south, particularly in the San Cristól and Sánchez Ramírez provinces, are known for pictographs displaying a high quality of workmanship, realism, scenes of daily life, and rituals. The western frontier zone with Haiti and the north remain the least-surveyed regions of the country for archaeological sites. Nonetheless, pictographs of high aesthetic value are known from locations in the Pedernales and Bahoruco provinces, in addition to Cueva de la Cidra in the central mountain range.

Frequently, the designs are executed within cave entrances or in the lighted to semiobscure regions. I have only encountered one example of a pictograph on the exterior of a cave, although historic sources mention the custom of painting certain rocks situated in open-air environments. It has also been my experience that a high percentage of the pictographs are found to the right of the entrance and at higher levels, including head height and ceilings. Less frequently, I have observed images painted in difficult-access places such as those without light or requiring some means of support for execution.

The Dominican pictographs represent a rich and varied body of visual expression that has been little studied. What we do know suggests that, like the petroglyphs, they can be grouped into broad styles. My classification scheme involves five categories named after caves typical of the style: Berna, José María, Hoyo de Sanabe, Borbón, and La Cidra.

Independent of any conceptual ordering of the painted figures, I consider that their principal themes comprise a preoccupation with daily life, sexual situations, the religious cycle of people, and a studious examination of plants and animals. An "impressionistic" manner of execution is evident, along with a high degree of knowledge, observation, and skill seen in the production of simple to involved compositions. In some styles the talent needed to synthesize and simplify the effort to render plants and animals, as well as humans and their activities, is considerable. Caves for pre-Columbian cultures were places of sanctuary, with the rock art forming part of their ceremonial and ritual cycle presided over by shamans.

Cueva de Berna Pictograph Style

At present, I consider the Cueva de Berna pictograph style limited to this cave located in La Altagracia Province. The cave is also unique in having an associated radiocarbon date of 1800 B.C., derived from materials within the cave, placing human activity there at the beginning of the Archaic Age, 2000 B.C.

Abstract and geometric designs are present, including concentric circles, spirals, and linear designs painted in ochre, orange, red, and black. Some 30 images have been noted, although probably more existed in the past, found

both to the left and to the right of the cave's entrance in the natural light section.

Cueva José María Pictograph Style

This style, found in the José María, Ramoncito, El Puente, and Las Maravillas caves, La Altagracia Province, is characterized by a variety of figures organized into panel compositions. Thick brushes or fingers were employed to apply the black coloring, with evidence for the preparation and use of the color still found in the caves.

Cueva José María possesses more than 1,200 pictographs executed in expansive panels incorporating anthropomorphic and zoomorphic figures alongside easily identifiable plants and artifacts of daily life. The pictographs represent an exceptional opportunity for the study of not only Dominican but also Caribbean rock art. The cave is situated in a national park that provides protection as well as research opportunities for the pictographs and is one of the few rock art sites with such a status in the country.

Cueva Hoyo de Sanabe Pictograph Style

Cueva Hoyo de Sanabe located in the center of the country in Sánchez Ramírez Province and Cueva de la Línea in the Parque Nacional de los Haitises, Samana Province, to the east, best exemplify a style concerned with representing shamans and other magicoreligious cultural aspects (Figure 7.2). I consider this interpretation of the images to be well grounded. The design elements employed to compose the figures were carefully selected and likely reflect secret shamanistic knowledge. The presence of masklike facial images and the particular execution techniques also point to production by a specialized group or class of people. The Hoyo de Sanabe and Borbón styles (discussed next) share certain design elements, but taken as a whole the two are nonetheless distinct.

Cuevas de Borbón Pictograph Style

The Borbón cave complex, San Cristóbal Province, comprises more than 50 individual caves, 23 of which possess painted designs, especially Caves 1, 2, 3, and 4 and the Bridge Cave. The complex has been known since 1876, with its pictographs distinguished by finely drawn compositions of anthropomorphs and zoomorphs. The humanlike figures tend to be represented as linear or sticklike, while birds predominate among the zoomorphs and are most often portrayed in association with human or anthropomorphic activities.

Panels contain scenes of hunting, fishing, game-playing, and shamanistic activities and practices (Figure 7.3). Investigators have suggested that the panels of interconnected humanlike figures refer to the *areytos* or communal

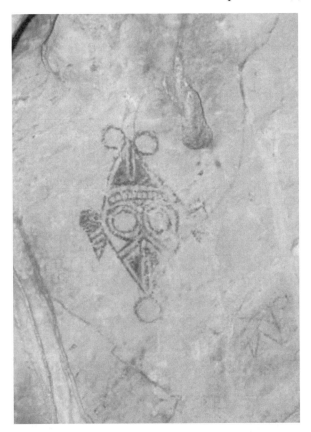

Figure 7.2. Dominican Hoyo de Sanabe pictograph style, masked facial image, Cueva Hoyo de Sanabe, Sánchez Ramírez Province (photograph by López Belando, 2000).

ceremonies described by the early chroniclers. Depictions of the *cohoba* ritual, also noted in ethnohistoric sources, have been suggested for certain scenes, which additionally are associated with the greatest diversity of zoomorphic figures (Hayward, Atkinson, and Cinquino, Introduction, this volume). Further animal portrayals include manatees, sharks, a man mounted on what appears to be a horse, animal sexual activities, and the spawning of a turtle.

Cueva de la Cidra Pictograph Style

One of the characteristics of the Cueva de la Cidra style concerns the relatively high percentage (33 out of 172, or 19 percent) of white pictographs with kaolin clay as the likely source for the color. Before the discovery of this assemblage in the late 1990s, only two such images had been documented in

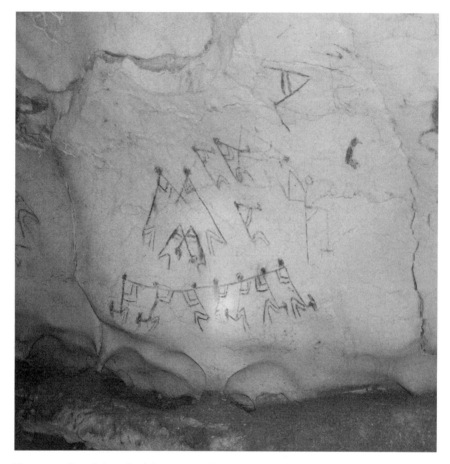

Figure 7.3. Dominican Borbón pictograph tradition, panel, interconnected humanlike figures, Cueva de Borbón No. 2, San Cristóbal Province (photograph by Atiles Bidó and López Belando, 2005).

the Cueva José María in the Parque Nacional del Este. Cueva de la Cidra is located in the north at the Parque Nacional Nalga de Maco, between the provinces of Santiago Rodríguez, San Juan de la Maguna, and Elías Piña.

The white-colored pictographs are found within 23 m of the cave entrance, to the right and in natural light. Their heights vary from 10 cm to slightly over 2 m from the floor. The pigment is thick, white with a bluish tinge, and appears to have been applied with a spatula-like instrument in thick lines.

The themes also vary. At the entrance naturalistic scenes predominate, including an owl with wings extended atop a tree with geometric figures at the base. Another involves a snake partially concealed among the surfaces of

a rock. Other images comprise a mask, two anthropomorphic figures, and geometric designs. Figures in the darker regions of the cave display evidence of an orange color beneath.

The principal attributes of the entire tradition comprise the following: thick-lined figures, probably applied with a spatula-like artifact; naturalistically depicted figures at normal size; a predominance of geometric designs, such as triangles, crosses, and framed circles, with a tendency to repeat the designs to form new motifs; and a preference for execution at the cave entrance.

Concluding Remarks

Outright destruction and vandalism of rock art sites remains a serious problem within the Dominican Republic. Even well-meaning groups, including speleological societies and those interested in preservation, have negatively impacted caves with and without rock art. The practice of altering cave interiors and laying down cement walkways to provide for tourist or public access, in addition to preservation attempts by ill-trained and unsupervised individuals, results in the elimination of the images, as well as incomplete or no documentation. The Cuevas Hoyo de Sanabe and La Línea and the Cueva de Borbón No. 1 are among the locations thus affected.

I hasten to add that the Museo del Hombre Dominicano possesses an archaeology department with experienced and available personnel who can undertake and supervise rock art studies. The museum is officially designated to perform this task and through its archaeology department can be transformed into an effective coordinating center for local, regional, and international rock art research.

Dominican researchers also need to elaborate the physical and cultural contexts for rock art. Reconstruction of the natural environment prior to the arrival of the Europeans, increased use of direct dating of pictograph pigments coupled with linking rock art sites to likely associated and datable habitation sites, and recording the physical characteristics of caves and other locations are among the necessary and continuing efforts.

8

Rock Art of the Dominican Republic and Caribbean

Adolfo López Belando,
with contributions by Michele H. Hayward

Translation by Michele H. Hayward

Introduction

The Dominican Republic possesses over 500 rock art sites, a number that continues to grow, as even the recent official registry of 453 locations in Table 7.1 of the previous chapter in this volume demonstrates. The relatively short tradition of Dominican rock art investigations, coupled with substantial unexplored areas, means that it is still possible to be the first to experience the wonder and magnificence of this rich body of past cultural expression.

While we know that the carving and painting of images on rock surfaces came to an abrupt end with the arrival of the Spanish to Hispaniola some 500 years ago, we are less certain of when these activities began. Their execution may have followed shortly after the arrival of populations to the island during the Lithic and Archaic ages, around 4000 B.C. (Hayward, Atkinson, and Cinquino, Introduction, this volume).

Early Spanish chroniclers of the contact-period Taíno describe an involved religious belief system in which caves played special roles as sacred places. Fray Ramón Pané (1974:31) is quoted in the previous chapter as stating that the inhabitants "painted" their caves. Pedro Mártir de Anglería (1979:194), an early compiler of observations of the Taíno culture, reports that "[t]hey visit caves as on a pilgrimage, as we do when we go to Rome or the Vatican, the seat of our religion" (translation by Michele H. Hayward). *Cemís,* made of stone, clay, wood, or cloth, might also be kept there. This class of supernatural beings was considered to possess magical powers and could be invoked for favors and protection (Hayward, Atkinson, and Cinquino, Introduction, this volume; Rouse 1992:14, 118–119).

Early reports also suggest that communion or contact with spiritual beings was achieved with the aid of a local hallucinogenic. *Cohoba* was inhaled through a tube to achieve altered states of consciousness (Hayward, Atkinson, and Cinquino, Introduction, this volume; Rouse 1992:14, 118–119) in which

visions of the supernatural world were conceived and dialog took place with the spirits. It may be that much of pre-Hispanic rock art production was strongly influenced by this ritual. Many of the present images may prove to have been inspired by thoughts and actions experienced by the human participant during these altered states.

Whatever the motivating source, the pictographs in particular possess certain differences in painting style and distribution that I have employed to define discrete or formal schools. This scheme, developed over many years of inspections of Dominican and other Caribbean rock art, intimately interconnects with the history of cultural groups on Hispaniola, as well as other islands (López Belando 1993, 2004, 2005), even though we as yet do not fully understand the character or details of this intertwining. This classificatory approach has been employed by other investigators in the Dominican Republic such as José Gabriel Atiles Bidó (see Chapter 7, this volume). Nonetheless, what follows represents my view of the nature of rock art in past Dominican and Caribbean societies.

Dominican Pictograph Schools

As implied above, dissimilarities in execution, iconography, composition, and location that separate the pictograph schools are assumed to relate to the different cultural groups on the island. I recognize three pictograph schools. The José María school's primary locations are in the southeast of the country, at the Parque Nacional del Este and the nearby Cueva de las Maravillas, La Altagracia Province. The Borbón school represents the most expansive style, named after the first caves with this type of pictographs discovered in the nineteenth century. The Berna school is currently found in only three caves in the Dominican Republic, one of them located in La Altagracia Province and the other two in Pedernales Province (López Belando 2007:139–140).

José María Pictograph School

The Parque Nacional del Este's Cueva José María, with its presently inventoried 1,200 pictographs, stands out as the premier type-site of this school. The images immediately impress one with their vibrancy and may contain numerical, calendrical, and cosmological references, among other themes (Figure 8.1). The originality of the painted depictions makes them unique and pivotal to the understanding of Caribbean rock art development, and they may well play a similar role from a wider perspective (López Belando 2007:140).

The fact that pre-Columbian peoples chose to paint on rock surfaces should not obscure this school's links to modern painting that also utilizes

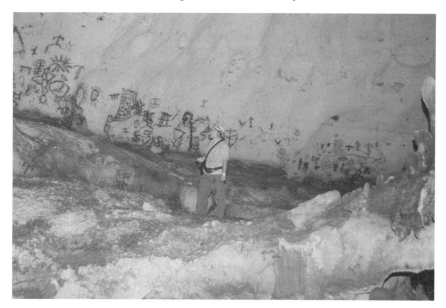

Figure 8.1. Dominican José María pictograph school, Cueva José María, Parque Nacional del Este, La Altagracia Province (photograph by López Belando, 2005).

various surfaces, including cloth, clay, and prepared panels, for expressive effect. This body of pictographs powerfully echoes modern-day European art traditions, as seen in the works of the contemporary Spanish artists Miguel Barceló and Antoni Tapies (López Belando 2007:140).

Tapies's repetitive use of the cross motif and use of certain compositional rules and contrasting color schemes all find their counterparts in the José María images. Barceló's devices to effect a sense of space or volume are rooted in repeated applications of pigment to designs, a technique readily apparent in the pictographs of these cave settings. Here the image-makers' compositions skillfully blend natural surface reliefs along with painted designs (López Belando 2007:140).

The characteristics that define this school are as follows: (1) an association with a grouping of petroglyphs located at the mouth of the cave, always in natural light and generally executed on a rock formation that stands out due to its form and location; (2) placement of the pictographs in the main chamber beginning at the entrance; (3) lack of superimposition; (4) apparent selection of image heights to keep the observer in ritual positions such as almost prone or on one's knees in order to fully appreciate the images; (5) employment of natural rock relief to provide a sense of volume or space to the figures; (6) absence of perspective; (7) placement of the images to facilitate

detailed examination; and (8) a tendency toward panel compositions instead of single to few images dispersed throughout a cave system.

The José María school can be found outside the Dominican Republic, in particular on Mona Island. This small, 13,580-acre territory is composed of limestone with numerous caves and rockshelters. The island lies between Hispaniola and Puerto Rico and is politically attached to the latter government (Dávila Dávila 2003:15–17; Figure 1.1, this volume). Stylistically the pictographs of the Mona Island caves Negra, de Espinar, and de los Balcones display the same characteristics as those of the Parque Nacional del Este locations and Cueva de las Maravillas. The tendency toward large images occurs in both assemblage sets, while the manner of execution using apparently fingers is found in the Dominican caves and some of the Mona Island cave figures.

Dávila Dávila's (2003) comprehensive study of Mona Island's archaeological resources includes the location and description of 11 sites that range from the Lithic Age through early contact. The aceramic Cueva de los Caracoles yielded a radiocarbon date of 2380 B.C. from a middle stratigraphic horizon, indicating even earlier initial use and island occupation. Dávila Dávila concludes that Cueva de las Caritas, one of the island's four rock art cave sites, also dates to the preceramic period, in part because of the cave's proximity, some 80 m, to Cueva de los Caracoles and in part because its petroglyph-only assemblage is similar to that of the Dominican Cueva de Berna site. Cueva de Berna contains both petroglyphs and pictographs radiocarbon dated to around 2000 B.C. (see discussion below). The other three caves just mentioned with primarily pictographs, Dávila Dávila suggests, date to the Ceramic Period, in particular the later Taíno phase.

Such correspondences should perhaps not be surprising given the ethnohistorically noted close relationships between the Taíno of Hispaniola and Puerto Rico. Daily communication was apparently maintained across the Mona Passage via canoes for a variety of purposes including trade. Jamaica and the southeast section of Puerto Rico are roughly the same distance from the southwest portion of Hispaniola. Yet the Taíno name for this section has been translated as "back of the island," further suggesting stronger cultural ties with Puerto Rico to the east over other close neighbors to the west (Rouse 1992:7, 16–17).

Strong ties are also noted archaeologically between the two islands. Indeed, Rouse deliberately organized his chronological chart for Northern Antillean cultures along interchannel zones based on their ceramic traditions. Such traditions he felt exhibited greater similarity between adjacent islands than within a given island (see Rouse 1992:52, Figure 14). Both Hispaniola and Puerto Rico are broken down into eastern and western sections. The

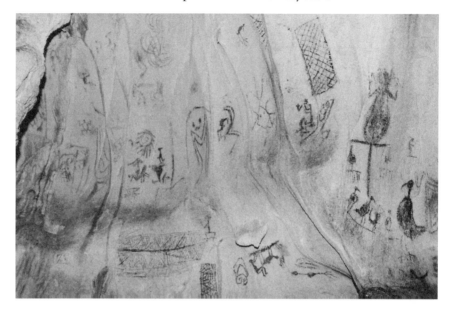

Figure 8.2. Dominican Borbón pictograph school, Cueva Hoyo de Sanabe, Hatillo, Sánchez Ramírez Province (photograph by López Belando, 1995).

Dominican Republic and western Puerto Rico are grouped under the Mona Passage; eastern Puerto Rico and the Virgin Islands under the Virgin Passage; and Haiti with eastern Cuba under the Windward Passage. While subsequent research has expanded our understanding of the relationships between material cultural traditions and the people who produced them, the concept that at various times and places within the Caribbean interisland ties were more consequential than intraisland ones has not been seriously challenged (Hofman et al. 2007).

Borbón Pictograph School

Although this tradition can be found in many parts of the country, exemplary locations include the following: the Borbón caves in the south of the country, San Cristóbal Province; the Parque Nacional de los Haitises in the east, Samana Province; the Cueva Hoyo de Sanabe in the center, Sánchez Ramírez Province (Figure 8.2); and the Cuevas Guácaras de Comedero designated 1 through 5 in the interior Cibao Valley, also in the Sánchez Ramírez Province (López Belando 2007:141).

Magical, sacerdotal, and naturalist themes predominate in the Borbón school. The precision with which the native executors defined animals and objects denotes a high level of sensitivity to their surroundings. In contrast

to the José María school wherein image-makers painted designs in a Picasso-like manner, people in this school employed formal and subtle rules to yield realistic portrayals, albeit frozen in time. The telluric force of the cave walls so informs the images that they generate the sensation of assimilation with the rock surface, as opposed to a modern-day painted advertisement on the side of a barn. Nature itself appears as the primary source of inspiration, with detailed birds, fish, mammals, and stylized human figures present (López Belando 2007:140–141).

Attributes of this school include use of monochrome colors, generally black or dark gray; the lack of a sense of space or volume; the presence of isolated cases of figures painted with perspective; a tendency to favor small-scale and thinly painted designs; normally grouping of pictographs into panels but occasionally isolated figures; absence of superimposition; placement in semidark to natural light zones; within these zones apparent location of figures according to certain criteria; and the presence of a high percentage of bird designs.

Exceptions to this set of characteristics also exist. For example, Cueva de la Cidra in the northern Parque Nacional Nalga de Maco contains pictographs that are large scale and polychrome or white only (see the Cueva de la Cidra description in Atiles Bidó, Chapter 7, this volume). These or other variations from the trait list I consider minor and not to rise to the level of a separate style.

Interisland extension of the Borbón school is also evident at sites in Jamaica (based on personal inspection) and Puerto Rico (from examination of the literature and personal inspection). Mountain River Cave in Jamaica possesses priestly as well as stylized figures with birds and humanlike images predominating, executed in black. All of these images are identical to this school's examples in Dominican cave locations. The Jamaican Potoo Hole Cave exhibits the same style of painting and designs as those of Dominican caves, in particular the Borbón and Guácaras de Comedero locations.

I have noted images that are typical of the Dominican pictograph schools in publications on Puerto Rican rock art, especially in the book *Pictografías, Petroglifos,* by Nelson Collazo (2002). The pictographs on pages 24, 25, and 26, for example, strongly echo the imagery of the Borbón school. Unfortunately, the author does not provide the locations for the designs. The quality of the photographs and descriptions necessary to assign other pictographs in Collazo's publication with surety to a particular school is also lacking. Nonetheless, the majority of the designs and their size range suggest affinities with the José María school.

In regard to actual sites on Puerto Rico, my examination of the Cueva Lucero pictographs in Juana Díaz Municipio provides additional evidence for

Figure 8.3. Dominican Berna pictograph school, Cueva de Berna, La Altagracia Province (photograph by López Belando, 2005).

the presence of the Borbón school. Cueva Lucero's images (described in the next chapter) are strikingly similar to those of the Cueva Hoyo de Sanabe and Borbón caves in the Dominican Republic.

Berna Pictograph School

Magic and mystery also come to mind when describing the Berna school pictographs. Cueva de Berna (Figure 8.3), one of the three documented locations of this school, represents an extensive system that contains hundreds of petroglyphs at its entrance, but its principal gift concerns the painted images found in the interior. Red-colored designs executed on the ceilings have been affected or altered by overlying deposits from the cave's parent limestone material. Human burials were also found within the cave (López Belando 2007:141).

The two remaining locations with these types of pictographs are Cuevas las Abejas and las Manos, both in Pedernales Province. Las Abejas is located in the Hoyo de Pelempito area on the frontier with Haiti and also contains pictographs with associated archaeological materials including preceramic artifacts. Las Manos, with its more than 100 red-painted human handprints (López Belando 2007:141), was first discovered by Morbán Laucer and García Arévalo (Morbán Laucer 1979).

The Berna tradition does not treat us to natural depictions. Just the opposite, these pictographs represent geometric and abstract designs. Additional traits not already mentioned in the previous chapter include a high proportion of small-scale designs; normally grouping of pictographs into panels but occasionally isolated figures; absence of superimposition; placement in semi-dark to natural light zones; within these zones, preference for execution in nooks and cave ceilings; and association of the pictograph sites with nearby human burial locations. Cryptic, forceful, and simple in design, these traits leave the observer wondering and meditating upon their meaning, which at present eludes us (López Belando 2007:141).

The pictographs possess enough similarities with ones from certain Cuban cave locations, including Punta del Este in Isla de Pinos and Cueva Ambrosio in Veradero (Núñez Jiménez 1975), that I would group both the Dominican and Cuban assemblages into a single school.

In Cuba, these cave sites are associated with preceramic groups, before 2000 B.C. As noted in the previous chapter, Cueva de Berna yielded a radiocarbon date of 1800 B.C., indicating placement at the Lithic/Archaic age divide. In addition to apparent corresponding date ranges, the use of comparable colors (ochre and red), the execution of similar designs focusing on circles or spirals, the preference for placement of the images within the caves in areas of natural light, and the association of the caves with human preceramic burials in the Dominican Republic as well as in Cuba all suggest production by the same or related cultural groups. Berna school–like images can also be found at the Quadirikiri cave on Aruba off the coast of Venezuela, with characteristics very similar to those of the Dominican Republic and Cuba.

Dominican Petroglyphs

Petroglyphs in the Dominican Republic are especially abundant in caves but are also found on riverine and mountain rock outcrops. Within caves, they are frequently located at the entrances and often configured as simple humanlike faces. Cave assemblages infrequently number in the hundreds, although Cueva de Berna in the east of the country with over 300 images, Cueva la Colmena in the southeast with some 250, and La Piedra del Indio with over 150 in the central mountain range comprise remarkable examples to the contrary (López Belando 2007:142, 144).

Virtually all of the 500-some Dominican sites contain petroglyphs, which, along with those of Haiti, marks Hispaniola as the island with the largest number of carved images to date, as well as that with the greatest number within a cave setting in the Antilles. Puerto Rico appears to possess a compa-

rable number of rock art sites. However, this tally also includes a minor percentage of pictograph-only locations, while sites with petroglyphs normally register under 50 (Hayward, Roe, et al., Chapter 9, this volume). Forty petroglyph sites and two mixed-form locations are known from Jamaica, with the single highest number of images recorded at Warminster/Genus Cave with 62 figures (Loubser and Allsworth-Jones, Chapter 5, this volume). Although published figures are minimal, six of Cuba's 70 recorded petroglyph sites contain 27 or fewer carved figures each (Linville 2005:Table 5.1). The highest known image frequency for the remaining Caribbean occurs on Guadeloupe, with 1,200 petroglyphs distributed among 27 locations (Richard, Chapter 10, this volume).

As with pictographs, dating and establishing relationships among the carved image assemblages and particular cultural groups remain elusive. For the Dominican Republic, any chronological framework will require much more research into comparative stylistic analysis, as well as relating rock art sites and the materials in them to securely dated related habitation sites and artifacts. Nonetheless, in the discussion below, a few specific associations have been advanced.

Although others (Atiles Bidó, Chapter 7, this volume) have classified Dominican petroglyphs into formal styles, I prefer a two-part division based on physical location. Geometric designs are tied to rock formations in or near waterways, as well as in mountain locales (Figure 8.4). Within the Caribbean, the Dominican Republic possesses a high number of images that often consist of crosses, circles, spirals, and occasionally simply drawn anthropomorphic figures. Petroglyph and pictograph geometric designs are similar, and I have pointed to certain correspondences between the Anamuya petroglyph and Berna pictograph styles. Both exhibit a predominance of abstract and geometric designs, in addition to the concurrence of motifs like concentric circles and spirals. Such a linkage may denote execution of at least one petroglyph category during the preceramic period (López Belando 2007:143).

The Guayabal boulders in the south of the country (Azua Province), the Sierra Prieta mural in the center (Sánchez Ramírez Province), and the Anamuyita rocks in the east (La Altagracia Province) are noteworthy locations of non-cave-setting petroglyphs (López Belando 2007:143).

The mural class of petroglyphs is associated with caves, often comprising humanlike facial designs of two round eyes and an encircled straight-line or round mouth. Other recurrent motifs include fully outlined humanlike figures. Occasionally, these petroglyphs are coupled with pictograph assemblages of the Borbón and José María schools. They are frequently carved on stalagmites but can also be found on inaccessible cave features. Their relationship with painted images in caves that contain ceramics indicates their pro-

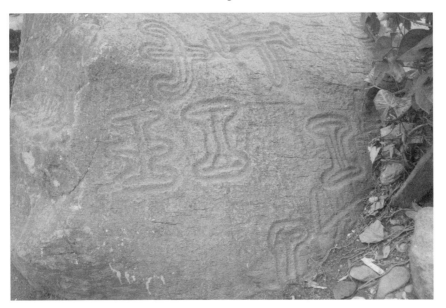

Figure 8.4. Dominican geometric petroglyphs, Guayabal boulder, Azua Province (photograph by López Belando, 2003).

duction during the Ceramic Period (López Belando 2007:143–144), beginning as early as 1380 ± 60 B.C. for Hispaniola, according to recent radiocarbon dates (Atiles Bidó and López Belando 2006).

The Cueva de Berna petroglyph-pictograph assemblages suggest that petroglyphs were also executed during the Preceramic Period. The carved and painted images likely date to the Lithic or Archaic age, with the possible extension of the petroglyph form of the school farther east. While I have drawn strong parallels between the cave's pictographs and like images from Cuban and Aruban locations, Dávila Dávila (2003:178–179) has argued for equally close correspondences between the Berna petroglyphs and those of the Cueva de las Caritas on Mona Island (see above discussion). He notes that the Dominican and interchannel island assemblages are similar in terms of elaboration, design, and context. Small (under 50 cm in diameter), simple humanlike faces and abstract appendage-like motifs pecked into the cave's interior surfaces characterize both sets of petroglyphs. Thus, the Berna pictographs, in addition to the cave's petroglyphs, may point to widespread ties and shared elements of a common religious system among peoples from the northern South American offshore islands and the Greater Antilles.

The foregoing observations also underscore Haviser's (2001) argument for direct ties among Aruba, Bonaire, Curaçao, and the Greater Antilles dur-

ing the Lithic and Archaic ages. He follows up on Valencia and Sujo Vol-
sky's (1987) delineation of pictograph production movement from the in-
terior Orinoco basin of Venezuela down its western rivers to the coastal
region of Tucacas and then out into the Caribbean. Drawing upon similari-
ties in cultural material attributes, environmental characteristics, and radio-
carbon dates, Haviser suggests that Archaic Ortoiroid people leaving the
continental coast first occupied Curaçao. All or some of these groups then
migrated to Cuba and Hispaniola, and perhaps to Mona Island as well. Sub-
sequent continental-area population movements appear complex, with dif-
ferent groups intermixing along the Venezuelan and Colombian coasts and
coastal islands including Curaçao, Bonaire, and Aruba.

It also appears that this proposed Ortoiroid movement from western
coastal Venezuela through Curaçao to the Greater Antilles represents a rela-
tively major and rapid advance. Haviser (2001) provides a date range of 3630–
1450 B.C. for certain Tucacas region groups. His earliest listed radiocarbon
date for Curaçao comes from the St. Joris #1 site with a calibrated range
of 2870–2330 B.C. The site is also associated with nearby pictographs. Pre–
2000 B.C. dates for Cuban pictograph locations were noted above. In his in-
vestigation of Cuban rock art, Maciques Sánchez (2004) suggests that Pre-
ceramic groups may have begun producing pictographs as early as around
7000 B.C. (one radiocarbon date), but more clearly from at least 1049 B.C. The
Dominican Cueva de Berna pictographs and petroglyphs have been radio-
carbon dated to 1800 B.C., with the Mona Island Cueva de Las Caritas petro-
glyphs possibly having been executed ca. 2380 B.C.

Coppa et al.'s (2008) recent study addressing migratory routes into the Ca-
ribbean through analysis of dental morphological trails is relevant to this dis-
cussion. Tooth samples were collected from a number of sites in the region
including Cuba, the Dominican Republic, Puerto Rico, and Venezuela. Only
one sample from the Dominican Republic was dated to the Preceramic, or
2500–2000 B.C., from the site of Cueva Roja. The remaining samples from
those islands just mentioned dated to the Ceramic Period or post–250 B.C.
The authors conclude that their analyses of the tooth samples support a two-
major-migration model of island settlement: Preceramic and Ceramic.

Regarding the origin and direction of the Preceramic settlement, they
note that Florida was an unlikely source. Lacking samples from Central
America and minimal representative ones from Venezuela, the authors de-
cline to comment on their origin probabilities. One of their results supports
a Preceramic Venezuelan connection in that strong affinities were observed
between the Dominican Cueva Roja site and the later-in-time, though still
aceramic, Cuban samples—an expected result that is consistent with a west-
ern coastal Venezuelan–Curaçao–Greater Antilles migratory route as indi-
cated by the rock art data.

The Legal Framework for Dominican Rock Art

Legislation concerning the protection of cultural resources, including rock art, includes the following statutes:

1. Ley No. 316, Sobre el Patrimonio Cultural de la Nación, May 23, 1968. The statute contains explicit references on the protection of archaeological resources.
2. Ley No. 318, Sobre la Creación del Museo del Hombre Dominicano, June 10, 1972. The museum is charged with the responsibility for all things related to archaeological investigations within the country.
3. Ley No. 564, Para la Protección y Preservación de los Objetos Etnologicos y Arqueológicos Nacionales, September 27, 1973. The law contains detailed stipulations covering the Museo del Hombre Dominicano's cultural resource responsibilities.
4. Decreto No. 268, Declaración de Zona Arqueológica de las Cuevas que Contienen Arte Ruprestre Prehispánico, October 3, 1978. The law makes the Museo del Hombre Dominicano responsible for the protection of the Cueva de las Maravillas and Cuevas de Borbón.
5. Decreto No. 297/87, June 3, 1987, a decree that declares all caves, similar structures, and underground caverns within the country the natural patrimony of the nation. The decree prohibits the destruction and physical or ecological alteration of such locations, as well as the removal of cultural resources. The statute also assigns protection responsibilities for the caves and underground structures to public order forces.
6. Ley No. 64-00, General de Medio Ambiente y Recursos Naturales, August 18, 2000. The law makes the Secretaria de Estado de Medio Ambiente y Recursos Naturales responsible for the protection of caves and in addition declares their natural, cultural, and archaeological resources the patrimony of the nation.
7. Ley No. 202-04, Sectorial de Areas Protegidas, August 3, 2004. The law sets aside two areas as national monuments because of the regions' rock art assemblages: the Reserva Antropológica Cuevas de Borbón o del Pomier and the Río Cumayasa Cueva de las Maravillas.

Even though the Dominican Republic has enacted legislation to protect cultural resources, including rock art, the present statutes nonetheless lack clarity and concreteness. Furthermore, the statutes are also ambiguous concerning managerial responsibilities for caves and their cultural resources. This should be of particular concern given that rock art is one of the country's most significant classes of cultural resources, both for its quantity as well as for its quality.

As outlined above, two governmental entities at the secretarial level are currently charged with this task: Cultura (Museo del Hombre Dominicano) and Medio Ambiente y Recursos Naturales. The laws, however, fail to assign specific institutional responsibilities or interagency norms with respect to the protection of rock art and archaeological resources.

Conservation Issues

It is lamentable that both professional and public interest in, and knowledge about, Dominican rock art remain minimal. Many of the rock art sites could be opened to the public in addition to researchers. The lack of institutional understanding of the importance of these images, limited economic resources, and difficulties in planning for access to rock art sites are among the factors contributing to this situation.

Proper development of rock art site accessibility involves several factors. Among the competing interests that must be balanced are conservation of the images in addition to the resident fauna at a location; an acknowledgment that cave or other rock art settings represented special locations to prehistoric people; a recognition that a fuller understanding of the role these images played in a prehistoric context entails maintaining the integrity of the rock art sites; and a concern for the safety and enjoyment of visitors and researchers. Present examples range from rustic and inadequate access to significant sites, such as Cueva de Berna, to overimproved locations designed as tourist attractions, such as Cueva de las Maravillas.

Investigation of Dominican rock art is open. As already discussed, Cueva José María represents an especially impressive rock art site from a Caribbean as well as a worldwide perspective. Approximately 1,200 pictographs have been examined and assigned to a particular style, yet they account for perhaps only half of those present in other parts of the cave system that have not been evaluated. The large number of pictographs, along with the undoubtedly rich and varied iconographic themes, also suggests the site can be considered at present the premier ritual or ceremonial center on Hispaniola. Two other rock art ritual centers deserve special mention: the Cueva del Ferrocarril in the Parque Nacional de Los Haitises, with some 900 pictographs, and the Cueva Hoyo de Sanabe, with over 1,000 painted designs of exceptional quality. The Cueva del Ferrocarril also represents an instance where a greater number of images were present before the cave was adversely impacted.

9

Rock Art of Puerto Rico
and the Virgin Islands

Michele H. Hayward, Peter G. Roe, Michael A. Cinquino,
Pedro A. Alvarado Zayas, and Kenneth S. Wild

History of Rock Art Research

North Americans, particularly Jesse W. Fewkes (1903), Irving Rouse (1949), and Monica Frassetto (1960), along with Ricardo Alegría (1941) from Puerto Rico, provided initial surveys and commentaries on the nature and dating of Puerto Rico's rock images in the first half of the twentieth century. Since the 1970s, rock art investigations have increased in volume and scope, involving nonlocal and local avocational and professional archaeologists.

Resident avocational groups include the Fundación Arqueológica, Antropológica e Histórica de Puerto Rico (which has published notes on individual finds in its *Boletín Informativo*) and the Sociedad Guaynía de Arqueología e Historia. These two groups include most of the older generation of archaeologists on the island including Juan González Colón, whose 1979–1980 island-wide survey updated that of Rouse (1949).

By the 1980s, cultural resource management (CRM) programs (see below) were initiated. Both the federal entity, the State Historic Preservation Office (SHPO), and the Instituto de Cultura Puertorriqueña (ICP), the commonwealth counterpart, have archived many reports that mention rock art loci. These reports, the results of government-required local surveys and excavations, while not widely available, can be consulted locally. The sites are also identified in a comprehensive listing of rock art locations and associated bibliography compiled by Dubelaar et al. (1999).

The Departamento de Recursos Naturales of the ICP formed another institution that began to publish information on rock art sites (Dávila Dávila 2003) and to foment several local avocational groups, including the Sociedad Sebuco. Many of the publications of such groups, however, are ephemeral and difficult to acquire, even locally. Much was known in the oral tradition, including information about some of the most impressive sites like Cueva Lucero in the south highlands, which remained unpublished until recently (see

below). The archaeological program of the University of Puerto Rico, at the San Juan Río Piedras campus, has largely neglected rock art research.

Investigation of the island's carved and painted images has instead been a focus of another graduate center, the Centro de Estudios Avanzados de Puerto Rico y el Caribe. Marlén Díaz González (1990) and José Rivera Meléndez (1996) completed their Master's theses on the pictographs of the Cueva la Catedral and a series of rock figures in the Cayey region, respectively. Another Centro graduate under ICP's auspices and a co-author of this chapter, Pedro Alvarado Zayas (1999), is involved in an island-wide survey of rock art sites that will expand upon existing inventories.

In the 1980s, a new private foundation, the Centro de Investigaciones Indígenas de Puerto Rico (currently inactive), also became involved in rock art research under Peter Roe's direction (Roe 1991, 1993a; Roe and Rivera Meléndez 1995; Roe et al. 1999). The other authors of this chapter have, in the past few years, conducted various rock art studies and conservation efforts (Cinquino et al. 2003; Hayward et al. 2002; Hayward et al. 1992a, 1992b; Hayward et al. 2001, 2007; Wild 2003).

Local investigators are also engaged in active research. Carlos Pérez Merced (1996) wrote his Master's thesis on a collection of rock images at the ICP and subsequently surveyed sites along two rivers (Pérez Merced 2003). Ángel Rodríguez Álvarez has undertaken a survey for rock art sites along the Río Blanco, has devised a classificatory scheme for petroglyphs, and is also investigating the astronomical implications of rock art alignments in the Caribbean (respectively, Rodríguez Álvarez 1991, 1993, 2007). José Oliver's (1998, 2005) iconographic studies at the multiple-ball court site of Caguana (summarized below) deserve special mention; he is also engaged in a survey of settlements and associated rock art in the Caguana area (Oliver 2006).

Cornelius N. Dubelaar's 1995 survey of the Lesser Antilles and Virgin Islands, in addition to his U.S. Virgin Islands 1991 article, provides a comprehensive review of sources concerning the then-known rock art of the archipelago, where observations began as early as 1793. He also provides detailed descriptions, measurements, photographs, line drawings, and other data for three of the six sites in the island grouping: Congo Cay and Reef Bay on St. John and Salt River on St. Croix.

Michele Hayward, John Farchette, and Gary Bourdon in 2003 reported a fourth location containing petroglyphs at Robin Bay in St. Croix, while carved images near the Botany Bay settlement on St. Thomas have been registered (Vescelius 1976). Despite doubts concerning the authenticity of the Botany Bay petroglyphs (Vescelius 1976) and suggestions that the Reef Bay drawings are wholly or in part African in origin (Dubelaar 1991:947), extant documentation indicates these two petroglyph assemblages are in fact pre-

Hispanic. Peter Drewett (2007) adds the sixth site to the tally with one petroglyph noted at the Belmont site on Tortola in the British Virgin Islands.

Rock Art Characteristics

Number of Sites and Locations

Puerto Rico and the Virgin Islands occupy the northeast Caribbean Sea between the other Greater Antillean islands and the more numerous Lesser Antillean islands (Figure 1.1, this volume). Puerto Rico comprises an extensive coastal plain encircling a mountainous interior that serves as the source of more than 1,300 rivers and streams (Toro Sugrañes 1982). The island's abundant lithic raw materials include plentiful boulders along these waterways, as well as hundreds of rock surfaces (walls, solution pits, stalagmites, stalactites) in caves and rockshelters within the interior and along the plains. The smaller Virgin Islands possess a similar topography, though with proportionately fewer waterways and a less extensive coastal plain (Davis 2002:15–16). Hilly and steep terrain surrounded by a coastal plain also characterizes the British Virgin Islands (Climate Zone 2006).

The pre-Hispanic inhabitants of these islands produced rock art at a variety of locations and in great numbers. Some 500 sites have been recorded for Puerto Rico, with the Virgin Islands also possessing a relatively high density of images. While government-required archaeological surveys and academic investigations have examined large areas of these islands, significant portions remain, especially on Puerto Rico. Present site inventories, including those maintained by SHPO and ICP and elaborated by Dubelaar et al. (1999) and Alvarado Zayas (1999), represent minimum numbers.

Table 9.1 presents the inventory of rock art sites on the respective islands by physical location (Hayward et al. 2002). Out of a total of 536 sites on Puerto Rico, 412 (77 percent) possess reported locations distributed among caves/inland rock formations, boulders along waterways, stone slabs lining ball courts, and beach rock. For the Virgin Islands, the Congo Cay, Botany Bay, and Robin Bay site images are located on rock outcroppings at the ocean edge. The petroglyphs at Salt River and Belmont occur on ball court boulders; the former at present are in the Danish National Museum, Copenhagen. The Reef Bay figures overlook a pool at the base of a small waterfall (Drewett 2007; Dubelaar 1995; Hayward et al. 2003; Vescelius 1976).

Caves, rockshelters, and inland rock formations, along with watercourses, comprise the most common locations for the Puerto Rican images. Caves combine both pictographs and petroglyphs, while rivers and streams contain only petroglyphs that are frequently carved on boulders (Dubelaar et al. 1999).

Table 9.1.
Distribution of Rock Art Sites by Physical Location for Puerto Rico and
the Virgin Islands

Site Type	Number of Sites	Percentage
Puerto Rico[a]		
Cave/rockshelter/mountain location	279	52
Waterways/coastal	92	17
Ball courts/plazas	39	7
Beach rock	2	<1
Undetermined	124	23
Total	536	
Virgin Islands[b]		
Ocean edge	3	50
Ball court	2	33
Waterway	1	17
Total	6	

[a]Source: Hayward et al. 2002.
[b]Sources: Drewett 2007; Dubelaar 1995:453–479; Hayward et al. 2003; Vescelius 1976.

The minor percentage of rock images at ball courts or plazas reflects the low frequency of these prepared surfaces as a site type. For Puerto Rico, Alegría (1983:115–116) lists at least 79 examples of ball courts or plazas (Hayward, Atkinson, and Cinquino, Introduction, this volume) distributed among 72 sites. While most exhibit only one ball court or plaza, Caguana in the central mountainous interior possesses several structures (Alegría 1983:66–88, 115; Oliver 1998:6–27). Ball courts date to the beginning of the Late Ceramic Period, A.D. 600, with their maximum period of growth from A.D. 1200 to 1500 (Alegría 1983:117; Oliver 1998:29; Rouse 1992). Alegría (1983:117) reports that petroglyphs are commonly found on the rocks lining ball courts or plazas, adding that boulders in 18 of the sites and nearby rivers contain images.

Only two cases of petroglyphs at beach locations are recorded for Puerto Rico. The large Ceramic Period village site of Maisabel on the north coast of Puerto Rico possesses 32 images carved into a partially inundated horizontal lithified former dune surface (Roe 1991). On the northwestern coast, one beach petroglyph is associated with the site of Ensenada (Alémán Crespo et al. 1986).

Image Types

Classification schemes specific to Puerto Rican petroglyphs and pictographs are varied. Frassetto (1960) devised a fourfold framework that included abstract and geometric forms, a mix of zoomorphic and various human and

animal head forms, enclosed forms, and more completely detailed head and body images. Rivera Meléndez (1996) developed a scheme with 6 main classes and 18 subtypes for his investigation of images from various sites in Cayey Municipio. Five types with 16 subtypes were devoted to categorizing carved humanlike faces with or without bodies and animal figures. The sixth type with two subtypes was reserved for pictographic representations.

For the present discussion we have organized the rock art of Puerto Rico, as well as that of the Virgin Islands (for which no specific scheme has been developed), into a threefold scheme: anthropomorphic, zoomorphic, and geometric/abstract. Combinations of these three classes are also evident (Dubelaar et al. 1999:7).

Anthropomorphic designs, or humanlike simple to complex faces with or without body elements, make up the most frequently occurring figures. Simple faces range from two to three circles, pits, or dashes indicating a visage (Figure 9.1a) to these elements being partly or wholly enclosed (Dubelaar et al. 1999:8). The Cueva de Mora site exhibits a more developed face with encircled pitted eyes, a dashed mouth, and possible cheek elements sporting semicircular headgear ending in ears or ear spools (Figure 9.1b). Double or triple enclosed visages represent common motifs, as do conjoined groups of images where the outline of one image partially forms the outline of another. Both of these motifs are illustrated in Figure 9.1c, which shows two interconnected facial images from the El Palo site in Guayama Municipio.

Body elements attached to faces are varied and can be minimal to elaborate. One example from La Piedra Escrita takes the form of two curved lines on opposing sides of a straight line, possibly suggesting arms and legs, below an encircled pitted-eyed, ovoid-eared face with a top hat (Figure 9.1d). A pictograph from Cueva de Mora illustrates a recurrent motif: the wrapped or enclosed body image (Figure 9.1e). The figure possesses a tabular-eared face with slanted eyes, a mouth, and a head design element. The body forms a rectangle with multiple internal horizontal lines lacking external, though likely folded inward, appendage depiction. Zoomorphic forms tend to be realistic and frequently include bats, turtles, and birds (Figure 9.2a, b), while common geometric or abstract designs comprise crosses, spirals, intertwining half-circles (Figure 9.2c, d) and varying arrangements of straight and curved lines and pits (Dubelaar et al. 1999:8–9).

Image Production Techniques

For pictographs, the image-makers commonly employed red, white, orange, and black colors, alone or in combination. A range of mineral, vegetable, and animal sources were used to produce the hues, including carbon, kaolin, hematite, the juice of a local fruit (*Genipa americana*), and bat guano. Both

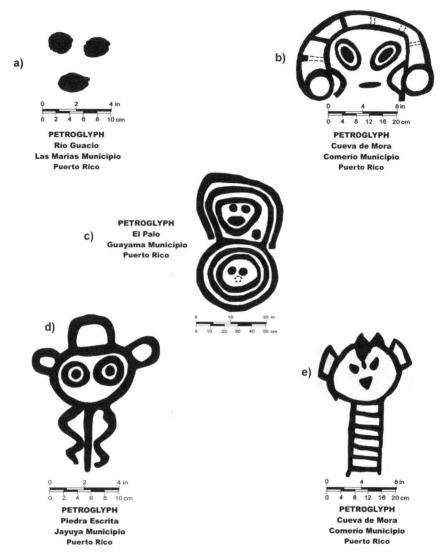

a)

PETROGLYPH
Río Guacio
Las Marías Municipio
Puerto Rico

b)

PETROGLYPH
Cueva de Mora
Comerío Municipio
Puerto Rico

c)

PETROGLYPH
El Palo
Guayama Municipio
Puerto Rico

d)

PETROGLYPH
Piedra Escrita
Jayuya Municipio
Puerto Rico

e)

PETROGLYPH
Cueva de Mora
Comerío Municipio
Puerto Rico

Figure 9.1. Selected anthropomorphic images from various rock art sites in Puerto Rico (Hayward et al. 1992a, 1992b; Roe and Rivera Meléndez 1995; Roe et al. 1999; used with permission).

pictographs and petroglyphs are found on such rock types as granite, granitic porphyry, quartz diorite, dolomite, and limestone (Dubelaar et al. 1999:2). Abrading and pecking or percussion comprised the primary petroglyph production techniques. Normally, stone hammers and chisels were used to outline the image, followed by rubbing with stones and with sand and water to obtain a smooth surface (Rodríguez Álvarez 2008:341, 347–348).

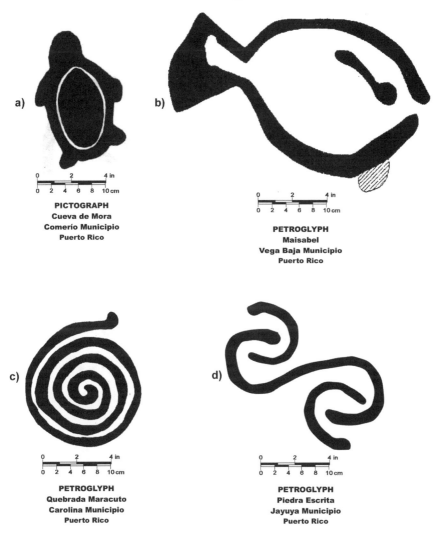

a)

PICTOGRAPH
Cueva de Mora
Comerío Municipio
Puerto Rico

b)

PETROGLYPH
Maisabel
Vega Baja Municipio
Puerto Rico

c)

PETROGLYPH
Quebrada Maracuto
Carolina Municipio
Puerto Rico

d)

PETROGLYPH
Piedra Escrita
Jayuya Municipio
Puerto Rico

Figure 9.2. Selected zoomorphic and abstract images from various rock art sites in Puerto Rico (Hayward et al. 1992a; Roe 1991; Roe et al. 1999; used with permission).

Image and Site Distributions

In Puerto Rico, petroglyphs outnumber pictographs, with a very minor frequency of painted petroglyphs reported. Only petroglyphs are found in the Virgin Islands and none are painted. Exclusively petroglyph sites predominate on Puerto Rico, with significantly lesser but about equal numbers of pictograph-only or mixed-image sites. A high percentage of sites remain unverified as to location or presence of image types (Drewett 2007; Dubelaar 1995; Hayward et al. 2002; Hayward et al. 2003; Vescelius 1976).

Information on the number of images per site is even harder to obtain. Published references (Dubelaar et al. 1999 and Hayward et al. 2002, in addition to SHPO and ICP agency site files) reveal a wide range of images per site from as few as one to over 100 in at least two locations (Cueva del Indio, Las Piedras Municipio, and Cueva Lucero, Juana Díaz Municipio, the latter described below). Of those sites with numerical data, most have counts below 50. Image tallies for the Virgin Islands are as follows: St. John—Reef Bay, 25, and Congo Cay, 7; St. Croix—Salt River, 11 (Dubelaar 1995:453–479), and Robin Bay, 2 (Hayward et al. 2003); St. Thomas—Botany Bay, 13 (Vescelius 1976); and Tortola—Belmont, 1 (Drewett 2007).

Documentation Status

The documentation status of Puerto Rico's more than 500 sites remains patchy and deficient. Information on most sites ranges from a single-source reference with scant details to Alvarado Zayas's (1999) ongoing survey to provide systematic comparable data on the images and their physical parameters (Dubelaar et al. 1999; Hayward et al. 2002).

Only a few sites possess published documentation that combines maps, scaled reproductions, photographs, descriptions, or interpretation (local, comparative, chronological). The history of Cueva Lucero illustrates the nature of local recordation. Though known from historic times, it was not until Alvarado Zayas compiled his several years of research for this book that a comprehensive description of the site's images has been made available in print. (The following description by Alvarado Zayas was translated by Michele H. Hayward.)

Cueva Lucero represents one of a number of caverns within the Cerro de las Cuevas limestone hills of the south-coast Juana Díaz Municipio. The cave contains four chambers or galleries with carved and painted figures (Figure 9.3). The principal entrance to the cave is through a small gap that opens into one of these chambers, designated Gallery B. The space is long and low, measuring 15 m long and 5 m wide by 1½ m high. Petroglyphs have been carved into the chamber's walls at two locations: at the opposing entrance or exit and at the immediate interior of the outside entrance. Most of the 18 figures (9 per grouping) comprise simple individual humanlike facial designs and two wrapped body forms that can be seen in natural light.

To the left of Gallery B lies Gallery A, a larger area, also open to abundant natural light due to the collapse of its roof. Rock walls encircle the approximately 20-×-26-m floor that again possesses 18 petroglyphs.

While the number of images remains the same in both chambers, those of Gallery A are more elaborate. Simple humanlike faces are engraved on the walls or their projections, alongside at least three examples of complex fa-

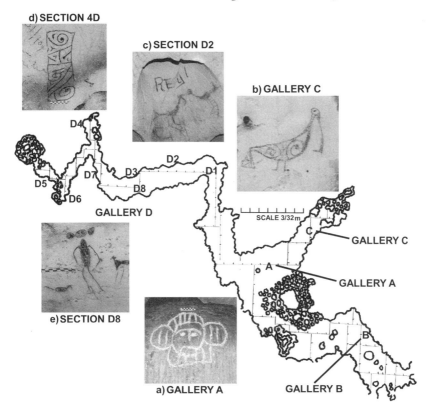

Figure 9.3. Plan of Cueva Lucero, Galleries A–D with representative images (plan and photographs by Alvarado Zayas).

cial designs. One of these is depicted in Figure 9.3a, with its detailed head-gear, prominent ears, and internal facial elements attached to a shortened wrapped body.

Which chamber the natives considered the entrance is unclear. Alvarado Zayas argues that Gallery B was the opening, for two reasons. Archaeological research indicates that all or nearly all of the inhabited or special-purpose cave sites were marked with rock art at their entrances. The Cueva del Caballo in Carolina Municipio and the Cueva Ventana in Guayanillas Municipio serve to illustrate this pattern, with petroglyphs located at the immediate openings of the caves.

Second, Gallery A's roof collapse represents a relatively recent event that might have occurred during a major earthquake in 1918. Further, human bones and ceramic fragments made in the Chican Ostionoid Capá style of the Late Ceramic Period, A.D. 1200–1500 (Rouse 1992; Figure 1.2, this vol-

ume), were found beneath the fallen rubble. These conditions imply that the chamber's vault in the pre-Hispanic past was intact, leaving only three small openings to provide natural, but diffuse, lighting, with one of these openings being the outside entrance to the gallery.

Gallery C lies to the north of Gallery A and contains only pictographs. The 10 images are outlined in carbon and belie a high degree of control over the subject matter. Realistic portrayals of birds involve apparent mating and feeding scenes, as well as one bird figure with geometric designs on its body plucking a worm from the ground (Figure 9.3b). Other animals include turtles, although some investigators consider the images to represent bats, and one *coquí,* a small local species of frog. Still other images lack the compositional form or theme of the animal grouping and are likely recent nonnative additions. Graffiti has been a problem within the cave since the nineteenth century, with carbon, metal objects, and spray paint used to leave names, dates, and designs (see Figure 9.3c).

Gallery D, northwest of Galleries A through C, represents the largest chamber with the highest number of images: at least 78 pictographs and one petroglyph. Alvarado Zayas recognizes eight individual groupings here, based on differences in content and design.

Access to Gallery D is obtained from the extreme northwest portion of Gallery A via a constricted tunnel 70 cm high, 80 cm wide, and 15 m long. The tunnel opens up to a spacious interior that at the northern end possesses a hole in the ceiling that lets in fresh air and minimal light. When one looks up, the light source resembles a star in the night sky, a condition from which the cave derives its name: Cueva Lucero, Cave of the Star or Starlight.

Section D1 is the first space that one encounters upon exiting the connecting tunnel. The section's lone pictograph represents a complex facial image, possibly of a *cemí,* whose design elements closely resemble those on the shoulders of Capá style ceramic vessels of the Late Ceramic Period, A.D. 1200–1500.

To the immediate right of Section D1 lies a grouping of five pictographs in Section D2. A complex, feminine-appearing face with headgear attached to a wrapped body form; an infantile-looking face and body form; and birds being captured with a net (Figure 9.3c; note graffiti above the figures) are among the images.

Continuing to the right or west are Sections D3 and D4. Section D3 possesses 10 pictographs expressing a faunal or animal theme. Bird images predominate, followed by a fish, spider, and two lizards. Section D4 occupies a small space at the far end of the chamber and completes the images on Gallery D's north rock surfaces. The grouping of seven pictographs introduces a new theme to the cave's assemblage, that of abstract designs made up of en-

closed straight or curvilinear lines, one of which is illustrated in Figure 9.3d. Three simple to complex anthropomorphic figures complement the four abstract designs.

Sections D5 through D8 are found on the chamber's south rock wall surfaces, where Section D5 begins the sequence from the west end moving eastward. A mix of themes and forms is evident in this grouping of 12 pictographs and one petroglyph. A large (2 m long) serpent signals the entrance to Section D5, which otherwise contains simple to complex anthropomorphic and abstract designs. The serpent's head and tail are connected via a zigzag body. The petroglyph represents a humanlike face carved into a projection of the gallery's wall.

Section D6 comprises a grouping of three anthropomorphic faces attached to body elements that are more sketchily detailed. The seven pictographs of Section D7 return to increased complexity in expressing four anthropomorphic figures, alongside two likely animal forms and one fish.

Section D8 lies opposite D3 and exhibits a grouping of 34 pictographs representing a mural-like composition. Animal forms including fish and birds, anthropomorphic figures, and abstract designs form an interconnected and varied work. Nature is prominently figured, with birds in different poses, scenes of fishing with rêmoras (use of a fish attached to a line that would adhere to other fish), and a figure possibly dancing or taking part in a ceremony, depicted in Figure 9.3e.

Dating

Direct dating methods for Puerto Rican or Virgin Islands rock art have not been applied or developed. Apart from the presence of datable materials at rock art sites, as in the case of Cueva Lucero outlined above, time frames for rock art assemblages have been advanced largely on the basis of associations of the images with adjacent archaeological sites or stylistic comparisons to other assemblages. Such approaches entail certain difficulties, including issues of contemporaneity (multiple occupational phases at or near rock art sites) and validity (ability to directly link rock art and other site types (Dubelaar et al. 1999:15–16).

Initial settlement on the main island of Puerto Rico parallels that of the larger Greater Antillean islands of Cuba and Hispaniola, with habitation sites dating from the Lithic through Archaic ages, ca. 4000–250 B.C. The Virgin Islands archipelago may not have been settled until the Archaic Age. People producing Saladoid style ceramics arrived in Puerto Rico and the Virgin Islands by at least 250 B.C. While the nature of new and resident population relationships remains in debate, subsequent cultural development in the Early

and Late Ceramic periods (250 B.C.–A.D. 600; A.D. 600–1500) is nonetheless marked by increasing political centralization, social differentiation, economic diversity, and regionalization of ceramic styles (Hayward, Atkinson, and Cinquino, Introduction, this volume; Rodríguez Ramos 2005; Rouse 1992; Figure 1.2, this volume).

In reference to these broad cultural divisions, researchers consider the bulk of Puerto Rican rock art to have been produced during the Late Ceramic and early Contact periods, A.D. 600–1524. Evidence for continued post-contact carving or painting of images is minimal (Dubelaar et al. 1999:17).

Evidence for preceramic production is also minimal but this may have occurred on Mona Island, which lies between Puerto Rico and Hispaniola (Figure 1.1, this volume). Dávila Dávila (2003) links one of four rock art caves on the small island, Cueva de las Caritas, to one of the island's habitation sites, Cueva de los Caracoles. Material from the latter site yielded a radiocarbon date of 2380 B.C. and it lies only 80 m from Cueva de las Caritas. Furthermore, Dávila Dávila considers that Cueva de las Caritas's petroglyph-only assemblage is similar in execution, design, and context to the petroglyphs of the mixed type Dominican Cueva de Berna (see site description in López Belando, Chapter 8, this volume), radiocarbon dated to between 1890 and 1255 B.C. The three other rock art caves with primarily pictographs, he considers, date to the Ceramic Period, and in particular the later Taíno phase.

The most critical advancement in dating Puerto Rican rock art concerns Roe's (2005; Roe and Rivera Meléndez 1995) proposed threefold relative sequence. This ordering goes beyond single-site chronological considerations and offers opportunities for on-island or wider-area testing. The framework rests on the selection of three rock art assemblages with direct associations to datable materials and on the componential analysis and seriation of the assemblages' anthropomorphic figures. The three rock art assemblages are the Maisabel petroglyphs carved into beach rock, ca. A.D. 800–1000; the boulder petroglyphs from the El Bronce ball court site, ca. A.D. 1100–1200; and the boulder petroglyphs from the Plaza A ball court of Caguana, at the end of the sequence.

Once the relative chronological positioning of the assemblages was established, Roe next undertook a componential analysis of the figures. Each grouping's images were broken down into individual design elements, for example, rounded, oval, or heart-shaped dimensions for the head, as well as 19 other body parts. The exercise produced sets of modes comprising the relative percentages of the dimensions for each of the 20 body parts. He then applied the statistical technique of seriation to these elements in much the same

manner as is done for pottery to produce varying design frequencies corre-lated to the three time periods.

Phase A, from A.D. 600 to 1000, begins the modeled chronology with such common or diagnostic traits as the predominance of simple round faces, a vertical nose element, the presence of faces with rays normally located below the face, and depictions of enclosed bodies with simple faces. In Phase B, A.D. 1000–1200, round faces continue but with additions: concentric eye-balled eyes, horizontal hourglass-shaped eyes, rays above and below the face, a nose, and more complex crowns or headgear. The detail, elaboration, and size, both of the figure and of the rock it is carved into, increase in this phase. The trend toward elaboration of facial and body parts reaches its maximum development by Phase C, A.D. 1200–1400, with such unique elements as nos-trils, lip lines, a V-shaped hairline, and a heart-shaped face being added to the design repertoire.

Although Roe's proposed sequence has been minimally applied, Hayward et al. (2003) undertook a cross-island comparative analysis employing the published images from four of the U.S. Virgin Islands locations. While time-sensitive design elements or motifs were largely lacking from Salt River, the enclosed eyes and mouth of a frog suggest assignment to Phase B. The ball court itself with the petroglyph-adorned boulders is associated with the lat-est occupational phase, A.D. 1200–1500.

Robin Bay, Reef Bay, and Congo Cay all exhibit Phase C design elements (heart-shaped heads); the latter two assemblages Phase B attributes (enclosed or encircled eyes); and Robin Bay's other petroglyph is consonant with Puerto Rican images of the latter Phase A, A.D. 800–1100. The site form for Botany Bay also reports linkage of its petroglyphs with the Late Ceramic Period, spe-cifically A.D. 1100–1500 (Vescelius 1976).

Both the Robin Bay and the Botany Bay petroglyphs can be related to vil-lage sites with ceramics spanning the Early to Late Ceramic periods, though with a primary occupation phase of A.D. 600–1200 indicated for Robin Bay (Hayward et al. 2003) and the Late Ceramic to early Contact periods for Botany Bay (Vescelius 1976). The Reef Bay and Congo Cay figures represent relatively isolated rock art sites (Dubelaar 1995). Specific references to dat-ing of these two petroglyph groupings include the Congo Cay images being Chicoid (A.D. 1300–1600) in style and similar to modeled pottery lugs of the same period. The small, narrow, steep-sided island of Congo Cay also has an additional site or deposit with Chican Ostionoid style ceramics (Robinson 1977). The ball court with the petroglyph at Belmont appears to date from around A.D. 1200 to near or at contact (Drewett 2007).

On the basis of internal and cross-island stylistic comparisons, the pro-

duction of Virgin Islands rock art is most clearly dated to post–A.D. 1000, although nearby habitation sites span a longer prehistoric period and even reach into historic times. The incorporation of stylistic comparisons into rock art dating methods can be used to narrow or refine the range of possible execution phases.

Interpretation

Interpretations of Puerto Rican and Virgin Islands rock art range from simple assertions (for example, "anthropomorphic humanlike faces represent an individual's or a group's ancestors") to well-articulated frameworks that relate the images to other cultural subsystems. Researchers frequently rely on ethnohistorical accounts of the natives at the time of European contact, ethnographic analogies from the culturally related lowland South American Indians, and concepts from the fields of anthropology, rock art, and related disciplines. Interpretive examples cover single or a few images, the same class of figures found in different locations, all the images at a single site, and island rock art in general (Dubelaar et al. 1999:10).

To illustrate the variability and nature of interpretive efforts, two case studies are outlined. The first is among the minor number of well-constructed instances that attempt to place the images within cultural contexts. The second represents the more common examples of lower-order or restricted efforts that seek to interpret a few images or those with less extensive use of comparative information and ethnohistoric or ethnographic databases (Dubelaar et al. 1999:15).

Iconographic Analysis of Petroglyphs at Caguana

Oliver (1998, 2005) offers a comprehensive iconographic analysis and interpretation of the civic-ceremonial site of Caguana. Located in the northwestern Puerto Rican municipality of Utuado, Caguana possesses 11 to 12 ball courts and plazas, in addition to other structural remains dating to the Late Ceramic Period, primarily A.D. 1300–1450/1460.

Drawing on ethnohistoric accounts of the contact-period Taíno, modern South American native religious and cosmological beliefs, and anthropological concepts of art and ritual within a structuralist approach, Oliver argues that Caguana represented a special place of interconnections. Diverse social segments within the same or even across different polities were brought together, as was the living with the nonliving world.

The large, centrally located Plaza A, with the near totality of Caguana's surviving petroglyphs (22 out of 27), demonstrates this articulation most clearly. The west-side alignment of boulders exhibits an ordered sequence

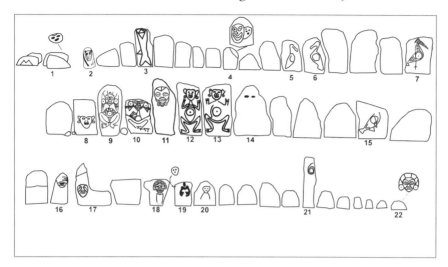

Figure 9.4. The petroglyph sequence along the west side of Plaza A, Caguana, Puerto Rico. Oliver (1998) devised the numbering system (redrawn by Alexander G. Schieppati from Oliver 1998:Figure 39; used with permission).

dominated by centrally located, fully executed anthropomorphic figures flanked by zoomorphic and less elaborated anthropomorphic images (Figure 9.4). Oliver contends that the central figures represent the ancestors and descendants of the governing *caciques* of Caguana manifested as *cemís* (Hayward, Atkinson, and Cinquino, Introduction, this volume).

A focus of ceremonial activity at Plaza A would have been the performance of *areytos*. According to chroniclers, *areytos* involved dancing and singing that acted out histories or events and were undertaken for a variety of purposes, including marking political alliances and religious events (Hayward, Atkinson, and Cinquino, Introduction, this volume). Such rites undertaken at this plaza would have underscored the political and religious preeminence of Caguana, as well as its rulers. The current *cacique*'s accomplishments would have been listed, adding to the recital of those of his predecessors. The petroglyphs conceived of as *cemís* were not merely static representations of these ancestors but active participants in the ceremonies and witnesses to the validation of the current *cacique* and sociopolitical order that linked individuals to various social strata as well as formed connections between groups.

These petroglyph *cemís* not only played a role in the sacred/secular plaza activities, but also, Oliver posits, they recreated certain aspects of contact-period Taíno cosmology and beliefs that he projects backward in time to their immediate prehistoric predecessors. The sequential ordering of the figures

(see Figure 9.4) serves to divide the cosmos into two opposing though complementary sets of four domains each. The southern set of petroglyphs 1 to 10 corresponds to the four primordial domains of Coaybay, Bagua/Ocean, Guanín/Sky, and Ancestors.

Petroglyph-*cemí* 1, a simple face, represents the domain of dead spirits, along with the doglike image of Petroglyph-*cemí* 2. Doglike beings were considered guardians of the nonliving, with this particular petroglyph perhaps representing the entrance to the Coaybay domain, where the dead resided in an island world complete with a *cacique*. Petroglyph-*cemí* 3, a fish standing upright with the head portion missing, represents the primordial ocean or Bagua domain. Again, a guardian role is implied for the petroglyph, as a physically manifested *cemí* concerned with maintaining the abundance of fish and marine life. The latter represented a critical resource for island environments with minimal terrestrial sources of animal protein.

The Guanín/Sky domain is suggested by the probable pelicans of Petroglyph-*cemís* 5 and 6 and Petroglyph-*cemí* 7, a long-beaked bird and possible heron representation. Birds are associated not only with the sky but also with the land where they nest and with the ocean where they feed. These petroglyph-*cemís* rendered as birds may have governed the actions and success of fishermen as they harvested riverine and maritime resources, as well as being linked to the preceding guardian or master fish-*cemí*.

Two petroglyphs that do not appear to be directly associated with one of the four primordial domains occupy a position on either side of the bird grouping of figures. The atypical rendering of an exaggerated smiling face on Petroglyph-*cemí* 4 might refer to the "jester," a mischievous and unrestrained personage in South American native mythology. This is the opposite of the reserved behavior expected for ceremonial occasions. The minimally rendered heart-shaped facial image of Petroglyph-*cemí* 8 also exhibits ear spools, indicators of high rank. This is also the first clear depiction in the sequence of an anthropomorphic figure.

Immediately adjacent are found the two most fully executed anthropomorphic figures at Caguana. The detailed carving of Petroglyph 9 suggests that the figure represents an old, but fertile, high-status female. A vulva is clearly depicted; the intricate headdress and ear spools denote high rank, along with a semicircular design in the middle of the headdress that may illustrate a *guaíza* or face mask emblem noted by chroniclers as worn only by *caciques* on the forehead or as part of a necklace; the chest triangular motifs with line incisions suggest protruding rib bones and old age; and the lower portion of the body is fleshy, with the froglike legs attached to a prominent abdomen or navel indicative of procreation and life. The petroglyph images a *cemíified cacica* or female chieftess-*cemí,* in Oliver's terminology, the ances-

tress who gave birth to the line of Caguana's *caciques*. Oliver argues that her consort is displayed as Petroglyph-*cemí* 10 next to her, based on a similar rendering.

We now pass from the primordial domains, whose representations can be read as a sequential creation story from the nonliving world to that of oceans, sky, and humans, to the ordinary domains. Petroglyph-*cemís* 11 through 22 in the northern portion of the plaza divide the other half of the cosmos into the four domains of Descendants, Turey or Bright Sky, Uniabo, and Arcabuco. Here the sequence can be read as stressing the present world that at first only intercommunicates with the nonliving world but is eventually completely drawn into the domain of Coaybay—a story that tells of creation and birth balanced by decay and death.

The complement to the pair of ancestor-*cemís* is a pair of descendant-*cemís*, carved onto the boulders as Petroglyphs 12 and 13. Their lack of headdress, their simple ear spools, and their fleshy bodies suggest younger personages with lower status and rank than the ancestral pair. These figures might represent physically manifested *cemís* in charge of the protection of elite children or all living people who are related to these progenitors.

The bird of Petroglyph-*cemí* 15 signifies the sky domain of the living, Turey, recalling its counterpart in creation time, the Guanín/Sky domain. Likewise the facial image with tears of Petroglyph-*cemí* 17 signifies the earthly water domain of Uniabo, in opposition to the fish-indicated primordial oceans of Bagua. Human death is indicated by the intricate headgear and ear spools of the facial image with enclosed body of Petroglyph-*cemí* 18; such anthropomorphic facial/enclosed body motifs are considered to depict the dead wrapped in bandages or hammocks for burial (see Roe 1997a:154).

The parallel to the primordial Coaybay domain is the forest domain of Arcabuco. Although located in the ordinary cosmos, it becomes a supernatural place at night when, according to Taíno oral tradition, the *opías* or spirits of the dead take flight from Coaybay to journey or feed in the forest. Petroglyph-*cemí* 19, if interpreted as an owl-like figure, stands in for this domain since owls and bats for the Taíno were associated with *opías*. The high-status facial image of Petroglyph-*cemí* 22, perhaps depicted as emerging from underground, might represent the *cacique* of Coaybay. Such a personage located at the very end of the sequence can also be viewed as a point of contact bringing together the two sets of domains, in effect forming a repeating cosmic life cycle.

This cosmic life cycle rendered in stone, Oliver contends, also particularizes the model for the body politic of Caguana. Petroglyph-*cemí* 11, an anthropomorph, occupies the central position within the sequence and is portrayed as a facial image with a *guaíza* or facemask emblem below, exclusive to

caciques. He or she mediated between the primordial and ordinary worlds in order to ensure proper cosmic, sociopolitical, and religious order. Actual *caciques* were expected to do the same through intercommunication with *cemís* and other supernatural forces. The *areytos* would have emphasized the present and past *cacique*-ancestor *cemís'* successes in maintaining the balance of forces, resulting in the good order and material well-being of the people. A final note: those petroglyphs not already discussed take on ancillary or helping roles within the cosmic order.

The Role of Petroglyphs at Reef Bay, St. John, U.S. Virgin Islands

Ken Wild, the fifth author of this article, posits a role and meaning for the Reef Bay petroglyphs that combines archaeological and ethnohistoric data with specific observed aspects of Taíno aesthetic expression. The assemblage is located in the U.S. Virgin Islands Reef Bay Valley National Park. Anthropomorphic facial and facial-body images predominate and can be divided into four groupings. The largest grouping of 13 figures, measuring 3 m from end to end, faces a spring-fed pool (Figure 9.5). The three other sets are situated at strategic observational points around the pool.

Analysis of certain ceramic designs recovered from 600 years of sequential pre-Columbian occupation at the two nearby sites of Cinnamon Bay and Trunk Bay, reflects the shift from simple to complex chiefdoms. In the Virgin Islands this shift is also indicated by other lines of archaeological evidence including the presence of the ball courts at Salt River on St. Croix and Belmont on Tortola (Drewett 2007). The mechanism for the change likely involved an elite authority that increased and legitimized its power through the manipulation of existing religious cultural components including rituals for ancestors and religious symbols.

At Cinnamon Bay and Trunk Bay the symbolic imagery depicted in *adorno* (modeled and applied) images on ceramics changes over time from anthropomorphic to anthropomorphic faces with a zoomorphic bat nose. Bats reside in both the natural world of the living and the supernatural realm of the non-living. They would symbolize the open connection between the two spheres. Herrera Fritot and Youmans (1946:69–83) identify this combined imagery as "humanized faces that highlight the isomorphism between these animals and the souls of the dead."

Ceramics with bat-nose *adornos* at Cinnamon Bay increase substantially after the introduction of this motif, beginning around A.D. 1300, as does the addition to the bat-motif *adornos* of headgear or headdresses, which the chroniclers also report were only worn by *caciques* (Rouse 1992:11–12). Rouse's (1992:14–15) description of contact-period Taíno society provides a possible use for these bat-nosed ceramics as vessels for food offerings to

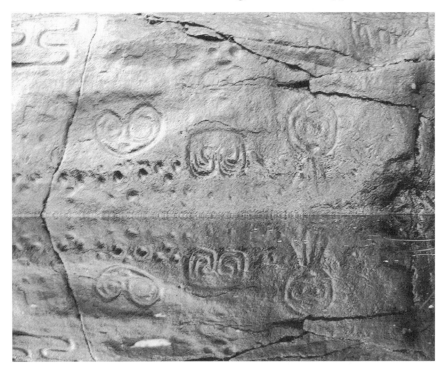

Figure 9.5. Portion of the Reef Bay, St. John, U.S. Virgin Islands, petroglyph assemblage on a rock outcropping overlooking a still pond where the images are inversely reflected (photograph by Wild, 2005).

cemís. The elites, including chiefs and religious specialists, both possessed the physical representations of *cemís* and served as mediators between the everyday world and the world of the *cemí* spirits. The process of power enhancement of Late Ceramic Virgin Islands societies can be viewed as one in which the elites, by expropriating the bat design, symbolically provided themselves with a direct link to their ancestors. Claims of more effective control of *cemís* would have also raised their ancestors' status vis-à-vis other groups' deceased relatives.

Wild believes that the Reef Bay petroglyphs also mirrored the area's increasing sociopolitical development. Comparable imagery and designs are evident on the *adorno* ceramic offering vessels and the petroglyphs. The encircled eyes design on the ceramic *adornos,* for instance, can be found on several of the petroglyphs. Further, a ceramic vessel fragment from Trunk Bay dating to A.D. 900–1200 possesses a heart-shaped *adorno* face paralleling the heart-shaped faces of two petroglyphs at the site, one of which is depicted in Figure 9.5.

Similar or identical faces and symbols of the rock images and on ceramics contain and project the same symbolic meaning (Wild 2001). This isomorphism involving motifs that symbolize the connection between the natural and supernatural worlds, in addition to enhanced elite control of *cemí* spirits, suggests a reason for the execution of petroglyphs at the specific location of Reef Bay. At dusk, bats will circle and swoop down into freshwater sources, indicating, perhaps, to the island's past inhabitants, a place where the ancestors gather.

Another reason for the petroglyphs' location may have to do with Roe's (1997a:148) comments concerning the duality or mirrored/reflective imagery often found on Taíno objects that again represent both the natural and the supernatural worlds. This duality is present at Cinnamon Bay, where ceramic effigies depict this mirrored imagery. What better place to carve the images of these two worlds than where their ancestors would return to the everyday world and at the finest mirror available to Amerindians, a pool of water.

Legal Frameworks for Protection of Rock Art Sites

The responsibility for the management of cultural resources, including rock art sites, on Puerto Rico and the Virgin Islands is divided among United States federal, state, and local governments. The federal government, primarily through the State Historic Preservation Office (SHPO) system and other agencies, maintains supervision of sites on specifically federal lands within these two politically separate entities. The Commonwealth of Puerto Rico and the Virgin Islands, a territory, through the same or additional governmental agencies, perform a similar function for sites on commonwealth or territorial and privately owned lands.

The National Historic Preservation Act of 1966 (and amendments) sets forth the basic requirements for federal review, oversight, and protection of cultural resources on United States government land. Construction activities that in any way affect federal land need to take into account possible impacts to cultural resources before such projects can proceed. This act also created the SHPO system, with an office in each state and political dependency. The SHPOs, among other tasks, serve as review agencies in the determination of possible impacts, as well as being primary repositories for information on prehistoric and historic sites, including rock art.

The process for determining possible impacts to cultural resources is outlined under Section 106, Review and Compliance, of the 1966 National Historic Preservation Act. The process involves three phases: Phase I, determining the presence of cultural resources within the project area; Phase II,

determining resource significance; and Phase III, developing a plan to avoid or mitigate the resource. In the case of rock art sites, Phase III measures would involve extensive recording and in extreme cases physical removal of the images to a repository. Collectively these investigations are documented in cultural resource management (CRM) reports.

Determining the importance of a resource that would require avoidance or a mitigation-level investigation has a specific meaning in federal law. A site, district, or artifact must meet certain criteria to be considered "significant" or eligible for the National Register of Historic Places (subsection 36 CFR, Code of Federal Regulations, 60, of the 1966 act). Criteria for rock art sites normally involve the artistic value (number of images and degree of execution) of the images or their ability to provide further data on the prehistory or history of an area (their relationship to sociopolitical development or an understanding of past religious or cosmological systems). The SHPO reviews the eligibility documentation and recommends that a resource be placed on the National Register (National Park Service 2006).

Both Puerto Rico and the U.S. Virgin Islands possess parallel cultural resource protection laws. Ley 112, Ley de Protección del Patrimonio Arqueológico Terrestre de Puerto Rico, was enacted in 1988 and contains various provisions (Instituto de Cultura Puertorriqueña 2006). Principally, the statute declares that all sites, objects, documents, and other archaeological materials within the jurisdiction of Puerto Rico are considered cultural patrimony, including rock art sites.

The law also created the Consejo para la Protección del Patrimonio Arqueológico Terrestre de Puerto Rico to oversee the preservation of archaeological resources. This council establishes regulations concerning investigations on the island, as well as reviewing construction projects done with state or private funding and requiring studies in cases of potential impact. The process complements the review of projects involving federal land, monies, or permits, as outlined above.

The Programa de Arqueología y Etnohistoria of the Instituto de Cultura Puertorriqueña works with the council in the review process. The institute was set up in the 1950s with the broad mandate to promote Puerto Rican culture through such activities as sponsoring artisan festivals and educational programs. The program at that time was responsible for the protection and promotion of archaeological resources. Since the 1988 bill, the program has taken on the larger part of the project review process, in addition to maintaining an inventory of historic and prehistoric sites, a task also undertaken in cooperation with the council, itself part of the institute.

The U.S. Virgin Islands state or territorial cultural resource protection law (Virgin Islands Act No. 6234, Bill No. 22-0112 1998, Chapter 17 of Sec-

tion 1, Title 29) acknowledges a federal-state-territory partnership for cultural resource protection established through the National Historic Preservation Act. Unlike Puerto Rico's system, the Virgin Islands Antiquities and Cultural Properties Act makes the State Historic Preservation Officer responsible for the implementation of both territorial and federal preservation laws. The officer is also the commissioner of the Department of Planning and Natural Resources with the SHPO, equivalent to the Division for Archaeology and Historic Preservation within this department.

Provisions of the act include devising a plan for the survey of the islands' cultural resources; maintaining a listing of resources; setting up a permit process to conduct archaeological investigations on territorial public lands; and extending the permit process to private lands when commercial projects are involved. Civil and criminal penalties are established for violations of the act, primarily in the form of fines. Any fines, along with monies from other sources, go into the Archaeological Preservation Fund to be used to implement the act's provisions.

The legal framework in Puerto Rico and the Virgin Islands is instructive on two points:

1. The differing local structures reflect the particular histories of political integration with the United States and particular means of cultural expressions and identity.
2. The system sets up, at best, complementary and, at worst, competing claims for the management of cultural resources. In theory, if not in practice, federal law prevails.

The effectiveness of these laws in protecting cultural resources on these islands can only be summarized here as being overall good or moderate, but less so with regard to rock art sites. Graffiti remains a problem and formal legal or National Register status ranges from minimal for Puerto Rico to excellent for the Virgin Islands.

For Puerto Rico only eight of the 536 locations with rock art are listed on the Register: five are exclusively rock art sites (Cueva del Indio, Cueva de los Indios, Cueva de Mora, La Piedra Escrita, Quebrada Maracuto) while the other three are ball court sites with petroglyphs—Caguana, Tibes (Centro Ceremonial Indigena), and Palo Hincado (National Park Service 2006). Many more are certainly eligible but either have not been officially proposed in the perhaps 20 cases with sufficient documentation or lack the necessary level of recordation to undertake the nomination effort (Hayward et al. 2002). In contrast, all five of the U.S. Virgin Islands locations with petroglyphs are listed on the National Register (National Park Service 2006).

The Rock Art of Guadeloupe, French West Indies

Gérard Richard

Translation by James R. Fish; revision of translation
by Michele H. Hayward, Lesley-Gail Atkinson,
and Michael A. Cinquino

History of Research

Father Breton's seventeenth-century sketches of rock art on Guadeloupe represent the earliest record of pre-Hispanic carved images on the island (Breton 1978). Breton did not, however, believe the petroglyphs were produced by "the savages," instead attributing them to the Spanish who occupied the island prior to the arrival of the French. Two centuries later, in the 1980s, Cornelius Dubelaar conducted the first systematic rock art survey in the Lesser Antilles, including Guadeloupe. He subsequently published his results in two books: *South American and Caribbean Petroglyphs* (1986a) and *The Petroglyphs of the Lesser Antilles, The Virgin Islands and Trinidad* (1995). Dubelaar recorded six sites in Guadeloupe, with a total of 313 petroglyphs. He also noted that the archipelago of Guadeloupe encompassed more than 50 percent of the reported petroglyph sites in the Lesser Antilles.

In 1991 and 1992, Alain Gilbert and I had the opportunity to update Dubelaar's inventory. Construction projects and the passing of hurricanes such as Marilyn (1995) and Lenny (1999), along with additional field investigations, increased the tally to nearly 1,200 petroglyphs from 27 sites distributed within seven communes.

Geographic Distribution

Guadeloupe is the principal island within the archipelago of Guadeloupe (see Figure 1.1, this volume). The island is divided into two main geological zones, Basse-Terre and Grande-Terre. The western region, Basse-Terre, is volcanic, mountainous, and well drained. Grande-Terre, which is located to the east, is primarily limestone, with characteristic arid karstic plateaus.

Rock art site distribution within the island varies according to the two

geological zones. The most notable petroglyph sites are found in the southern region of Basse-Terre, at the base of the dominating La Soufrière volcano. The rock art sites are especially frequent in an area delineated by the Pérou River at Capesterre-Belle-Eau and the Plessis River between the Baillif and Vieux-Habitant communes.

In Grande-Terre, petroglyphs are found at the rockshelter Abri Patate, located in a dry valley within the Moule Commune. They are also found at the cave site Grotte du Morne Rita north of the town of Capesterre de Marie Galante, on Marie Galante, an adjoining island within the Guadeloupe archipelago.

Environment

I, along with others, believe rock art locations were primarily selected by the native people because of environmental factors, in particular, specifically, freshwater resources. In most cases, sites are located in proximity to a freshwater source such as a waterfall or river mouth, as evidenced by the Pont Bourbeyre site. The following descriptions of Guadeloupe's rock art sites illustrate this relationship between water sources and rock art.

Site Descriptions

Basse-Terre Petroglyph Locations

Capesterre-Belle-Eau. Father Breton mentioned this site, located at the mouth of the Pérou River, in his chronicles, revealing that these petroglyphs are distinct from those at the principal sites at Trois-Rivières in Basse-Terre. A large geometric anthropomorphic face with crying eyes over a shield marked by a St. Andrew's type cross predominates. The incisions are deep except for two big ears, which frame the face, that are barely visible. This location at the mouth of the Pérou River was the only known site in this area until the mid-1980s, when three other sites were discovered along the Bananier River (1984); further sites were later found at Islet Pérou (2000) and along the Grand Carbet River (2003).

Bananier River. In 1984, Henry Petitjean Roget discovered an engraved rock and a flat milling stone in the Bananier riverbed. Deep grooves outline the image framed by two ears, with the shape of the rock suggesting a zoomorphic representation. Seven years later, I located, farther downriver, a second elongated rock. This time there was no doubt that it represented a manatee, an animal sacred to the Amerindians. The river location is also close to a mangrove, the natural home of this species.

Islet Pérou. At the end of 1999, Hurricane Lenny generated a current in the

Pérou River powerful enough to overturn a boulder weighing nearly 10 tons. The formerly buried part concealed several engraved anthropomorphic faces and the design of a bird's head. This zoomorphic motif is rare in the Lesser Antilles. It is similar to those encountered at the Taíno sites in the Greater Antilles, particularly at the Caguana ball court in Puerto Rico, that investigators have suggested represent the mythical bird Inriri, a woodpecker.

Grand Carbet River. In June 2003, while a bridge was being widened at the Grand Carbet River, several large boulders from the left riverbank were extracted. One of the boulders was covered with cupules or circular pits and a number of humanlike faces, some of which were similar to those found at the Bananier River location. This boulder was removed and placed at the entrance to the Trois-Rivières Regional Council offices.

Trois-Rivières Rock Art Grouping

The Trois-Rivières district presently contains five large rock art groupings: the Petit Carbet River, the Anse des Galets, the Anse Duquerry, the Propriété Derussy, and the Parc Archéologique des Roches Gravées. Also present is a series of isolated rocks dispersed haphazardly that were, in the past, likely part of the current observed groupings.

Petit Carbet River. The source of this river is found at the base of La Soufrière Volcano. The Petit Carbet River merits particular attention, as the last half mile of its course contains five rock art sites.

VALLÉE D'OR AND THE HABITATION VALLÉE D'OR. The Vallée d'Or and Habitation Vallée d'Or locations encompass two rock art assemblages, six isolated rocks with figures, and associated stone tools that are dispersed over 350 m in the riverbed and along the riverbank. The images are generally of simple anthropomorphic faces made up of a circle encompassing three cupules or pits for the eyes and mouth.

THE OLD COLONIAL BRIDGE OR YÉBÉ SITE. The second location lies 500 m downriver from the first grouping, on a large vertical boulder. Only a small (50 cm), genderless anthropomorphic image with arms and legs is visible. The petroglyph's discoverer, Carloman Bassette, named the figure the "Yébé character."

PONT BOURBEYRE. The Pont Bourbeyre site spans 40 m on both sides of a 5-m-high waterfall. An important group of carvings is found on a boulder that overhangs the waterfall. It appears that a number of additional carvings were present on the boulder that have been worn away by water erosion. Fifteen petroglyphs are still identifiable on the side where there is less erosion. The most complete image consists of a head on a torso crossed by two lines.

BASSIN CARAÏBE. The fourth location is situated 150 m upstream from the mouth of the Petit Carbet River. The river at one point along its course be-

gins a rise of about 3 to 4 m. Prior to this there is a large basin with petroglyphs on the surrounding rocks. At the time of our 1991 survey, these carvings were barely visible. They have, however, since disappeared, likely erased by water erosion due to the rising level of the river.

MOUTH OF THE PETIT CARBET RIVER. The fifth location in the Petit Carbet River area is found on the left bank of the river's mouth. The grouping includes two principal boulders with petroglyphs. One is covered by 14 encircled pairs of eyes facing across the river, while the second one, set back from the first boulder, consists of a sort of mask and several pits.

Anse des Galets. About 225 m northwest of the Petit Carbet River mouth is the Anse des Galets or Plage des Galets site, which was discovered by Carloman Bassette in 1995. The location consists of a jumble of volcanic rocks sitting over a small spring. Nine boulders show traces of engravings; also present are two flat milling stones. Some 20 figures have been identified, two of which are large and awe inspiring (at least to the modern observer). These two anthropomorphic figures can be identified as to gender and perhaps represent a woman in a childbirth position flanked by a masculine individual. The site is a source of freshwater and near the sea, which reinforces the water resource–rock art linkage hypothesized above.

Anse Duquerry. Engraved boulders are found on a plateau encompassing 2.5 acres situated 250 m southwest of the mouth of the Petit Carbet River and 10 m above sea level directly overlooking the small beach of Anse Duquerry. We have identified 12 carved rocks and 3 milling stones, in addition to associated stone tools. The boulders at this site are generally small, and several probably have been moved since the Amerindian occupation. In Guadeloupe, French law requires that excavations must be done prior to the construction of public facilities and infrastructure: preliminary excavations at this site during parking-lot construction have revealed traces of occupation dating from the end of the Saladoid to the Troumassoid (post–A.D. 300; see Figure 1.3, this volume).

Propriété Derussy. A key group of engraved rocks occupies an alluvial terrace dominating the outer bank of a large meander in the Petit Carbet River between the Yébé site and that of the Habitation Vallée d'Or. The assemblage is found on a private agricultural estate belonging to the Derussy family. Two distinct loci are evident: (1) a concentration of 17 rocks in a 200-m² area and (2) 23 rocks, some of which appear to have been intentionally placed, in a circular arc around a central pile of boulders. One of these boulders has a richly decorated face. As of 1992, the inventory stood at 76 boulders with 258 petroglyphs.

Parc Archéologique des Roches Gravées. For the general public, the Parc Archéologique des Roches Gravées is the most popular rock art site on Guade-

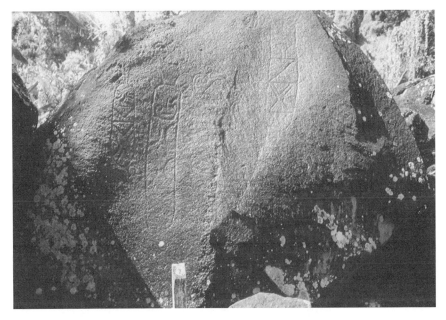

Figure 10.1. Enclosed-body petroglyph forms, Parc Archéologique des Roches Gravées, Trois-Rivières (photograph by Richard, 1992).

loupe. The area contains a large collection of petroglyphs of high aesthetic value amid a field of andesitic boulders. The series of rupestrian scenes exhibits rich and varied representations from simple faces indicated by three pits encircled by a groove, to *cemí* figures, to complex face and enclosed body forms as indicated in Figure 10.1. A mirrored upside-down anthropomorphic figure on a boulder at this site, illustrated in Figure 10.2, strongly echoes the reflective imagery of the petroglyph-adorned rock panel around a pool of water at the U.S. Virgin Islands Reef Bay location (see Chapter 9). Overlapping, dual, and inverted images involving similar designs or morphing into different designs are characteristic devices found in Caribbean material culture from ceramics to lithics, as well as rock art (Roe 1997a:148).

Baillif and Vieux-Habitant Area Petroglyphs

The Plessis River Site, St. Robert Section. The Plessis River petroglyph assemblage, in the commune of Vieux-Habitant, consists of a principal boulder, situated on the right bank of the river, and several satellite rocks found on either the left bank or in the middle of the riverbed. The principal rock overhangs a substantial basin. The facade faces downstream and presents a series of at least 20 engravings.

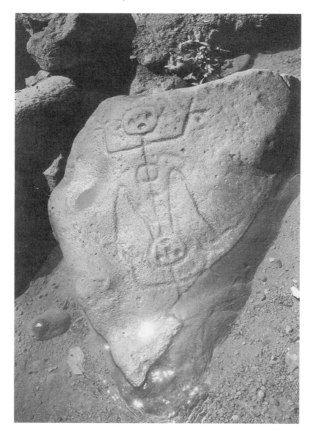

Figure 10.2. Mirrored anthropomorphic petroglyph, Trois-Rivières (photograph by Richard, 2002).

In the territory of the Baillif Commune, on the left bank of the Plessis River, there are three andesitic boulders decorated with diverse engravings, one of which is a grimacing humanlike face with enormous ears. After the passing of Hurricane Marilyn in 1995, I discovered, upstream from this location, three additional anthropomorphic faces carved on a boulder along the riverbank. These carvings look more sculptural than simple engravings, and this is one of the special features among the carved rocks on the Plessis River (Figure 10.3). Several faces are carved on the angles or other protuberances of the rock, in order to give them a greater depth.

Cousinière Grosse Roche. A post-Saladoid site (A.D. 600), Cousinière Grosse Roche, was discovered in 2000 by a survey team from the Regional Directory of Cultural Affairs. The isolated rock contains a dozen simple faces and is situated on the left bank of the Plessis River upriver from the St. Robert site. A dozen simple humanlike faces cover the rock.

Figure 10.3. Facial petroglyph in relief, Plessis River, Baillif/Vieux-Habitant Commune (photograph by Richard, 1996).

Some flat milling stones were discovered at the mouth of the Baillif River in the aftermath of Hurricane Marilyn (1995). They are associated with a site occupied by Amerindians dating to the Cedrosan Saladoid period (ca. A.D. 300–500).

Grande-Terre Petroglyph Locations

Abri Patate. Christian Stouvenot discovered Abri Patate in March 2003 while conducting archaeological surveys of natural cavities that were occupied by Amerindians. Located in the karst zone of the Moule Commune, the site contains 14 petroglyphs, one of which is an anthropomorphic figure. All of the engravings are found on the concretions under the overhang of the shelter and face the exterior.

One group is of particular interest in that an anthropomorphic face has

been realistically done, on a stalactite, in a hanging form. The two eyes are slightly almond-shaped and are clearly marked. The ridge of the nose and its two nostrils are hollowed out and they top a wide-open mouth. The presence of stalagmites, stalactites, and natural shallow basins in which freshwater collects is remarkable in this particularly dry environment. This probably explains the selection of this site to house the rock art, as the neighboring caves do not contain water basins and were not apparently utilized.

Marie Galante Island Rock Art

Grotte du Morne Rita. The Grotte du Morne Rita is the only location on the small island of Marie Galante with rock art. Situated in the commune of Capesterre de Marie Galante, the cave represents a large collapsed chamber. Petroglyphs have been carved onto various small to large boulders in the center, as well as engraved or scratched on an inner wall. The site also contains two pictographs that are visible at the mouth of the cave.

The majority of the images are simple forms of anthropomorphic faces, some of which have been defaced by contemporary graffiti. The images depicted in Figure 10.4 include a petroglyph/pictograph combination of carved eyes that appear to be "crying," with the face and body simply outlined in white paint. A circular face crossed by two parallel lines and a group of fine lines organized in geometric shapes are among the other motifs.

Classification of Rock Art Sites

Alain Gilbert has devised a threefold classification scheme for the rock art of Guadeloupe based on stylistic comparisons:

A. Simple faces, represented by two eyes and a mouth encircled by a groove;
B. Elaborate faces, given attributes such as ears or a very stylized body; and
C. Detailed anthropomorphic or zoomorphic representations—for example, some are given nasal appendages and some human representations are complete with sexual attributes.

The scheme at present does not include other attributes such as execution techniques, compositional considerations, depth of the carvings, or the extent of pigment use. The image-makers undoubtedly considered these and other characteristics when designing and executing their figures.

Associated Cultural Groups

Only a minor number of surveys and excavations have been completed for island habitation sites such as the Grotte du Morne Rita (Bodu 1980), Du-

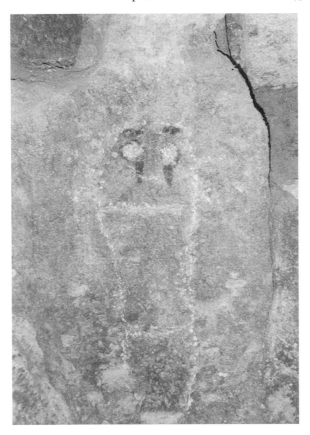

Figure 10.4. Face and wrapped-body petroglyph/
pictograph with crying eyes from Grotte du Morne Rita,
Marie Galante Island (photograph by Richard, 1992).

querry and Derussy (Hoffman 1995:28–29), Duquerry (Richard 2001), and
Abri Patate (Stouvenot and Richard 2005). This limited information indi-
cates sustained island occupation began toward the end of the first phase of
the Early Ceramic Period by Saladoid peoples, A.D. 300, and continued into
the Late Ceramic marked by the Troumassoid and Suazoid ceramic series
(A.D. 600–900; see Figure 1.3, this volume).

Preliminary surveys were conducted while work was being done on the
Anse Duquerry parking lot, revealing various prehistoric deposits including
the presence of pits and postholes. The identifiable ceramic fragments suggest
occupation during the second phase of the Early Ceramic Period, A.D. 250 to
650, as well as the probable presence of the Suazoid culture.

A surface find of a bowl fragment adorned with a pudgy stippled handle
is similar to the ceramics of the Suazan Troumassoid site of Morne Cybèle

on the plateau of Désirade. While no stratigraphic link exists between dated habitation and rock art sites, the rather meager evidence is consistent with an early hypothesis that places most of the rock art production between the fourth and tenth centuries A.D.

Interpretation

Henry Petitjean Roget argues that one characteristic is common to almost all sites: their location near or at freshwater resources. The connection is not a simple one of the rock art serving to identify such a source but in fact relates to the threat of a lack of water (Petitjean Roget 2003). Repeated droughts struck Amerindians throughout their history. They saw sources dry up, basins evaporate, and water stop seeping from the caves and noted the disappearance, perhaps forever, of water from the rivers, in addition to a lack of rain when they needed it for their crops.

The petroglyphs would be, according to Petitjean Roget, a magical and tangible means to guard against the return of a world without water, the burnt world that is spoken of in so many South American oral traditions. He speculates that such practices date to as early as A.D. 700.

Protection of Rock Art Sites

Two rock art sites on Guadeloupe are currently classified as historical monuments: the Grotte du Morne Rita at Capesterre de Marie Galante and the Parc Archéologique des Roches Gravées at Trois-Rivières. Four other major sites are in the process of acquiring this designation: (1) the Plessis River site in the Baillif/Vieux-Habitant Commune, (2) the Anse des Galets site at Trois-Rivières, (3) the Engraved Rocks site of the Petit Carbet River at Trois-Rivières, and (4) Abri Patate in the Moule Commune.

Contextual Analysis of the Lesser Antillean Windward Islands Petroglyphs

Methods and Results

Sofia Jönsson Marquet

Introduction

Rock art sites in the Lesser Antilles have long been known, as well as being the object of investigation by various individuals (Dubelaar 1995). Most of this area's rock art research can be characterized as descriptive. Data such as the geographical locations of the sites and the recording of the engraved images are made the focus of studies. Normally, minimal interpretation of the iconography or the rock art's relevance to the sociopolitical and religious components of local cultures is advanced.

Contextual analysis, I argue, offers a means to expand our higher-order understanding of rock art in the Lesser Antilles, as it has in other regions (see, for example, Díaz-Granados Duncan 1993). In contextual analysis, the focus is placed on viewing rock images as integral parts of their physical and cultural contexts, instead of as isolated elements (see Jönsson Marquet 2002 for an extended presentation).

Specifically, in this chapter I aim:

1. To highlight the significance of investigating rock art as a complement to other archaeological data, using as a case study the petroglyphs of the Lesser Antillean Windward Islands.
2. To examine the possible presence of a distinctive Windward Islands petroglyph patterning. These islands have been considered a homogenous cultural area based on the use and production of similar ceramic styles. A contextual analysis approach should provide a means to identify a parallel arrangement of these islands' petroglyph assemblages.
3. To establish a spatial-temporal framework for the petroglyphs through cross-referencing petroglyph and other cultural component data. Changes in petroglyph design elements and motifs can be expected to correlate with archaeologically detectable changes in sociopolitical and religious organi-

zation. Two factors for the southern Lesser Antilles, however, may miti-
gate against making any such linkages: (1) the symbols or iconography of
cultures, including rock art, tend to be resistant to changes even in the face
of differing sociopolitical and environmental contexts; (2) at present the
sociopolitical organization of the area also appears to have been very stable,
even though distinct changes in other cultural aspects took place, as in pot-
tery styles. Throughout the Early and Late Ceramic periods, societies can
be characterized as largely egalitarian, dominated by a "big man" system
with a low degree of social differentiation (Boomert 2001). This stands in
contrast to the increasing sociopolitical development in the Greater Antil-
les in the Late Ceramic, where a two-tiered division into elites and com-
moners and complex chiefdoms were evident by the end-period Taíno cul-
tures (see Hayward, Atkinson, and Cinquino, Introduction, this volume).

I chose to concentrate my research on four of the Windward Islands: Gre-
nada, St. Vincent, St. Lucia, and Martinique (see Figure 1.1, this volume).
They were selected for their geographical proximity to the South American
continent, the origin for the Lesser Antillean Ceramic Age populations, and
for their common geological volcanic origin. Standardization of the data-
base through selection of prehistoric societies that shared a similar origin and
range of environmental possibilities should reduce the number of variables
that would help explain any differences in petroglyph patterning.

While all four islands possess petroglyph sites, they are not evenly distrib-
uted, as can be noted from Table 11.1. A total of 262 figures have been re-
corded from 26 sites comprising isolated boulders and one rockshelter. An-
thropomorphic images dominate in the sample (77 percent), and of those half
can be classified as simple faces. Zoomorphic and geometric designs are also
present. Geometric and abstract designs not readily identifiable, while not
counted due to difficulties in identifying discrete images, were nonetheless
included in further analyses.

No obvious chronological indicators such as superimposition or sociopo-
litical events are evident to aid in time-space-iconographic interpretations.

Methodology

The methodology involved three interrelated phases: (1) the recording of
petroglyph site and image attributes, (2) the statistical analysis of the attribute
database, and (3) the correlation of petroglyph sites with other site types and
environmental data. Hypotheses or statements of interpretation and those re-
garding a chronological framework became possible after the statistical and
comparative analyses.

Table 11.1.
Distribution of Petroglyph Sites and Images by Island

Island	Number of Sites	Number of Images
Grenada	5	131
St. Vincent	12	55
St. Lucia	7	42
Martinique	2	34
Total	26	262

Recording of Site Data

Information obtained for each of the 26 sites included their geographical location and topographic details, the site type (boulder, rockshelter), and the number and general type of petroglyphs present, as well as the location of nearby dated prehistoric sites. Recorded data for each of the petroglyphs consisted of such attributes as rock type; location of the image on the rock face; method of production; dimensions, orientation, and conservation status; physical state of the rock surface; relationship to other figures or design motifs; and condition and color of the patina.

Color slides and black-and-white photographs were taken of the images that were reproduced via tracings at a scale of 1:1 onto transparent plastic rolls of film. Finally, the petroglyph and non-petroglyph sites were located on topographic maps and the field forms transferred to a computerized database (Microsoft Access) especially devised for this study.

Statistical Analysis

A typological approach was employed to classify the 262 figures in order to yield units of analysis appropriate for componential analysis and distributional studies. Four general classes and seven anthropomorphic subtypes were intuitively derived. The four general classes were (A) anthropomorphs, (B) zoomorphs, (Ca) geometrical designs and (Cb) geometrical abstract motifs, and (D) unidentifiable figures.

The large anthropomorphic group was further divided into seven subtypes: (A1) small, simple faces (partial or complete outlines of faces with minimal internal or external elaborations), (A2) developed faces (partial or complete outlines of varied facial and eye shapes with more elaborate internal or external design elements), (A3) other types of simple figures (outlines of body shapes with only simple face design elements), (A4) complex faces and figures (often larger, well-detailed images frequently executed in an imposing or aggressive manner and sometimes with a toothed mouth; the

bodies can be developed and accompanied by several attributes), (A5) enclosed bodies (facial images with attached appendage-less bodies but with internal design elements), (A6) squatting figures (images that have legs and arms in a squatting form, sometimes referred to in the literature as "lizard-anthropomorphs"), and (A7) composed images (interconnected separate figures, one on top of the other).

I next undertook a componential analysis of the anthropomorphic figures (see Roe 1991 for a similar approach) that were deconstructed or broken down into individual design elements. For example, 17 different head shapes were identified, including circular, oval, heart shaped, triangular, and concentric circular. Eyes, noses, ears, headgear, attached facial elements, internal facial elements, bodies, arms, and legs were similarly treated. The design elements were then tallied per site and island and entered into the database. Subsequent analysis aimed to establish correlations among petroglyph sites and between these and other site type characteristics including proximity to the nearest recorded archaeological site, physical location, and techniques of production.

Four observations regarding the correlations or distributional patterns can be made. The first is that spirals were generally found near a water source. Second, different insular traditions could be found on only two islands during any one archaeologically defined period. Third, these design elements also appeared to be symbols that derived their meaning from local cultural contexts including socioreligious relationships, kinship, and underlying taboo rules. Their usage among these islands denotes participation within a common or shared socioreligious system. Fourth, only St. Lucia exhibited an internal island pattern, associated with abraded and finely pecked, enclosed body images. Design elements differed in the northern and southern ends of the island that are not simply due to differential design influences from Martinique to the north or St. Vincent to the south.

Comparative Analysis

The attempt to link petroglyph and other site types on these islands through an examination of their temporal and spatial distributions provided few significant recognizable patterns. Factors contributing to this situation included (1) the lack of micro-environmental data, (2) the existence of only a few radiocarbon dates, (3) the primary reliance on surface collections to estimate the date and extent of sites, and (4) the unequal division of the archaeologically defined periods for the Windward Islands. Those periods and times are as follows: the first phase Early Ceramic, 400 B.C.–A.D. 300 (700 years); the late phase Early Ceramic, A.D. 300–500 (200 years); the first phase Late Ceramic, A.D. 500–1000 (500 years); the second phase Late Ceramic, A.D. 1000–1300

(300 years); and the final phase Late Ceramic, A.D. 1300–1600 (300 years) (see also Figure 1.3, this volume).

Nonetheless, certain associations were evident. The Early Ceramic (400 B.C.–A.D. 300) settlements were located closer to petroglyph sites than other phase settlements. The Early and Late Ceramic (post-A.D. 300) multicomponent sites that lay closest to petroglyph locations had a higher number of images in contrast to sites of other phases. The Late Ceramic (A.D. 1000–1500/1600) period possessed the highest number of petroglyph sites.

Results

Faugère-Kalfon (1997:89) considers that the identification of rock art traditions should be preceded by a study of the images and production techniques, as well as a comparative study of associated archaeological material. For this investigation employing the contextual analysis approach, the results of the design-element analysis established that little variation exists in production techniques, with pecking predominating among most of the sites. By adding current, though limited, temporal and locational data on non-petroglyph archaeological sites, in addition to a fourth category of geographical and environmental information, I was able to identity four traditions.

Tables 11.2 through 11.5 summarize each of the traditions' characteristics. The sites assigned to the traditions and their typological classifications, primary production techniques, and physical locations are correlated. Further, these four traditions were placed within a temporal framework (Table 11.6). I stress that the definition of the traditions and their associated spatial-temporal dimensions remain preliminary. Further testing is needed.

Tradition A: Simple and Geometrical Designs

The initial and earliest tradition, probably related to the arrival of the first ceramic-producing populations into the Lesser Antilles, occurs on St. Lucia and St. Vincent (Figures 11.1 and 11.2; Table 11.2). The tradition is typified by simple geometric and anthropomorphic designs, which are almost never in association with each other. They are unelaborated; the geometric designs are often circular, and pecking comprises the primary production technique. All are located on the southern coast or in near-coastal environments of the two islands.

No compositional rules that order individual figures into paired or higher-order groupings are evident, and individual figures cover the entire rock surfaces of whatever size. It is also unclear whether particular rock surfaces were chosen for executing certain designs or vice versa. The petroglyph sites on St. Vincent are confined to single rock faces, while those on St. Lucia include

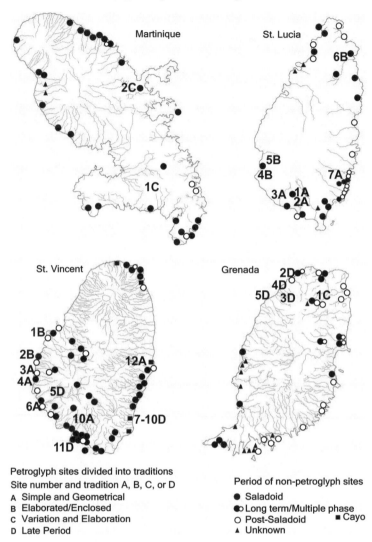

Figure 11.1. Distribution of petroglyph sites by tradition and time period for the Lesser Antillean Windward Islands.

images distributed over 1 to 10 boulders. Nearby sites, including the rock-shelter, suggest a date range from A.D. 200–300 for this grouping of petroglyph sites, designated Tradition A.

Tradition B: Elaborated and Enclosed

The same two islands again account for Tradition B, which comprises enclosed body figures formed through incision, abrading, carving, and fine

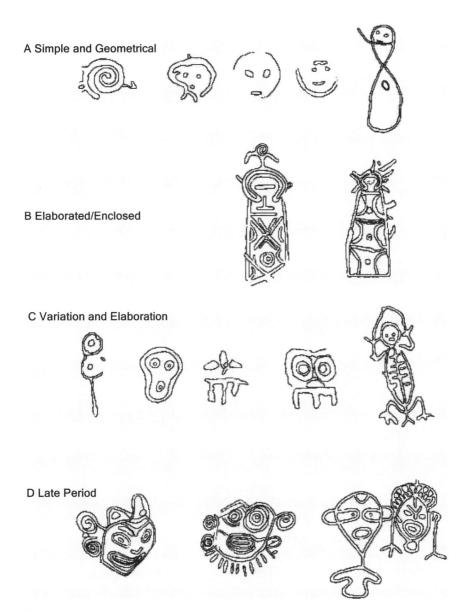

A Simple and Geometrical

B Elaborated/Enclosed

C Variation and Elaboration

D Late Period

Figure 11.2. Representative images of petroglyph traditions from the Lesser Antillean Windward Islands.

Table 11.2. Windward Islands Petroglyph Tradition A Characteristics

Island/Site	Typology	Production Technique	Geography	Environment
		St. Lucia		
Balembouche	Simple heads	Primarily pecked	South	River valley
Cachibour	Spirals		Interior	
Balembouche 2	Simple heads	Primarily pecked	South Interior Close to coast	River valley
Anse Ger	Simple head	Primarily pecked	South Interior Close to coast	Close to river
Choiseul	Simple figure	Possibly pecked	South On the coast	Plateau
		St. Vincent		
Buccament Bay	Simple heads Simple figures Spirals Abstract	Possibly carved	South Interior Close to coast	Rockshelter
Mount Wynne	Circles Lines	Carved Circular Percussion	South Interior Close to coast	Field
Peter's Hope	Simple head	Primarily pecked	South Interior Close to coast	Field
Colonarie	Geometrical Abstract		Southeast Interior Close to coast	River
Sharpes Stream	Geometrical Abstract		South Interior	Stream

pecking (Figures 11.1 and 11.2; Table 11.3). The lines forming the images are either fine or broad and exhibit little variation. These figures are composed of faces that often lack internal design elements. The faces are attached to bodies on which the appendages are folded inward or not depicted externally. The bodies themselves possess varying arrangements of straight and curved lines, with and without circles. The figures are found on single vertical surfaces and tend to be located in forests or close to the coast. The nearby site of Anse des Pitons on St. Lucia suggests a date for Tradition B figures around the end of the Early Ceramic, A.D. 500.

Table 11.3. Windward Islands Petroglyph Tradition B Characteristics

Island/Site	Typology	Production Technique	Geography	Environment
		St. Lucia		
Stonefield Estate	Enclosed unidentified zoomorph	Finely pecked Incision	Southwest Interior	High placement forest
Jalousie	Enclosed Simple heads	Abrasion	Southwest Coast	Ocean
Dauphin	Enclosed unidentifiable	Incision	Northwest Coast	River
		St. Vincent		
Barrouallie	Enclosed Complex figure	Carved	Southwest Interior	High placement forest
Petit Bordel	Enclosed Simple figure	Incision	Center West Interior	High placement forest

Tradition C: Variation and Elaboration

Tradition C is found on the other two islands of Grenada and Martinique that anchor the two ends of this section of the Lesser Antilles (see Figure 1.1, this volume). This tradition includes facial and full-body figures that exhibit a great deal of variability, as well as unidentifiable but figurative geometrical designs on the same rock surface as the anthropomorphs (Figures 11.1 and 11.2; Table 11.4). In some instances, rock surfaces appear to have been chosen to accentuate certain design features such as the execution of asymmetrical figures. Images from the sites within this category are found on boulders and panels that have been produced through the unification of gross and fine pecking. The environmental settings are also variable.

At one of this tradition's locations, Mount Rich in Grenada, the first of four boulders appears to have been executed during two periods. The visibility, patination, and preservation of the designs, equally exposed to the sun and elements, could indicate a temporal succession of production. The nature of the figures suggests that the same cultural group had returned and continued to use the boulder to eventually cover all visible sides. Two of the five surfaces maintain a certain order of execution. The zoomorphs, complex images, and figurative geometrical designs are on one vertical side, while simple

Table 11.4. Windward Islands Petroglyph Tradition C Characteristics

Island/Site	Typology	Production Technique	Geography	Environment
Grenada				
Mount Rich	All except abstract	Finely and grossly pecked	North Interior	High placement River valley
Martinique				
Foret	Simple	Finely and grossly pecked	South Interior	High placement
Montravail	Developed Complex heads Simple figures			
Galion	Simple Developed Complex heads Geometrical Figurative	Finely and grossly pecked	Northeast Interior Close to ocean	Mangrove

faces predominate on the horizontal surface. This deduction may remain hypothetical, since it is reported that the boulder fell down the valley from the overlying plateau and thus might have been exposed differently during the production of the petroglyphs.

I rely on associations with ceramics to estimate the beginning of Tradition C. An assemblage found close to the Galion site on Martinique by J. P. Giraud (personal communication 1999) is dated to the late Early Ceramic period, around A.D. 400–500. The modeled heads on vessels with such attributes as concentric circles for the eyes and open mouths, distinctive for the Saladoid-Barrancoid ceramic style (see Figure 1.3, this volume), evoke design parallels in this petroglyph grouping.

Tradition D: Late Period

An overall increase in the size, a tendency to coarse rather than finely executed figures, and a high degree of variability mark Tradition D, found on Grenada and St. Vincent. Images include simple, developed, or complex faces, zoomorphs, and geometric figures (Figures 11.1 and 11.2; Table 11.5). Production techniques involve pecking and carving, with the sites confined to the northwest coast in Grenada and the southern portion of St. Vincent, as are all the petroglyph sites on this latter island. Calibrated dates from Duquesne Bay, Grenada, and noncalibrated dates from Indian Bay, St. Vincent, indicate production between A.D. 985 and 1400.

Table 11.5. Windward Islands Petroglyph Tradition D Characteristics

Island/Site	Typology	Production Technique	Geography	Environment
		Grenada		
Duquesne Bay	Geometrical Complex figure Developed head	Pecked Carved	Northwest Coast	Ocean
River Sally	Simple head Developed head Simple figure Complex face	Pecked	Northwest Coast	River Ocean
Between Waltham and River Sally	Simple face	Pecked	Northwest Coast	Ocean
South of Victoria	Complex head Simple head	Pecked	Northwest Coast	Ocean
		St. Vincent		
Layou	Simple face Complex face Unidentifiable	Pecked	Southwest Interior	High placement River
Indian Bay Point	Simple head Developed head	Carved	South Coast	Ocean
Yambou 1–4	Simple face Developed face Complex figure Simple figure Zoomorph	Possibly carved	Southeast Interior Close to coast	River

New design elements are added, but the older ones are still incorporated into what can now be considered design layouts that feature larger, centrally placed figures surrounded by smaller facial images. Just as certain facial images of Tradition C petroglyphs call to mind modeled head *adornos* on pottery of the same period, two large triangular heads of this tradition resemble the large three-pointed objects or *cemís* (see Hayward, Atkinson, and Cinquino, Introduction, this volume) that are known from the Late Ceramic Greater Antillean Taíno cultures.

The combination of design elements and the large size of Tradition D petroglyphs must have left prehistoric, and even modern, people with a sense of the preeminence of these images within local or perhaps regional physical and cultural contexts.

A comparable trend toward larger and more elaborate petroglyphs at the end of the Late Ceramic Period is also noted for the Greater Antilles. Oliver

(1998, 2005), in particular, has argued that Caguana, Puerto Rico (see Hayward, Roe, et al., Chapter 9, this volume), with its large, imposing carved petroglyphs served as a symbol, on a monumental scale, for the local as well as regional populations. The petroglyphs may have further been viewed as active participants or links between the physical and spirit worlds and among the different social strata of society.

I propose a similar role and meaning for the Windward Islands Tradition D petroglyphs. During the post-Saladoid (A.D. 1000–1400), ceramic styles are considered to have developed largely due to local influences, and a significant increase in archaeological sites is observed. Although no ball courts or plazas have been reported for Grenada and St. Vincent, and a stratified sociopolitical system appears lacking, a change in the execution and location of petroglyphs is noted. A larger percentage of the images are situated close to the coast, making them more visible for larger groups of people. Their execution represents an elaboration in size, design elements, and composition from the earlier petroglyph assemblages. The figures may have been seen as territorial or ethnic group markers; as social identifiers (simple faces represented lower social status individuals that surrounded the larger central image of higher-status individuals); and as points of contact between the sacred and profane worlds.

Conclusions

The contextual analysis approach involves integrating rock art data with archaeological site and environmental information. The application of this method to Windward Islands petroglyphs, I consider, has proven effective in advancing our understanding of the role and meaning of these carved images within the region's prehistoric societies.

Although our control over the time-space-iconographic attributes of petroglyph and non-petroglyph sites from these four Windward Islands remains minimal, the analysis thus far is suggestive of a common interaction sphere throughout the Ceramic Period. Particularly by the post-Saladoid, A.D. 1000–1400, the observed trends in petroglyph and ceramic traditions indicate a higher degree of exchange of goods, people, and ideas among the southern Lesser Antillean islands than among the northern Lesser or Greater Antilles. Relationships were also maintained with these zones, in addition to the South American mainland. Hofman et al.'s (2007) study of material distribution patterns in the Lesser Antilles further suggests that these exchange networks involved shifting multiple levels of continental, regional, and island centers of social, economic, political, and religious influence.

Table 11.6 presents the proposed spatial-temporal framework. The ar-

Table 11.6. Chronological Periods, Ceramic Series, and Petroglyph Traditions for the Windward Islands

Time Period	Ceramic Series Dates	Selected Sites	Petroglyph Tradition Dates	Selected Sites
Late Ceramic	Cayo Complex, A.D. 1250–1600	Argyle Beach, Fanny	Tradition D, late, A.D. 985–1400	Indian Bay, Yambou Vale, Layou, Duquesne Bay, River Sally, Waltham–River Sally, South of Victoria
Late Ceramic	Suazoid Series/Suazan Troumassoid Subseries, A.D. 1000–1250	Macabou, Anse Trabaud, Paquemar, Indian Bay, Layou, Mount Wynne, Buccament, Savanne Suazey, Sauteurs, Duquesne	Tradition C, variation and elaboration, A.D. 400–500	Mount Rich, Galion, Foret Montravail, Stonefield
Late Ceramic	Troumassoid Series Troumassan Troumassoid Subseries, A.D. 550–1000	Diamant, Troumassée, Grand Anse, Point Canelles, Point de Caille, Arnos Vale	↕	
Early Ceramic	Cedrosan Saladoid with Barrancoid influences, A.D. 300–550		Tradition B, elaborated and enclosed, A.D. 500	Estate, Jalousie, Dauphin, Barrouallie, Petit Bordel
Early Ceramic	Early Cedrosan Saladoid, 400 B.C.–A.D. 300	La Sale, Vivé Fond Brulé, Point Canelles, Point de Caille, Post Office, Buccament, Pearls	Tradition A, simple and geometrical, A.D. 200–300	Buccament Bay, Mount Wynne, Peter's Hope, Sharpes Stream, Colonarie, Balembouche 1 & 2, Choiseul, Anse Ger

chaeologically defined broad periods within the Early and Late Ceramic are paired with their corresponding ceramic series and representative sites that are linked to the four petroglyph traditions and selected rock art locations. Additional research linking site excavations and specialized investigations (faunal, radiocarbon, and ceramic) with the rock art image and location data is needed to refine and test this model.

12

Prehistoric Rock Paintings of Bonaire, Netherlands Antilles

Jay B. Haviser

Prehistoric Rock Art Research

Dominee G. Bosch, as part of his notes concerning a visit to the island in 1836, was the first to mention Bonairean rock paintings (Bosch 1836:219). Father Antonius J. van Koolwijk's 1875 sketches of the Onima pictographs constitute the earliest documentation of Bonairean prehistoric rock paintings. Shortly thereafter, Karl Martin (1888:134) noted that Bonaire possessed two pictograph sites, one at Onima and the other at what is today known as Playa Druifi. He further noted a similarity between these drawings and those he had seen in Guyana and the Orinoco region. In 1907, Paul A. Euwens published the 1875 drawings by Koolwijk and referred to these drawings as "hieroglyphic writings" (Euwens 1907:194). In 1916, H. ten Kate also believed he detected actual letters in the Bonaire drawings, from sketches, not actual observations, yet he attributed the drawings to Arawakan (prehistoric Caribbean) people (Kate 1916:544).

Almost 30 years later, in 1941 and 1943, Father O. Paul Brenneker wrote two short articles about the rock drawings of Bonaire. In his 1941 report Brenneker identified seven pictograph sites on the island, at Spelonk, Grita Cabaai, Kasimati (Kaomati), and four locations at Ceroe Pungi/Ceroe Plat, or the Onima/Fontein area. In 1943, he published sketches of the drawings at the additional site of Pos Calbas. In partial response to Brenneker's work, Willem van de Poll (1950:169) wrote a newspaper article about the Spelonk site, in addition to compiling a photographic report in *Nos Tera* (van de Poll 1952:93). Karl Maier, R. Lemminga, Arnoldo Broeders, and P. Wagenaar Hummelinck (see Hummelinck 1972:1) photographed additional painted images in the 1940s, 1950s, and 1960s. In 1953, Hummelinck began what would become a comprehensive and professional four-volume series concerning the rock drawings of Aruba, Curaçao, and Bonaire. In Volume 1, Hummelinck (1953) mentions the background of previous investigations

and provides certain information about the Fontein and Pos Calbas sites on Bonaire.

Hans Feriz's (1959) inventory of the Onima and Spelonk pictographs includes a comment that the drawings were similar to Mayan glyphs. Ten years later, Charles Lacombe stated in a newspaper interview with Richard Pothier (1970) that he had identified two or three Mayan hieroglyphics from Onima, yet Lacombe never published any scientific report to back his claim. Investigating the Lacombe statement, Hummelinck contacted Alan Craig, who was also mentioned in the newspaper article. Craig reported to Hummelinck that he was unconvinced the markings were Mayan glyphs (Hummelinck 1972:11), an opinion shared by Hummelinck and me.

Hummelinck's Volume 1 (1953) of the aforementioned rock art series listed only seven pictograph sites for Bonaire. Volumes 2 and 3 (Hummelinck 1957, 1961) contained no mention of Bonairean locations, while Volume 4, published in 1972, included 14 rock painting sites for Bonaire.

Other brief mentions of Bonairean pictograph sites are found in Hartog (1978:10–11), Nooyen (1979:22, 1985:10–11), and Hummelinck (1979). In 1992, Hummelinck recompiled his 1972 inventory into one of the most thorough studies thus far of rock art sites for the island. Dubelaar referred to the Hummelinck listings in his 1995 compendium of Lesser Antillean rock art sites (Dubelaar 1995).

During my own field survey of Bonaire in 1987 (Haviser 1991), combined with subsequent reassessments (Haviser 2007), all of Hummelinck's (1992) pictograph sites, except for Kaomati (B1) and Santa Barbara (B13), were re-identified. One possible new site was identified at Barcadera (B-78). No carved images or petroglyph sites have been confirmed for Bonaire (Haviser 1991; Hummelinck 1972, 1992).

Prehistoric Origins of Rock Art

Archaic Age people settled on Bonaire around 1300 B.C. (Haviser 2001), followed by ceramic-producing groups ca. A.D. 500. Both groups derived from a movement out of the Orinoco River basin into northwestern Venezuela and the various coastal Caribbean islands, though much later than in the areas to the east (see Hayward, Atkinson, and Cinquino, Introduction, this volume).

Within Venezuela, all of the known prehistoric rock painting sites have a very specific and limited areal distribution. Pictograph locations are found (1) downstream along the Orinoco River and along the Apure, Guanare, and Portugesa rivers that branch into northwestern Venezuela; (2) downstream of the Tocuyo, Aroa, and Yaracuy rivers that drain into the Caribbean Sea; and (3) downstream from the Carache River to Lake Maracibo. Migrating people clearly carried their rock painting traditions as part of their cultural

heritage from Amazonia into the Caribbean and specifically to Bonaire as evidenced by the close correspondences between these two traditions.

Pictograph sites have not been documented from eastern Venezuela, the eastern Venezuelan coastal islands, and the modern Guyana region countries of Suriname or French Guyana (Dubelaar 1986b:198). Hundreds of rock painting sites, however, are known from adjacent Brazil (Guidon 1975:57; Schobinger 1976); these include positive handprint motifs.

Pigment sources used in prehistoric rock drawings have been identified from work in Venezuela and Curaçao. Red paints, common on Bonaire, were derived from mineral and vegetable materials, or both. Minerals used in Venezuela comprise red ochre and iron oxide (Valencia and Sujo Volsky 1987:130). Vegetable sources include *rarana* (tree resin) and *Bixa orellana* (red onote seed), as noted by Cruxent (1955:5–6) at Río Cunucunuma, and *Arrabidea chica* (chica) and *Bursera simaruba* (caraña), according to Valencia and Sujo Volsky (1987:130). On the neighboring island of Curaçao, excavations at the Savonet pictograph site produced ground red hematite and tree resin droplets directly beneath the rock art (Haviser 1995). Most of the sites in Venezuela exhibit only red paint alongside shades of red, white, and black. The black paint is derived from carbon (Valencia and Sujo Volsky 1987:133).

Pictograph Site Characteristics

All pictograph sites on Bonaire possess certain general characteristics. The most salient attribute concerns their location—every one is associated with Middle Terrace limestone caves and rockshelters. According to the 1975 edition of the Munsell soil color chart, prehistoric rock paintings on Bonaire were executed employing three basic colors: reds (in the range of 7.5YR 4/6–3/6), browns (in the range of 2.5YR 3/2–5YR 2/4), and black (2.5YR 2/0).

At certain sites, modern "fake prehistoric paintings" were observed produced with a brown (10YR 4/4) latex paint. Additional fake prehistoric pictographs were detected at the Spelonk site. Here, with the aid of texts dating to 1927, several red-colored designs previously thought to be prehistoric were determined to be historic. These conditions prompted an examination of the problem or issue of distinguishing authentic prehistoric rock paintings from later replications. Initial results of this effort are presented below.

Rock Painting Site Descriptions

Two parallel systems of rock art site identification are in use on Bonaire. The first represents names or numbers that were originally given to sites by investigators, for instance, Grita Cabaai or B12. The second corresponds to an official two-part government code for all types of prehistoric sites on Bonaire,

as in the site number for Grita Cabaai, B–52, in which *B* indicates the island, Bonaire, and *52* indicates the sequentially assigned site number.

Grita Cabaai (B-52)

Brenneker first noted the Grita Cabaai site in 1941, which Hummelinck subsequently recorded as B12. The drawings are positioned 4 to 5 m above the present ground surface and from 1 to 2 m in from the edge of a rockshelter, on the interior wall to the west side of the nearby hill Grita Cabaai.

Each of the approximately 15 pictographs represents a handprint, for which fingers were used to apply the paint. Most are drawn as full adult- or child-sized positive handprints. All are red-colored, but dots and lines of the brown "fake painting" latex are also present.

Ceru Cachu Baca (B-45)

Brenneker (1941) refers to the Ceru Cachu Baca site as Ceru Pungi; Hummelinck does not include it in his 1972 listing. Ceru Cachu Baca is situated on a limestone hill in the plain between Fontein and the road to Rincon. The pictographs lie 3 to 4 m above the present ground surface at the east end of this hill where two large rockshelters are found. Red smudges, lines, and amorphous smears account for the majority of the assemblage.

Pos Calbas (B-3)

Brenneker in 1943 was the first to illustrate the images from the Pos Calbas site, which Hummelinck later identified as B7. The drawings are located in a low cave with a large natural freshwater reservoir. The ceiling is only 1 to 2 m above the present ground surface. Approximately 15 red designs have been identified, primarily comprising parallel lines, crosses, dot-in-circles, and circles with radii motifs.

Playa Druifi (B-71)

Playa Druifi was first noted by Martin in 1888 and was identified by Hummelinck as Wecua B14. The pictographs range from 2 to 3 m above the surface of a rockshelter to the northwest of Playa Druifi. About 10 faded images are still visible, drawn in red and brown colors. The most common motifs consist of parallel lines, dots, straight lines, and smudges.

Onima (B-49/B-50)

Two closely associated sites correspond to those first noted by Koolwijk and classified as three locations by Hummelinck (1972:12–14): B2 equals B-50, while B3 and B4 make up B-49. The most impressive of these three locations is B3 (B-49), the upper Onima drawings (Figure 12.1). B4 is at a different nearby location in Inoma.

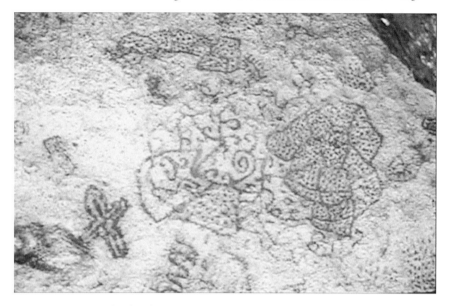

Figure 12.1. Upper-level prehistoric red monochrome pictographs from the Onima site, Bonaire (photograph by Haviser, 1987).

At least 45 individual pictographs have been identified on the upper rock surfaces of the Onima site. Fibrous materials were primarily used to complete the red images; occasional images were fashioned in brown. Motifs include outlined crosses, concentric circles, dot-in-circles, "nested" curved lines, curved and straight lines, dots, and positive handprints. The drawings are located 3 m in from the rockshelter overhang edge, at 4 to 5 m above the present ground surface.

The other principal site at Onima, B-50, Hummelinck's B2, is found in another rockshelter about 25 m northwest of B-49. These pictographs are situated 2 to 3 m above the ground surface and about 1 m in from the rockshelter edge. Use of both fibers and fingers to apply the red, brown, and black paint is evident. Infrequent examples of "fake" latex painted designs are also present where modern black lines overlie the older red and brown paints. Approximately 30 drawings have been identified, whose primary designs comprise circles with radii, concentric circles, dot-in-circles, and curved or straight lines. In several cases, the circles with radii are situated such that the circle occupies a natural hole in the limestone rock, with outward-radiating lines.

Fontein (B-43)

Euwens identified the Fontein site in 1907. It was not noted by Brenneker in 1941 but was classified by Hummelinck in 1953 as site B5. Fontein represents pictographs found on the south and east faces of a large boulder, locally called

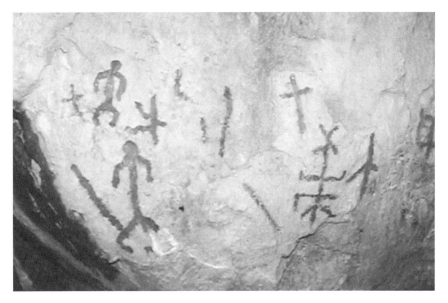

Figure 12.2. Prehistoric and modern overlay pictographs at the Fontein site, Bonaire (photograph by Haviser, 1987).

Piedra di Compafuru. The boulder lies at the southern edge of the Fontein Plantation in an open field about 2 m from rock cliff areas without protection from the natural elements. The images also lie about 200 m west of the largest freshwater spring on Bonaire.

All of the boulder's approximately 30 pictographs are prehistoric, save four modern brown latex painted images (Figure 12.2). Additionally, at least five examples possess brown latex carefully applied over the original red lines. A comparison of Hummelinck's 1953 illustrations (Hummelinck 1953:Figure 33) with the present latex images shows that some of the original motifs, including two anthropomorphic figures, have been painted over, as well as modified with the latex material. Furthermore, many of the present latex paint motifs seem to be of modern fantasy pseudo-letters, with no prehistoric stylistic similarities. It is rather curious to note that during my 1987 survey (Haviser 1991), a sign indicating the direction to the "Indian Inscriptions" was painted with the same brown latex paint!

Roshikiri (B-36/B-37)

The two Roshikiri sites are located 800 to 1,200 m west of the large Spelonk cave and are listed by Hummelinck as B10 and B11. The drawings are all red colored, with predominantly fiber-applied paint forming curved lines, outlined crosses, snake patterns, and dot-in-circles, in addition to numerous full, positive handprints of both adults and children. Several of these handprints

show fibrous striations across the palm of the hands, suggesting either something was in the hands with the paint or the paint was scraped off the palms in irregular striped patterns. The pictographs occupy the rockshelter's ceiling, 1 to 3 m above the present ground surface. Rainwater collection is a well-documented phenomenon at these rockshelters.

Spelonk (B-34/B-35)

The Spelonk caves once possessed the most extensive collection of rock paintings on Bonaire. Designated by Hummelinck as B6, B8, and B9 (he separated one cave into two sites), the site comprises three large adjacent cave systems. It is a tragedy that these significant pictograph assemblages have been almost completely destroyed by modern graffiti and abuse. The illustrations by Hummelinck in 1972, and the few extant prehistoric drawings (Figure 12.3), illustrate images composed with red, brown, and black colors. As at Onima (B-50), modern black and brown paints overlie the prehistoric red paints. A few examples of the brown latex paint were also noted. Brenneker reported a minimum of 305 prehistoric images for these caves in 1941, while Hummelinck mentioned only 95 drawings in 1972. I concluded from my 1987 survey (Haviser 1991) that this number had fallen to around 50 undisturbed drawings. A more recent inspection reduces that number even further to around 20 in all. The pictographs are positioned within 6 to 8 m of the cave entrances and from about 1.5 to 2.5 m above the ground surface.

Primary motifs at the Spelonk caves comprise dot-in-circles, curved or straight lines, outlined crosses, snake patterns, zoomorphs, anthropomorphs, circles with radii, concentric circles, handprints, "nested" curved lines, and dots. During my 1987 study (Haviser 1991), the field crew observed that rainwater would collect in the caves and remain for several days to weeks due to much cooler temperatures within the caves.

Barcadera (B-78)

Barcadera possesses a rather complicated history, with the probability that more than one pictograph location is present. In 1972, Hummelinck identified paintings at the Barcadera seashore and designated them as the Santa Barbara site (B13). Based on my inspection of this location in 1987 (Haviser 1991) and that of Dubelaar in 1995, we question whether these images are actually pictographs. They more likely represent natural discolorations in the rock.

Brenneker in 1946 mentioned drawings at Barcadera, and in 1972 Father M. Arnoldo Broeders noted images in a karst cavern approximately 25 m inland from the sea (Hummelinck 1972:17). During the 1987 survey (Haviser 1991), I was shown a karst cavern by Mr. Ruzo, around 75 m inland from the sea and some 200 m northwest of the large Barcadera Cave. At least six

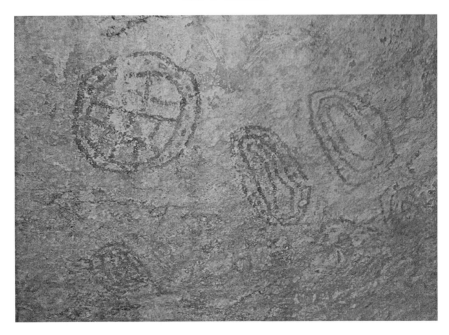

Figure 12.3. Original prehistoric pictographs at the Spelonk site, Bonaire (photograph by Haviser, 1987).

drawings were identified and given the site designation of Barcadera (B-78). The pictographs were red colored and consisted of smudges, crosses, and lines painted by fingers. The images have been executed on the south wall 1.5 to 2 m above the surface of a large permanent freshwater pool.

To further complicate site identification, another large cave with stone steps and a cistern, also called Barcadera, was mapped by Hummelinck with the help of Frans Booi and van der Brand in 1972, but no drawings were reported at that time (Hummelinck 1979:146). Yet in a 1981 listing of rock drawing sites at the Bonaire Department of Culture, the Barcadera Cave is identified as a noteworthy rock painting site that was newly renamed "Urudyan Blancu," based on the mythologies of Frans Booi. When I visited this cave location in 1987, all the Urudyan Blancu images were drawn with the "fake prehistoric" latex paint, with no evidence of authentic prehistoric figures (see Haviser 1991; Hummelinck 1992).

Regional Associations of Style and Distribution

It is important to differentiate between pictographs and petroglyphs when addressing rock art in the Netherlands Antilles. Many authors discuss or group

together these two types of rock images because of similar motifs (Boman 1908; Rouse 1949). Certain authors also argue that carved images preceded painted designs (Prous 1977:54; Thurn 1883:409), while others contend the reverse (Guidon 1975:396; Klein 1972:18; Mentz Ribiero 1978:8). I am in agreement with Dubelaar (1986a:3), who is of the opinion that at least some overlap in production of the two forms might have occurred. It should be remembered that Bonaire possesses no petroglyphs, thus reinforcing the reconstructed cultural link between this island and the ancestral Venezuelan homeland area that also lacks carved images.

When compared with the Lesser Antilles and Central and South America, Bonairean rock image designs and techniques clearly demonstrate a closer affinity to South America than the other two areas. A specific association with the Venezuelan states of Falcon, Bolivar, and Amazonas, as well as the middle to upper Orinoco basin and into Amazonia, has already been postulated.

An examination of various motifs of Bonairean pictographs in light of the regional distribution of their petroglyph counterparts suggests additional associations within the area. Dubelaar's (1986a:Figures 12–16) plotted locations of petroglyph designs termed *pilot motifs* (certain motifs selected to define a South American classification scheme) across South America and the West Indies include those for three motifs that are common to Bonaire: the outlined cross, concentric circle, and "nested" curved lines. The feline motif, although not reproduced as rock images on Bonaire, should nonetheless be considered a shared regional design. The image is highly concentrated in the northern Venezuela/Orinoco area and also appears on a carved jaguar pendant and a carved ocelot bone talisman on Bonaire. Additional carved pendants found on the island, most commonly of frogs, may also relate to the iconography and production of rock art. The majority of South American frog motifs occur as pictographs, not as petroglyphs. Carved frog motifs occur at only 12 locations, and of these sites all save one are found north of the Amazon (Dubelaar 1986a:111).

Both Dubelaar and I would further point out that the outlined cross and concentric circle motifs are widespread within South America and the West Indies, showing little regional variation. Circumscription, on the other hand, marks the "nested" curved lines motif that is limited to northern South America, predominantly in Amazonia, the Orinoco basin, and northern Venezuela.

Dubelaar (1986a:133) even stated that "the petroglyphs of the Northern coastal mountain range of Venezuela, though geographically disconnected from the Amazon Basin, have more pilot motifs in common with Amazonia than those adjoining the Orinoco Basin." This evidence, combined with the limited areal distribution of pictograph sites previously discussed for

Venezuela, strengthens the premise of prehistoric Bonairean origins from Amazonia.

In regards to the meaning of the area's rock images, two native names have survived that refer to prehistoric rock paintings in Venezuela: "Tepumereme" (*tepu* = stone, *mereme* = painted) from the Middle Orinoco region, and "Ippaianata" (*ippa* = stone, *ianata* = writing) from Baniva in the Upper Orinoco (Valencia and Sujo Volsky 1987:35). The distinction between writing and simply painting may be an example of the variety of uses rock painting possessed in prehistoric society.

The association of rock art at certain limited sites has led some investigators to suggest that rock art locations functioned as boundary markers of either social or political territories (Tormo 1951:559; Valencia and Sujo Volsky 1987:93). Others have suggested that rock art sites represented religious symbols and centers (Frikel 1969:116; Nooyen 1985:11; Núñez Jiménez 1975:237), with authors such as Straka (1964:266) and Branner (1884:1191) suggesting a specific worship relationship with freshwater at rock art sites. Still other theories relate rock art sites with astronomic calculations (Vignati 1967). Dubelaar (1986a:82) offers the most appropriate approach to interpreting rock images when he states, "Petroglyphs probably are predominantly meaningful figures, but do not contain an explicit message." Dubelaar is implying that an accurate or specific interpretation could most likely be made only by the image-maker and secondarily by fellow individuals in the creator's cognitive world who would understand the symbolic representations.

Investigative Status of Prehistoric Rock Images

The rock paintings of Bonaire represent a form of cultural expression having its most ancient roots in Amazonia—traditions that were carried down the Orinoco and Apure rivers to northwestern Venezuela and then on to Bonaire. The distribution of rock painting sites and specific motifs tend to confirm this migration pattern.

A localized distribution of rock painting sites on Bonaire is indicated, in which the heaviest concentration of sites occurs in the area of Onima and Fontein, as well as farther east on the north coast at Roshikiri and Spelonk. I add for future research that the largest permanent freshwater spring on Bonaire is at Fontein and that of the 13 rock painting sites, six (or 46 percent) were associated with standing water catchments. This relationship of rock art site to water finds a parallel with the Hato site on Curaçao, which lies near the largest freshwater spring on that island (Haviser 1987). The distribution of pictograph sites on Bonaire also demonstrates that these sites were not situ-

ated near major villages, suggesting a purpose or function that required distance from places of residence.

The modern use of rock art sites by the ethnographic cognate Guarekena people of Amazonia, Venezuela, suggests a possible function for the prehistoric Bonairean examples. The Guarekena use these locations for male initiation ceremonies, at which females are not allowed (Valencia and Sujo Volsky 1987:76–77). Carrying the analogy forward, the presence of adult and child handprints on Bonaire could be related to young males in the initiation rites; the distance from the villages could relate to a separation from the females; and the presence of water could relate to some specific requirement of the initiation ceremony (perhaps hygienic, for cleaning of wounds).

Dating of Bonairean pictographs is lacking due to the very small amount of organic material used in the paint and limited associations with recovered artifacts. Chronological indicators from Venezuelan coastal rock art sites point to island production during the Ceramic Period, while those from Aruba and Curaçao suggest the possibility of a Late Archaic beginning. Excavations at Cueva de los Petroglifos, Falcon, Venezuela (an adjacent mainland region; Perera 1970:57–58), yielded ceramic artifacts in situ with other materials. Studies by J. E. Vaz (1977) of the degree of patination of limestone rocks with petroglyphs at Chipaque, also in Falcon, produced a well-founded date of post–A.D. 1000 for the rock images.

A series of radiocarbon-dated sites with and without associated rock art indicate a Curaçao-Bonaire-Aruba sequential occupation from the Venezuelan coast around 2500 B.C. On Curaçao several rock art sites occur near Archaic settlements radiocarbon dated to 2540–2515 B.C. Additionally, materials from the Savonet rock art site were radiocarbon dated to 1405 B.C. The site is multicomponent, with the rock art more likely associated with the Archaic rather than Ceramic Period occupational phase (Haviser 1995, 2001). On Aruba, a Late Archaic to Early Ceramic transitional date of A.D. 1000 was obtained from a paint sample at one site (see Kelly, Chapter 13, this volume). While at least a certain percentage of Archaic pictographs appear to have been executed on Curaçao and Aruba, most or many of the images were produced during the Ceramic Period, a situation likely to have occurred on Bonaire as well.

Repeated prehistoric episodes of rock painting are evident at the Onima and Spelonk sites, where black paint overlies red paint. Black over red painting, in a prehistoric context, has also been noted in Venezuela (Valencia and Sujo Volsky 1987:133), while the same and reverse application of colors is found at the Cuban site of Punta del Este, Isla de la Juventud (Núñez Jiménez 1991:932). This overlay of colors could relate to the arrival on Bonaire of new stylistic influences at different periods in prehistory.

Authentic vs. Replicated Rock Images

Destruction and abuse of prehistoric pictographs on Bonaire began in the historic period and continues today. Vandalism, painting over past images, and adding new ones have all taken their toll. The latter class includes postcontact, intentionally reproduced prehistoric designs that not only impact the context of the rock designs but also on Bonaire have led to various misrepresentations and misinterpretations of the archaeological record.

As part of my interest in addressing the problem of distinguishing authentic from replicated rock art, I undertook a separate study of examples from several cave sites on the island that employed a combination of techniques including precise color comparisons, material texture analysis, and stylization (Haviser 2007). A planned mass density analysis on the paint sample could not be completed, rendering preliminary the results of this investigation based on the other techniques.

Nonetheless, various instances of later overlain and new designs were identified on the basis of differences in color, texture, and design. The most obvious and extreme examples comprised images outlined with latex paint, particularly at Barcadera and Fontein. The Spelonk site eventually became the primary focus for the study, when a painting in red pigment displaying a date of "1927" was noted as having very similar red color and texture to several of the believed authentic paintings (Figure 12.4a).

Using the "1927" painting as the indicator for later replications and a "shark" image as the indicator for the original prehistoric pictographs, I established that the replication paints were consistently in the darker ranges of the Munsell (7.5R) red colors, with an obvious appearance of more density to the paint material (thus the planned mass density analysis), while the originals were in the lighter red (7.5R) range and far more thinly layered on the limestone rock. The replication samples tended to peel at the edges, due to their greater thickness, while the originals tapered in thickness at the edges of the paint.

Criteria to separate authentic from replicated designs were clearly present at the Fontein and Barcadera sites. Certain designs possessed an obvious similarity to elements of a local oral tradition developed by a resident culture expert in the 1970s to 1980s. The myth is frequently illustrated in the artwork of a local artist, using many of the same symbols. Both publications about and artwork related to this oral tradition are currently for sale by the local expert and artist on Bonaire. The Spelonk replications are more difficult to distinguish from the originals, since a serious attempt was made to make the new designs as faithful as possible to the prehistoric ones, often recreating the new motif adjacent to the old one.

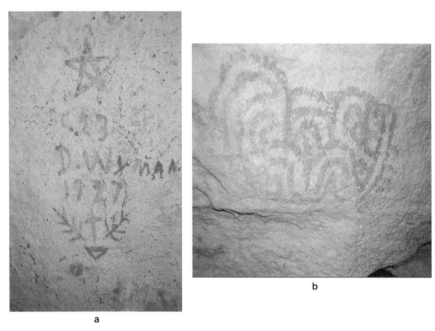

Figure 12.4. Modern 1927 design (a) and reputed Mayan glyph representation (b) at Spelonk Cave, Bonaire (photograph by Haviser, 1987).

A separate and unique example at Spelonk concerns the "Mayan" motif (Figure 12.4b), which conforms to the replication baseline colors and density and may suggest an intention to create evidence for a Mayan presence on Bonaire. The art deco popularity of Mayan styles in the 1920s and 1930s may have been a stimulus for this replication, which did indeed get media attention about Mayans on the island in the 1960s.

Accessibility is clearly a key factor in the opportunity for prehistoric rock art destruction, as evidenced at the popular visiting areas of Fontein and Barcadera that allow for a maximum of public exposure and potential for graffiti and rock image replications. The Spelonk Cave, easily accessible by automobile as far as the front of the cave, contains a significant amount of graffiti, dating back to the nineteenth century, in addition to modern random spray painting. In the past (as noted via the written dates), graffito artists avoided the original rock figures. However, since the 1980s, and primarily since the 1990s, graffiti now tend to be painted directly on top of the prehistoric images. The Onima site constitutes the prime example of this recent trend where the more accessible lower drawings (1 to 2 m above the ground) were impacted by graffiti, while the upper drawings (4 to 5 m above the ground) (see Figure 12.1) were not. A counter case concerns the Roshikiri site, also

easily accessible, which has not had its original pictographs impacted by graffiti. This may relate to the fact that fewer people in the general population seem to know of this site.

Perhaps the more significant and disturbing issue involves the motivations to create rock image fakes. Most prehistoric rock painting sites of the Caribbean and northern South America have suffered some form of destruction through vandalism. Frequently, this defacement results from human cravings to "leave a mark" and write one's name at an unusual place, which then causes damage to the original designs and context.

The intentional creation of "fake paintings" and rock image replications raises the level of destructiveness by directly affecting the scientific value and interpretation of prehistoric rock art sites. These falsifications involve an explicit manipulation of historical evidence, such that archaeologists must consider this possibility for future investigations. Individuals with specific agendas may undertake manipulation of data for their amusement or economic benefit, thus altering archaeological evidence to conform to their goals. Whether this takes the form of trying to create a link with Mayan ancestors or the marketing of newly created local mythologies, it is still a fabrication of cultural heritage and must be publicly condemned by the professional community. An archaeologist's responsibility includes attempts to identify fakes when possible and then to notify the proper authorities to protect rock art sites from further criminal acts of manipulation and destruction.

13

Rock Art of Aruba

Harold J. Kelly

Introduction

The island of Aruba lies approximately 30 km north of Venezuela's Para-
guanà peninsula (see Figure 1.1, this volume) and measures roughly 10 km
wide by 31 km long (Dijkhoff and Linville 2004). Aruba possesses a high
site density suggesting that Preceramic groups beginning around 2500 B.C.–
A.D. 1000 and later Ceramic Age peoples, post–A.D. 1000, had successfully
adapted to this island setting (see Figure 1.3, this volume). Rock art sites are
also numerous and represent one of the few aspects of Amerindian heritage
still in their primary context. The images are therefore of great value for un-
derstanding the ways in which these people interacted with and modified
their environment.

The rock paintings involved past populations who made and used them
for ceremonial and religious purposes. They also for centuries have fascinated
observers, enthusiasts, and, in past decades, professional archaeologists who
have come to the island. Pictographs represent the first aspect of Aruban ar-
chaeology that was documented. As early as 1827, R. F. van Raders (cited in
Coomans 1997:102–104) reported on and illustrated the Fontein cave rock
paintings. Additionally in the early 1800s, Father P. A. Euwens (cited in Har-
tog 1980) mentioned the presence of 30 pictographic locations but without
providing further information.

Later, in the 1880s, Father A. J. van Koolwijk (1885) initiated the first ar-
chaeological investigations on the island wherein 27 rock art sites were iden-
tified. The rock art expert Wagenaar Hummelinck (1953, 1992) during the
1950s studied and documented the rock painting sites identified by Koolwijk
in the 1880s (cited in Hartog 1980:25).

The current rock art tally of Aruba consists of 300 to 350 individual rep-
resentations at 22 sites. This revised number from the older previous sur-
veys just mentioned reflects the ongoing effort to revisit or locate rock art

sites, with the expectation that all formerly reported and any new sites will be added to the list.

All of the individual figures are pictographs save for two petroglyphs. Monochrome and polychrome pictographs are located in areas that appear to have been chosen for particular reasons and are, or can be, associated with nearby habitation sites.

The two known petroglyphs may not be pre-Hispanic. Their very low number compared to the large body of pictographs; shallow depth of a couple of millimeters; dissimilar motifs and differential deterioration rates compared to pictographs in the same area (worse than the pictographs) suggest they were executed by historic or modern peoples. One of the petroglyphs consists of a circular motif similar to pictograph designs, yet the other comprises a rectangle that lacks pictographic analogues. Normally the older the rock art the higher the degree of deterioration. In this case the more weathered petroglyphs are found on the same boulder formation as the less affected pictographs that form part of the rock art assemblage dated around A.D. 1000 (see below). The differential weathering rates certainly point to distinct execution times. Since the pictographs were produced at the end of the Preceramic and beginning of the Ceramic Period, the deterioration rates along with the other information further point to later rather than earlier execution for the petroglyphs.

Distribution of the Rock Painting Sites

While more than 300 pictographs have been recorded at 22 locations, the total number is estimated to be higher as research efforts further refine our perception of the database. Rock paintings are confined to two separate areas: the interior and the northeastern coast of the island. Most of the pictographs in the interior are located on dolerite boulder formations, most frequently in the cavities protected from direct sunlight. The cave site of Canashito constitutes the only exception. Painted images from the northeastern coast are located on the walls and ceilings of limestone caves in the entrances, in halls inside the caves, or in small chambers that lie deeper within the caves.

Past image-makers employed red, white, and brown pigments to execute the figures. Research carried out by Versteeg on the red and white pigments categorized the red component as an organic iron oxide and the white component as chalk (Versteeg and Ruiz 1995). Even though no research has been done involving the brown hue, it too very likely contains iron oxide.

A paint sample, employing the AMS method (accelerated mass spectrometry), yielded a date of A.D. 1000, indicating that image production began around the transitional period between the Preceramic, 2500 B.C.–A.D. 1000,

and the Ceramic Period, A.D. 1000–1515 (Versteeg and Ruiz 1995). Aruba's rock art has been considered either a development that started at the end of the Preceramic Period or one that is associated with the arrival of Ceramic Age populations. Alternatively, the rock art tradition could reflect the incorporation of a preceramic tradition and subsequent modification by later inmigrating ceramic-producing groups.

Another factor bearing on the island's rock art temporal development concerns documented site distributional patterns. Most of the pictograph sites are located in the immediate vicinity of other archaeological sites or form part of other locations.

Five of the 22 rock painting sites occur in the northeastern-coast limestone caves and three of these are in direct association with a considerable habitation or prolonged-use Ceramic Period site. Smaller sites, interpreted as temporary similar-period encampments, are present near two other pictograph cave sites and presumably were used by the inhabitants of these settlements for ceremonial and ritual activities. Sixteen of the inland pictograph rock dolerite boulder or formation sites lie in close physical association with Ceramic Period sites ranging from temporary encampments to large habitation sites. The remaining inland pictograph cave site, Canashito, lies near a Ceramic as well as a Preceramic site.

Characteristics of Aruban Pictographs

Aruban rock paintings include anthropomorphic, zoomorphic, and geometric motifs. The latter class of images predominates and can be found on dolerite formations, as well as in limestone caves. It is also the only category that contains examples in all three colors.

Geometric motifs vary from simple to complex and are executed as isolated figures, in groups, or as part of larger compositions. These multidesign compositions are larger than either single or group images and only occur on the dolerite rock formations. The Ayo site, for instance, spans several meters where various intertwined motifs have been painted in white and red in the convex cavities of the formation.

Simple geometric motifs consist mostly of straight or curved lines that do not form any distinguishable patterns, at least to the modern observer. Complex designs range from spherical to hexagonal as separate designs or connected to one another by straight lines. Additional complex geometric motifs that do not fall into the aforementioned categories are present and are primarily found as isolated figures or as part of larger groupings with other motifs. While geometric images were produced using all three colors, red was the exclusive color employed in cave settings.

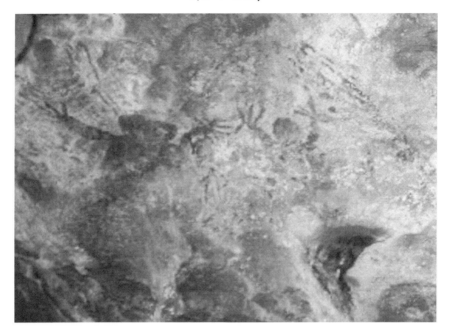

Figure 13.1. Anthropomorphic figures in the Quadirikiri pictograph cave, Aruba (Archaeological Museum of Aruba, photograph by Angela, 2005; used with permission).

Anthropomorphic motifs also occur on dolerite rock formations and to a lesser extent in caves. Cave-setting images comprise humanlike facial designs, hand shapes, and more detailed facial and body motifs. The more elaborate figures are exclusive to two locations: the northeastern-coast Quadirikiri and the inland Canashito sites. Quadirikiri possesses the highest number of anthropomorphic motifs among cave sites, which include facial designs with eyes depicted, handprints, and humanlike forms executed singly or in pairs. A dynamic aspect is immediately evident in these figures, indicated by such design elements as outstretched, over-the-head arms, as seen in Figure 13.1. To the list of pictograph cave sites can be added the coastal site of Fontein that, while it does not contain full anthropomorphic figures, does contain hand shapes.

The most developed and complex anthropomorphic motifs occur at the inland Cunucu Arikok dolerite formation, located in the Arikok National Park. This location has several formations that contain a wide range of motifs from simple humanlike figures to complex anthropomorphic compositions (Figure 13.2). The complex humanlike figures form stylized shapes, which I consider to represent individuals within Amerindian societies who were of great importance and had a direct relation to the purpose of the site

Figure 13.2. Anthropomorphic pictograph within the Arikok National Park, Aruba
(Archaeological Museum of Aruba, photograph by Angela, 2005; used with permission).

and activities carried out. The paintings represent active depictions of sha-
mans conducting rituals and ceremonies related to the acquisition of visions
and shamanistic voyages. The pictographs may even depict specific shamans.
Whether or not they stand in for particular shamans, the paintings provide
insights into the actions related to the ceremonies and rituals carried out by
these individuals.

Two anthropomorphic and associated geometric motifs at this site also
speak to the ritual and visual sense of past Aruban populations. A human
figure forms part of a composition together with a circular motif, as seen in
Figure 13.3. The grouping, I propose, represents a person walking on a field
with a tool on his shoulder after a day's work. In this interpretation, the mo-
tifs reflect cultivation activities and may have figured into actual rituals or
ceremonies related to fertility or an abundant harvest. This depiction should
therefore be viewed more as a "painting" than a pictograph since it depicts a
scene in a dynamic manner. Furthermore, the usage of two colors indicates
a deliberate attempt by the "painter" to express his vision/view to other
people. It has been argued that Amerindians did not produce "art" in the
Western sense of interactive, expressive, or message-making contexts. Yet this
polychrome composition demonstrates that it had a meaning not only as a ref-

Figure 13.3. Polychrome anthropomorphic (red pigment, darker shade) and geometric (white pigment, lighter shade) composite pictograph within the Arikok National Park, Aruba (Archaeological Museum of Aruba, photograph by Angela, 2005; used with permission).

erence to the working of land, cultivation, and the underlying ceremonial aspect but also as a means of individual expression as befits a "Western artist." The grouping further is made up of a unique polychrome arrangement of red and white colors that can be considered a concrete portrayal, as well as an expressive one, since both a message and its esthetic enhancement are evident. The second example consists of an anthropomorphic figure intertwined with geometric patterns that is also depicted in an active, engaging manner.

Zoomorphs make up the least numerous category of pictographs and are principally found on dolerite rock formations. In the cave sites of Fontein, Quadirikiri, and Canashito they do occur but to a lesser extent. Fontein pos-

Figure 13.4. Zoomorphic polychrome pictograph depicting a red-bodied bird (darker shade) with white feathers or rays (lighter shade) within the Arikok National Park, Aruba (Archaeological Museum of Aruba, photograph by Angela, 2005; used with permission).

sesses a single abstract zoomorphic figure, while Canashito has a few simply rendered terrestrial and marine animals. Quadirikiri exhibits several figures of simple, abstract, and more realistically rendered animals, including iguanas and turtles.

The dolorite rock formation zoomorphic assemblage, in contrast, contains more complicated, elaborate, and naturalistically illustrated terrestrial and marine animals in red or red and white. Identifiable terrestrial animals include reptiles and birds such as iguanas and the local species of warawara bird. Marine animals comprise sharks, fish, turtles, and a probable manatee. Cunucu Arikok again stands out as a notable location for its complex zoomorphic images, as it does for anthropomorphic ones. It is also unique for possessing anthropomorphic as well as zoomorphic motifs, with one such image reproduced in Figure 13.4.

Even though rock paintings in red, brown, and white can be found throughout the island, a distinct preference for the use of red in cave settings is apparent. All the depictions in both the northeastern-coast caves and the inland one of Canashito are either in red or in a shade of red with the exception

of one brown pictograph at Fontein. No white images are found in cave settings. This may have been due to factors such as contrast wherein the red color is more visible against the whitish background of the limestone caves. The contrasting red color would make it possible to readily distinguish the drawings and their characteristics on the cave walls and ceilings by means of natural light.

The pre-Hispanic cultures of Aruba displayed sensitivity to their tangible and intangible natural resources, as is evident in their rock paintings and specifically their pictograph cave sites. The suitability of caves as a medium for painting depends on a range of factors. Two of the most important ones in regards to Aruban caves concern a suitable surface on which to paint and the availability of a light source. The Amerindians chose surfaces that provided good contrast and durability for the motifs, in addition to locations that had natural lighting. They did not elect to use artificial lighting such as torches to execute rock art in darkened settings as other groups have done.

The cave settings, as noted before, are, with one inland exception, located on the northeastern coast. Here the landscape is composed of limestone terraces where several caves are found in proximity to one another. These caves occur in the lower and middle terrace walls (approximately 30 to 40 m above sea level) and vary in depth, size, and length. All of the selected caves have areas completely or partially lit by natural light and where paintings were done either on the walls and ceilings of the entrances or in halls and chambers (some lie deeper inside the cave). The rock art within caves varies in terms of its location; some images are painted at the entrances and others are located in various parts of cave interiors. This differential distribution may signal a functional relationship. Those images near the entrances possess a more informative character and may have been intended for general viewing, while cave interior images refer to specific meanings related to the "other/spirit world" and were meant to be seen by selected individuals.

The Fontein cave illustrates this sensitivity with its numerous (around 30) geometric, anthropomorphic, and zoomorphic motifs painted in red on various areas of the ceiling. The cave has a total length of 95 m yet the paintings occur in the first 35 m of the cave in the flat portions of the ceiling, which is illuminated by daylight. Deeper inside the cave are larger halls but there is no natural illumination and the ceiling and wall surfaces are irregular; no images are present. Wagenaar Hummelinck (1953:117) first noted this pattern of associations in the cave as part of his investigations in the 1950s. Hummelinck mentioned that Fontein had paintings situated on the flat roof of the cave as far as daylight penetrated.

Next to Fontein lie two caves named Quadirikiri. The larger cave has a

maximum length of 150 m and comprises a long corridor with two sizable chambers situated in the first 50 m and open surfaces that could have served for painting images. Even so, the larger cavern was not chosen for such a purpose. Likely mitigating factors include the depth of the cave in relation to available illumination and the presence of very irregular and dark-colored surfaces making the application and distinction of motifs difficult.

East of the large Quadirikiri Cave is the smaller one consisting of an entrance hall and two corridors to the north and south with a maximum depth of 30 m. Though less extensive, it nonetheless was chosen as the location for the production of a large number of pictographs. Red-colored geometric, anthropomorphic, and zoomorphic motifs are found in the entrance hall and both corridors. An interesting detail concerns the concentration of different anthropomorphic images from simple hands to more complex human-like figures and facial characteristics such as eyes.

All the paintings within the smaller Quadirikiri cave receive some direct sunlight and most do for the entire day. Certain pictographs are, in contrast, only illuminated during specific parts of the day. These paintings occur in a small chamber inside the south corridor that lies relatively close to the entrance of the cave and is more difficult to access. I suggest that this chamber was specifically selected due to these characteristics in order to paint particular geometric, anthropomorphic, and zoomorphic motifs. These images, applied to the walls and ceiling of the chamber, are furthermore only visible during the morning due to the positioning of the cave openings. The distinctiveness of the chamber together with the specific types of motifs, their location, and illumination during the morning clearly shows that this chamber and the paintings had a very special meaning. The creators wished the images to be seen during restricted parts of the day and likely by certain people during special ceremonies.

Regional Associations

The rock paintings of Aruba should not be seen as a local, isolated development. A clear association exists between this island's pictographic assemblages and those of mainland South America and the other two near-continental former Dutch colonial islands of Bonaire and Curaçao, as well as the remaining Antilles.

Pre-Hispanic Amerindians migrated from the Middle Orinoco region of Venezuela to the islands of Aruba, Bonaire, and Curaçao and throughout the Antilles bringing with them their continentally derived cultures, including a rock art tradition. As might be expected from their proximity to each other

and the mainland, the islands of Aruba, Bonaire, and Curaçao share similar geometric, zoomorphic, and anthropomorphic motifs. In particular, these islands possess analogous concentric circles, circle and bar, and cross designs.

Inter-Antillean similarities can be noted for Aruba, Bonaire, and the Dominican Republic where parallel bird forms can be found. Aruba and Curaçao share comparable anthropomorphic images together with the island of Cuba. Aruba also possesses zoomorphic motifs analogous to those in the Dominican Republic and Cuba, as well as the South American countries of Colombia, Chile, and Peru (Núñez Jiménez 1986).

The most striking parallel with other regions concerns the correspondence in polychrome paintings from Aruba and Venezuela. As far as it is known, only these two areas contain red and white polychrome paintings. Pictographs from other Caribbean regions were produced using these and additional colors, but not in this color combination.

The antecedent Venezuelan rock painting tradition is considerable and elaborate. Two aspects of the subsequent modification of this tradition as it spread with pre-Hispanic populations migrating from the Middle Orinoco region into the Caribbean island arc are worthy of note. These societies only made polychrome paintings in Aruba, and they only made them at the site of Cunucu Arikok—a cave setting that contains the most complex anthropomorphic pictographs on the island.

Legislation Protecting Rock Art Sites

Legal frameworks for the protection of Aruba's cultural heritage have developed in parallel with the rest of the Caribbean region's colonial past. Legislation from the Netherlands, adopted at the beginning of Dutch rule and continuing into the twentieth century, provided inadequate protection or no means to implement the laws. These ordinances were never adapted to the particular circumstances of Aruba and often resulted in negative impacts to the island's cultural resources.

The Monument Ordinance is one such example. Enacted in the 1920s, the statute is only now proving effective through the efforts of the local Aruban government. In the 1990s, the government instituted the Monument Council and Monument Fund, in addition to an Office of Monuments. The latter agency has documented all architectural monuments and focuses on their protection. In the absence of adequate legislation, the protection of Aruba's archaeological heritage, including rock art sites, has been for some time the main focus of the Archaeological Museum of Aruba (AMA). The AMA has concentrated on creating a "protection network" by allying government

with nongovernment agencies involved with land-use issues. This approach has been successful in the development of protective legislation and policy regulation at such sites as Ayo and Arikok. Currently the Arikok National Park's substantial number of pictographs is protected by national legislation. The Ayo pictograph location is covered under regulations established by the Department of Public Works and supported by the AMA.

The most recent significant development in the realization of conservation legislation occurred with the adoption of the Wet op de Ruimtelijke Ordenning (zoning legislation). A particular aim of the Ruimtelijke Ordenning is to ensure that in the future all construction or other land-use projects will have to take into account the natural and cultural value of the area. Despite this positive development the lack of adequate protective legislation remains a major handicap for conservation efforts.

Management and Protective Measures

The principal agencies involved in rock art site management are the Arikok National Park, the AMA, and the Department of Public Works. The Arikok National Park has its own park rangers who manage the sites, while the Department of Public Works and the Scientific Department of the Archaeological Museum supervise the Ayo location. Active surveillance of the Fontein and Arikok cave sites takes the form of park rangers posted on the sites seven days a week who also give guided tours to visitors. The Scientific Department has put in place site-control measures at Ayo.

Management plans have been developed by the above agencies for the conservation of rock painting sites. Arrangements at Ayo include regular visits by Department of Public Works personnel in charge of maintaining the protective fencing around the site, in addition to inspections by the AMA to determine the status of and any negative impacts to the rock art. The Arikok National Park pictographs are under permanent surveillance by the rangers and are also regularly inspected by the AMA. The surrounding community of the Ayo site protected the area long before a formal management plan was in place. The rock drawings in both the National Park and Ayo are popular tourist attractions and frequently visited by the local population. Ayo's location in an attractive natural landscape further draws people for recreational activities.

Additional protection measures include the use of iron bars in front of the Fontein, Cunucu Arikok, and Ayo sites; restricting access to the paintings unless under supervision by park rangers or agency personnel; nonpublication of site locations; and digital photographic documentation of the images during

site visits. These measures have significantly reduced damage, primarily in the form of vandalism, to the pictographs at the conserved sites. Much more needs to be done to develop and integrate legal, agency, and human frameworks for the protection of Aruba's rock images, as well as all forms of the island's past cultural resources.

Documentation and Research of Rock Painting Sites

Rock art comprises a unique medium through which past peoples expressed their perception of the world in different motifs and colors. Aruban rock art sites corresponded to sacred places for rituals and ceremonies, where the figures can be thought of as representing the materialized thoughts and ideas of the Amerindian inhabitants of the island. This kind of context provides critical insight into their religious, ritual, and shamanistic practices, as well as another dimension for enhanced understanding of the island's past cultural development.

In order to safeguard this valuable source of information it is imperative to protect and conserve the rock paintings in the best possible manner. In addition to the legal and practical conservation measures already taken and outlined above, continued research and documentation of the rock painting sites should be carried out.

Recent projects include Versteeg and Ruiz's (1995) follow-up to Hummelinck's work involving a survey and inventory of rock art locations. One result of this investigation concerned the observation that rock art sites were located along parallel lines across the island. This pattern was not observed for habitation sites. In 1996, van Leeuwen and Versteeg undertook a study of the possible distributional patterns of the images and who the image-makers might have been (preliminary results cited in Dijkhoff and Linville 2004:48).

Currently an effort is under way to create a geo–database. This effort, the Aruba Survey Project, will record the locations, sizes, and additional features of all prehistoric and historic sites on the island, including those with rock art. For rock art sites, specific information will include physical location, presence of nearby sites, number and characterization of the images, conservation status of the site, global positioning system (GPS) coordinates, digital pictures, and videos of site sections.

A GPS camera will be employed to take photographs of the designs thus also placing them in precise relationship to their location within the site. The pictures can then be linked by means of the GPS coordinates to the archaeological site maps (topographical and photographic) and the digitized documentation form. It will then be possible to obtain an integrated view of the

locations, distributions, and relationships among rock image sites, as well as between these sites and other site types. The resulting informational system is expected to aid in the management and conservation of the rock art sites, in addition to stimulating further research with more advanced or sophisticated methods.

14

A New Method for Recording Petroglyphs

The Research Potential of Digitized Images

George V. Landon and W. Brent Seales

Introduction

In this chapter we outline a method for recording, preserving, and visualizing rock art, in particular petroglyphs. The process creates accurate three-dimensional (3-D) textured models of carved surfaces, making the intricate geometry clearly and readily available for study. Rock art researchers can overcome problems concerning limited access to the images and the lack of investigative tools for the images, as well as expand research opportunities through interactive computer techniques.

The Instituto de Cultura Puertorriqueña graciously granted permission to use our technology (Seales and Landon 2005) in the summer of 2004 on the petroglyph-adorned boulders that line the central Plaza A of the Late Ceramic Period (A.D. 1300–1460) civic-ceremonial site of Caguana, Utuado Municipio (local political division), Puerto Rico (Oliver 2005). The rich detail of the carved images has invited various iconographic interpretations (see especially Oliver 1998, 2005, summarized in Hayward, Roe, et al., Chapter 9, this volume). In contrast, application of new technology to improve the recording and dissemination of the petroglyphs has been limited.

Accepted standards for recording rock art have remained the same for many years. Two of the most prevalent techniques involve tracing and photography (Loendorf 2001). Both of these methods possess obvious limits. Tracing requires physical contact with each petroglyph and the quality of the image reproduction depends on the recorder's perception and accuracy. Photography introduces a loss of information that is inherent when capturing a real-world object with a two-dimensional picture. While lighting certainly enhances image details, it can also limit them. For either method, all recording decisions, such as light position in photography, must be made while on site. In the Caribbean, as elsewhere, the destructive forces of natural elements, in addition to postexecution human alterations, can affect the figures

on rock surfaces. Accurate recording techniques thus become critical in addressing the possibilities for information loss.

Recently, state-of-the-art technology has provided researchers with more accurate renderings of different types of rock surfaces. Goskar et al. (2003) and Wessex Archaeology and Archaeoptics Ltd. (2006), for example, have employed laser-based acquisition techniques to scan the boulders at Stonehenge. These authors' results provide an improved record of Stonehenge carvings underscored by their discovery from their high-resolution 3-D scans of previously undetected carvings of axelike shapes on Stone 53. The Digital Michelangelo Project has produced very precise recordings of Michelangelo's David sculpture (Levoy et al. 2000). The scans yielded enough detail to allow further study of even the chisels Michelangelo used when carving the statue. In this case, obvious parallels exist for investigators interested in the tools used to carve designs on rock surfaces. Cultural Heritage Imaging (Mudge et al. 2006) has developed Polynomial Texture Maps as a means of acquiring many possible lighting positions and generating one cohesive texture image of the rock art surface.

Our solution to problems of recording and preservation begins with the development of a laser-based scanner in order to acquire high-resolution scans of carved surfaces. This scanner also has to be flexible enough to allow recording in remote areas while still producing images to the quality standards needed for digital preservation. We additionally discuss investigative possibilities for the digitized rock images resulting from our or others' methods. Remote or off-site examination of these digitized images or virtual copies becomes feasible through networks, such as the Internet, using various display techniques, ranging from computer monitors to high-resolution tiled projector displays. In addition, structuring of the data is important and can play a facilitative role in further study. This becomes apparent when one wishes to save expert annotation and markup employed in subsequent studies using tools such as interactive lighting and false coloring.

Preservation through Digitization

The availability of new technologies further underscores the need for more robust recording techniques in rock art research. For example, both Wasklewicz et al. (2005) and Barnett et al. (2005) employed 3-D scanning for recording rock art; in particular, the former measured degradation of the rock images using recorded models. Barnett and colleagues relied on a commercial scanner from Konica Minolta Sensing Americas, Inc. (2006), while Wasklewicz and colleagues used one from Cyra (Leica Geosystems HDS, LLC 2007). Commercial offerings provide obvious benefits to researchers who

need "out of the box" scanning. The ease of use offered by these systems can also be a limiting factor, since preset configurations may not be compatible for some task-specific uses.

To digitize the Caguana petroglyphs, we concluded that commercial scanners did not provide enough customization possibilities to obtain the desired high-quality images, given the nature of the petroglyphs. Consequently, the development of a high-fidelity replication system required a custom platform, including commodity hardware and custom software. As with any on-site operation, our team faced difficulties in completing the recordings of the petroglyphs. We needed to consider such issues as obtaining a power source for electronic devices and protecting equipment from weather conditions.

The acquisition system we designed uses a combination of off-the-shelf hardware and a software application that we developed to synchronize the hardware components (Landon and Seales 2006). The hardware includes four FireWire-based grayscale digital video cameras with a resolution of 640 × 480 pixels, costing $650 each, and two 6.3-megapixel digital still cameras with computer-controlled USB connectivity selling for $500 each. Finally, a $500 red laser stripe generator mounted on a serial-controlled pan/tilt unit costing $2,000 kept the price of the entire system under $10,000. Figure 14.1 depicts the hardware arrangement as it was being used to record one of the bird-form petroglyphs from Caguana.

A single computer runs the software application that drives the six cameras and synchronizes the laser movements with the image acquisition. A large tripod contains all of the equipment, with the cameras calibrated to record their respective physical distances from each other. The scanning process sweeps the laser stripe across the surface of the rock, while the four video cameras each obtain a unique view of the laser as it progresses. The line appears deformed depending on the viewing angle of each camera and the topography of the surface. For each of the discrete points on the line, the software estimates the point's position for each camera view. This information permits any point's distance from the cameras to be triangulated, with all such configured points employed to reconstruct the rock's surface in three dimensions. The two high-resolution still cameras capture color images of the surface, referred to as texture maps, to complete the reconstructed or virtual replica with information from the visible spectrum of light. The system yields a submillimeter-accurate 3-D model with an average of 350,000 discrete points and a corresponding high-resolution surface. To increase overall resolution of the final 3-D reconstruction for each petroglyph, we performed two or more scans in subsections of each surface. Multiple scans can be combined to at least double the overall scan resolution.

It is worth noting that accuracy results may vary greatly between rock art

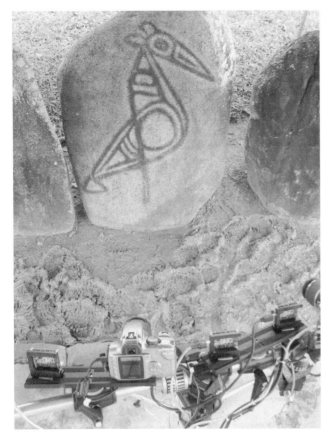

Figure 14.1. Equipment set up to scan the petroglyphs of Plaza A, Caguana, Puerto Rico (photograph by Landon and Seales, 2004).

assemblages or even among the images within the same assemblage, depending on the individual rock materials. Issues such as surface properties may interfere with how a laser responds when illuminating a surface. We performed thorough testing of our scanning system before we began the digitization process to ensure that our results would be consistent with our recording requirements. This may be a limiting factor for some commercial systems for which internal parameters cannot be adjusted to compensate for light-source interaction with varying rock material compositions.

We employed Raindrop Geomagic Studio software (Geomagic, Inc. 2007) to enhance, merge, and manipulate the individual 3-D modeled scans. This software package offers the ability to analyze each subsection scan to reduce noise and merge multiple scans to generate complete 3-D models of, in this

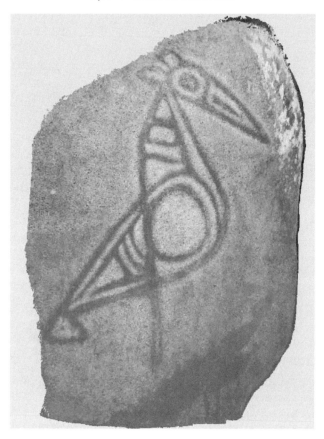

Figure 14.2. Digitized 3-D image with high-resolution texture of a bird-form petroglyph at Plaza A, Caguana, Puerto Rico (image by Landon and Seales, 2004).

experiment, the Caguana petroglyphs. Figure 14.2 illustrates one of the composite 3-D models of the carved images, a bird or Oliver's (1998:Figure 47) petroglyph number 7.

For our custom scanner, we determined the necessary durability and portability requirements based on the accessibility of the Caguana site. This location is open to the public with no structural interference and with ready vehicular admittance. For more remote, undeveloped sites, access with standard electronic components is still quite difficult. This difficulty easily shows why tracing and photography have remained the most prominent recording forms of rock art. However, great strides in the miniaturization of electronic components and power supplies are rapidly reducing the difference in requirements for these capture devices.

Whether a custom-developed 3-D scanner or a commercially available product is used, we argue as have others (see, for example, Trinks et al. 2005) that enhanced data collected by digitization represents a significant addition to present rock art recording methods. In some cases, this provides the same information as the well-known methods discussed above, while adding an entirely new data set: the geometry of the surface.

While the capture of surface geometry is paramount for the recording of petroglyphs, we consider that this geometry is also important for pictographs. Accurate depth recordings of images executed on nonplanar surfaces add to the set of characteristics (color, form, application technique) available for analysis. Geometric details, such as various surface nonuniformities caused by the underlying material, can provide invaluable information on the provenience and meaning of pictographs.

Enhanced Research Potential

Three-dimensional digitization of rock art not only serves to preserve the images and their rock surfaces but, more compellingly, the foregoing and related methods also enhance research opportunities of the now-digitized figures. In particular, advanced forms of access are available for these virtual assemblages. Interactive web pages may provide access to the images over the Internet. For enhanced off-site viewing, large-scale displays offer new and unique ways to access the digitized data through full-scale viewing of the figures. Methods for structuring data in hierarchical formats offer a more effective means of storing the digitized data. These formats facilitate annotation and markup applied in a layered context that can be turned on and off depending on individual need. Researchers are able to use such tools as interactive lighting and false coloring to remove ambiguities.

The Virtual Petroglyphs

The acquisition of accurate high-resolution geometric data and high-resolution texture images for objects such as petroglyphs enables the creation of a virtual representation of the object. For the Caguana petroglyphs, we were able to generate complete 3-D models of each of the petroglyphs we scanned. Since the iconography itself represents the most important aspect of the rocks, we chose to scan only the front side of the carved boulders. A model of the entire boulder was subsequently created using interpolation of the scan data.

The availability of high-quality digital assemblages can greatly reduce or even eliminate, in some cases, the need for physical access to the rock art. Metric frame surface recordings make possible submillimeter-precise mea-

surements of surface features, such as carving depth. Further, many rock art sites are subject to tightly controlled policies for access and handling or are located in remote outdoor regions. Consequently, access to digital-image data sets becomes especially important.

Beyond expanding access, much research depends on specific kinds of activities that digital collections can support in a way that may actually be better than analyzing the original. In particular, we have encouraged new kinds of interactions with the modeled petroglyphs that build on the nature of digital representations.

Improved Access

Digitized images represent a reproduction format that provides additional levels of access to rock art beyond the physical. Two such levels or routes of access that we have addressed involve Web-based applications and immersive environments.

The Web can provide access to preserved petroglyphic archives using a VRML (virtual reality mark-up language) plug-in (Parallel Graphics, Inc. 2006) available for Web browsers. These applications allow users to interact directly with 3-D content via their Web browser. The broad availability of Internet access facilitates unparalleled admission to digital collections. Users may interact with objects in real time, while modifying properties such as viewpoint and surface properties.

Extremely high-resolution immersive environments offer additional effective means to access digitized rock art databases. We have explored the use of multiprojector tiled displays for creating a high-performance immersive environment in which to view high-resolution objects (Raskar et al. 1999). Many independent video projectors are automatically calibrated, creating one cohesive high-resolution display.

This technology provides a way to view the highest resolution of the virtual images at true-to-life scale and offers researchers the ability to study objects with near lifelike interaction. In a larger space, it is possible for multiple viewers to examine the same content simultaneously, offering more collaborative opportunities for investigators.

Enhanced Markup with Advanced Tools

A 3-D digital copy of any artifact, including an image on a rock surface, combined with many standard and newly developed research tools can enhance the study of these objects. The digitized versions of petroglyphs can be tested or modified without fear of permanently damaging the actual piece. Taking multiple scans over time and comparing results can measure weathering and

deterioration. This information integrated into models for degradation can create accurate approximations of the surface quality at specific times in the future (Barnett et al. 2005).

One intuitive tool for studying petroglyphs involves modifying the lighting on the surface of the stone. Interactive lighting is closely related to recording methods using photography. Similar to the effect of using mirrors or flashlights for photographic recording, a virtual light source can be positioned in a way that casts dark shadows across the carvings. Virtual light-source positioning can simulate the "raking" light effect often used by investigators. By using this technique, one can see shadows and surface detail that dramatically highlight the shape of the carvings.

Given a shape model with texture properties, a user can choose to display an actual or artificial textured surface. The "realistic" view shows the model with actual texture under the choice of natural (captured) lighting conditions. A caveat concerns the coloring and cleanliness of the surface, conditions that might interfere with the clarity of the image. False coloring of the image, by applying a single color to the surface, can eliminate such interference.

These technologies allow users to interact with petroglyphs in novel ways, as well as potentially providing an environment for more accurate and repeatable measurements than on-site research.

Contextual markup is an important operation enabled by digital acquisition. Since the data are stored in a completely digital format, "metadata" can be inserted into the models that allow expert users to make detailed observations about each object. For example, investigators can create virtual markings, which the viewer shows or hides depending on his or her preference, on the surface of the rocks to highlight carvings.

Researchers can then use interactive tools to develop new ideas concerning specific features of the images and their production that can then be stored as an additional layer of annotation. This is essential for advanced users, who are able to integrate a diverse set of reference material and provide expert analysis related to the particular geometry of an object. These researchers want the ability to record that information and connect it to the digitized data.

One of the fully executed anthropomorphic images from Caguana serves to highlight the limitations of the physical approach compared to the digital. Figure 14.3a displays the figure as drawn by one investigator, Oliver (1998:166, Figure 56), while Figure 14.3b illustrates the outline provided by digital enhancement with application of false coloring. The application of surface details and information or markup makes for conditions that remain constant so that researchers may spend as much time as necessary with each

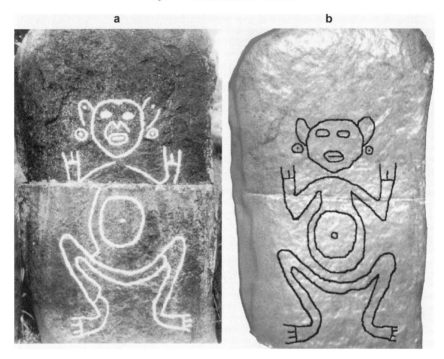

Figure 14.3. One of the Caguana anthropomorphic figures as drawn by Oliver (1998:Figure 53; used with permission) (a) contrasted with the same image in digitized form (b) with different details (image by Landon and Seales, 2004).

model. By providing the option of layering markup, investigators may create multiple versions of the same carving depending on interpretation. This allows several researchers to directly compare their analysis with the work and progress of others in a highly collaborative environment.

Conclusion

The study of rock art relies primarily on accurate recording and measurement. Our development of a customized 3-D scanning system proved successful in obtaining detailed renderings of the Caguana petroglyphs, as well as their underlying surface geometry. This technique joins other customized or commercially available laser scanning systems (see, for example, Barnett et al. 2005 and Trinks et al. 2005) that have raised the level of recording precision over such conventional procedures as tracings and standard or digital photography. While multiple reproduction methods are likely to remain of utility, at least in the near future, we nonetheless encourage the continued development and application of laser-scanning procedures.

Digitized 3-D images of rock art, whether from laser scanning or other methods including photogrammetry, generate new techniques for the study of the figures (see also Trinks et al. 2005). In particular, we highlight that the Caguana petroglyphs are now available for study as virtual images via networks like the Web; the production of display systems for public viewing and investigation from remote locations; and use of interactive lighting to enhance surface detail. We also have pointed out that contextual markup tools are now possible with which researchers can independently add notation to regions of the rock image, while also linking with various other media.

Acknowledgments

We would like to thank Adlín Ríos Rigau, Director of the Museum and Parks Program, for her assistance in the development of this project and the Instituto de Cultura Puertorriqueña for providing access to these important cultural resources. In addition, we would like to thank Herman Acuna, Professor of Computer Science at the University of Puerto Rico, Río Piedras Campus, for his guidance in this project. The National Science Foundation generously supported this work under Grant No. CNS-0121438.

15

The Mute Stones Speak

The Past, Present, and Future of Caribbean Rock Art Research

Peter G. Roe

Introduction

Historically, rock art research in the Antilles involved image documentation and classification, complemented by diverse levels of interpretation and conservation efforts. Until recently progress in the investigation of the region's rock art has been hampered by various factors: (1) geography, (2) developmental history, (3) dating methods, (4) conceptual biases, (5) data set limitations, (6) uneven methodologies, and (7) interpretive concepts.

1. Geography: The noncontiguous nature of island groupings, variable island geology (volcanic vs. sedimentary), and differing topographies make for differential investigative access within the area.
2. Developmental history: The American, English, Dutch, Danish, French, and Spanish colonial powers have all influenced postcolonial political, social, legal, and economic development. Different languages, as well as divergent theoretical and methodological approaches, form a legacy that provides for both a positive and negative research environment.
3. Dating methods: The very limited number of suggested dates for individual sites or proposed relative chronologies (see Dubelaar 1995:15–17 and Frassetto 1960) have restricted the understanding of rock art development and its relationship to the wider cultural context.
4. Conceptual biases: Professionally trained archaeologists in the Caribbean (Roe 1993b) and elsewhere (Whitley 2001) have tended not to view rock art as amenable to scientific examination or critical to cultural reconstruction. Yet rock art is also conceded to be integral to past societal functioning.
5. Data set limitations: Archaeologists attempt to formulate empirical data sets from disparate realms, encompassing everything from ceramic characteristics to ethnohistoric reconstruction and rock art features. The un-

critical use of such data sets as European accounts of the native population at the time of contact and the religious systems of native South American lowland societies have also restricted efforts to interpret rock art (Roe 1993b).

6. Uneven methodologies: Researchers in the Caribbean have not developed systematic methods. Although multiple recording procedures are necessary for any particular rock art locale, no set of standard methods is used.

7. Interpretive concepts: The foregoing state of rock art studies has made it difficult to generate higher-order interpretations of Caribbean rock art, conduct comparative and integrative analyses, or even apply concepts from other rock art areas and disciplines.

In contrast to this older Caribbean picture, improvements in dating techniques, documentation efforts, and methodologies have contributed to the worldwide growing acceptance and advancement of rock art studies (Whitley 2001). This characterization also now applies to the Caribbean (Roe 1993b).

Several topics on the status of Caribbean rock art are presented in Tables 15.1 through 15.7. Within the tables a first-order Greater and Lesser Antilles division is followed by a second-order island listing either from north to south or by descending numerical order. Categories include survey and documentation status, site and image density distributions, rock art location patterns, dating schemes, and conservation status. I then assess the nature of each category's information, make certain interpretive or synthesizing statements based on available data, and suggest avenues for future research.

Survey and Documentation of Rock Art Sites

Fundamental to any analysis of the region's rock art is locating the sites and accurately recording their images. The present survey status for Caribbean islands reflects varying degrees of incompleteness (Table 15.1). This is perhaps most critical for the Greater Antillean islands, which still possess significant acreage to examine. Nor should the Lesser Antilles be discounted, as illustrated by the recent doubling of sites on Guadeloupe (Richard, Chapter 10, this volume) and the discoveries of new sites in the Virgin Islands (Drewett 2007; Hayward et al. 2003) and Dominica (Stephan Lenik, personal communication 2007). Research designs should address locating not only rock art sites but associated habitation and other site types as well.

The recording of known sites has been uneven (see Table 15.1). Dubelaar's 1995 survey is an exception, with data from orientations to references included for all the then-recorded sites in the Lesser Antilles, Trinidad, and

Table 15.1. Rock Art Survey and Documentation Status

Island/Area	Survey Status	Documentation Status
	Greater Antilles	
Bahama Islands	Incomplete	Scaled site maps, scaled drawings, descriptions, and photos for 6 sites[1, 2]
Cuba	Incomplete; 65% of karst region explored[3]	Photos and sketches by early researchers; maps of various sites; several summaries of site data available; efforts toward a National Rock Art Registry[3]
Jamaica	Fairly complete	94% of caves with rock art listed on official registry; 77% mapped, 34% photographed or illustrated[4]
Puerto Rico	Incomplete	Minor number of the over 500 rock art sites well documented; for most sites documentation is limited or uneven[5]; 3-D scanned digitized images from Caguana ball court[6]
Mona Island	Substantially complete	Detailed data, with locations, descriptions, scaled maps, drawings, and photographs for 4 sites[7]
Hispaniola		
Haiti	Incomplete, especially for southern region[8]	In past 20 years, surface surveys conducted for all site types; digitized data for some 1,000 sites with radiocarbon dating of selected sites; site form information includes location, site type, associated materials, area estimations, photos, and sketches; 7 rock art sites have uneven documentation, remainder require additional study[8]
Dominican Republic	Incomplete; 30% of caves explored for presence of rock art[9]	Small number of 500+ sites well documented; majority remain to be investigated[9, 10]
U.S. Virgin Islands		
St. John	Fairly complete	Congo Key and Reef Bay have descriptions, specific locations, sketches with measurements, references, general site and image photos, and limited additional characteristics[5, 11]; Reef Bay has additional locational, photographic, and interpretive information[5]
St. Thomas	Fairly complete	Botany Bay with National Register–level documentation including description and locational data[5]

Island/Area	Survey Status	Documentation Status
St. Croix	Fairly complete	Salt River and Robin Bay have descriptions, locations, sketches with measurements, references, general site and image photos, and limited additional characteristics[5, 11]
British Virgin Islands		
Tortola	Incomplete	Verbal description and location[12]
	Lesser Antilles	
Anguilla		Descriptions, locations, sketches with measurements, references, general site and image photos, and limited additional data[11]; additional documentation (photos and maps) and interpretation for Fountain Cavern and Big Spring sites[13]
St. Martin		Moho Bay destroyed; 2 other sites have descriptions, locations, sketches with sparse measurement data, references, general site and image photos, and limited additional data[11]
St. Barthélémy		No sites[11]
Saba		No sites[11]
St. Eustatius		No sites[11]
Barbuda		The lone site has description, location, sketches with measurements, references, photos of images, and limited additional data[11]
St. Kitts		4 sites have descriptions, locations, sketches with measurements, references, general site and image photos, and limited additional data[11]; additional study of Stone Fort River site[14]
Nevis	Systematic surface survey effort[15]	No sites[11]
Antigua		No sites[11]
Montserrat		No sites[11]
Guadeloupe	Incomplete	12 sites or locations have descriptions, locations, sketches with measurements, references, general site and image photos, and limited additional data[11]; these and other sites have documentation including publications, photos, drawings, and GPS data[16]; computerized inventory of archaeological sites, including rock art locations[17]

Continued on the next page

Table 15.1. *Continued*

Island/Area	Survey Status	Documentation Status
Marie Galante		Site has description, location, sketches with measurements, references, general site and image photos, and limited additional data[11]
Dominica	Incomplete	1 unconfirmed mention of a site[11]; 1 new location[18]
Martinique		Forêt de Mon Travail has description, location, sketches with measurements, general site and image photos, and limited additional data; mention with few details for other 2 sites[11]; extensive documentation, dating, and interpretive details for Forêt de Mon Travail and Le Galion[19]
St. Lucia	Incomplete; south half of island reasonably complete; ongoing systematic survey and excavation plan[20]	5 sites have descriptions, locations, sketches with measurements, references, general site and image photos, and limited additional data; 1 unrelocated site[11]; extensive documentation, dating, and interpretive details for 7 sites[19]
St. Vincent		13 sites have descriptions, locations, sketches with measurements, references, general site and image photos, and limited additional data[11]; extensive documentation, dating, and interpretive details for 12 sites (excluding Lowman's Bay)[19]
Barbados		The only site has description, location, sketches with measurements, references, general site and image photos, and limited additional data[11]
Grenadines/ Canouan Petit St. Vincent		Canouan Island site has descriptions, locations, sketches with measurements, references, general site and image photos, and limited additional data[11]; Petit St. Vincent site has short description[21]
Grenada		6 sites have descriptions, locations, sketches with measurements, references, general site and image photos, and limited additional data[11]; extensive documentation, dating, and interpretive details for 4 sites (excluding Pomme Rose)[19]; Victoria site destroyed[11, 19]
Tobago		No sites[11]
Trinidad		1 site has description, location, sketches with measurements, references, photos of images, and limited additional data; second site described[11]

Island/Area	Survey Status	Documentation Status
Bonaire		Sites recorded and inventoried; documentation principally as sketches from 1950s–1970s and more recently with print, slide, and digital photography of some sites; data housed at National Archaeological Anthropological Museum (NAAM)[22]
Curaçao		Sites recorded and inventoried; documentation principally as sketches from 1950s–1970s and more recently with print, slide, and digital photography of some sites; data housed at National Archaeological Anthropological Museum (NAAM)[22]
Aruba		Fontein, Quadirikiri, Arikok, and Ayo sites inventoried; detailed drawings, UTM digitized coordinates, digital photos, and studies along with other data available in published or archived formats; documentation housed at The Archaeological Museum of Aruba[23]

Sources:

1. Winter, Chapter 2, this volume.
2. Núñez Jiménez 1997.
3. Fernández et al., Chapter 3, this volume.
4. Atkinson 2003b.
5. Hayward, Roe, et al., Chapter 9, this volume.
6. Landon and Seales, Chapter 14, this volume.
7. Dávila Dávila 2003.
8. Beauvoir-Dominique 2006.
9. Atiles Bidó, Chapter 7, this volume.
10. Lopez Belando, Chapter 8, this volume.
11. Dubelaar 1995.12. Drewett 2007.
13. Crock 2006.
14. Richard 2008.
15. Wilson 2006.
16. Richard and Petitjean Roget 2006.
17. Stouvenot 2008.
18. Lenik, personal communication 2007.
19. Jönsson Marquet 2002.
20. Keegan et al. 2007.
21. Martin 2008.
22. Haviser 2006.
23. Kelly 2006.

the Virgin Islands. His image reproduction is schematic, however, with sometimes inaccurate single-line drawings that do not reflect the visual impact of the images. He does, however, supply black-and-white photographs so depictions can be compared with the originals and he also provides metric measurements. Distributional patterns are described and dates are suggested, but little interpretation is attempted because, being moderns, he argues, we should never offer specific iconographic or symbolic analyses of the figures. Nonetheless, the sheer standardization of information for a large number of sites makes this compilation useful for comparative studies. Researchers, in-

cluding Petersen et al. (2003) and Jönsson Marquet (2002, Chapter 11, this volume), have expanded upon Dubelaar's survey with accurate recording of sites on several Lesser Antillean islands.

The status of rock art recording is less favorable in the Greater Antilles. Area-wide surveys similar to Dubelaar's are lacking. On most of the islands only a minority of sites are well documented. Newer techniques, such as three-dimensional (3-D) scanning and advanced photography, are not widely employed in research.

Much of the documentation, however, is available in published format, and many countries are establishing site inventories and associated materials. Computerization of the registries is also under way, though it is not as yet matched by a comparable effort to develop a regional database. The current situation nevertheless represents a substantial improvement over earlier recordation efforts that consisted of freehand sketches and poor-quality photographs.

Advancements have been and should continue to be made in documenting the region's rock art sites and images. Multiple methods should be employed, aided by the expansion of newer techniques to obtain accurate location and age determination. Investigators must take into account the total context of sites. Rock art sites were deliberately chosen for a number of reasons involving the physical characteristics of particular locales, their position vis-à-vis the larger sociopolitical and settlement systems, and their placement within the cosmological or celestial system. In this regard more than maps, GPS points, and sextants or total instrument stations may be needed to establish a site's "true" location.

Noninvasive or less-invasive methods should be the goal of any image reproduction effort. These include photography in a variety of forms (regular, digital, infrared) and under different conditions (day, night, plane view, and oblique angles), along with drawings to scale and rubbings aided by transparent plastic sheet tracing. As Landon and Seales demonstrate in this volume (Chapter 14), superior surface details for petroglyphs can be obtained by 3-D laser scanning. The interrelationships of individual images with other figures and settings should be established. Standardization of documentation techniques remains a critical goal, as does the elaboration and maintenance of regional rock art inventories and archives.

Spatial Distributions

Rock art can be found throughout the culturally defined Greater Antilles but is absent for several Lesser Antillean islands (see Table 15.1). The rather small Mona Island, to the east of Puerto Rico, possesses the highest site den-

sity within the Greater Antilles (0.0727) (Table 15.2), though closely followed by Puerto Rico (0.0618), then the U.S. Virgin Islands (0.0143), the Dominican Republic (0.0103), the British Virgin Islands (0.0065), Jamaica (0.0034), Cuba (0.0017), the Bahamas (0.0009), and Haiti (0.0007). Given the incomplete nature of surveys in this area, a more likely ordering would be Puerto Rico/Mona Island, Hispaniola, the Virgin Islands, Jamaica, Cuba, and the Bahamas.

High site densities for the remaining Caribbean islands are found on Aruba (0.1158), Curaçao (0.0858), St. Martin (0.0588), Bonaire (0.0486), and Anguilla (0.0364). The lowest site densities are in Barbados (0.0023), Dominica (0.0013), and Trinidad (0.0004) (Table 15.2). Echoing an observation by Dubelaar (1995:22), most of the larger (greater than 85 km^2) remaining islands have rock art, while most of the smaller ones (less than 85 km^2) do not. Antigua, Nevis, and Tobago with 280, 98, and 302 km^2, respectively, represent the only three exceptions to the larger-island rule, complemented by three exceptions to the smaller-island rule, St. Martin, Anguilla, and the Grenadines (Dubelaar 1995:21–24).

Image frequency data are less complete and precise than site density calculations (Table 15.3). In the Greater Antilles, general figures are available for Puerto Rico, Cuba, Hispaniola, and Jamaica. The number of images per site ranges from one to the low hundreds for petroglyphs, with the range for pictographs reaching into the low thousands. The total tally of images would then number several thousand for these islands. The nine recorded sites for the Bahamas contain over 90 figures, yielding an average of 10 per site. Mona Island, with a reasonably complete survey status, possesses four rock art sites with 65 designs for a 16-per-site average or 1.182 images per square kilometer. The image densities for the U.S. and British Virgin Islands figure to approximately half (St. John, 0.6531) or less (St. Thomas, 0.1857; St. Croix, 0.0588; Tortola, 0.0061) of that of Mona Island, perhaps hinting at the straits interaction zone importance of that otherwise small, rocky, and dry outpost.

Image densities for the remainder of the Caribbean islands arc display an upper- to mid-range reordering of the site density distribution. Guadeloupe, for example, occupies the middle of the site density sequence yet possesses the single highest number of images at over 1,100 with a concentration of 0.6463 for a fourth-place ranking behind Aruba (1.579–1.842), St. Kitts (0.8452), and Anguilla (0.7272). Perhaps this marks the pivotal importance of Guadeloupe as the last of the Greater Antillean–affiliated Leewards (Hofman et al. 2007). Those islands such as Barbados, Dominica, and Trinidad at the lower end of the site density distribution are also near the bottom of the image density sequence (Dubelaar 1995:26).

Rock art locations may be grouped into five categories: caves and rock-

Table 15.2. Rock Art Site Densities

Island/Area	Area in km^2	Number of Sites	Site Density
Greater Antilles			
Mona Island	55	4[1]	0.0727
Puerto Rico	8,897	550+[2]	0.0618
Jamaica	11,424	39[3,4]	0.0034
Cuba	110,860	192[5]	0.0017
Bahama Islands	10,070	9[6]	0.0009
Hispaniola			
Dominican Republic	48,380	500+[7]	0.0103
Haiti	27,560	18[8,9]	0.0007
U.S. Virgin Islands	349	5	0.0143
St. John	49	2[10]	0.0408
St. Thomas	70	1[2]	0.0143
St. Croix	221	2[2,10]	0.0090
British Virgin Islands	153	1	0.0065
Tortola	62	1[11]	0.0161
Lesser Antilles			
Aruba	190	22[12]	0.1158
Curaçao	443	38[13]	0.0858
St. Martin	34	2[10]	0.0588
Bonaire	288	14[14,15]	0.0486
Grenadines	45	2[10,16]	0.0444
Anguilla	344	12[10,17]	0.0349
St. Vincent	55	2[10]	0.0364
St. Kitts	168	4[10]	0.0238
Grenada	345	6[10,17]	0.0174
Guadeloupe	1,702	27[18]	0.0159
St. Lucia	615	6[10,17]	0.0098
Marie Galante	152	1[10]	0.0066
Barbuda	160	1[10]	0.0063
Martinique	997	3[10,17]	0.0030
Barbados	440	1[10]	0.0023
Dominica	787	1[19]	0.0013
Trinidad	4,828	2[10]	0.0004
Total		1,468+	

Notes: There are discrepancies in site tallies among the sources. Plus sign indicates additional sites.

Sources:
1. Dávila Dávila 2003.
2. Hayward, Roe, et al., Chapter 9, this volume.
3. Atkinson 2003b.
4. Atkinson, Chapter 4, this volume.
5. Fernández et al., Chapter 3, this volume.
6. Winter, Chapter 2, this volume.

7. López Belando, Chapter 8, this volume.
8. Beauvoir-Dominique, Chapter 6, this volume.
9. Beauvoir-Dominique 2006.
10. Dubelaar 1995.
11. Drewett 2007.
12. Kelly, Chapter 13, this volume.
13. Rancuret 2008.
14. Haviser 2006.
15. Haviser, Chapter 12, this volume.
16. Martin 2008.
17. Jönsson Marquet 2002.
18. Richard, Chapter 10, this volume.
19. Lenik, personal communication, 2007.

shelters, in or along waterways, open-air rock formations (interior or ocean edge), ball courts, and beach rock (Table 15.4). In the Greater Antilles, cave contexts are exclusive on the Bahamas and Mona Island, while predominating on Cuba, Jamaica, and Hispaniola. Puerto Rico exhibits the greatest degree of diversity, with rock art being found in all five locations. The island also possesses the highest relative percentages of waterway (often river boulder) and ball court contexts.

Beginning with the Virgin Islands and continuing south through the Lesser Antilles to Trinidad, the number of cave locations diminishes. None are present in the Virgin Islands; instead, images are distributed among two ball courts, two ocean-edge positions, and one waterway/pool site. Ten cave sites are found scattered from Anguilla to Barbados. Waterways or river valleys (32 sites) and ravines (11 sites) make up the majority of the remaining rock art locations, followed by 13 open-air sites. No images are found carved onto ball court boulders as the islands from Sombrero and Anguilla southward lack such sites. Caves once again predominate or are exclusive on the near-continental islands of Aruba, Bonaire, and Curaçao. Several investigators, among them Versteeg (in Dubelaar 1995:24, 27), Richard (Chapter 10, this volume), and Petitjean Roget (2003), have stressed the recurrent physical association between rock art sites and water sources (fresh or oceanic) from Anguilla to Trinidad, as has Haviser (Chapter 12, this volume; Haviser 2006) for Bonaire and Curaçao.

Petitjean Roget (2003) suggests that this linkage derives from a magical or symbolic attempt to mitigate against the ever-present threat of lack of water. I have argued (Roe 2005) that this spatial association may be linked to a particular class of Puerto Rican rock art: the wrapped body form as ancestor. The wrapped ancestor form marks the various locations where water as both life-giving and life-taking most immediately occurs. South American lowland oral tradition relates how one's ancestors emerged from caves with

Table 15.3. Rock Art Image Densities

Island/Area	Area in km²	Number of Sites	Image Data	Image Density
			Greater Antilles	
Mona Island	55	4[1]	65 images; average of 16 images per site[1]	1.182
Puerto Rico	8,897	550+[2]	Range of images per site is 1–100+; most sites have 50 or fewer; 2 sites have 100+[2]	N/A
Cuba	110,860	192[3]	For 46 sites: range of images is 1–213 per pictograph site; 1–5 images per petroglyph site; total of 754+ images, for average of 16+ images per site[4]	N/A
Bahama Islands	10,070	9[5]	90+ images; average of 10 images per site[5]	N/A
Jamaica	11,424	39[6,7]	Range of images per site is 1–35; most have at least 1 petroglyph image; 5 sites with pictographs have 2–200 images[6,7]	N/A
Hispaniola				
Dominican Republic	48,380	500+[8]	Petroglyph image numbers range from 1–400; pictograph image numbers range from 1–2,500[9]	N/A
Haiti	27,560	18[10,11]	Range of images is 1–100[10]	N/A
U.S. Virgin Islands	349	5	58	.1662
St. John	49	2[12]	32; average of 16 images per site[12]	.6531
St. Thomas	70	1[2]	13; average of 13 images per site[2]	.1857
St. Croix	221	2[2,12]	13; average of 6.5 images per site[2,12]	.0588
British Virgin Islands	153	1	1	.0065
Tortola	62	1[13]	1; average of 1 image per site[13]	.0061
			Lesser Antilles	
Aruba	190	22[14]	300–350; 14 to 16 images per site[14]	1.579–1.842
St. Kitts	168	4[12,15]	142+; average of 36 images per site[12,15]	.8452
Anguilla	55	2[12]	40; average of 20 images per site[12]	.7272
Guadeloupe	1,702	27[16]	1,100+; average of 41 images per site[16]	.6463
Bonaire	288	14[17,18]	167+; average of 12 images per site[17]	.5799
Grenada	345	6[12,19]	126; average of 21 images per site[12,19]	.3652
Marie Galante	152	1[12]	47; average of 47 images per site[12]	.3092
St. Vincent	344	12[12,19]	66+; average of 6 images per site[12,19]	.1919
St. Lucia	615	6[12,19]	39; average of 7 images per site[12,19]	.0634
St. Martin	34	2[12]	2; average of 1 image per site[12]	.0588

Island/Area	Area in km^2	Number of Sites	Image Data	Image Density
Grenadines	45	2[12, 20]	2; average of 1 image per site[12, 20]	.0444
Martinique	997	3[12, 19]	33; average of 11 images per site[12, 19]	.0331
Barbados	440	1[12]	8; average of 8 images per site[12]	.0181
Barbuda	160	1[12]	2; average of 2 images per site[12]	.0125
Dominica	787	1[21]	7; average of 7 images per site[21]	.0089
Curaçao	443	38[22]	N/A[22]	N/A
Trinidad	4,828	2[12]	Several[12]	≤1

Notes: There are discrepancies in image tallies among the sources. Plus sign indicates additional images.

Sources:

1. Dávila Dávila 2003.
2. Hayward, Roe, et al., Chapter 9, this volume.
3. Fernández et al., Chapter 3, this volume.
4. Linville 2005.
5. Núñez Jiménez 1997.
6. Atkinson 2003b.
7. Atkinson, Chapter 4, this volume.
8. López Belando, Chapter 8, this volume.
9. Atiles Bidó, Chapter 7, this volume.
10. Beauvoir-Dominique, Chapter 6, this volume.
11. Beauvoir-Dominique 2006.
12. Dubelaar 1995.
13. Drewett 2007.
14. Kelly, Chapter 13, this volume.
15. Richard 2008.
16. Richard, Chapter 10, this volume.
17. Haviser, Chapter 12, this volume.
18. Haviser 2006.
19. Jönsson Marquet 2002.
20. Martin 2008.
21. Lenik, personal communication 2007.
22. Rancuret 2008.

the life-giving waters of birth; they guard their descendants' water resources found in or emanating from caves and waterways; they end their life's journey in caves that are also the portals to the subaquatic underworld of a triple-tiered cosmos (Sky World, Earth, Subterranean Waters).

I also find this particular wrapped ancestor–water source linkage in the petroglyphs at St. Lucia, well beyond the edge of the Greater Antillean interaction sphere of the Leewards. Image-makers here portrayed standard dead ancestors wrapped in the crosshatches of their hammock strings (Dubelaar 1995:Figure 172) like those in the Greater Antilles, but they much more frequently transformed those strings into the vertically stacked concave lines of the skeletal vertebral column using the shamanic device of x-ray depiction (Dubelaar 1995:Figures 159, 162, 164, 170).

Image distribution patterns suggest several other discrete tendencies (Table 15.5). With the exception of two pictographs identified by Richard (Chapter 10, this volume; disputed by Dubelaar 1995:42, 388–389) on Marie Galante, only petroglyphs are found from the Virgin Islands southward to Trinidad. The reverse applies to Aruba, Bonaire, and Curaçao, where pictographs

Table 15.4. Rock Art Site Locations

Island/Area	Number of Sites	Description
	Greater Antilles	
Bahama Islands	9[1]	8 solution caves; 1 solution hole[1]
Cuba	192[2]	Vast majority in cave and cavelike settings; 3 open air; 1 boulder along river[2]
Jamaica	39[3, 4]	Vast majority in caves or on nearby boulders; ½ of sites along watercourses[3, 4]
Puerto Rico	550+[5]	In descending frequency: caves and inland rock formations, boulders along watercourses, stone slabs lining ball courts, and beach rock[5]
Mona Island	4[6]	Caves[6]
Hispaniola		
Haiti	18[7, 8]	14 cave; 3 riverbed; 1 ball court[7, 8]
Dominican Republic	500+[9]	Primarily caves; rockshelters; rock formations; boulders along waterways; open air[9, 10]
U.S. Virgin Islands		
St. John	2[11]	1 on boulder at pool base; 1 on rocky outcrop at ocean edge[5, 11]
St. Thomas	1[5]	Rocky outcrop at ocean edge[5]
St. Croix	2[5, 11]	1 ball court; 1 rocky outcrop at ocean edge[5, 11]
British Virgin Islands		
Tortola	1[12]	Ball court[12]
	Lesser Antilles	
Anguilla	2[11]	Caves[11]
St. Martin	2[11]	1 in river valleys and ravines region (on hilltop); 1 in cave[11]
Barbuda	1[11]	Cave[11]
St. Kitts	4[11]	1 in river valleys and ravines region; 1 coastal; 1 on solitary rock in field; 1 unknown[11]
Guadeloupe	27[13]	24 on rocks/boulders in and along creeks/rivers; 1 on solitary rock in field; 2 in caves[13]
Marie Galante	1[11]	Cave[11]
Dominica	1[14]	Hilltop near spring, ravine locale[14]
Martinique	3[11, 15]	1 in river valleys and ravines region; 1 on hilltop; 1 in caves[11, 15]
St. Lucia	6[11, 15]	3 in river valleys and ravines region; 1 coastal; 1 on solitary rock in field; 1 unknown[11, 15]

Island/Area	Number of Sites	Description
St. Vincent	12[11, 15]	4 along/in creeks/rivers; 4 in river valleys and ravines region; 1 coastal; 2 on solitary rocks in field; 1 in rockshelter[11, 15]
Barbados	1[11]	Caves[11]
Grenadines	2[11, 16]	Solitary rock in field[11]; solitary rock near coast[16]
Grenada	6[11, 15]	2 along/in creeks/rivers; 2 coastal; 1 on solitary rock in field; 1 unknown[11, 15]
Trinidad	2[11]	1 on rock on riverbank; 1 on boulder[11]
Bonaire	14[17, 18]	Every site associated with Middle Terrace limestone caves and rockshelters[17]
Curaçao	38[18, 19]	Rockshelters; caves (both almost always associated with water)[18]; 36 rockshelters, 2 caves[19]
Aruba	22[20]	Dolerite boulder formations; limestone caves[20]

Note: Plus sign indicates additional sites.

Sources:
1. Winter, Chapter 2, this volume.
2. Fernández et al., Chapter 3, this volume.
3. Atkinson 2003b.
4. Atkinson, Chapter 4, this volume.
5. Hayward, Roe, et al., Chapter 9, this volume.
6. Dávila Dávila 2003.
7. Beauvoir-Dominique, Chapter 6, this volume.
8. Beauvoir-Dominique 2006.
9. López Belando, Chapter 8, this volume.
10. Atiles Bidó, Chapter 7, this volume.
11. Dubelaar 1995.
12. Drewett 2007.
13. Richard, Chapter 10, this volume.
14. Lenik, personal communication 2007.
15. Jönsson Marquet 2002.
16. Martin 2008.
17. Haviser, Chapter 12, this volume.
18. Haviser 2006.
19. Rancuret 2008.
20. Kelly, Chapter 13, this volume.

are exclusive except for two possible petroglyphs on Aruba (Kelly, Chapter 13, this volume) and some four petroglyph sites on Curaçao (Haviser Table 15.5). This disparity highlights the northern South American rather than Antillean affiliation of those islands. The Bahamas, Jamaica, Puerto Rico, and Hispaniola possess a majority of petroglyph sites, while pictograph sites outnumber petroglyph sites on Cuba and Mona Island. While petroglyphs and pictographs tend to occur separately, both forms are sometimes found together throughout the Greater Antilles (such as the three related Puerto Rican caves of Lucero, Mora, and La Catedral, discussed below).

Of the three anthropomorph categories (including theri-anthropic and avi-anthropic forms), zoomorphs, and geometric or abstract, the first class of

Table 15.5. Rock Art Image Site and Type Data

Island/Area	Description
Greater Antilles	
Bahama Islands	7 petroglyph sites; 1 pictograph site; 1 mixed types; 90+ petroglyph images, mostly anthropomorphic with several geometric and abstract images[1]
Cuba	122 pictograph sites; 60 petroglyph sites; 10 mixed types; simple anthropomorphs predominate in eastern region; geometric designs predominate in western region[2]
Jamaica	34 petroglyph sites; 3 pictograph sites; 2 both; petroglyph images mostly anthropomorphic/simple oval faces; pictographs have anthropomorphs (full body images) and zoomorphs; in general there are very few zoomorphs and even fewer geometric designs[3, 4]
Puerto Rico	Petroglyph sites outnumber pictograph and mixed sites 2 to 1; mainly anthropomorphs followed by zoomorphs and geometric designs[5]
Mona Island	1 petroglyph site; 1 pictograph site; 2 mixed types; 18 petroglyph images; 47 pictograph images; mostly anthropomorphs; some zoomorphs and geometric designs; 1 site has grouping of 4 handprints[6]
Hispaniola	
Haiti	Petroglyphs outnumber pictographs; anthropomorphs, zoomorphs, abstract images[7]
Dominican Republic	Majority petroglyphs with significant percentage of pictographs; mostly abstract/geometric designs; some anthropomorphs and zoomorphs[8, 9]
U.S. Virgin Islands	
St. John	2 petroglyph sites; 32 images: 24 anthropomorphs, 8 geometric designs[5, 10]
St. Thomas	1 petroglyph site; 13 images[5]
St. Croix	2 petroglyph sites; 13 images: 10 anthropomorphic, 1 zoomorphic, 2 indeterminate[5, 10]
British Virgin Islands	
Tortola	1 petroglyph site; 1 anthropomorph[11]
Lesser Antilles	
Anguilla	2 petroglyph sites; 40 images: 37 anthropomorphs, 3 abstract[10]
St. Martin	2 petroglyph sites; 1 anthropomorph, 1 zoomorph[10]
Barbuda	1 petroglyph site; 2 anthropomorphs[10]
St. Kitts	4 petroglyph sites; 65 images: 56 anthropomorphs, 9 abstract designs[10]; 77 additional images mostly simple faces and some enclosed figures[12]

Island/Area	Description
Guadeloupe	27 petroglyph sites; 1,100+ images[13]; Dubelaar subset of images (419)[10]: 325 anthropomorphs, 92 zoomorphs, 2 abstract designs
Marie Galante	1 petroglyph site; 47 images[10,13] plus or including 2 pictographs: 43 anthropomorphs, 4 abstract designs
Dominica	Petroglyphs; 7 anthropomorphs[14]
Martinique	3 petroglyph sites; Dubelaar subset: 16 anthropomorphs[10]; Jönsson Marquet subset: 25 anthropomorphs, 8 geometrics[15]
St. Lucia	6 petroglyph sites; Dubelaar subset: 15 anthropomorphs[10]; Jönsson Marquet subset: 27 anthropomorphs, 2 zoomorphs, 9 geometric designs, 1 undetermined[15]
St. Vincent	12 petroglyph sites; Dubelaar subset: 66 images: 46 anthropomorphs, 1 zoomorph, 19 abstract[10]; Jönsson Marquet subset: 45 anthropomorphs, 3 zoomorphs, 9 geometric designs, 2 undetermined[15]
Barbados	1 petroglyph site; 8 images: 5 anthropomorphs, 3 abstract[10]
Grenadines	2 petroglyph sites; 1 anthropomorph[10]; 1 geometric[16]
Grenada	6 petroglyph sites; Dubelaar subset: 109 images: 94 anthropomorphs, 1 zoomorph, 14 abstract[10]; Jönsson Marquet subset: 108 anthropomorphs, 6 zoomorphs, 9 geometric designs, 3 indeterminate[15]
Trinidad	2 petroglyph sites; anthropomorphs, zoomorphs; geometric designs[10]
Bonaire	14 pictograph sites; at least 15 handprint images; geometric designs; some anthropomorphs and zoomorphs[17,18]
Curaçao	38 sites with pictographs, 4–5 also with petroglyphs[18,19]; primarily geometric designs; some zoomorphs, rarely anthropomorphs[18]
Aruba	20 pictograph sites; 2 petroglyph sites; 300–350+ images; majority geometric designs with a few zoomorphs, anthropomorphs, and handprints[20]

Note: Plus sign indicates additional types, but specific number unknown.

Sources:
1. Winter, Chapter 2, this volume.
2. Fernández et al., Chapter 3, this volume.
3. Atkinson 2003b.
4. Atkinson, Chapter 4, this volume.
5. Hayward, Roe, et al., Chapter 9, this volume.
6. Dávila Dávila 2003.
7. Beauvoir-Dominique, Chapter 6, this volume.
8. Atiles Bidó, Chapter 7, this volume.
9. López Belando, Chapter 8, this volume.
10. Dubelaar 1995.
11. Drewett 2007.
12. Richard 2008.
13. Richard, Chapter 10, this volume.
14. Lenik, personal communication 2007.
15. Jönsson Marquet 2002.
16. Martin 2008.
17. Haviser, Chapter 12, this volume.
18. Haviser 2006.
19. Rancuret 2008.
20. Kelly, Chapter 13, this volume.

images predominates in the Greater and Lesser Antilles. Dubelaar (1995:27–29, 32–33) has emphasized the high percentage of small (average 23 × 25 cm), largely simple to elaborate humanlike facial images from Anguilla to Grenada. Although data are decidedly imprecise, size may correlate with image type, as pictographs tend to be larger and more complex than petroglyphs. Aruba, Bonaire, and Curaçao again stand out as distinct, with geometric motifs outnumbering anthropomorphs and zoomorphs.

Chronological Patterning

Dating Frameworks and Techniques

Improved chronological control over rock art sites in the past few years has come through direct dating for sites and the proposal of several island or regional relative sequences (Table 15.6). Such data indicate that (1) Caribbean rock art can be grouped into Preceramic, Ceramic, and Historic traditions; (2) the primary period of production occurs during the Ceramic Period; and (3) production may be discontinuous in some areas, while (4) certain linkages can be made between attribute distribution patterns and sociocultural developmental trends.

Dates of the rock art, along with a number of radiocarbon dates from associated materials, span the entire precontact period. Pictograph production appears with the first inhabitants of Cuba, perhaps as early as 7000 B.C., and Maciques Sánchez (2004) has grouped these images into the Unconnected Lines Style, with a seemingly random patterning of lines and dots executed in black. The succeeding Non-Concentric and Concentric Lines Styles, beginning around 350 B.C. and A.D. 850, respectively, introduce such characteristics as geometric shapes, red coloring, and the presence of some petroglyphs. These three styles are linked with Preceramic populations that apparently survived through the Ceramic Period until contact, as well as coexisting with Taíno groups. The latter arrived in Cuba by the Late Ceramic Period, A.D. 600, bringing with them rock art that emphasized figurative (anthropomorphic, geometric) designs and the first incising of petroglyphs.

Archaic Age pictographs are likely from Aruba, Bonaire, and Curaçao, in addition to the late Lithic or early Archaic Age carved and painted images from Cueva de Berna in the Dominican Republic. One of the petroglyph sites on Mona Island, Cueva de las Caritas, may be associated with a preceramic occupation, but the simple faces and wrapped figures that adorn its walls do not pertain to it, contrary to Dávila Dávila's (2003) conclusion and López Belando and Michele Hayward's (Chapter 8, this volume) suggestion. Although sites from these early periods have been documented from the Lesser Antilles, the Virgin Islands, and Puerto Rico, rock art production does

Table 15.6. Rock Art Chronological Indicators

Island/Area	Description
Greater Antilles	
Bahama Islands	A.D. 600–1500, based on only Late Ceramic Period occupation; possible early Historic images[1]
Cuba	Maciques Sánchez's relative sequence (based on radiocarbon dating of associated materials): Preceramic Styles 7000 B.C.–A.D. 955, Unconnected Lines Style 350 B.C. or A.D. 485–1492, Non-Concentric Lines Style A.D. 850–Contact, Concentric Lines Style Ceramic Style A.D. 500–Contact, Figurative Style with three substyles: Lineal Schematic, Filled Schematic, and Schematic and Geometric[2] Prehispanic, early Hispanic, African slave[3]
Jamaica	A.D. 600–1500, based on only Late Ceramic Period occupation[4]
Puerto Rico	Generally accepted as Late Ceramic through early Contact (A.D. 600–1524); Roe's relative sequence (based on radiocarbon dating of associated materials): Phase A, A.D. 600–1000 Phase B, A.D. 1000–1200 Phase C, A.D. 1200–1400[5]
Mona Island	Late Archaic, 1 site, based on physical association with a nearby site radiocarbon dated to 2380 B.C. Ceramic, 3 sites, especially Late Ceramic, Taíno culture[6]
Hispaniola	
Haiti	4000 B.C.–A.D. 1500+, Lithic/Archaic, Ceramic, postcontact African[7]
Dominican Republic	Radiocarbon dates for materials in direct association with Cueva de Berna indicate Archaic period, 1800 B.C.; 4000 B.C.–A.D. 1500, Lithic/Archaic, and Ceramic[8, 9]
U.S. Virgin Islands	
St. John	A.D. 1000–1400, Late Ceramic based on application of Roe's sequence[5]
St. Thomas	Late Ceramic based on association with sites of St. John and St. Croix[5]
St. Croix	A.D. 800–1500, Late Ceramic based on application of Roe's sequence[5]
British Virgin Islands	
Tortola	A.D. 1200, Late Ceramic, suggested dating[10]
Lesser Antilles	
Anguilla	A.D. 400–1500, Terminal Early Ceramic through Late Ceramic[11]
St. Martin	Suggested dating (Petitjean Roget) for Lesser Antilles in general beginning ca. A.D. 600, Terminal Early Ceramic[12]

Continued on the next page

Table 15.6. *Continued*

Island/Area	Description
Barbuda	Suggested dating (Petitjean Roget) for Lesser Antilles in general beginning ca. A.D. 600, Terminal Early Ceramic[12]
St. Kitts	Suggested dating (Petitjean Roget) for Lesser Antilles in general beginning ca. A.D. 600, Terminal Early Ceramic[12]; site with nearby settlement dating to Saladoid and Post-Saladoid or Early to Late Ceramic[13]
Guadeloupe/ Marie Galante	Suggested dating (Gilbert): 250 B.C.–A.D. 600, Huecoid and Saladoid Early Ceramic peoples Phases 1 and 2; Phase 3 Late Ceramic[12] Suggested dating, end of Early Ceramic to Late Ceramic, A.D. 600–900[14]
Martinique	Suggested dating (Gilbert): 250 B.C.–A.D. 600, Huecoid and Saladoid Early Ceramic peoples Phases 1 and 2; Phase 3 Late Ceramic[12] Jönsson Marquet suggests Early Ceramic, 400 B.C.–A.D. 300, through final phase Late Ceramic, A.D. 1300–1600[15]
St. Lucia	Jönsson Marquet suggests Early Ceramic, 400 B.C.–A.D. 300, through first phase Late Ceramic, A.D. 500–1000[15]
St. Vincent and the Grenadines	Not definitive: range of A.D. 1000–1500, also Early Ceramic or older[16] Jönsson Marquet suggests Early Ceramic, 400 B.C.–A.D. 300, through final phase Late Ceramic, A.D. 1300–1600[15]
Barbados	Late Ceramic, ca. A.D. 1100–1500[17]
Grenada	Jönsson Marquet suggests late phase Early Ceramic, A.D. 300–500, through final phase Late Ceramic, A.D. 1300–1500[15]
Bonaire	Of Aruba, Bonaire, Curaçao grouping, Bonaire second-oldest occupation, associated with red-, brown-, black-painted more complex designs[18, 19] Later Archaic for incipient development with majority of images made during Ceramic Period, A.D. 500–1500[18, 19, 20]
Curaçao	Of Aruba, Bonaire, Curaçao grouping, Curaçao oldest occupation, associated with only red-painted least complex designs[18, 19] 1405 B.C. radiocarbon date from materials in Savonet rock art site; both Archaic and Ceramic period use, with rock art more likely associated with Archaic phase[21] Several rock art sites in close proximity to radiocarbon-dated Early Archaic occupations, 2540–15 B.C.; many also produced during Ceramic, A.D. 500–1500[18, 19, 22]
Aruba	Of Aruba, Bonaire, Curaçao grouping, Aruba youngest occupation, associated with white-, red-, brown-, black-painted most complex designs[18, 19] A.D. 1000 AMS-derived date from one paint sample indicates transition between Preceramic, 2500 B.C.–A.D. 1000, and Ceramic, A.D. 1000–1515, periods; most rock art sites directly associated with Ceramic settlement sites[23]

Sources:

1. Winter, Chapter 2, this volume.
2. Maciques Sánchez 2004.
3. Fernández et al., Chapter 3, this volume.
4. Atkinson, Chapter 4, this volume.
5. Hayward, Roe, et al., Chapter 9, this volume.
6. Dávila Dávila 2003.
7. Beauvoir-Dominique, Chapter 6, this volume.
8. Atiles Bidó, Chapter 7, this volume.
9. López Belando, Chapter 8, this volume.
10. Drewett 2007.
11. Crock 2006.
12. Dubelaar 1995.
13. Richard 2008.
14. Richard, Chapter 10, this volume.
15. Jönsson Marquet 2002.
16. Martin 2006.
17. Farmer 2005.
18. Haviser and Strecker 2006.
19. Haviser 2001.
20. Haviser, Chapter 12, this volume.
21. Haviser 1995.
22. Rancuret 2008.
23. Kelly, Chapter 13, this volume.

not appear to have begun there until the later Early Ceramic in the Lesser Antilles and until the Late Ceramic in the Virgin Islands and Puerto Rico. All rock art in Jamaica and the Bahamas also belongs to the Late Ceramic Period, in these cases because permanent settlement did not occur until then. Post-contact production by African groups has been well documented for sites in Cuba (Fernández Ortega et al., Chapter 3, this volume) and Haiti (Beauvoir-Dominique, Chapter 6, this volume).

In addition to the seriation for Cuban pictographs by Maciques Sánchez (2004) and my three-phase ordering for Puerto Rican anthropomorphic petroglyphs, Gilbert (1990) proposes a relative chronology for Guadeloupe and Martinique based on images from those islands. While some of his conclusions are doubtful (a Huecoid association for an early phase, although no similar images are known from Vieques or Puerto Rico, its principal loci), his sequence has heuristic value. Sophia Jönsson Marquet (Chapter 11, this volume) has assayed a four-phase sequence for the Windwards, also not without inconsistencies. Her third phase contains motifs that are simpler than those of her second phase, while both stages appear to have overlapping beginning and ending dates. The order may be inverted, or perhaps partially contemporaneous. Yet her corpus and variables are carefully chosen and multidimensional, yielding hope that her seriation will be refined and extended.

Cross-media isomorphisms offer another technique to date rock art. After accounting for media-based differences, the procedure involves the charting of structural and pictorial parallelisms between rock art and other forms of carving in obdurate materials like shell-wood-bone, as well as incising in yielding media like clay. If any of those latter examples are well dated, then, by extension, so too is the rock art.

This technique remains woefully underemployed in the Caribbean. This is unfortunate since cross-media isomorphic studies have proved their effec-

tiveness in charting chronological placement and cultural affiliation for especially difficult-to-place individual and local rock art sites. Further, these types of studies certainly can and should be integrated into wider existing or future time-space frameworks.

Present examples of the technique's application include the similarities I noted in the depiction of the rayed-face design between Elenan Ostionoid ribbed vertical handle figurative *adornos,* or decorative lugs, and contemporary petroglyphs (Roe 2004). For two of my three sequential phases for Puerto Rico (Roe 1993b) I incorporated likenesses between Classic Taíno *menhir* or large boulder petroglyph body incisions and the incised designs on contemporary Chican Ostionoid (Capá) above-shoulder, below-rim continuous incised design panels on restricted bowls.

Apart from Puerto Rico, two notable case studies involve the Lesser Antilles and Cuba. Annie Cody (1990) devised a four-part classification of Grenada petroglyphs while noticing design and decorative motif similarities with Modified Saladoid pottery from the Pearls site. Calvera and Funes (1991:Figure 7) pointed out isomorphisms between pictographs in the Cueva el Indio and the ceramics of the Samí I and II sites in Cuba.

In terms of rock art traditions, a distinction can be made between the rock art of the earliest preceramic and that of the later ceramic-producing populations, with lower Central American and northwest South American origins for preceramic groups and northeast South American lowlands origins for ceramic populations.

Preceramic peoples produced primarily pictographs, consisting largely of abstract and geometric designs. In fact, more than 90 percent of the Cuban pictographs may be associated with Archaic cultures (Dacal Moure and Rivero de la Calle 1996:36). Perhaps such images mirrored the small-scale and egalitarian nature of their society by emphasizing simple geometric designs like concentric circles (Dacal Moure and Rivero de la Calle 1996:Color Plates 3–4, Black and White Plates 10–11). The unpatterned lines that also characterize Caribbean Lithic and Archaic traditions parallel unstructured images and the profusion of similarly unordered early hand stencils of South American Paleo-Indian cave sites.

In contrast, ceramic-producing populations created more equal distributions of pictographs and petroglyphs and in an increasing array of types and complexity. Differences in elements, motifs, and layouts mark each of the traditions. For example, although patterns of concentric lines are present in both Preceramic and Ceramic contexts, in the latter they are stylistically different, having a more complex syntax and appearing with simple anthropomorphic faces (compare Figures 4 and 15 in Maciques Sánchez 2004).

Cuba provides the most convincing evidence for continuous production

from the Lithic through Historic periods. This may not be the case elsewhere in the region. The Early Ceramic Saladoid peoples moving into the Lesser Antilles, Virgin Islands, Puerto Rico, and easternmost Hispaniola by at least 250 B.C. apparently did not immediately produce rock art. This gap is especially marked in Puerto Rico, assuming my proposed chronology is correct. The association of rock art on this island with only Ostionoid groups relates to the concept of culture lag and the increasing sociopolitical structure of the post-Saladoid Late Ceramic Period.

Culture lag involves a tendency for different cultural institutions, despite their mutual interaction, to change at disparate rates. This occurs when the internally conservative realms of ideology (religion, visual expression) transform more slowly than the environmental-adaptive aspects of techno-economy or social structure. This is particularly the case when movement over space and time are involved, as cultures tend to bring their conceptual as well as physical baggage with them.

The Saladoid conceptual framework, as deducible from their diet and material culture, reflected their lowland South American homeland, rather than that of their new island homes. The material culture was characterized by what I have termed "personal presentation" items that focus on individuals, societal subgroups, and status. These items included pottery manufactured in a variety of complex vessel shapes with plastic and painted designs, as well as small, intricately worked beads and stone pendants of frequently exotic materials. Such items are clearly consonant with Amazonian peoples' ethno-aesthetic emphasis on the need to produce new items for social or ceremonial occasions and on the requirement for personal creativity (Roe 1995a, 1997b).

Saladoid visual depictions also harkened back to South American origins, with such fauna as tapir, capybara, and monkeys commonly modeled into effigy handles on vessels or as hollow polychrome-painted ceramic figurines. Artisans were looking backward, to where they came from, rather than at their new surroundings. The same mental constraints may have functioned to delay rock art production, even though Puerto Rico possessed an abundance of suitable locations. Perhaps not being used to having rock resources or to producing rock art in their original largely alluvial homeland, the new arrivals simply did not avail themselves of the now plentiful rock surfaces to create petroglyphs or pictographs.

By pre-Taíno times, around A.D. 600, outlooks began to change as adjustments to the distinct island environment took hold. New fauna were increasingly detailed on items from pottery to stonework. While rock art occurs in caves and along watercourses, it is especially linked with the initial Late Ceramic appearance of ball courts that normally incorporate flanking rock

boulders frequently adorned with carved images. It is no accident that both of these elements, at least for the Caribbean, appear at the same time. They represent a shift in the material culture from "personal presentation" to "public power," as Oliver (1998, 2005) and I (Roe 1993b) have argued for the premier ball court complex and petroglyphs of Caguana.

Ball court petroglyphs display an increase in complexity and layout that mirrors the evolving sociopolitical structures. The early Tibes ball court site (González Colón 1984) possesses small, simple humanlike faces that become more elaborate at later ball court sites such as El Bronce (Robinson 1985). At the latter site an emphasis on facial embellishments including elaborate headgear, necklaces, and ear adornments is evident, all of which may reflect status, gender, ethnic affiliation, or other group identity. Insular fauna is also depicted in the shape of a large profiled shark alongside a human face. By near-contact times, as at Caguana or the newly discovered Jacana ball court site near Ponce (Toner 2008), fully rendered anthropomorphs are being executed, status or group identity elements are enhanced, and the use of island fauna such as dolphins proliferates. Even though the iconography and layout can be read as the visual representations of oral tradition, they can also be interpreted as sociopolitical proclamations of privilege.

Rock Art Dating and Stylistic Delineation

An area of investigation that involves the testing of chronological models concerns stylistic definition in the Caribbean. Apart from the delineation of preceramic vs. ceramic traditions, the most active research into this question has centered on the eastern half of Hispaniola by Dominican investigators. Beauvoir-Dominique (Chapter 6, this volume) also provides an important update of the documentation of Haitian Amerindian rock art on the western half of the island.

Atiles Bidó (Chapter 7, this volume) includes descriptive criteria for the demarcation of two Dominican petroglyph schools: the Anamuya and Chacuey. The five pictographic schools recognized by Atiles Bidó or the three delineated by López Belando (Chapter 8, this volume) are more geographically circumscribed than those of petroglyphs. Some are confined to a single cave, thus showing a pattern of greater differentiation that, perhaps, as on the South American mainland, argues for its greater antiquity. Most occur in black, complemented by red and white hues. The mode of application is either positive or negative and the paint is applied in fine or thick lines. The method of application, in particular, seems to be a useful stylistic-recognition trait. Unfortunately, we lack regional site maps showing the exact territorial extent of these schools.

An example of a micro-stylistic grouping on Puerto Rico may be defined

as the Mora style, which centers on three caves: Mora, Lucero, and La Cate-dral. The common denominators involve the relationship between each of the caves' petroglyph and pictograph groupings, a friezelike image arrange-ment, and micro-macro-cosmic recapitulation.

The Cueva de Mora near Comerío in the central highlands represents a huge mountain limestone cavern complete with two solution tube entrances, above and below a giant central chamber (Roe 2005). The greatest accumula-tion of both life-sized pictographs and petroglyphs on the island can be found inside. The small petroglyphs, most of them simple faces and enclosed figures (Roe 2005:Figures 8.18a–c), "guard" both upper and lower portals, while the contemporaneous central chamber contains only pictographs. Many of these latter images comprise polychrome versions of enclosed anthropomor-phic figures (Roe 2005:Figure 8.19). Enclosed figures have been interpreted as representing dead ancestors wrapped in their hammocks, with the internal crosshatched lines indicating hammock netting (Roe 2005:326–327). Stylis-tically, both the petroglyphs and the pictographs in this cave date to the early Taíno period (A.D. 1200–1350).

Apparently the central chamber pictographs comprised the major cult images, full of shamanistic iconography and directly reflective of the early chronicler Fray Pané's writings. We have not only a structural relationship between two forms of rock art, petroglyphs and pictographs, but also a pat-tern of functional complementarity (*peripheral solution-tube entrance petro-glyphs : portal "guardians" :: central pictographs : major "cult images"*).

The entire upper dry, or visited, cave and the lower wet, or nondecorated, cave chambers form a microcosmic recapitulation of the indigenous macro-cosm. The waters of the lower cave begin the subaquatic travels of the Spirits of the Dead to the rivers below and ultimately to the sea and the Island of the Dead in the west.

This reconstruction corresponds to the same multileveled world of super-imposed floating or curved platters (Siegel 1997:Figure 1) deducible from the oral traditions and the chronicler-recorded mythologies, themselves a conser-vative legacy of the prototypical Amazonian cosmos (Roe 1982:Figure 3).

We can even speculatively map this iconographic-media-and-spatial di-chotomy (*portal guardian petroglyphs/central chamber pictographs*) of cosmologi-cal import onto the two-tiered rank society of the developing proto-Taíno chiefdom social structure. Perhaps male representatives (lineage elders) of the commoners could visit the guardian petroglyphs, to worship their ancestors in the accessible solution tube entrances, while the noble elite and their sha-mans could pass beyond them and had exclusive access to the interior. This hidden and inaccessible central chamber contained large, complex, and life-sized polychrome pictographs. Beyond those images, far above and stretching

into the semidarkness beyond the light boundary, lay, painted upon the upper walls and ceiling, their entire cosmological framework, revealing ample esoteric knowledge for such a privileged audience. In this manner rock art imitated social life, reinforcing it with images drawn from its mythic charter.

Another, parallel, case of petroglyph/pictograph spatial division is present at Cueva Lucero located in southeastern Puerto Rico (see description by Alvarado Zayas, Chapter 9, this volume). There, petroglyphs also occupy a "guardian" position at the entrance (Galleries A and B) while pictographs reside in the large interior chamber, accessible to the elite. Within the cavern there are other, even more restricted areas (Galleries C and D), which are so narrow that perhaps only shamans entered to execute the pictographs (Walker and González Colón 2002:9). A further point of structural contrast between petroglyphs and pictographs, at least in Puerto Rico, concerns the tendency for the former to be in dimly lit entrances while the pictographs reside in completely dark interior spaces, thus forming the further congruent equation *petroglyphs : dimly lit, semipublic entrances :: pictographs : completely dark, fully sacred and restricted elite places* (Roe et al. 1999).

The last member of the Mora style was mapped and recorded by Marlén Díaz González (1986, 1990). It, too, is a limestone solution cavern, Cueva la Catedral of Bayaney, Hatillo, part of the extensive Camuey system near Arecibo in the west-central highlands. La Catedral also has petroglyphs near the entrance (Figure 15.1a), semilit by ceiling apertures, along with unique plastered red ochre faces. They lead to a central chamber with a dark, uninhabited wet cave lying below a sinkhole (Figure 15.1b), like Mora, and to larger and more elaborate pictographs in a long lateral chamber (Figure 15.1d), the visual focal point. These pictographs (Figures 15.2 and 15.3) are stylistically similar to those at Mora and Lucero and also echo the Taíno pictographs in Hispaniola (Figure 15.4h-1 to h-7), especially the avian fauna at Cuevas de Borbón. They were first roughed out in black charcoal and then painted in red ochre, perhaps with a vegetable-oil binder. As at Mora, in the deepest interior the red has become fugitive, leaving black monochrome drawings. Alternatively, a unique superimposition of red pictographs over the black ones (Figure 15.4h-12/13) may imply the latter's temporal priority.

Most important, a test excavation at the base of the drawings uncovered a hearth 30 cm below the surface in a well-sealed stratum. Its carefully collected charcoal yielded the congruent date (compatible with the stylistics of the drawings) of B.P. 550 ± 70 or A.D. 1330–1470.

The whole series of pictographs (Figures 15.2–15.4), along with Díaz González's triangulated ground plan (Figure 15.1), I have recast and redrawn using her photos and drawings as guides (Díaz González 1986, 1990). Her 1:1

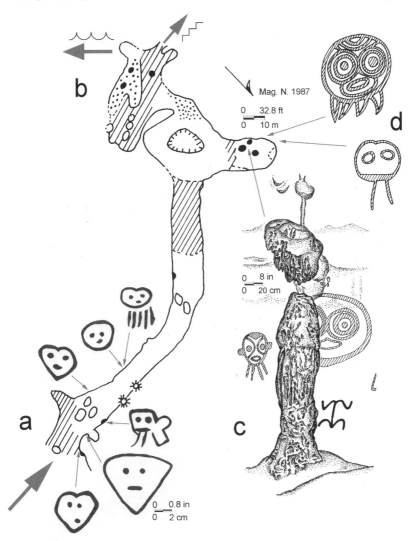

Figure 15.1. Plan and rock art of Cueva la Catedral, Hatillo Municipio, Puerto Rico (redrawn and recast from Díaz González 1986, 1990).

tracings maintained all the spatial relationships, with the recast images now forming another veritable frieze.

I have relabeled the following groups from Díaz González (1990) to correspond to more thematically—and spatially—related clusters. They begin with a "secular" group (Figure 15.2a) including an intricate rayed face (Figure 15.2a-1), like the plumed head at Mora, and another large and elabo-

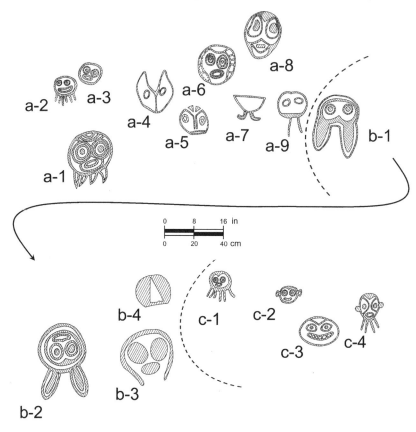

Figure 15.2. Cueva la Catedral pictographs, Group a–c, Hatillo Municipio, Puerto Rico (redrawn and recast from Díaz González 1986, 1990).

rate early semicircular crowned face (Figure 15.2a-6), all representative of elite *cacical* personages. Group b shows an inverted rabbitlike head (Figure 15.2b-2) along with a large ghostly head (Figure 15.2b-3), introducing "sacred" ancestral themes. A rayed face in Group c (Figure 15.2c-1) replicates a petroglyph from the entrance (Figure 5.1a), thereby arguing for their contemporaneity, again as at Mora and Lucero. Several heads (Figure 15.2c-1 to c-4) betray the characteristic V-shaped Taíno hairline producing the typical heart-shaped heads of my final Phase C dating sequence. One even sports rare teeth in a smiling mouth (Figure 15.2c-3), recalling the carved shell "denture" inlays in wooden sculptures.

Group d (Figure 5.3d-1 to d-4) sees several small, curvilinear stick, froglike figures (Figure 5.3d-2), perhaps alluding to the *cemí* Attabeira frog progenitrix. A huge goggled-eyed owl face (Figure 15.3d-1) introduces that

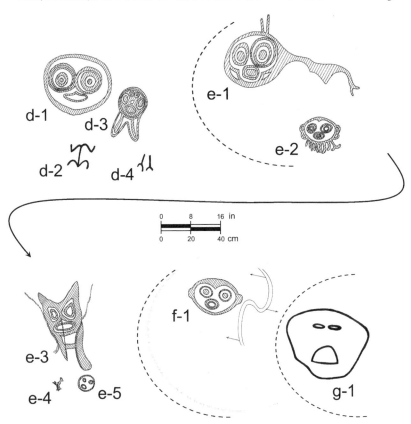

Figure 15.3. Cueva la Catedral pictographs, Group d–g, Hatillo Municipio, Puerto Rico (redrawn and recast from Díaz González 1986, 1990).

companion and herald of the dead. The owl and the froglike figures bracket a large phallic-looking stalagmite that rises erect and nearly enters a vagina-like curved stalactite painted red (Figure 15.1c). Díaz González (1990:44) reasonably infers that this geofact pair has been made to look like a bloody mons pubis and vagina (mythically, intercourse causing first menstruation, hence fertility). These fecund consort organs, like excessively libidinous somatic South Amerindian imagery, also carry mortal connotations (too much life force is deadly, as is inferred from the dangerously seductive nocturnal Opía of Taíno oral tradition), hence the skull-like rayed face (Figure 15.3d-3) of this group.

Progressing farther into the dark passage, our sequence continues with Group e centered on a large goggled-eyed head trailing a snakelike element (Figure 15.3e-1) (just as the small Puerto Rican boa hangs from branches

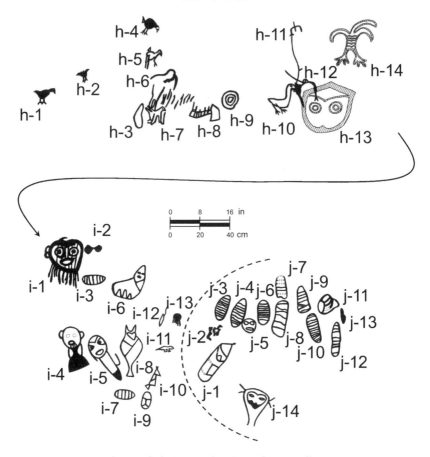

Figure 15.4. Cueva la Catedral pictographs, Group h–j, Hatillo Municipio, Puerto Rico (redrawn and recast from Díaz González 1986, 1990).

at the mouths of caves to catch the departing bats at dusk) and an oversized pointed-eared bat head (Figure 15.3e-3). The latter is painted on a triangular ridge of dripstone that replicates the same volumizing strategy employed at Mora.

After another heart-shaped head (Figure 15.3f-1) there is a spatial hiatus until a large fugitive black-painted head of Group g (Figure 15.3g-1). Then, following another lacuna, little birds appear in Group h (Figure 15.4h-1 to h-7). They are like their Dominican counterparts and may add the winged vehicles of "shamanic ascent" to the mural. Alternatively, they could depict a bird-trapping episode with one pictograph (Figure 15.4h-8) representing the trap. After the last red-painted figures, an anthropomorphic face (Figure 15.4h-13) and a large, complex heraldic bird (Figure 15.4h-14) lead to

the next group, Group i, which depicts the last rayed face (Figure 15.4i-1) of the mural.

This group intensifies the "sacred" theme by depicting the upper part of the first complete wrapped ancestor (Figure 15.4i-4) or, as Díaz González (1990:157) believes, ancestress. He or she appears along with a complete example of a wrapped figure (Figure 15.4i-5) and a curious eared (bat?) wrapped figure (Figure 15.4i-8). The most important image in this group is a unique seated wrapped ancestor whose face actually materializes, chrysalis-like (Figure 15.4i-6). He is the graphic "key" that identifies the otherwise enigmatic wrapped lozenges (Figure 15.4i-3, i-7) that now appear.

This figure also introduces the last group, j, the most sacred, in, predictably, the dimmest end of the chamber. I suggest that these lozenges, which predominate in this group (10 of the 14 images: Figure 15.4j-1, j-3, j-4, j-6 to j-12), figuratively stockpiled at the end of this dark passage, are the wrapped ancestors themselves. Indeed, their tightly bound bodies may have actually been placed in such cave galleries. It may be no coincidence for an Amerindian culture that modeled culture on nature that such carefully sequestered and enveloped dead look like so many stashed egg capsules in an ant nest's subterranean tunnels and are particularly evocative given that culture's life-death nexus.

While superficially these images look just like netted "geometric" or "abstract" lozenges, Figure 15.4i-6 proves that they are really representational images of the wrapped ancestors themselves, but with their heads hidden inside the wrapping. Moreover, the lined lozenges appear very similar to the lozenge-shaped torsos of the more complete wrapped figures with their own internal lines.

These Cueva la Catedral lozenges appear with a single long-necked, triangular heart-shaped head (Figure 15.4j-14) with closed slitlike, or dead-indicating, eyes, attached to an upper torso that I interpret to represent the *cemí* in-dwelling within a three-pointer. Perhaps the *cemí* is Yúcahu, the male god of manioc, and hence represents horticultural fertility. Maybe the wrapped dead, like an elongated cassava tuber, embody rebirth as the source of the sustenance of the living (see also Roe 1995b), thereby completing the life-death-life circuit.

A similar case of the coexistence of petroglyphs and pictographs has been recorded for Caverna de Patana in southeastern Cuba, in roughly the region where the Taíno first entered the island. There, a guardian anthropo-morphic petroglyph was incised into a stalagmite that was positioned near the entrance while on the sides a complex pictographic group of anthrozoo-morphic figures appear to be emerging from the interior. Analysts (Dacal Moure and Rivero de la Calle 1996:46) suggest that this conjunction made

up yet another frieze, in effect paraphrasing the important emergence myth of the guardian-turned-to-stone Mácocael as recorded by Pané (1974). In both cases the conjunction of these two major types of visual expression possesses a strong narrative function, on the level of myth (Caverna de Patana) as well as on the level of the sacred cosmology it generates (Mora, Lucero, La Catedral).

Regarding Lesser Antillean stylistic diversity, Jönsson Marquet (Chapter 11, this volume) notes that in the Windward Islands, St. Lucia's north displays a different design pattern than the south. I suggest two additional examples. If one examines the petroglyphs from Grenada through the Grenadines to St. Vincent of the Windwards it becomes apparent that motifs such as an extended thin medial line that projects from heads or other parts of drawings (Dubelaar 1995:Figures 10 and 36, no. 31, for Grenada, Figure 78 for Canouan in the Grenadines, and Figures 82-2, 100-2, 100-4, 100-6, and 119-1 for St. Vincent) create a unique local grouping. Similarly, the lozenge-like eyes of St. Vincent petroglyphs that extend laterally beyond the head-like wings are another unique graphic local device (Dubelaar 1995:Figures 125-2, 125-6, 132-1) that may find cross-medium similarities in ceramics, helping to date them.

Similar detailed discriminations can be applied to rock art syntax rather than just elements or motifs. This is what allowed, for example, the definition of a "Mora school" in Puerto Rico, the systematic use of spatial patterning (flanking guardian complementarity in petroglyphs vs. greater elaboration in central pictographs) along with apparent frieze organization and micro-macro-cosmic recapitulation. In turn, such a school might articulate with one of the Dominican schools as defined in this volume to build multi-island interaction spheres that may also be evident in other domains.

Rock Art, Paradigms, and Migration

Hofman et al.'s (2007) recent and comprehensive survey of long-distance exchange and interaction spheres in the Lesser Antilles mentions ceramics, lithics, and bone and shell artifacts as evidence, but not petroglyphs. As outlined in the beginning of this chapter, such trends I trust are fading. Rock art data are clearly relevant to questions of sociopolitical development in the region and, I will argue here, of relevance in both new paradigm and old migration debates.

Reconstructions of chronology, culture history, and process in the pre-contact Caribbean are currently undergoing significant revisions, especially since the death of Irving Rouse, their principal architect. His vision of regional social development was firmly grounded in an intimate exposure to northern South American culture history. He viewed ceramic-producing

horticultural societies, the Taíno in particular, as derived from this area (Rouse 1992). Challenges are emerging as a new generation of Caribbean scholars emphasizes local complexities or autochthonous origins over the panoramic scope of Rouse.

Both regional and nationalist elements are involved in this revisionism. This is not just simple parochialism, however, but is abetted by important new findings such as the possible Archaic parallel origin of rudimentary ceramics in Hispaniola (Atiles Bidó and López Belando 2006) and the recent chemical evidence for experimentation with cultigens among similar populations (Pagán Jiménez and Rodríguez Ramos 2007). William Keegan (2007), for example, has argued, along with his student Reniel Rodríguez Ramos (Keegan and Rodríguez Ramos 2007), for the Archaic origin of the Classic Taíno of Puerto Rico and Hispaniola, thus denying an Amazonian affiliation. These debates are central to regional studies of petroglyphs and pictographs since the rock art, by exhibiting a continental affiliation, contradicts the new non–lowland South Amerindian position. Another scholar, Samuel Wilson (1997), sees much greater ethnic diversity in the Antilles than populated Rouse's reconstruction, based as it was on peoples rather than ethnic groups. This argument too lends itself to autochthonous development rather than lowland South Amerindian migration.

Both of these perceptions are rooted in new readings of the ethnohistorical literature and novel interpretations of the archaeological evidence. Latterly, it is partly steeped in the old perception that Ostionoid pottery looks so different from that of the antecedent Saladoid tradition that it cannot be a descendant. Instead, Ostionoid ceramics must represent either a separate migration (Alegría 1997:18) from the South American mainland or the product of distinct descent from the even earlier Huecan Saladoid series (Chanlatte Baik 2007) or, in a recent turn, indigenous Hispaniolan Archaic ceramics (Keegan and Rodríguez Ramos 2007).

Rouse (1992) and I (Roe 1989), in contrast, have argued that social and informational processes better explain the ceramic devolution or changes that we see from the earlier painted Saladoid series to the plastic-decorated Ostionoid series. Moreover, we see this differential process of evolution from the perspective of a cultural continuum originating with the earliest Saladoid migrants and continuing down to the latest Taíno descendants over some 2,000 years. While we emphasize the firm Amazonian-Guianan roots of the ancestral migrants, we also stress the profound local accommodations and adaptations of their Caribbean descendants.

To show that this was a continuum, and not the effect of separate migrations or distinct regional antecedents, I charted the strong stylistic elements that united earliest Saladoid with latest Taíno style via a componential and

generative grammatical analysis (Roe 1989), as well as a symmetry analysis (Roe 2004). Peter Siegel (2007) has made a similar argument based on site settlement structure between Saladoid and current lowland Amazonian (particularly Guianan) village plans.

In terms of ritual behavior and its material cultural lowland parallels, the detailed pictographs of the Cuevas de Borbón school (Pagán Perdomo 1978b) in the Dominican Republic also argue for continuity. One can do the ethnography of the Taíno using them just as one can conduct ethnographic inquiry utilizing the pottery of the ancient Moche of Peru. There are no better examples of modern lowland South Amerindian ethnography, in everything from *cohoba*-taking to *areytos* (see Hayward, Atkinson, and Cinquino, Introduction, this volume), than its iconography, something that many Dominican archaeologists have recognized.

Lastly, on a mythic and cosmological level, I (Roe 1982:191) and many others (López Baralt 1985; Robiou Lamarche 2003) have long argued for an Amazonian derivation of Classic Taíno oral tradition as recorded by such early chroniclers as Fray Ramón Pané (1974). If the Taíno are the descendants of Archaic Caribbean populations, why is it that all their art, their myths, their multileveled cosmology, and even their ethno-astronomy are decidedly Amazonian?

Does this leave Rouse's synthesis unmodified or the arguments of critics baseless? Not at all: the new data reinforce the cultural resiliency of the indigenous Archaic substratum, both that of the Casimiroid series on Hispaniola and that of the Ortoiroid across the Straits of Mona frontier in Puerto Rico. These were the native or local groups that the Saladoid, both Cedrosan and Huecan, had to confront. As Angostura on the north coast or Maruca on the south coast of Puerto Rico illustrate, their villages were larger, more sedentary, and their technology more advanced than anything previously contemplated (Rodríguez Ramos 2005:4–6). That strength helps to explain two aspects of Saladoid settlement patterns: their isolated or discrete nature and their exclusive placement along the coasts of Puerto Rico. It also illuminates what kept Saladoid populations from expanding either into the interior there or into more than a toehold on eastern Hispaniola. The resident Archaic inhabitants were not about to easily concede land or resources to any new arrivals.

Saladoid populations did not begin to penetrate the interior of Puerto Rico until the end of the Early Ceramic Period, around A.D. 350. The crudity of later Ostionan Ostionoid and particularly Meillacan pottery in Hispaniola might indeed reflect Archaic influences from groups that already possessed a rudimentary ceramic tradition, as Veloz Maggiolo et al. (1974), Keegan (2007), Keegan and Rodríguez Ramos (2007), and López Belando

(2007) have argued. Such a change is an important modification of Rouse since he placed Meillacan pottery in the Ostionoid series.

However, I do not follow Keegan (2007) in also hiving Ostionan Ostionoid away from the Saladoid tradition and deriving it too from the Archaic peoples, largely because of its close relationship to Elenan Ostionoid as Rouse (1992) pointed out. Nevertheless, there may be some Archaic pottery influence in certain of the Ostionan materials, particularly the exaggerated boat-shaped "winged" vessels with their crude anthropomorphic *adornos*.

My own experience with Early Elenan pottery (Roe et al. 1990), including a recent detailed analysis of more than 40 similarly dated whole vessels from the Puerto Rican site of San Lorenzo, demonstrates that clear continuities, as well as progressive simplifications, firmly link the Early Elenan Ostionoid with both the Later Ostionoid and earlier Saladoid styles. This internal developmental ceramic consistency for the Puerto Rican eastern interchannel zone is paralleled in Lundberg's (2007) analysis of Virgin Islands early ceramics and can be demonstrated for at least certain Lesser Antillean islands.

Caribbean rock art studies are further affected by the recent "chronometric hygiene" approach to radiocarbon dates initiated by Fitzpatrick (2006). Such efforts are needed, given a tendency to accept such dates without critical examination in a region characterized by the bioturbation of midden deposits. After single-only dates for sites, as well as questionable ones, were rejected, Fitzpatrick noted a paucity of early dates in the Lesser Antilles that could be used to support the traditional "stepping-stone" model of early Saladoid advance from South America up the Lesser Antillean chain, stopping at most if not all of the islands. Dates now emphasized the early entry into the eastern Greater Antilles (specifically Puerto Rico) and the adjacent Virgins and other Leewards. It implies, as Callaghan (2003) suggested, based on his computer simulations of voyage probabilities into the Caribbean, that the early Saladoids might have made it to Puerto Rico and adjacent regions directly, bypassing or only stopping off at the islands of the Lesser Antilles. Later voyages could also have done the same thing, explaining the nonappearance of some rock art motifs, such as faces with rays, concentric circles, frog-bodied anthropomorphs, and those with diamond-shaped torsos (Dubelaar 1995:38).

We can combine these data with Dubelaar's (1995:27), based on a comprehensive survey of the rock art of the Guianas, eastern Venezuela, and the Lesser and Greater Antilles (through Puerto Rico), showing the rock art of the Caribbean differs significantly from that of the mainland, despite some general and specific parallels. If the Saladoid original horticultural migrants had brought rock art with them such stylistic dissimilarity would not be found. This new association may reinforce my earlier assertion that Saladoid

populations produced no rock art in the Greater Antilles. That is, if petroglyphs and (figural) pictographs come in with the Early Ostionoid in the Puerto Rico/Virgin Islands interchannel zone, as my seriation suggests, then an initial direct Saladoid arrival without them would make of Antillean rock art an indigenous development, perhaps one emerging out of the social processes already outlined. On the other hand, its general similarity to the rock art of the Guianas, specifically in the wrapped body figures, would still support the broad "out of Amazonia" hypothesis of Rouse, especially when this rock art is compared with the rock art of other New World regions as Fewkes (1903:463–464) noted long ago.

Certainly, later direct contact is indicated by the specific near-identical rendering of the Elaborate Type hemispherical-crowned and radially rayed wrapped figures of the Lesser Antilles (Dubelaar 1995:Figure 119-1, Yambou Valley, St. Vincent) and those recorded in much greater abundance and variety from eastern Guyana and western Suriname (Dubelaar 1986a). Their appearance in both places certifies later direct interaction and diffusion while their general similarity to earlier Greater Antillean wrapped figures, both crowned and uncrowned, sketches a more general Amazonian-Guianan derivation for all such images.

New chronometric hygiene, when coupled with the "Age-Area Hypothesis" (the old Germanic "Culture Circle" notion that archaic styles can be found on the periphery of a cultural sphere), may also explain why although there are no Greater Antillean Saladoid petroglyphs or pictographs, there are unequivocal Lesser Antillean ones. Sites such as Golden Rock in St. Eustatius indicate that Saladoid culture hung on far longer in the Lesser than in the Greater Antilles. Locally this period is called "Terminal or Modified Saladoid" and dates from the sixth to the ninth centuries A.D.

In effect, the Late Saladoid petroglyphs in the Lesser Antilles date to the same time as the Early Ostionoid images of the Greater Antilles and probably were stimulated by them. Moreover, as this and Dubelaar's survey show, Trinidad, supposedly the first of the "stepping-stones" to the Lesser Antillean Windwards, has one of the lowest densities of rock art in the Caribbean. The petroglyphs that do exist there are directly evocative of Guianan motifs in their diamond-shaped torsos (Dubelaar 1995:Figure 643).

In the other direction, from Puerto Rico to the rest of the Greater Antillean islands, Atkinson's data (Chapter 4, this volume) modify Lee's (1990, 2006) cross-media dating of Jamaican petroglyphs exclusively with the local Meillacan pottery, the White Marl style of the Late Ceramic. Instead, Atkinson suggests that the island's first petroglyphs came in with the earliest Ostionan Ostionoid migrants, before the Meillacan occupation. This pattern once again emphasizes the fact that both figural (as distinct from

the much earlier Archaic geometric) pictographs and petroglyphs are essentially an Ostionoid (Elenan and Ostionan) development. Such an association would account for the clear cross-media isomorphisms between Elenan handle *adornos* and petroglyph faces-with-rays motifs as far away as Utuado (Roe 2004:Figure 7.8b). Westward, to Cuba, the great stylistic differences between the Archaic pictographs and the later Taíno petroglyphs are further evidence for an Ostionoid origin of the phenomenon. The same can be said for the Bahamas (Winter, Chapter 2, this volume). Thus rock art supports the new "direct contact" (see also Dubelaar 1995:38) model rather than the "stepping-stone" model for South Amerindian horticulturalist-ceramicist movement into the Caribbean.

Conservation Issues

The colonial legacy of the Caribbean is evident in the multiple frameworks for the legal protection and conservation of cultural resources, including rock art, outlined in Table 15.7 and detailed in this volume. The legal frameworks vary from robust legislation to weak laws and minimal effectiveness to no formal protection. Management plans are in place for some areas, as are community-based monitoring and protection strategies. Yet much more needs to be done to both document and preserve the region's rock art (see also discussion by Haviser and Strecker 2006).

Such efforts are critical since human and natural negative impacts on the images range from drastic to hard to detect. On one visit to a cave site, I was confronted with the evidence of the chiseling-out of at least one large petroglyph. More insidious is the retouching or defacement of the rock art with paint or other materials, as pointed out in this volume. Entire re-creations of false pictographs and petroglyphs are also evident, due to such factors as antiquarian play or even the creation of tourist attractions (Haviser, Chapter 12, this volume). Chemical analysis of the paints and patina studies, as well as stylistic analysis and prior surveys, can often identify such forgeries or additions (Haviser, Chapter 12, this volume), but not always.

The continued reuse of rock art sites in the Antilles comprises a further factor in their study, as well as in the development of preservation strategies. Modern residents may use the same locations and their features that were the focus of past Amerindians as loci for current rituals. Atiles Bidó (2003:66) reports that local people use Cueva de la Cidra in the central cordillera of the Dominican Republic as a church. They even drape a central stalagmite with clothing and identify it with La Virgen de la Altagracia and make offerings to it. Beauvoir-Dominique (Chapter 6, this volume) describes the complex interrelationship between past Amerindian and modern Haitian religious

Table 15.7. Rock Art Legal and Conservation Status

Island/Area	Description
	Greater Antilles
Bahama Islands	Antiquities, Monuments, and Museum Act, 1997 provides for "the preservation, restoration, documentation, study and presentation of sites and objects of historical anthropological, archaeological and paleontological interests"; defines criteria for antiquity, monument, and artifact status and patrimony of cultural remains; sets excavation laws and procedures; covers preservation funding.[1]
Cuba	The Protección al Patrimonio Cultural y Natural and the Monumentos Nacionales y Locales laws in 1976 laid the foundation for conservation through the establishment of a cultural property register and definition of criteria for determining register status; the Comisiones Nacional y Provincial de Monumentos and provincial governments also charged with conservation efforts and designation of protection of all archaeological sites; special protection status for rock art sites; on-site guards for certain locations.[2]
Jamaica	The Jamaica National Heritage Trust (JNHT) Act of 1985 addressed issues of damage and destruction with regards to national monuments and protected national heritage; as of 2003, 33 of the 35 known cave-art sites were recorded in the JNHT National Sites and Monuments Inventory; Mountain River Cave only site listed as "protected"; Two Sisters Cave in process of being listed as protected; JNHT mainly responsible for promoting, preserving, and protecting island's archaeological heritage and has defined criteria for what should be considered protected; despite this, rock art research and site protection need improvement.[3]
Puerto Rico Mona Island	The 1966 National Historic Preservation Act instituted basic requirements for federal review, oversight, and protection of cultural resources on U.S. land; Law 112 in place that declares all sites, documents, objects, and other archaeological remains cultural patrimony; federal agencies (State Historic Preservation Offices) maintain supervision on federal lands; commonwealth oversees commonwealth/territory and private land; Consejo para la Protección del Patrimonio Arqueológico Terrestre de Puerto Rico set up to oversee archaeological preservation; minimal efforts for special designation and protection of rock art sites.[4] Law 111 (1985) provides for the protection and conservation of caves, caverns, and sinkholes with or without rock art; the Departamento de Recursos Naturales charged with its implementation[5]
Hispaniola	
Haiti	Various pieces of legislation: 1984, creation of Bureau of Ethnology for the protection of archaeological remains; 2005, Decree on the Environment that classifies natural sites protected from physical alterations; all pre-Columbian vestiges having scientific or artistic

Island/Area	Description
Haiti (*continued*)	value classified as archaeological objects and are to be curated; archaeological excavations subject to authorization by Department of Interior on recommendation of Bureau of Ethnology; Haitian constitutional stipulation that archaeological, cultural, historical, architectural, and folklore treasures are part of the national heritage; National Parks and Natural Sites administration; signatory of UNESCO; restructuring of governmental bodies to enhance conservation efforts of cultural resources.[6, 7]
Dominican Republic	Laws or decrees Nos. 316 (1968), 318 (1972), 564 (1973), 268 (1978), 297/87 (1987), 64-00 (2000), and 202-04 (2004) currently on record to protect cultural resources, with lack of clarity regarding cave site management a problem; two governmental bodies, Cultura (Museo del Hombre Dominicano) and Medio Ambiente y Recursos Naturales, charged with conservation of resources but lack specifics as to responsibilities.[8]

U.S. Virgin Islands

Island/Area	Description
St. John St. Thomas St. Croix	The Antiquities and Cultural Properties Act of 1998 (Virgin Islands Act No. 6234, Bill No. 22-0112 1998, Chapter 17 of Section 1, Title 29) complements United States federal laws; sites owned by the Virgin Islands government are protected under the law; National Parks sites also protected under park policies and guidelines; fairly effective rock art site management and protection plan.[4, 9]

Lesser Antilles

Island/Area	Description
Anguilla	Two rock art sites are owned by the government of Anguilla; areas containing images closed off to public; current legislation to provide funding for environmental issues regarding protected areas.[10]
Guadeloupe Marie Galante	Grotte du Morne Rita at Capesterre de Marie Galante and Parc Archéologique des Roches Gravées at Trois-Rivières classified as historical monuments; four other sites in process of acquiring this designation: Plessis River site, Baillif/Vieux-Habitant; Anse des Galets site, Trois-Rivières; Engraved Rocks site, Petit Carbet River at Trois-Rivières; and Abri Patate at Moule.[11] Cultural patrimony laws are similar to French national protection laws; application for cultural resource archaeology required for any urban development; administrative bodies slow to act in regards to decisions for protection of petroglyph sites.[12]
St. Vincent Grenadines	Protection under laws of trespass for sites on private property; legislation under consideration.[13]
Barbados	Petroglyph site put on tentative list under consideration for nomination under UNESCO.[14]

Continued on the next page

Table 15.7. *Continued*

Island/Area	Description
Trinidad Tobago	Heritage management agencies: National Trust of Trinidad and Tobago, National Archaeological Committee of Trinidad and Tobago, National Museum, Tobago Trust and Museum, Archaeology Centre at University of the West Indies; legislation: Marine Areas Preservation and Enhancement Act (1970), National Trust Act of 1991, Protection of Wrecks Act (1994); signatory to UNESCO's World Heritage Convention; well-grounded preservation framework, with improvements needed in interagency cooperation, site registry, enforcement, and public awareness.[15]
Bonaire Curaçao	Protected under current archaeological sites legislation that states that only sites listed as monuments are covered by governing laws (two in Bonaire, three in Curaçao); sites within national parks are protected by National Park ordinances.[16]
Aruba	Protection of rock art sites overseen by Archaeological Museum of Aruba; museum allied with government/nongovernment agencies to aid in development of legislation for protection and regulation of sites; recent legislation to ensure all future construction/land projects consider natural and cultural values of area; museum, park, and public work agencies maintain own personnel for site control, conservation, and policing.[17, 18]

Sources:
1. Data provided by the Gerace Research Center, Bahamas.
2. Fernández et al., Chapter 3, this volume.
3. Atkinson 2003b.
4. Hayward, Roe, et al., Chapter 9, this volume.
5. Rodríguez Álvarez 2008.
6. Beauvoir-Dominique, Chapter 6, this volume.
7. Beauvoir-Dominique 2006.
8. López Belando, Chapter 8, this volume.
9. Wild 2006.
10. Crock 2006.
11. Richard, Chapter 10, this volume.
12. Richard and Petitjean Roget 2006.
13. Martin 2006.
14. Farmer 2005.
15. Reid and Lewis 2007.
16. Haviser 2006.
17. Kelly 2006.
18. Kelly, Chapter 13, this volume.

sites, including those with rock art. Pre-Hispanic carvings are given modern garb as the caves housing them continue to function as cult sites.

Conclusion: On the Nature of Caribbean Rock Art

Hayward et al. (2007), in their discussion of the nature of Puerto Rican rock art in particular, stress the uniqueness of each rock art site within an overall recognizable pattern. I prefer to focus on two defining but general charac-

teristics of the region's rock art: the high percentage of humanlike faces and the images' role in social contact or border displays.

The anthropomorphic emphasis of the region's rock art is clear: it has, for example, double the percentage found in the Guianas (Suriname specifically). This fact, first highlighted by Dubelaar (1995:29, nn. 4, 5) in his regional survey, can have several independent causes. The first may be the simple paucity of other creatures to portray. Unlike the varied and impressive fauna of the mainland, the impoverished insular fauna of the Antilles simply lacked large animals other than humans to portray in rock art. Birds, which were present in great diversity, of course, are also disproportionately depicted in Antillean rock art, specifically in the pictographs of the Cuevas de Borbón in eastern Hispaniola (López Belando, Chapter 8, this volume, and Hayward, Roe, et al., Chapter 9, this volume) or the petroglyphs of the Warminster/ Genus rockshelter in Jamaica (Loubser and Allsworth-Jones, Chapter 5, this volume). Much of that, however, may be related either to the oral tradition (the owls and their association with the dead) or to shamanism and its avi-anthropic transformations of the power animal familiars, as much as to any documentary or sympathetic hunting magic imperatives.

The lack of specific South American faunal depictions in Greater Antillean rock art, despite their abundance in early Saladoid ceramics (Roe 1989), is yet another argument for the absence of Saladoid rock art in those islands. It also buttresses another explanation that might account for the prevailing anthropomorphic cast of Antillean rock art, that is, the "human-centric" argument I have already broached. The Early Ceramic period saw the origin of both architectural ball parks and their associated petroglyphs, precisely as the ceramics simplified and appeared in larger modes signifying the political importance of feasting (Roe 2002). In turn, all those aspects of material culture were the artifactual expressions of a two-tiered society that emerged as a result of successful ecological and subsistence reorientation to sea resources. They were themselves products of a cultural "settling-in" with a resultant demographic explosion and consequent social competition that came to characterize the eastern Greater Antilles.

All of this complexity emerged out of an original egalitarian Saladoid tribal heritage, with their "lateral view" of the world, in which one looked to each side, as it were, for aid and social support, specifically to kinsmen and animal or bird spirits on the same social plane as oneself. In contrast, the new social landscape would have produced the "vertical view" of followers, as commoners, looking upward to those who controlled their lives, the emerging elite. If other, more powerful, humans now controlled one's fate, and no longer equivalent kinsmen by one's side or animal spirits at one's elbow, then

of course one's art will become more "human-centric," hence anthropomorphic. Pre-Hispanic Caribbean chiefdoms thus became characterized by human faces staring from every boulder and peeking out of every cavern, a profoundly "humanized" and "sign-posted" social landscape of inequality.

The second overarching characteristic of both Antillean and related lowland South Amerindian rock art concerns its role in the signaling of contact and borders. Nothing so humanizes the landscape, converting it from nature to culture, than the permanent and immobile iconography of rock art. And nothing serves better to signal the boundaries and frontiers, as well as the corridors of contact, of human domains than the long-distance visible carvings or paintings of rock art. Not only does rock art signal kin-based joint ownership of and exclusive access to valuable resources, such as optimal fishing areas, but also it fixes such exclusive ownership in the immemorial past.

The fact that the rock art of Puerto Rico, like its ball courts and their ceremonial regalia and iconography, is the most elaborate in all the Caribbean may not be unrelated to its position as the last outpost on the border between the Greater and the Lesser Antilles. Puerto Rico also straddles the Vieques Sound and the Virgin Islands to the east, as well as the Mona Passage and Hispaniola to the west.

Thus, it may be no accident that Mona has the highest density of rock art of any of the Antilles, in part precisely because of its rocky and inhospitable nature. The Mona Passage was the center of the eastern Taíno chiefdoms and their associated prestige ceramics in eastern Hispaniola, various wares of which spread as items of trade from Puerto Rico to Saba (Hofman et al. 2007:Figure 10) in the Leewards. During the earlier Elenan Ostionoid, the center of rock art had been in the Puerto Rico/Virgin Islands interchannel zone, so the fulcrum was moving to the west. Yet, despite the incredible profusion of styles in eastern Hispaniola and the fact that some of its caves have by far the greatest number of pictographs in the Caribbean (Keegan 2007), there is nothing in Hispaniola to rival the complexity of the frieze at Caguana or the structural intricacy of the pictographs and petroglyphs of the Mora, Lucero, and La Catedral caves.

The only other place where petroglyphs approach the number, scale, and pictorial complexity of the Puerto Rican images—and that is only for petroglyphs, not pictographs—is Guadeloupe. Perhaps it is no accident that this island is also the last on the border between the Greater Antillean–affiliated Leeward Islands and the South American–affiliated Windward Islands of the Lesser Antilles, as defined by other media (Hofman et al. 2007). Rock art thus appears to be a highly visible "signpost" of social transition and confrontation, its signaling functions active on many levels, from cosmology and oral tradition to social organization and techno-economy.

In summation, a long-delayed florescence of rock art investigation in the Caribbean promises to illuminate many domains of past as well as present cultures. Further advances in documentation, stabilization, and interpretation can only add to this expanding corpus. With any luck, and much hard work, such images from the past will never die but will continue to inform and animate the Antillean cultural landscape, not only for its current inhabitants but also for all humanity.

References Cited

Aarons, G. A.
 1988 The Mountain River Cave. *Jamaica Journal* 21(3):19.
Alberti Bosch, Narciso
 1979 Sepulturas indígenas de Santo Domingo [originally published 1912].
 Presentación de Bernardo Vega. *Boletín del Museo del Hombre Dominicano*,
 No. 12, pp. 327–346. Santo Domingo, Dominican Republic.
Alegría, Ricardo E.
 1941 Petroglifos indígenas. *La Torre* 2(55):6.
 1983 *Ball Courts and Ceremonial Plazas in the West Indies.* Yale University Publi-
 cations in Anthropology, No. 79. Yale University, New Haven, Connec-
 ticut.
 1997 An Introduction to Taíno Culture and History. In *Taíno: Pre-Columbian
 Art and Culture from the Caribbean,* edited by Fatima Bercht, Estrellita
 Brodsky, John Alan Farmer, and Dicey Taylor, pp. 18–33. Monacelli Press
 and El Museo del Barrio, New York.
Aléman Crespo, Harry E., Eduardo Questell Rodríguez, and Edgar J. Maíz López
 1986 *Informe de evaluación cultural (Fases 1A-1B), construcción balneario público, Bo.
 Ensenada, Rincón, Puerto Rico.* Prepared for Municipio de Rincón, Antonio
 Hernández Virella, ingeniero consultor. Oficina Estatal de Preservación
 Histórica (SHPO #09-13-85-19), San Juan, Puerto Rico.
Allsworth-Jones, Philip
 2008 *Pre-Columbian Jamaica.* University of Alabama Press, Tuscaloosa.
Alonso, Enrique, Hilario Carmenate, Carlos Díaz, Carlos Rosa, María R. González,
Esperanza Blanco, Jorge L. Ruiz, and Dialvys Rodríguez
 2004 Pinar del Río: Arte rupestre. Paper presented at the II Taller Internacional
 de Arte Rupestre.
Alonso Lorea, J. R.
 2003 Un modelo de análisis a una variante gráfica en arte rupestre: Las series de
 círculos concéntricos rojos y negros alternos. In *Rupestre Web: Arte rupestre
 en América latina.* Electronic document, http://rupestreweb.tripod.com/
 series.html, accessed August 22, 2007.

Alvarado Zayas, Pedro A.
 1999 Estudio y documentación del arte rupestre en Puerto Rico. In *Trabajos de investigación arqueológica en Puerto Rico, tercer encuentro de investigadores,* edited by Juan Rivera Fontán, pp. 97–102. Instituto de Cultura Puertorriqueña, División de Arqueología, San Juan.

Anati, Emmanuel
 1994 *World Rock Art: The Primordial Language.* Edizioni del Centro, Capo di Ponte, Italy.

Anon.
 1896 Jamaica Wooden Images in the British Museum. *Journal of the Institute of Jamaica* 2(3):303–304.

Arrazcaeta Delgado, Roger, and Robin García
 1994 Guara: Una región pictográfica de Cuba. *Revista de Arqueología* 15(160):22–31. Madrid.

Arrazcaeta Delgado, Roger, and Fidel Navarrete Quiñones
 2003 Cueva de la Cachimba: A New Finding Place of Prehistoric Rock Art in Cuba. Translated by H. Lange. In *The World of Petroglyphs,* StoneWatch. Electronic document, www.Stonewatch.de, accessed March 15, 2005.

Arrom, José Juan
 1997 The Creation Myths of the Taíno. In *Taíno: Pre-Columbian Art and Culture from the Caribbean,* edited by Fatima Bercht, Estrellita Brodsky, John Alan Farmer, and Dicey Taylor, pp. 68–79. Monacelli Press and El Museo del Barrio, New York.

Atiles Bidó, José Gabriel
 2003 La cueva de la Cidra: La pictografía de un pájaro carpintero y su coincidencia con el mito de Pané y las leyendas suramericanas del origin de las mujeres. *El Caribe Arqueológico* 1:64–72. Santiago de Cuba.

Atiles Bidó, José Gabriel, and Adolfo López Belando
 2006 El sito arqueologico La Punta de Bayahibe: Primeros agricultores tempranos de Las Antillas asentados en la costa sureste de la isla de Santo Domingo. Editora de Revistas, Santo Domingo, Dominican Republic.

Atkinson, Lesley-Gail
 2003a The Distribution of the Taíno Cave Art Sites in Jamaica. *Proceedings of the Congress of the International Association for Caribbean Archaeology* 19(2):300–312. Aruba.
 2003b The Status and Preservation of Jamaican Cave Art. Paper presented at the Fifth World Archaeological Congress (WAC). The Catholic University of America, Washington, D.C.
 2005 Jamaican Cave Art: An Overview. *Proceedings of the Archaeological Society of Jamaica's Annual Symposia 2002–2004.* Archaeological Society of Jamaica, Kingston.

Atkinson, Lesley-Gail, and Audine Brooks
 2006 From Mountain River Cave to Potoo Hole: An Overview of Jamaican Rock Art. Paper presented at the First Expert Meeting on Rock Art in

the Caribbean and the UNESCO World Heritage List, Basse-Terre, Guadeloupe.

Barnett, T., A. Chalmers, M. Diaz-Andreu, G. Ellis, P. Longhurst, K. Sharpe, and I. Trinks
2005 3D Laser Scanning for Recording and Monitoring Rock Art Erosion. *International Newsletter on Rock Art (INORA)* 41:25–29.

Beauvoir-Dominique, Raquel
1995 Underground Realms of Being: Vodoun Magic. In *Sacred Arts of Haitian Vodou,* edited by D. J. Cosentino, pp. 153–177. UCLA Fowler Museum of Cultural History, Los Angeles.
1997 Puerto-Real: Pour une mise en valeur nationale, caraïbéenne et mondiale. Projet Route 2004, Port-au-Prince, Haiti.
2006 Appendix VII: ICOMOS Caribbean Rock Art Information Request Form for Haiti. In *Rock Art of Latin America and the Caribbean: Thematic Study,* pp. 75–78. ICOMOS (International Council on Monuments and Sites) World Heritage Convention, Paris.

Beeker, Charles D., Geoffrey W. Conrad, and John W. Foster
2002 Taíno Use of Flooded Caverns in the East National Park Region, Dominican Republic. *Journal of Caribbean Archaeology* 3:1–26.

Berchon, Charles
1910 *A través de Cuba. Relato geográfico descriptivo y económico.* Imprenta de Charaire, Sceaux (Paris).

Bercht, Fatima, Estrellita Brodsky, John Alan Farmer, and Dicey Taylor (editors)
1997 *Taíno: Pre-Columbian Art and Culture from the Caribbean.* Monacelli Press and El Museo del Barrio, New York.

Betancourt, José Ramón
1887 *Prosa de mis versos.* Delclos y Bosch, Barcelona.

Bodu, P.
1980 Rapports de prospection archéologique. Unpublished report. Direction des fouilles et antiquités de Guadeloupe, Basse-Terre.

Boman, Éric
1908 *Antiquités de la région Andine de la république Argentine et du désert d'Atacama.* Imprimerie Nationale, Paris.

Boomert, Arie
2000 *Trinidad, Tobago and the Lower Orinoco Interaction Sphere: An Archaeological/Ethnohistorical Study.* Cairi Publications, Alkmaar, The Netherlands.
2001 Saladoid Sociopolitical Organization. *Proceedings of the Congress of the International Association for Caribbean Archaeology* 18(2):55–77. Grenada.

Bosch, Dominee G.
1836 *Reizen in West Indië,* Vol. 2. Utrecht, The Netherlands.

Boyrie de Moya, Emil
1955 *Monumentos megalíticos y petroglifos de Chacuey República Dominicana.* Publicaciones de la Universidad de Santo Domingo, Vol. 97. Santo Domingo, Dominican Republic.

Branner, John C.
 1884 Rock Inscriptions in Brazil. *American Naturalist* 18(12):1187–1192.
Brenneker, O. Paul
 1941 Zeven Vindplaatsen van Indianen-tekeningen op Bonaire. *Amigoe di Curacao* 7:9. Curaçao.
 1943 Geschiedenis van Bonaire. *Amigoe di Curacao* 4:29. Curaçao.
 1946 Een Indianentekening aan de westkust van Bonaire. *Amigoe di Curacao* 7:11. Curaçao.
Breton, R.
 1978 *Relations de l'isle de la Guadeloupe, 1635–56.* Reprinted. Société d'Histoire de la Guadeloupe, Basse-Terre. Originally published 1929, J. Rennard, Paris.
Brinton, Daniel
 1898 The Archaeology of Cuba. *American Archaeologist* 2(10):253–256.
Callaghan, Richard T.
 2003 Comments on the Mainland Origins of the Preceramic Cultures of the Greater Antilles. *Latin American Antiquity* 14(3):323–338.
Calvera, Jorge, and Roberto Funes
 1991 Método para asignar pictografías a un grupo cultural. In *Arqueología de Cuba y de otras áreas antillanas,* Centro de Antropología, pp. 79–93. Editorial Académica de Ciencias de Cuba.
Calvera, Jorge, Roberto Funes, and F. Cuba
 1991 Investigaciones arqueológicas en Cubitas, Camagüey. In *Arqueología de Cuba y de otras áreas antillanas,* Centro de Antropología, pp. 522–548. Editorial Académica de Ciencias de Cuba, Havana.
Carlson, B., David Steadman, and B. Keegan
 2006 Birdland: Extinction Steadily Reduced a Major Food in the Taino Diet. *Times of the Islands* 74:64–69.
Chanlatte Baik, Luis A.
 2007 Evidencia huecoide en La República Dominica. *Proceedings of the Congress of the International Association for Caribbean Archaeology* 21(2):459–465. St. Augustine, Trinidad and Tobago.
Chapman, G. N.
 1982 An Improved Image-Intensifier Spectrograph for Recording Triboluminescent Spectra. *Journal of Physical Experiments and Scientific Instrumentation* 15:181–183.
Chippindale, Christopher, and Paul S. C. Taçon
 1998 *The Archaeology of Rock Art.* Cambridge University Press, Cambridge.
Cinquino, Michael A., Michele H. Hayward, and Frank J. Schieppati
 2003 Puerto Rican Rock Art Types: Their Distribution and Significance. *Proceedings of the Congress of the International Association for Caribbean Archaeology* 20(2):667–674. Santo Domingo, Dominican Republic.
Clarke, Colin
 1974 *Jamaica in Maps.* University of the West Indies, Kingston, Jamaica.

Climate Zone
 2006 *Climate Zone.com* (worldwide climate information and general geo-
 graphical statistics). Electronic document, www.climate-zone.com, ac-
 cessed September 10, 2006.

Clottes, Jean
 1998 La conquête de l'imaginaire. In *La Plus Belle Histoire de l'Homme,* edited
 by André Langaney, Jean Clottes, Jean Guilaine, and Dominique Simon-
 net, pp. 69–122. Seuil Points, Paris.

Cody, Annie
 1990 Faces and Figures on Grenada: Their Historical and Cultural Relations. In
 Rock Art Papers, Vol. 7. San Diego Museum of Man, San Diego.

Collazo, Nelson Rafael
 2002 *Pictografías, petroglifos.* Imprenta Llorens, Juana Díaz, Puerto Rico.

Collectif ISPAN (E. Lubin, G. Valmé, D. Dominique, D. Elie)
 1990 *Le système défensif Haïtien.* ISPAN (Institut de Sauvegarde du Patrimoine
 National), Port-au-Prince, Haiti.

Comisión de Oficiales
 1847 *Cuadro estadístico de la siempre fiel Isla de Cuba correspondence al año 1846.*
 Imprenta del Gobierno y Capitanía General, Havana.

Coomans, H. E.
 1997 Nieuwe archeologische gegevens uit de oude bronnen. In *Arubaanse Ak-
 kord, Opstellen over Aruba van voor de komst van de Olie industrie,* edited by
 L. Alofs, W. Rutgers, and H. E. Coomans, pp. 102–111. Stichting Libri An-
 tilliani, Kabinet van de Gevolmachtigde Minister van Aruba, Bloemen-
 daal, The Netherlands.

Coppa, Alfredo, Andrea Cucina, Menno L. P. Hoogland, Michaela Lucci, Fernando
Luna Calderón, Raphaël G. A. M. Panhuysen, Glenis Tavarez Maria, Roberto Val-
cárcel Rojas, and Rita Vargiu
 2008 New Evidence of Two Different Migratory Waves in the Circum-
 Caribbean Area during the Pre-Columbian Period from the Analysis
 of Dental Morphological Traits. In *Crossing the Borders: New Methods and
 Techniques in the Study of Archaeological Materials from the Caribbean,* edited
 by Corinne L. Hofman, Menno L. P. Hoogland, and Annelou L. van Gijn,
 pp. 195–213. University of Alabama Press, Tuscaloosa.

Cosculluela, Juan Antonio
 1918 *Cuatro años en la Ciénaga de Zapata.* Papelera Universal de Ruíz y Cía, Havana.

Crock, John G.
 2006 Appendix I: ICOMOS Caribbean Rock Art Information Request Form
 for Anguilla. In *Rock Art of Latin America and the Caribbean: Thematic Study,*
 pp. 65–66. ICOMOS (International Council on Monuments and Sites)
 World Heritage Convention, Paris.

Crocker, Jon C.
 1985 *Vital Souls: Bororo Cosmology, Natural Symbolism, and Shamanism.* Univer-
 sity of Arizona Press, Tucson.

Cruxent, José María
 1955 Petroglifos Venezolanos. *Revista Hombre y Expresión* 2(September). Socie-
 dad de Ciencias Naturales La Salle, Caracas, Venezuela.
Dacal Moure, Ramón, and Manuel Rivero de la Calle
 1986 *Arqueología aborigen de Cuba.* Editorial Gente Nuevo, Havana.
 1996 *The Art and Archaeology of Pre-Columbian Cuba.* Translated by David R.
 Watters and Daniel H. Sandweiss. University of Pittsburgh Press, Pitts-
 burgh.
Dávila Dávila, Ovidio
 2003 *Arqueología de la Isla de La Mona.* Editorial del Instituto de Cultura Puer-
 torriqueña, San Juan.
Davis, John R.
 2002 *Soil Survey of the United States Virgin Islands.* U.S. Department of Agricul-
 ture, Natural Resources Conservation Service, in cooperation with the
 Virgin Islands Department of Planning and Natural Resources, the Vir-
 gin Islands Cooperative Extension Service, and the U.S. Department of
 the Interior, National Park Service.
De Booy, Theodoor
 1912 Lucayan Remains on the Caicos Islands. *American Anthropologist*
 14(6):81–105.
De la Torre, José M.
 1847 Descubrimientos arqueológicos en Cuba. *Faro Industrial de La Habana*
 7(81):1. Havana.
Descourtilz, Michel Etienne
 1935 [1809] *Voyages d'un Naturaliste en Amérique, 1799–1803.* Dufart, Paris. 1935
 edition. Lib. Plon, Paris.
Díaz González, Marlén
 1986 *Informe sobre Cueva la Catedral: Inventario de cuevas.* Sociedad Espeleológica
 de Puerto Rico, Inc. Sub-Comité de Arqueología, San Juan, Puerto Rico.
 1990 Proyecto recuperación arqueológica arte rupestre de la Cueva de la Ca-
 tedral barrio Bayaney: Hatillo, Puerto Rico. Unpublished Master's thesis,
 Centro de Estudios Avanzados de Puerto Rico y el Caribe, San Juan,
 Puerto Rico.
Díaz-Granados Duncan, Carol Ann
 1993 The Petroglyphs and Pictographs of Missouri: A Distributional, Stylistic,
 Contextual, Temporal, and Functional Analysis of the State's Graphics.
 Vols. 1 and 2. Unpublished Ph.D. dissertation, Department of Anthro-
 pology, Washington University, St. Louis.
Dijkhoff, R. A. C. F., and M. S. Linville
 2004 *The Archaeology of Aruba: The Marine Shell Heritage.* Publications of the Ar-
 chaeological Museum of Aruba 10. Oranjestad, Aruba.
Dominique, Didier
 1993 *Sang-Souci.* Institut de Sauvegarde du Patrimoine National (ISPAN),

Centre de Recherches Urbaines—Travaux (CRU.T), Port-au-Prince, Haiti.

Downer, A., and R. Sutton
 1990 *Birds of Jamaica.* Cambridge University Press, Cambridge.

Drewett, Peter L.
 2007 Shifting Sand: The Belmont Archaeological Project, British Virgin Islands, from Prehistory to History. *Proceedings of the Congress of the International Association for Caribbean Archaeology* 21(2):747–751. St. Augustine, Trinidad and Tobago.

Dubelaar, Cornelius N.
 1986a *South American and Caribbean Petroglyphs. Koninklijk Instituut Voor Taal-, Land- en Volkenkunde.* Caribbean Series 3. Foris, Dordrecht, The Netherlands, and Riverton, New Jersey.
 1986b *The Petroglyphs in the Guianas and Adjacent Areas of Brazil and Venezuela: An Inventory with a Comprehensive Bibliography of South American and Antillean Petroglyphs.* Monumenta Archaeologica, No. 12. Institute of Archaeology, University of California, Los Angeles.
 1991 Petroglyphs in the U.S. Virgin Islands: A Survey. *Proceedings of the Congress of the International Association for Caribbean Archaeology* 13(2):944–973. Curaçao.
 1995 *The Petroglyphs of the Lesser Antilles, the Virgin Islands and Trinidad.* Publications of the Foundation for Scientific Research in the Caribbean, No. 35. Amsterdam.

Dubelaar, Cornelius N., Michele H. Hayward, and Michael A. Cinquino
 1999 *Puerto Rican Rock Art: A Resource Guide.* Panamerican Consultants, Inc. of Buffalo, New York, for the Puerto Rico State Historic Preservation Office, San Juan.

Duerden, J. E.
 1897 Aboriginal Indian Remains in Jamaica. *Journal of the Institute of Jamaica* 2(4).

Dunn, Oliver, and James E. Kelley, Jr.
 1989 *The Diario of Christopher Columbus's First Voyage to America 1492–1493.* University of Oklahoma Press, Norman.

Escobar Guío, Francisco, and Juan J. Guarch Rodríguez
 1991 Hipótesis sobre una nueva región del arte rupestre en Cuba. In *Estudios arqueológicos, 1989,* edited by J. Flebes, Lourdes Domínguez; J. M. Guarch; A. Matínez, and A. Rives, pp. 48–56. Anuario del Centro de Antropología, Editorial Academia de Ciencias de Cuba, Havana.

Euwens, P. A.
 1907 Historisch overzicht van het eiland Bonaire. *Neerlandia* 2:193–197. Amsterdam.

Farmer, Kevin
 2005 The Archaeological Heritage of Barbados: The path towards World Heritage Nomination, Annex 14. In *Caribbean Archaeology and World Heritage*

Convention, edited by Nuria Sanz, pp. 91–96. World Heritage Papers, No. 14, UNESCO World Heritage Centre, Paris.

Faugère-Kalfon, Brigite

1997 *Las representaciones rupestres del centro-norte de Michoacán.* Cuadernos de Estudios Michoacanos, No. 8. Centre Français d'Etudes Mexicaines et Centraméricaines, Sierra Leona, Mexico.

Feriz, Hans

1959 Zwischen Peru und Mexico. 2 vols. *Meded. Koninklijk Instituut voor de Tropen Amsterdam* 134:98–136. Aruba and Bonaire.

Fernández Ortega, Racso

1994 El arte rupestre en las cuevas funerarias aborígenes de Cuba. *Boletín Casimba,* Vol. 5, Series 1, No. 6. Órgano Oficial del Grupo Espeleológico "Pedro A. Borras." Sociedad Espeleológica de Cuba, Havana.

Fernández Ortega, Racso, and José B. González Tendero

2001a *El enigma de los petroglifos aborígenes de Cuba y el Caribe insular.* Editorial Juan Marinello, Havana.

2001b El mito del sol y la luna en el arte rupestre aborigen de las cuevas de Cuba. In *Rupestre Web: Arte rupestre en América latina.* Electronic document, http://rupestreweb.tripod.com/fernandez.html, accessed August 22, 2007.

2001c Afectaciones antrópicas al arte rupestre aborigen en Cuba. *Revista de Arte Rupestre en Colombia,* Vol. 4, No. 4. Grupo de Investigaciones de Arte Rupestre Indígena (GIPRI), Editorial Cultura de los Pueblos Pintores, Bogotá.

Fewkes, Jesse Walter

1903 Prehistoric Porto Rican Pictographs. *American Anthropologist* 5:441–467.

1904 Prehistoric Culture of Cuba. *American Anthropologist* 6(5):585–598.

Fincham, Alan G.

1997 *Jamaica Underground: The Caves, Sinkholes and Underground Rivers of the Island.* University of the West Indies Press, Kingston, Jamaica.

Fincham, Alan G., and A. M. Fincham

1998 The Potoo Hole Pictographs: A Preliminary Report on a New Amerindian Cave Site in Clarendon, Jamaica. *Jamaica Journal* 26(3):2–6.

Fitzpatrick, Scott M.

2006 A Critical Approach to ^{14}C Dating in the Caribbean: Using Chronometric Hygiene to Evaluate Chronological Control and Prehistoric Settlement. *Latin American Antiquity* 17(4):389–418.

Flint, R. F., and B. J. Skinner

1974 *Physical Geology.* John Wiley and Sons, New York.

Fouchard, Jean

1981 *Les Marrons de la Liberté* [*The Haitian Maroons*]. Edward W. Blyden, Port-au-Prince, Haiti.

Francis, Julie E.

2001 Style and Classification. In *Handbook of Rock Art Research,* edited by David S. Whitley, pp. 221–244. AltaMira, Walnut Creek, California.

Frassetto, Monica F.
 1960 A Preliminary Report on Petroglyphs in Puerto Rico. *American Antiquity*
 25:381–391.
Frikel, Protasio
 1969 Tradition und Archaeologie im Tumuk-Humak, Nordbrasilien. *Zeitschrift*
 fur Ethnologie 94:103–130. Dietrich Reimer Verlag, Berlin.
Frostin, Charles
 1975 *Les révoltes blanches à Saint-Domingue aux XVIIe et XVIIIe siècles (Haïti*
 avant 1789). Éditions de l'École, Paris.
García, Carlos A.
 2004 Arcano aborigen: Propuesta de herramienta virtual para el acercamiento
 a los dibujos rupestres cubanos de diseño geométrico, tridimensionales y
 cinéticos. Paper presented at the II Taller Internacional de Arte Rupestre,
 Havana.
García Arévalo, Manuel A.
 1997 The Bat and the Owl: Nocturnal Images of Death. In *Taíno: Pre-*
 Columbian Art and Culture from the Caribbean, edited by Fatima Bercht,
 Estrellita Brodsky, John Alan Farmer, and Dicey Taylor, pp. 112–123.
 Monacelli Press and El Museo del Barrio, New York.
García y Grave de Peralta, F.
 1939 Excursiones arqueológicas. Segunda parte. *Revista de Arqueología,* Época 1,
 Año 1, No. 3. Havana.
Geomagic, Inc.
 2007 *Raindrop Geomagic Studio.* Electronic document, http://www.geomagic.
 com, accessed July 15, 2007.
Gilbert, Alain
 1990 Les pétroglyphes de la Martinique et de la Guadeloupe, Petites Antil-
 les. Paper presented at the Congrès du Cinquantenaire de la Sociedad Es-
 peleologica de Cuba, Havana.
Gómez de Avellaneda, Gertrudis
 1963 *Sab.* Consejo Nacional de Cultura, Havana.
 [1839]
González Colón, José B., and Racso Fernández Ortega
 1998 *Descubren pictografías en Cueva Florencia, Carboneras, Matanzas.* Carta Infor-
 mativa No. 14, Época I, Sección de Arqueología, Comité Espeleológico
 de Ciudad de La Habana, Sociedad Espeleológica de Cuba.
 2001 *La Cueva Mural en el contexto del registro rupestre de la costa norte de Matan-*
 zas, Cuba. Noticias de Antropología y Arqueología: Especial 2001. Equipo
 NAyA. Electronic document, http://www.naya.org.ar, accessed Decem-
 ber 18, 2001.
 2002 La Cueva Mural: El estilo geométrico figurativo del norte de Matan-
 zas, Cuba. *Revista Escuela Antropología e Historia,* No. 30, México. Elec-
 tronic document, http://morgan.iia.unam.mx/usr/actualidades, accessed
 April 8, 2002.

González Colón, Juan
 1979– *Inventario Arqueológico de Puerto Rico.* Instituto de Cultura Puertorriqueña,
 1980 Centro de Investigaciónes, San Juan.
 1984 Tibes: Un centro ceremonial indígena—1979–1980 Rock Art Inven-
 tory. Unpublished Master's thesis, Centro de Etudios Avanzados de Puerto
 Rico y el Caribe, Old San Juan, Puerto Rico.
Goskar, T. A., A. Carty, P. Cripps, C. Brayne, and D. Vickers
 2003 The Stonehenge Laser Show. In *British Archaeology,* Vol. 73, edited by
 M. Pitts, pp. 9–15. Council for British Archaeology, London.
Granberry, Julian
 1955 A Survey of Bahamian Archeology. Unpublished Master's thesis, Depart-
 ment of Anthropology, University of Florida, Gainesville.
 1973 The Lucayans: Our First Residents. In *Bahamas Handbook and Business-
 man's Annual,* pp. 20–35. Dupuch Publications, Nassau, Bahamas.
Granberry, Julian, and John Winter
 1995 Bahamian Ceramics. *Proceedings of the Congress of the International Associa-
 tion for Caribbean Archaeology* 15:3–14. San Juan, Puerto Rico.
Griswold, Susan C.
 1997 Appendices. In *Taíno: Pre-Columbian Art and Culture from the Caribbean,*
 edited by Fatima Bercht, Estrellita Brodsky, John Alan Farmer, and Dicey
 Taylor, pp. 170–180. Monacelli Press and El Museo del Barrio, New York.
Guarch del Monte, José M.
 1987 *Arqueología de Cuba: Métodos y sistemas.* Editorial de Ciencias Sociales,
 Havana.
Guarch Rodríguez, Juan J., and Lourdes del R. Pérez
 1994 *Arte rupestre: Petroglifos Cubanos.* Ediciones Holguín, Holguín, Cuba.
Guerrero, Reinaldo, and Enrique Pérez
 2004 Contribución al estudio de las pictografías aborígenes de la zona de Diago,
 Catalina de Güines, provincia La Habana. Paper presented at the II Taller
 Internacional de Arte Rupestre, Havana.
Guidon, Niede
 1975 Peintures rupestres de Varzea Grande, Piaui, Brazil. *Cahiers d'Archaeologie
 d'Amerique du Sud,* Vol. 3. Paris.
Gutiérrez Calvache, Divaldo A.
 1994 "Cluster Analysis" en los pictogramas ornitomorfos del arte rupestre
 cubano. *Boletín Casimba,* Año 5, No. 6, Serie 2. Havana.
 2004 Simbolismo y funcionalidad del número en el arte rupestre de la cueva de
 los petroglifos del sistema cavernario de Constantino, Sierra de Galeras,
 Viñales, Pinar del Río, Cuba. In *RupestreWeb:Arte rupestre en América latina.*
 Electronic document, http://rupestreweb.tripod.com/numeros.html, ac-
 cessed February 12, 2007.
Gutiérrez Calvache, Divaldo, and H. Crespo
 1991 El arte rupestre en la Cueva de la Pluma, Cumbre Alta, Matanzas. *Boletín
 Casimba,* Año 3, No. 3, Serie 1, pp. 17–33. Havana.

Gutiérrez Calvache, Divaldo, and Racso Fernández Ortega
 2005 Estilos pictográficos en Cuba: Dificultades y problemas teórico-
 metodológicos. *Boletín del Gabinete de Arqueología,* Año 4, No. 4. Havana.
 2006 *Los petroglifos incisos de la Sierra de los Órganos: Estructura y análisis desde
 una aproximación arqueológica.* Resúmenes III Taller Internacional de Arte
 Rupestre, Havana.
Gutiérrez Calvache, Divaldo, Racso Fernández Ortega, and José B. González
Colón
 2003 Propuesta para un nuevo estilo ideográfico en el extremo más oriental de
 Cuba. *Revista Catauro,* Año 5, No. 8. Havana.
Harrington, Mark R.
 1921 *Cuba Before Columbus.* 2 vols. Indian Notes and Monographs, Museum of
 the American Indian. Heye Foundation, New York.
 1935 *Cuba antes de Colón.* Translated by A. Del Valle and F. Ortiz. Colección de
 Libros Cubanos, Vol. 32. Cultural S.A., Havana.
Hartog, Johan
 1957 *Bonaire.* Broeders De Wit, Aruba.
 1978 *A Short History of Bonaire.* De Wit, Aruba.
 1980 *Aruba zoals het was, zoals het werd. Van de tijden der Indianen tot op heden.*
 Reprinted. Van Dorp N.V., Aruba. Originally published 1953, De Wit,
 Aruba.
Haviser, Jay B.
 1987 Amerindian Cultural Geography on Curacao. *Uitgaven Natuurweten-
 schappelijke Studiekring voor Suriname en de Nederlandse Antillen,* No. 120.
 Utrecht, The Netherlands.
 1991 The First Bonaireans. *Reports of the Archaeological-Anthropological Institute of
 the Netherlands Antilles,* No. 10. Curaçao.
 1995 Test Excavations at the Savonet Rock Paintings Site, Curaçao. *Proceed-
 ings of the Congress of the International Association for Caribbean Archaeology*
 15:571–580. San Juan, Puerto Rico.
 2001 New Data for the Archaic Age on Curaçao. *Proceedings of the Congress of
 the International Association for Caribbean Archaeology* 19(1):110–121. Aruba.
 2006 Appendix III: ICOMOS Caribbean Rock Art Information Request Form
 for Bonaire/Curaçao. In *Rock Art of Latin America and the Caribbean: The-
 matic Study*, pp. 68–70. ICOMOS (International Council on Monuments
 and Sites) World Heritage Convention, Paris.
 2007 Distinguishing Authentic from Historical Replication Prehistoric Rock
 Art on Bonaire. *Proceedings of the Congress of the International Association for
 Caribbean Archaeology* 21(1):56–66. St. Augustine, Trinidad and Tobago.
Haviser, Jay B., and Matthias Strecker
 2006 Zone 2: Caribbean Area and North-Coastal South America. In *Rock Art
 of Latin America and the Caribbean: Thematic Study,* pp. 43–83. ICOMOS
 (International Council on Monuments and Sites) World Heritage Con-
 vention, Paris.

Hays-Gilpin, Kelley A.
2004 *Ambiguous Images: Gender and Rock Art.* AltaMira, Walnut Creek, California.
Hayward, Michele H., Michael A. Cinquino, and Mark A. Steinback
2002 *Multiple Property Nomination Form: Prehistoric Rock Art of Puerto Rico.* Prepared for the Puerto Rican State Historic Preservation Office, San Juan. Listed on the National Register January 16, 2002.
Hayward, Michele H., John Farchette III, and Gary M. Bourdon
2003 The Robin Bay Petroglyphs, St. Croix, U.S. Virgin Islands. *Proceedings of the Congress of the International Association for Caribbean Archaeology* 20(2):675–684. Santo Domingo, Dominican Republic.
Hayward, Michele H., Marisol J. Meléndez, and Marlene Ramos Vélez
1992a *Informe Preliminar 1. Documentación de tres sities de arte rupestre: Piedra Escrita, Jayuyua; Cueva del Indio, Las Piedras; Quebrada Maracuto, Carolina.* División de Arqueología, Instituto de Cultura Puertorriqueña, San Juan.
1992b *Informe Final. Documentación del sitio LM-4 arte rupestre, Río Guacio, Las Marías.* División de Arqueología, Instituto de Cultura Puertorriqueña, San Juan.
Hayward, Michele H., Frank J. Schieppati, and Michael A. Cinquino
2001 On the Status of Puerto Rican Rock Art Interpretation. *Proceedings of the Congress of the International Association for Caribbean Archaeology* 19(2):258–280. Aruba.
2007 Theorizing Past Religions and Puerto Rican Rock Art. *Proceedings of the Congress of the International Association for Caribbean Archaeology* 21(2):500–511. St. Augustine, Trinidad and Tobago.
Herrera Fritot, René
1938 Informe sobre una exploración arqueológica a Punta del Este, Isla de Pinos, realizada por el Museo Antropológico de la Universidad de la Habana: Localización y estudio de una cueva con pictografías y restos de un ajuar aborigen. *Revista Universidad de La Habana,* Nos. 20 and 21. Havana.
1939 Discusión sobre el posible origen de las pictografías de Punta del Este, Isla de Pinos. *Memorias de la Sociedad Cubana de Historia Natural,* Vol. 13, No. 5. Havana.
1942 Las pinturas rupestres y el ajuar Ciboney de Punta del Este, Isla de Pinos. *Revista Arqueología y Etnografía,* Año 1, No. 2. Havana.
Herrera Fritot, René, and Charles L. Youmans
1946 *La Calata: joya arqueológica antillana: Exploración y estudio de un rico yacimiento indígena dominicano y comparación de los ejemplares con los Cuba y otros lugares.* Havana.
Hilaire, Jeannot
1992 *L'Edifice Créole en Haïti.* 3 vols. Edikreyol, Fribourg, Switzerland.
Hodges, William
1979 L'Art rupestre précolombien en Haití. *Conjonction,* No. 143. Port-au-Prince, Haiti.
1984 *Roche Tampée.* Musée de Guahaba, Ronéo, Haiti.

Hoffman, C.

1995 *Signes Amérindiens: Roches gravées en Guadeloupe.* Trois-Rivières Parc Archéologique, Direction Régionale des Affaires Culturelles de Guadeloupe, Basse-Terre.

Hoffman, Charles

1973 Petroglyphs on Crooked Island, Bahamas. *Proceedings of the International Congress for the Study of the Pre-Columbian Cultures of the Lesser Antilles* 4:9–12. St. Lucia.

Hofman, Corinne L., Alistair J. Bright, Arie Boomert, and Sebastiaan Knippenberg

2007 Island Rhythms: The Web of Social Relationships and Interaction Networks in the Lesser Antillean Archipelago between 400 B.C. and A.D. 1492. *Latin American Antiquity* 18(3):243–268.

Howard, Robert Randolph

1950 The Archaeology of Jamaica and Its Position in Relation to Circum-Caribbean Culture. Unpublished Ph.D. dissertation, Department of Anthropology, Yale University, New Haven, Connecticut.

Hummelinck, P. Wagenaar

1953 *Rotstekeningen van Curaçao, Aruba and Bonaire,* Vol. 1. Uitgaven Natuurwetenschappelijke Werkgroep Nederlandse Antillen, Curaçao.

1957 *Rotstekeningen van Curaçao, Aruba and Bonaire,* Vol. 2. Uitgaven Natuurwetenschappelijke Werkgroep Nederlandse Antillen, Curaçao.

1961 *Rotstekeningen van Curaçao, Aruba and Bonaire,* Vol. 3. Uitgaven Natuurwetenschappelijke Werkgroep Nederlandse Antillen, Curaçao.

1972 *Rotstekeningen van Curaçao, Aruba and Bonaire,* Vol. 4. Uitgaven Natuurwetenschappelijke Werkgroep Nederlandse Antillen, Curaçao.

1979 *Caves of the Netherlands Antilles.* Uitgaven Natuurwetenschappelijke Studiekring voor Suriname en de Nederlandse Antillen, Vol. 97. Utrecht, The Netherlands.

1992 *The Prehistoric Rock Drawings of Bonaire and Curaçao.* Uitgeverij Presse-Papier, Utrecht, The Netherlands.

Imbert, Maura P.

2007 The Investigation of a Possible Megalithic Site on Greencastle Hill in the Island of Antigua, W.I. *Proceedings of the Congress of the International Association for Caribbean Archaeology* 21(2):477–485. St. Augustine, Trinidad and Tobago.

Instituto de Cultura Puertorriqueña

2006 Official web site of the Institute of Puerto Rican Culture. Electronic document, www.icp.gobierno.pr, accessed October 24, 2006.

Izquierdo Díaz, G., and A. Rives Pantoja

1991 Tendencias de desarrollo del arte rupestre cubano. In *Estudios Arqueológicos: Compilación de temas,* pp. 28–45. Editorial Academia, Havana.

Jiménez Lambertus, Abelardo

1978a En torno al cráneo Ciguayo descrito por el Dr. Alejandro Llenas en 1890. *Boletín del Museo del Hombre Dominicano,* No. 10, p. 239. Santo Domingo, Dominican Republic.

1978b Representación simbólica de la Tortuga Mítica en el arte cerámico Taíno. *Boletín del Museo del Hombre Dominicano,* No. 11, pp. 63–76. Santo Domingo, Dominican Republic.

1987 Mitología y Genética. *Boletín del Museo del Hombre Dominicano,* No. 20, pp. 13–16. Santo Domingo, Dominican Republic.

Jiménez Lambertus, Abelardo, Renato O. Rimoli, and Joaquín Nadal

1980 Exploraciones espeleológicas y Arqueológicas en los Parajes la Tina (Prov. La Vega), el Cigual y Monte Bonito (Prov. Azua). *Boletín del Museo del Hombre Dominicano,* No. 14. Santo Domingo, Dominican Republic.

Jönsson Marquet, Sofia

2002 *Les pétroglyphes des Petites Antilles Méridionales: Contextes physique et culturel.* BAR International Series 1051. British Archaeological Reports, Oxford.

Kate, H. ten

1916 Oudheden. De West Indische Eilanden. In *Encyclopaedie van Nederlandsch West-Indië, 1914–1917,* pp. 543–546. The Hague, The Netherlands.

Keegan, William

1985 *Dynamic Horticulturalists: Population Expansion in the Prehistoric Bahamas.* Ph.D. dissertation, Department of Anthropology, University of California, Los Angeles. University Microfilms, Ann Arbor, Michigan.

1997 *Bahamian Archaeology.* Media Publishing, Nassau, Bahamas.

2007 *Taíno Indian Myth and Practice: The Arrival of the Stranger King.* University Press of Florida, Gainesville.

Keegan, William F., Corinne L. Hofman, and Menno L. P. Hoogland

2007 St. Lucia Archaeological Research Project: An Update. *Proceedings of the Congress of the International Association for Caribbean Archaeology* 21(1):128–140. St. Augustine, Trinidad and Tobago.

Keegan, William F., and Reniel Rodríguez Ramos

2007 Archaic Origins of the Classic Taínos. *Proceedings of the Congress of the International Association for Caribbean Archaeology* 21(1):211–217. St. Augustine, Trinidad and Tobago.

Kelly, Harold

2006 Appendix II: ICOMOS Caribbean Rock Art Information Request Form for Aruba. In *Rock Art of Latin America and the Caribbean: Thematic Study,* pp. 66–68. ICOMOS (International Council on Monuments and Sites) World Heritage Convention, Paris.

Klein, Otto

1972 Cultura Ovalle: Complejo rupestre "Cabezas-Tiara." Petroglifos y pictografías del Valle del Encanto, Provincia de Coquimbo, Chile. *Scientia* 141:5-123. Valparaiso.

Konica Minolta Sensing Americas, Inc.

2006 Konica Minolta Sensing Americas, Inc. web site. Electronic document, http://www.minolta3d.com, accessed July 15, 2007.

Koolwijk, A. J. van

1885 Indiaanse Opschriften te Aruba. *Études archéologiques dédiées à Mr. C. Leemans,* pp. 183–184.

La Rosa Corzo, Gabino
1994 Tendencias en los estudios de arte rupestre de Cuba: Retrospectiva crítica. *Revista Cubana de Ciencias Sociales* 29:135–153.

La Selve, Edgar
1871 La République d'Haïti, ancienne partie française de Saint-Domingue. In *Le Tour du Monde, Nouveau Journal des Voyages,* Vol. 3. Hachette, Paris. Also available in an English translation by Brian D. Oakes at http://www.lyalls.net/haiti/Okap.html, November 29, 2004.

Landon, George V., and W. Brent Seales
2006 Petroglyph Digitization: Enabling Cultural Heritage Scholarship. *Machine Vision and Applications* 17(6):361–371.

Las Casas, Fray Bartolomé de
1951 *Historia general de las Indias.* 3 vols. Fondo de Cultura Económica, Mexico
[1527– City.
1566]

Lee, James W.
1969 Activity Jan.–Dec. 1969. *Archaeology Jamaica* 1969:2.
1974 Petroglyphs and Pictographs. *Archaeology Jamaica* (74-4:1–4).
1981 Field Trip to St. Elizabeth Petroglyphs. *Archaeology Jamaica* 81:7–8.
1990 Petroglyphs of Jamaica. *Proceedings of the Congress of the International Association for Caribbean Archaeology* 11:153–159, Figures 1–8. San Juan, Puerto Rico.
2006 The Petroglyphs of Jamaica. In *The Earliest Inhabitants: The Dynamics of the Jamaican Taino,* edited by Lesley-Gail Atkinson, pp. 177–186. University of the West Indies Press, Kingston, Jamaica.

Leica Geosystems HDS, LLC
2007 Leica Geosystems web site. Electronic document, http://www.leica-geosystems.com, July 15, 2007.

Les Jabier, José María Zuazua, Mikel López, Gaizka Carretero, Unai Bernaloa, P. Luís Hernández, Manuel Valdés, Vladimir Otero, et al.
1998 *Mogote—98 G.E.T.—C.E.P. expedición espeleológica vasco—Cubana.* G.E.T. Espeleologi Taldea, Bilbao, Spain.

Levoy, Marc, Kari Pulli, Brian Curless, Szymon Rusinkiewicz, David Koller, Lucas Pereira, Matt Ginzton, et al.
2000 The Digital Michelangelo Project: 3D Scanning of Large Statues. *SIGGRAPH '00: Proceedings of the Annual Conference on Computer Graphics and Interactive Techniques* 27:131–144.

Lewis-Williams, David
2002 *The Mind in the Cave: Consciousness and the Origins of Art.* Thames and Hudson, London.

Linville, Marlene S.
2005 Cave Encounters: Rock Art Research in Cuba. In *Dialogues in Cuban Archaeology,* edited by Luis Antonio Curet, Shannon Lee Dawdy, and Gabino La Rosa Corzo, pp. 72–99. University of Alabama Press, Tuscaloosa.

Loendorf, Larry
2001 Rock Art Recording. In *Handbook of Rock Art Research,* edited by David S. Whitley, pp. 55–79. AltaMira, Walnut Creek, California.

López-Baralt, Mercedes
1985 *El mito taíno: Lévi-Strauss en las antillas.* Ediciones Huracán, Río Piedras, Puerto Rico.

López Belando, Adolfo
1993 *La Cueva de José María.* Agencia Española de Cooperación Internacional, Proyecto Uso Público, Protección, y Recuperación de Vida Silvestre del Parque Nacional del Este. Santo Domingo, Dominican Republic.

2004 *El arte en la penumbra: Pictografías y petroglifos en las cavernas del Parque Nacional del Este.* Grupo BHD, PROEMPRESA. Santo Domingo, Dominican Republic.

2005 El arte rupestre en el Caribe insular, una propuesta de declaración seriada transnacional como Patrimonio Cultural Mundial. In *Caribbean Archaeology and World Heritage Convention,* edited by Nuria Sanz, pp. 166–172. World Heritage Papers, No. 14, UNESCO World Heritage Centre, Paris.

2007 La Cueva de José Maria, santuário prehispánico de la isla de Santo Domingo. *Perficit, Revista de Estúdios Humanísticos,* Tercera Época, Vol. 27, No. 1. Biblioteca San Estanislao, Salamanca, Spain.

Loubser, Johannes
2001 Management Planning for Conservation. In *Handbook of Rock Art Research,* edited by David S. Whitley, pp. 80–115. AltaMira, Walnut Creek, California.

Lovén, Sven
1935 *Origins of the Tainan Culture, West Indies.* Elanders Bokfryckeri Akfiebolag, Göteborg, Sweden.

Luna Calderón, Fernando
1982 Antropología y paleopatología de la Cueva de María Sosa, Boca de Yuma, Provincia la Altagracia. *Boletín del Museo del Hombre Dominicano,* No. 17, p. 149. Santo Domingo, Dominican Republic.

1997 *Análisis de un cráneo encontrado en el manantial de la Aleta Informe remitido al Patronato del Parque Nacional del Este.* Museo del Hombre Dominicano, Santo Domingo, Dominican Republic.

Lundberg, Emily R.
2007 A Monserrate Component in the Virgin Islands in the Context of Inquiry into the Saladoid-Ostinoid Transition. *Proceedings of the Congress of the International Association for Caribbean Archaeology* 21(1):338–346. St. Augustine, Trinidad and Tobago.

Maciques Sánchez, Esteban
1988 Búsqueda y análisis: El arte rupestre de Matanzas. *Boletín Museo, Centro Metodológico Provincial de Museos y del Museo Provincial Palacio de Junco,* Año 1, No. 1. Matanzas, Cuba.

2004 El arte rupestre del Caribe insular: Estilo y cronología. In *Rupestre Web: Arte rupestre en América latina*. Electronic document, http://rupestreweb.tripod.com/maciques.html, accessed August 22, 2007.

Mallery, Garrick
1893 Picture-Writing of the American Indians. *Tenth Annual Report of the Bureau of American Ethnology 1888–1889*. Smithsonian Institution, Washington, D.C.

Mangones, Edmond, and Louis Maximilien
1941 *L'art precolombien d'Haiti: Catalogue de l' Exposition Precolombienne*. Congres des Caraibes III, Port-au-Prince, Haiti.

Martin, K.
1888 *Bericht über eine Reise nach Niederländisch West-Indien I. Land und Leute*. Indianische Zeichnungen von Aruba, Leiden, The Netherlands.

Martin, Kathy
2006 Appendix VIII: ICOMOS Caribbean Rock Art Information Request Form for St. Vincent and the Grenadines. In *Rock Art of Latin America and the Caribbean: Thematic Study*, pp. 79–82. ICOMOS (International Council on Monuments and Sites) World Heritage Convention, Paris.
2008 St. Vincent and the Grenadines Rock Art. In *Rock Art in the Caribbean: Towards a Serial Transnational Nomination to the UNESCO World Heritage List*, edited by Nuria Sanz, pp. 362–370. World Heritage Papers, No. 24, UNESCO World Heritage Centre, Paris.

Mártir de Anglería, Pedro
1979 *Décades del Nuevo Mundo*. Sociedad Dominicana de Bibliófilos, Editorial Corripio CxA, Santo Domingo, Dominican Republic.

Massip, Salvador
1932 En la Isla del Tesoro. *Diario de la Marina* (Havana). June 16.
1933 Los descubrimientos arqueológicos de la región de Samá. *Diario de la Marina* (Havana). Serie de artículos.

Matos, Martín
1985 La cultura de los círculos concéntricos: puntuación aborígen. *Revista Santiago* 59:73–87. Santiago de Cuba, Cuba.

Mentz Ribiero, P. A.
1978 Arte repustre no Sul do Brasil. *Revista do CEPA* 7(August):1–27. Brasil.

Moore, Clark
1992 Les ateliers lithiques en Haiti. *Bulletin du Bureau National d'Ethnologie*, Numéro special (1987–1992), pp. 13–30. Port-au-Prince, Haiti.
1998 Archaeology in Haiti. Unpublished manuscript. Presentation by Nils Tremmee. Port-au-Prince, Haiti.

Morales, Oswaldo
1949 Guamuhaya: Estudio arqueológico de esta región indocubana. Revisión del llamado Hombre del Curial. *Revista de Arqueología y Etnología*, Año 4, Época 2, Nos. 8 y 9. Havana.

Morbán Laucer, Fernando

1979 *El arte rupestre de la Republica Dominicana: Petroglifos en la provincia de Azua.*
 Fundación Garcia Arevalo, Santo Domingo, Dominican Republic.

1982 Huellas de canibalismo en enterramientos secundarios de un grupo pre-
 cerámico de Samana. *Boletín del Museo del Hombre Dominicano,* No. 17,
 pp. 169–183. Santo Domingo, Dominican Republic.

Mosquera, Gerardo

1984 El arte abstracto de los aborígenes preagroalfareros cubanos. *Revista San-
 tiago* 37:83–98. Santiago de Cuba, Cuba.

Mudge, Mark, Tom Malzbender, Carla Schroer, and Marlin Lum

2006 New Reflection Transformation Imaging Methods for Rock Art and
 Multiple-Viewpoint Display. In *Proceedings of the Seventh International Sym-
 posium on Virtual Reality, Archaeology and Cultural Heritage (VAST 2006),*
 edited by M. Ioannides, D. Arnold, F. Niccolucci, and K. Mania, pp. 195–
 202. Eurographics.

Munsell

1975 *Munsell Soil Color Charts.* Macbeth Division of Kollmorgen Instruments
 Corporation, New Windsor, New York.

Mylroie, John

1988 Karst of San Salvador. In *Field Guide to the Karst Geology of San Salvador,*
 edited by J. Mylroie, pp. 17–43. Department of Geology and Geography,
 Mississippi State University.

National Park Service

2006 National Register of Historic Places results web site. Electronic docu-
 ment, http://www.cr.nps.gov/nr/results.htm, accessed October 31, 2006.

Newsom, Lee A., and Elizabeth S. Wing

2004 *On Land and Sea: Native American Uses of Biological Resources in the West In-
 dies.* University of Alabama Press, Tuscaloosa.

Nooyen, R. H.

1979 *Het Volk van de Grote Manaure: De Indianen op de Gigantes-Eilanden.*
 Montero, Willemstad, Curaçao.

1985 *Historia di Pueblo di Bonaeiru.* Bonaire Offset Printing, Kralendijk.

Núñez Jiménez, Antonio

1967 *Cuevas y pictografías: Estudios espeleológicos y arqueológicos.* Edición Revolu-
 cionaria, Havana.

1970 *Caguanes pictográfico.* Editorial Academia, Havana.

1975 *Cuba: Dibujos rupestres.* Editorial de Ciencias Sociales, Havana.

1986 *El arte rupestre Cubano y su comparación con el de otras áreas de América.* Havana.

1991 Síntesis del arte rupestre en Cuba. In *Proceedings of the Congress of the Inter-
 national Association for Caribbean Archaeology* 13(2):927–943. Curaçao.

1997 El arte rupestre del Amazonas al Caribe: Bahamas. *Espelunca* 3(2):6–72.

Oldham, Tony

2007 *Geology of Cuba.* Electronic document, http://www.showcaves.com/
 english/cu/Geology.html, accessed September 28, 2006.

Oliver, José R.

1997 The Taíno Cosmos. In *The Indigenous People of the Caribbean,* edited by Samuel M. Wilson, pp. 140–153. University Press of Florida, Gainesville.

1998 *El centro ceremonial del Caguana, Puerto Rico: Simbolismo, iconográfia, cosmovisión y el poderío caciquil Taíno de Boriquén.* BAR International Series 727. British Archaeological Reports, Oxford.

2005 The Proto-Taíno Monumental *Cemís* of Caguana: A Political-Religious "Manifesto." In *Ancient Borinquen: Archaeology and Ethnohistory of Native Puerto Rico,* edited by Peter E. Siegel, pp. 230–284. University of Alabama Press, Tuscaloosa.

2006 Taíno Interaction and Variability between the Provinces of Higuey, Eastern Hispaniola, and Otoao, Puerto Rico. Paper presented at the 71st Annual Meeting of the Society for American Archaeology, San Juan, Puerto Rico.

Olmos Cordones, Hernán, and Abelardo Jiménez Lambertus

1980 Primer reporte de petroglifos de los sitios de Palma Cana y el Palero, Provincia de La Vega. *Boletín del Museo del Hombre Dominicano,* No. 13, pp. 125–152. Santo Domingo, Dominican Republic.

Olsen, Fred

1973 Petroglyphs of the Caribbean Islands and Arawak Deities. *Proceedings of the International Congress for the Study of the Pre-Columbian Cultures of the Lesser Antilles* 4:35–46. St. Lucia.

Ortiz, Fernando

1943 *Las cuatro culturas indias de Cuba.* Biblioteca de Estudios Cubanos, Vol. 1. Editores Arellano, Havana.

Pagán Jiménez, Jaime R., and Reniel Rodríguez Ramos

2007 Sobre el origen de la agricultura en Las Antillas. *Proceedings of the Congress of the International Association for Caribbean Archaeology* 21(1):252–259. St. Augustine, Trinidad and Tobago.

Pagán Perdomo, Dato

1978a *El arte rupestre en el área del Caribe/Inventario del arte rupestre en Santo Domingo.* Fundación García Arévalo, Museo del Hombre Dominicano, Santo Domingo, Dominican Republic.

1978b Bibliografía sumaria sobre el arte rupestre en el Caribe. *Boletín del Museo del Hombre Dominicano,* No. 11, pp. 107–130. Santo Domingo, Dominican Republic.

1978c *Nuevas pictografías de la isla de Santo Domingo (Las Cuevas de Borbón).* Editora Alfa e Omega, Ediciones del Museo del Hombre Dominicano, Santo Domingo, Dominican Republic.

Pané, Fray Ramón

1974 *Relación acerca de las antigüedades de los indios.* Edited by José Juan Arrom. Siglo XXI Editores, Mexico City.

1999 *An Account of the Antiquities of the Indians.* Translated by Susan C. Griswold. Edited by José Juan Arrom. Duke University, Durham, North Carolina.

Parallel Graphics, Inc.
2006 Cortona VRML Client web site. Electronic document, http://www.
 parallelgraphics.com/products/cortona/, accessed October 25, 2006.
Pereira, Oscar
2004 La confluencia del arte rupestre aborigen y africano en las cuevas de Cuba:
 Estudio preliminar. Paper presented at the II Taller Internacional de
 Arte Rupestre, Havana.
Perera, M. A.
1970 Notas preliminares acerca de los petroglifos de algunas cuevas del Es-
 tado Falcón, Venezuela. *Boletín de la Sociedad Venezolana de Espeleología*
 3(1):51–61. Caracas, Venezuela.
Pérez Merced, Carlos A.
1996 Los petroglifos de la colección del Instituto de la Cultura Puertorriqueña.
 Unpublished Master's thesis, Centro de Estudios Avanzados de Puerto
 Rico y el Caribe, San Juan, Puerto Rico.
2003 Los grabados aborígenes de los ríos grande de Loiza, Turabo y Guayanes
 en Puerto Rico. *Proceedings of the Congress of the International Association for
 Caribbean Archaeology* 20(2):617–628. Santo Domingo, Dominican Re-
 public.
Perpiñá, Antonio
1889 *El Camagüey: Viajes pintorescos por el interior de Cuba y sus costas, con descrip-
 ciones del país.* Publicación de J. A. Bastinos, Barcelona, Spain.
Petersen, James B., Belinda J. Cox, Johan G. Crock, and Emma Coldwell
2003 Big Spring: A Ceremonial Petroglyph Site in Anguilla, Lesser Antilles.
 *Proceedings of the Congress of the International Association for Caribbean Archae-
 ology* 20(2):657–666. Santo Domingo, Dominican Republic.
Petersen, James B., Corinne L. Hofman, and Louis Antonio Curet
2004 Time and Culture: Chronology and Taxonomy in the Eastern Caribbean
 and the Guianas. In *Late Ceramic Age Societies in the Eastern Caribbean,* ed-
 ited by A. Delpuech and C. L. Hofman, pp. 17–32. BAR International Se-
 ries 1273. British Archaeological Reports, Oxford.
Petitjean Roget, Henry
1997 Notes on Ancient Caribbean Art and Mythology. In *The Indigenous People
 of the Caribbean,* edited by Samuel M. Wilson, pp. 100–108. University
 Press of Florida, Gainesville.
2003 Les Pétroglyphes des Antilles: Des gravures contre la peur de voir l'eau
 douce disparaître à jamais. *Proceedings of the Congress of the International As-
 sociation for Caribbean Archaeology* 20(2):587–591. Santo Domingo, Do-
 minican Republic.
Piña y Peñuela, Ramón
1855 *Topografía médica de la Isla de Cuba.* El Tiempo, Havana.
Pinart, Alphonse L.
1979 Notas sobre los petroglifos y antigüedades de las Antillas Mayores y

Menores. Translated by Manuel Cádenas. *Revista del Museo de Antropología, Historia y Arte de la Universidad de Puerto Rico* 1(1):71–88.

Porter, Anthony R. D.
 1990 *Jamaica: A Geological Portrait.* Institute of Jamaica, Kingston.

Pothier, R.
 1970 Miamian's Cave Discoveries Link Mayans to Antilles. *Miami Herald* 10 August, p. 20-A.

Prous, Andre
 1977 Missao de estudo da arte rupestre de Lagoa Santa. *Arquivos do Museu de Historian Natural* 2:51–65. Brazil.

Rainey, Froelich G.
 1941 *Excavations in the Ft. Liberté Region, Haiti.* Yale University Publications in Anthropology, No. 23–24. Yale University Press, New Haven, Connecticut.

Rancuret, André R.
 2008 Curaçao: A Stepping Stone in the Caribbean. In *Rock Art in the Caribbean: Towards a Serial Transnational Nomination to the UNESCO World Heritage List,* edited by Nuria Sanz, pp. 257–262. World Heritage Papers, No. 24, UNESCO World Heritage Centre, Paris.

Raskar, Ramesh, Michael S. Brown, Ruigang Yang, Wei-Chao Chen, Greg Welch, Herman Towles, W. Brent Seales, and Henry Fuchs
 1999 Multi-Projector Displays Using Camera-Based Registration. In *Proceedings of IEEE Visualization '99,* pp. 161–168. San Francisco.

Reid, Basil, and Vel Lewis
 2007 A History of Archaeological Heritage Management (AHM) in Trinidad and Tobago. *Proceedings of the Congress of the International Association for Caribbean Archaeology* 21(1):152–162. St. Augustine, Trinidad and Tobago.

Richard, Gérard
 2001 *Duquerry.* Direction Régionale des Affaires Culturelles de Guadeloupe. Bilan Scientifique 2001, pp. 58–60, Basse-Terre, Guadeloupe.
 2008 La station de pétroglyphes de Stone Fort River site de Bloody Point à Saint Kitts. In *Rock Art in the Caribbean: Towards a Serial Transnational Nomination to the UNESCO World Heritage List,* edited by Nuria Sanz, pp. 300–305. World Heritage Papers, No. 24, UNESCO World Heritage Centre, Paris.

Richard, Gérard, and Henry Petitjean Roget
 2006 Appendix VI: ICOMOS Caribbean Rock Art Information Request Form for Guadeloupe. In *Rock Art of Latin America and the Caribbean: Thematic Study,* pp. 74–75. ICOMOS (International Council on Monuments and Sites) World Heritage Convention, Paris.

Rimoli, Renato O.
 1980a Informe preliminar sobre el proyecto "paleofauna de cuevas y abrigos

rocosos en la República Dominicana." *Boletín del Museo del Hombre Dominicano,* No. 13, p. 165. Santo Domingo, Dominican Republic.

1980b Restos de fauna en el sitio de Escalera, Abajo Provincia de Puerto Plata. *Boletín del Museo del Hombre Dominicano,* No. 13. Santo Domingo, Dominican Republic.

Rivera Meléndez, José

1996 Apuntes para el estudio de la prehistória de Cayey. Unpublished Master's thesis, Centro de Estudios Avanzados de Puerto Rico y el Caribe, San Juan, Puerto Rico.

Rivero de la Calle, Manuel

1961 Descubrimiento de nuevas pictografías realizados en el país. *Revista de la Junta Nacional de Arqueología y Etnología,* Época 5, No. Unico, pp. 79–82. Havana.

1966 *Las culturas aborígenes de Cuba.* Editora Universitaria, Havana.

1987 La cueva número 1 de Punta del Este, Isla de la Juventud, Cuba. Joya arqueológica del arte rupestre antillano. *Actas del VIII Simposio Internacional de Arte Rupestre,* pp. 471–477. Museo del Hombre Dominicano, Santo Domingo, Dominican Republic.

Rivero de la Calle, Manuel, and Antonio Núñez Jiménez

1958 Excursiones arqueológicas a Camagüey. *Revista Islas de la Universidad Central de Las Villas* 1(1):90–123. Santa Clara.

Robinson, Linda Sickler

1977 *National Register of Historic Places Inventory: Nomination Form.* Congo Cay Archaeological District, St. Thomas, Virgin Islands. Prepared for the U.S. Department of the Interior, National Park Service. Listed on the National Register December 1978.

1985 The Stone Row at El Bronce Archaeological Site, Puerto Rico. In *Archaeological Data Recovery at El Bronce, Puerto Rico: Final Report, Phase 2,* edited by Linda S. Robinson, Emily R. Lundberg, and Jeffrey B. Walker, pp. 11–112. Archaeological Services, Inc., Fort Myers, Florida. Prepared for the U.S. Army Corps of Engineers, Jacksonville District.

Robiou Lamarche, Sebastián

2003 *Taínos y Caribes: Las culturas aborígenes antillanas.* 2nd ed. Editorial Punto y Coma, San Juan, Puerto Rico.

Rodríguez, Cayetano Armando

1976 *Geografía de la isla de Santo Domingo y reseña de las demás Antillas.* 2nd ed. Sociedad Dominicana de Geografía, Santo Domingo, Dominican Republic. Originally published 1915.

Rodríguez, Marcos, and Carlos Borges

2001 *El arte rupestre de Rodas.* Ediciones Mecenas y Ediciones Damují, Cienfuegos, Cuba.

Rodríguez Álvarez, Ángel

1991 A Preliminary Petroglyphs Survey along the Blanco River Puerto Rico.

Proceedings of the Congress of the International Association for Caribbean Archaeology 13(2):589–604. Curaçao.

1993 A Classification Scheme for the Puerto Rico Petroglyphs. *Proceedings of the Congress of the International Association for Caribbean Archaeology* 14:624–636. Barbados.

2007 Astronomía de los petroglifos de las Antillas. Paper presented at the meetings of the Internacional Association of Caribbean Archaeology, Kingston, Jamaica.

2008 Los petroglifos de Puerto Rico. In *Rock Art in the Caribbean: Towards a Serial Transnational Nomination to the UNESCO World Heritage List,* edited by Nuria Sanz, pp. 341–352. World Heritage Papers, No. 24, UNESCO World Heritage Centre, Paris.

Rodríguez Ferrer, Miguel

1876 *Naturaleza y civilización de la Grandiosa Isla de Cuba.* Imprenta J. Noguera, Madrid.

Rodríguez Ramos, Reniel

2005 The Crab-Shell Dichotomy Revisited: The Lithics Speak Out. In *Ancient Borinquen: Archaeology and Ethnohistory of Native Puerto Rico,* edited by Peter E. Siegel, pp. 1–54. University of Alabama Press, Tuscaloosa.

Roe, Peter G.

1982 *The Cosmic Zygote: Cosmology in the Amazon Basin.* Rutgers University Press, New Brunswick, New Jersey.

1989 Of Rainbow Dragons and the Origins of Designs: The Waiwai *Urufiri* and the Shipibo *Ronin ëhua. Latin American Indian Literatures Journal* 5(1):1–67.

1991 The Petroglyphs of Maisabel: A Study in Methodology. *Proceedings of the Congress of the International Association for Caribbean Archaeology* 12:317–370. Martinique.

1993a Cross-Media Isomorphisms in Taíno Ceramics and Petroglyphs from Puerto Rico. *Proceedings of the Congress of the International Association for Caribbean Archaeology* 14:637–671. Barbados.

1993b Advances in the Study of Lowland South American and Caribbean Rock Art. Paper presented at the 58th Annual Meeting of the Society for American Archaeology, St. Louis, Missouri.

1995a *Arts of the Amazon.* Edited by Barbara Braun. Thames and Hudson, London.

1995b Myth-Material Cultural Semiotics: Prehistoric and Ethnographic Guiana-Antilles. Paper presented at the 94th Annual Meeting of the American Anthropological Association, Washington, D.C.

1997a Just Wasting Away: Taíno Shamanism and Concepts of Fertility. In *Taíno: Pre-Columbian Art and Culture from the Caribbean,* edited by Fatima Bercht, Estrellita Brodsky, John Alan Farmer, and Dicey Taylor, pp. 124–157. Monacelli Press and El Museo del Barrio, New York.

1997b An Affecting Culture of Beauty and Ephemerality. In *Fragments of the Sky: The Art of Amazonian Rites of Passage,* edited by K. Yellis, pp. 1–22. Peabody Museum of Natural History, Yale University, New Haven, Connecticut.

2002 Jardines de Loiza: Analysis of the Ceramic Component. In *Evaluación de Recursos Culturales (Fase de Mitigación) Sitio de las Yucas (LO-26), Proyecto "Jardines de Loiza Apartment Complex, Barrio Mediania Baja, Loiza, Puerto Rico,"* by Juan González Colón, pp. 70–137. Prepared for Ing. Ricardo Sola, Sola, Tapia and Associates (SHPO #12-14-89-01), San Juan, Puerto Rico.

2004 Ghost in the Machine: Symmetry and Representation in Ancient Antillean Art. In *Embedded Symmetries: Natural and Cultural,* edited by D. Washburn, pp. 95–143. University of New Mexico, Albuquerque.

2005 Rivers of Stone, Rivers within Stone: Rock Art in Ancient Puerto Rico. In *Ancient Borinquen: Archaeology and Ethnohistory of Native Puerto Rico,* edited by Peter E. Siegel, pp. 285–336. University of Alabama Press, Tuscaloosa.

Roe, Peter G., and José Rivera Meléndez
1995 Recent Advances in Recording, Dating and Interpreting Puerto Rican Petroglyphs. *Proceedings of the Congress of the International Association for Caribbean Archaeology* 16(1):444–461. Basse-Terre, Guadeloupe.

Roe, Peter G., José Rivera Meléndez, and Peter DeScioli
1999 The Cueva de Mora (Comerío, PR) Petroglyphs and Pictographs: A Documentary Project. *Proceedings of the Congress of the International Association for Caribbean Archaeology* 17:20–59. Nassau, Bahamas.

Roe, Peter G., Agamemnon Gus Pantel, and Margaret B. Hamilton
1990 Monserrate Restudied: The 1978 Centro Field Season at Luquillo Beach. Excavation Overview, Lithics and Physical Anthropological Remains. *Proceedings of the Congress of the International Association for Caribbean Archaeology* 11:338–369. San Juan, Puerto Rico.

Romero, Alejandro
1997 El arte parietal en la provincia de Sancti Spíritus, Cuba. *Revista Espelunca,* Época Nueva, Año 3, No. 2. Sociedad Espeleológica de Cuba, Havana.

Roumain, Jacques
1943 Les outillages lithiques des Ciboneys d'Haïti. *Bulletin du Bureau d'Ethnologie* 2:22–27. Port au Prince.

Rouse, Irving
1941 *Culture of the Ft. Liberté Region, Haiti.* Yale University Publications in Anthropology, No. 24. Yale University Press, New Haven, Connecticut.

1949 Petroglyphs. In *Comparative Ethnology of South American Indians,* pp. 493–502. Handbook of South American Indians, Vol. 5, Julian H. Steward, general editor. Bureau of American Ethnology Bulletin 143. Smithsonian Institution, Washington, D.C.

1992 *The Taínos: Rise and Decline of the People Who Greeted Columbus.* Yale University Press, New Haven, Connecticut.

Rouzier, Sémexant

1890 *Dictionnaire géographique et administratif universel d'Haïti.* Imp. Charles Blot, Paris.

Saint-Méry, Moreau de

1984 *Description topographique, physique, civile, politique et historique de la partie française de l'isle de Saint-Dominque.* 2 vols. Société Française d'Histoire d'Outre-Mer, Paris.

Salgado, Antoine

ca. 1980 *Hauts-Lieux Sacrés dans le Sous-sol d'Haïti.* Ateliers Fardin, Port-au-Prince, Haiti.

Saunders, Nicholas

2005 *The Peoples of the Caribbean: An Encyclopedia of Archaeology and Traditional Culture.* ABC-CLIO, Santa Barbara, California.

Schobinger, Juan

1976 Classificación preliminar del arte rupestre sud-Americano. *Proceedings of the International Congress of Americanists* 98:387–388.

Seales, W. Brent, and George V. Landon

2005 The Museum and the Media Divide: Building and Using Digital Collections at the Instituto de Cultura Puertorriquena. *D-Lib Magazine* 11(50).

Sealey, Neil

1994 *Bahamian Landscapes.* 2nd ed. Media Publishing, Nassau, Bahamas.

Senior, Olive

2003 *Encyclopedia of Jamaican Heritage.* Twin Guinep, Kingston, Jamaica.

Siegel, Peter E.

1997 Ancestor Worship and Cosmology among the Taíno. In *Taíno: Pre-Columbian Art and Culture from the Caribbean,* edited by Fatima Bercht, Estrellita Brodsky, John Alan Farmer, and Dicey Taylor, pp. 106–111. Monacelli Press and El Museo del Barrio, New York.

2007 Dynamic Dualism: A Structural Analysis of Circular Communities. *Proceedings of the Congress of the International Association for Caribbean Archaeology* 21(2):525–536. St. Augustine, Trinidad and Tobago.

Siegel, Ronald K.

1992 *Fire in the Brain: Clinical Tales of Hallucination.* Plume, New York.

Smith, Greg C.

1995 Indians and Africans at Puerto Real: The Ceramic Evidence. In *Puerto Real: The Archaeology of a Sixteenth-Century Spanish Town in Hispaniola,* edited by K. Deagan, pp. 335–374. University Press of Florida, Gainesville.

Stevens-Arroyo, Antonio M.

1988 *Cave of the Jagua: The Mythological World of the Taínos.* University of New Mexico Press, Albuquerque.

Stouvenot, Christian

2008 Patriarche et bases de donnèes annexes en Guadeloupe: Un outil à com-

pléter par un système de'inventaire des sites d'art rupestre. In *Rock Art in the Caribbean: Towards a Serial Transnational Nomination to the UNESCO World Heritage List,* edited by Nuria Sanz, pp. 279–283. World Heritage Papers, No. 24, UNESCO World Heritage Centre, Paris.

Stouvenot, Christian, and Gérard Richard
2005 *Opération de Sondages.* Service regional d'archéologie Guadeloupe.

Straka, H.
1964 La Leyenda Bochica en Venezuela demostrada por petroglifos. *Sociedad Venezolana de Ciencias Naturales, Boletín* 107(25, June):261–269. Caracas, Venezuela.

Tabio, Ernesto E., and Estrella Rey Betancourt
1979 *Prehistória de Cuba.* 2nd ed. Editorial de Ciencias Sociales, Havana.

Thurn, Everard F. Im
1883 *Among the Indians of Guiana. Being Sketches Chiefly Anthropologic from the Interior of British Guiana.* Kegan Paul, Trench, London.

Toner, Mike
2008 Ghosts of the Taíno: Mystery and Controversy Haunt a Pre-Columbian Ceremonial Site in Puerto Rico. *Archaeology* 61(2):50–53.

Tormo, Elias
1951 Petroglifo Caiquetio. *Revista de Indias* 11:559–561. Consejo Superior de Investigaciones Científicas, Madrid.

Toro Sugrañes, José A.
1982 *Nuevo atlas de Puerto Rico.* Editorial Edil, Río Piedras, Puerto Rico.

Trapp, Douglas E.
2006 Barn owl information page. Electronic document, www.ourworld. compuserve.com/homepages/DTrapp/barnowli.html, January 2, 2006.

Trinks, I., M. Díaz-Andreu, R. Hobbs, and K. E. Sharpe
2005 Digital Rock Art Recording: Visualizing Petroglyphs Using 3D Laser Scanner Data. *Rock Art Research* 22(2):131–139.

Valencia, Ruby de, and Jeannine Sujo Volsky
1987 *El diseño en los petroglifos Venezolanos.* Fundación Pampero, Caracas, Venezuela.

van de Poll, Willem
1950 *De Nederlandse Antillen: Een fotoreportage van land en volk.* Gravenhage, The Netherlands.
1952 *Nos Tera,* p. 93. Aruba.

Vaz, J. E.
1977 Petroglifos de 1000 años de antiguedad en la Biblioteca de la Universidad Central de Venezuela. *El Nacional* (Caracas, Venezuela), November 29.

Veloz Maggiolo, Marcio
1970 Informe sobre una posible metodología para la interpretación y posible identificación de las pinturas rupestres Antillanas. *Revista Española de Antropología Americana* 5:317.

1972 *Arqueología prehistórica de Santo Domingo*. Fundación Crédito Educativa
 República Dominicana/McGraw-Hill Far Eastern, Singapore.
Veloz Maggiolo, Marcio, and Jesús García Galvan
1976 *Análisis de microscopia electrónica de pictografías en las Maravillas, Provincia de
 San Pedro de Macorís*. Anuario Científico 1(1). San Pedro de Macorís, Do-
 minican Republic.
Veloz Maggiolo, Marcio, Elpidio Ortega, and Plinio Pina Peña
1974 *El Caimito: Un antiguo complejo ceramista de las Antillas Mayores*. Museo del
 Hombre Dominicano, Serie Monográfica 3. Ediciones Fundación García
 Arévalo, Santo Domingo, Dominican Republic.
Versteeg, A. H., and A. C. Ruiz
1995 *Reconstructing the Brasilwood Island: The Archaeology and Landscape of In-
 dian Aruba*. Publications of the Archaeological Museum of Aruba 6.
 Oranjestad, Aruba.
Vescelius, Gary S.
1976 National Register of Historic Places Inventory—Nomination Form for
 Botany Bay Archaeological District, St. Thomas. Ms. on file with the Vir-
 gin Islands Department of Planning and Natural Resources, Office of Ar-
 chaeology and Historic Preservation. Charlotte Amalie, St. Thomas, U.S.
 Virgin Islands.
Vignati, M.
1967 Una interpretación astronómico-religiosa de las pictografías del Cerro
 Colorado, Cordoba. *Investigaciones y Ensayos Públicos de la Academia Nacional
 de la Historia* 2:37–47. Buenos Aires.
Viré, Armand
1941 *La Préhistoire en Haïti*. Imp. Ch. Monnoyer, Le Mans, France.
Walker, Jeffrey B., and Juan González Colón
2002 *Hacienda San Marin Project, Higuillar Ward, Dorado, Puerto Rico: Archaeologi-
 cal Report Stage II—Mitigation*. Prepared for Eng. Edmundo Colón Ariz-
 mendi, Colón, Díaz, Quiñonez and Associates. Submitted to Consejo para
 la Protección del Patrimonio Arqueológico Terrestre de Puerto Rico,
 San Juan.
Wasklewicz, T. A., D. Whitley, H. X. Volker, and D. Staley
2005 Terrestrial Laser Scanning: A New Method for Mapping, Imaging, and
 Analyzing Rock Art. *International Newsletter on Rock Art (INORA)*
 41:16–25.
Watson, Karl
1988 Amerindian Cave Art: Mountain River Cave, St. Catherine. *Jamaica Jour-
 nal* 21(2):13–18.
Webster's Online Dictionary
2006 *Hydrocyanic Acid*. Electronic document, www.websters-online-dictionary.
 org/hy/hydrocyanic+acid.com, accessed January 2, 2006.
Wessex Archaeology and Archaeoptics Ltd.
2006 *Stonehenge Laser Scans: An Application of Laser Scanners in Archaeology*. Elec-

tronic document, http://www.stonehengelaserscan.org, accessed August 10, 2006.

Whitley, David S.

1998 Finding Rain in the Desert: Landscape, Gender and Far Western North American Rock Art. In *The Archaeology of Rock Art,* edited by C. Chippindale and P. S. Taçon, pp. 11–25. Cambridge University Press, Cambridge.

2001 Rock Art and Rock Art Research in a Worldwide Perspective: An Introduction. In *Handbook of Rock Art Research,* edited by D. S. Whitley, pp. 7–51. AltaMira, Walnut Creek, California.

Whitley, David S. (editor)

2001 *Handbook of Rock Art Research.* AltaMira, Walnut Creek, California.

Wild, Kenneth S.

2001 Investigations of a "Caney" at Cinnamon Bay, St. John and Social Ideology in the Virgin Islands as Reflected in Pre-Columbian Ceramics. *Proceedings of the Congress of the International Association for Caribbean Archaeology* 18(2):301–310. Grenada.

2003 Defining Petroglyphs from the Archaeological Record. *Proceedings of the Congress of the International Association for Caribbean Archaeology* 20(2):639–646. Santo Domingo, Dominican Republic.

2006 Appendix IX: ICOMOS Caribbean Rock Art Information Request Form for the U.S. Virgin Islands. In *Rock Art of Latin America and the Caribbean: Thematic Study,* pp. 82–83. ICOMOS (International Council on Monuments and Sites) World Heritage Convention, Paris.

Williams, Denis

1985 Petroglyphs in the Prehistory of Northern Amazonia and the Antilles. In *Advances in World Archaeology,* Vol. 4, edited by Fred Wendorf and Angela E. Close, pp. 335–387. Academic Press, New York.

Wilson, Samuel M.

1997 Introduction to the Study of the Indigenous People of the Caribbean. In *The Indigenous People of the Caribbean,* edited by Samuel M. Wilson, pp. 1–8. University Press of Florida, Gainesville.

1999 Cultural Pluralism and the Emergence of Complex Society in the Greater Antilles. *Proceedings of the Congress of the International Association for Caribbean Archaeology* 18(2):7–12. Grenada.

2006 *The Prehistory of Nevis, a Small Island in the Lesser Antilles.* Yale University Publications in Anthropology, No. 87. Peabody Museum of Natural History, New Haven, Connecticut.

Winter, John

1990 *A Reconnaissance of Long Island, Rum Cay, and Conception Island—July 4–22, 1989.* Report to the Bahamian Department of Archives, Nassau, Bahamas.

1993 Petroglyphs of the Bahamas. *Proceedings of the Congress of the International Association for Caribbean Archaeology* 14:672–680. Barbados.

2001 Possible Analogies for a Paleoenvironment on San Salvador Island. *Proceedings of the Symposium on the Natural History of the Bahamas* 8:106–110.

Winter, John, and Mark Gilstrap

1991 Preliminary Results of Ceramic Analysis and the Movements of Populations into the Bahamas. *Proceedings of the Congress of the International Association for Caribbean Archaeology* 12:371–386. Cayenne, French Guiana.

Winter, John, Julian Granberry, and Art Leibold

1985 Archaeological Investigations within the Bahamas Archipelago. *Proceedings of the International Congress for the Study of the Pre-Columbian Cultures of the Lesser Antilles* 10:83–92. Fort-de-France, Martinique.

Contributors

Philip Allsworth-Jones is an archaeology research fellow at the University of Sheffield, England.

Pedro A. Alvarado Zayas is a senior archaeologist with the Instituto de Cultura Puertorriqueña.

José Gabriel Atiles Bidó is an investigator for the General National Archives Special Collections Department and the Natural History Museum and serves as the Secretary for Cultural Affairs in the Dominican Republic.

Lesley-Gail Atkinson is an archaeologist with the Jamaica National Heritage Trust.

Rachel Beauvoir-Dominique is co-founder of the Fondation Ayizan Velekete and a consultant for the Haitian Ministry of Culture and Communication.

Michael A. Cinquino is Director of the Buffalo, New York, office of Panamerican Consultants, Inc.

Racso Fernández Ortega is auxiliary investigator for the Fernando Ortiz Foundation and a professor at the National Speleological School.

José B. González Tendero holds a professorship at the National Speleological School and is an instructor in underwater cave exploration at the same institution.

Divaldo A. Gutierrez Calvache is co-coordinator for the Cuban Rock Art Project.

Jay B. Haviser is the archaeologist for the Netherlands Antilles.

Michele H. Hayward is a senior archaeologist with Panamerican Consultants, Inc.

Sofia Jönsson Marquet obtained her degrees from the University of Paris I, Sorbonne-Panthéon, Paris.

Harold J. Kelly is an archaeologist at the Scientific Department of the Archaeological Museum of Aruba.

George V. Landon is an assistant professor in computer science at Eastern Kentucky University.

Adolfo López Belando is an associate investigator at the Dominican Museum of Man and the Natural History Museum, Dominican Republic.

Johannes H. N. Loubser is an archaeologist and rock graphic specialist at Stratum Unlimited, LLC in Atlanta, Georgia.

Gérard Richard is territorial conservator, archaeologist, and chief of the Cultural Patrimony Service in Architecture and Archaeology for the Regional Council of Guadeloupe.

Peter G. Roe holds a professorship in anthropology at the University of Delaware in Newark, Delaware.

W. Brent Seales is an associate professor of computer science at the University of Kentucky, Lexington.

Kenneth S. Wild is a graduate of the University of Tennessee at Chattanooga and Florida State University with degrees in anthropology/archaeology.

John H. Winter is a professor at Molloy College in Rockville Center, New York, and field archaeologist for the Gerace Research Center on San Salvador Island, the Bahamas.

Index

Page numbers in italics refer to figures.

Aboukir Cave, Jamaica, 54

Abri Patate, Guadeloupe, 138, 143, 145, 146

abstract designs, 29, 33, 39–40, 49–51, 80, 83, 90, 96–97, 109–111, 118, 119, 124, 125, 148, 149, 181, 211, 218, 227

African, 34, 82, 85, 86, 116; ceramics, 85; legal framework, 87; rock art production, 34, 79, 85, 217

Amazon, 14, 65, 163, 169, 170, 171, 219, 229–230, 232; native belief, 71–72, 74, 221, 230; rock art of, 169–170, 232

Amerindian, 13, 55, 74, 82, 140, 175, 178, 186, 220, 225, 227, 229, 230, 233, 238

Anamuya Petroglyph Style, Dominican Republic, 94, 110, 220

Anamuyita Rocks, Dominican Republic, 110

ancestor, 10, 15, 84, 87, 92, 128, 174; ancestor worship, 20–21; ancestral, 20, 73, 131, 169, 224, 229; dead ancestors, 11, 17, 73, 129–134, 207, 209, 221, 227; dead spirits, 66, 74, 130–131, 221

Anguilla, 5, 205, 207, 214

Anse des Galets, Guadeloupe, 44, 139, 140, 146

Anse des Pitons, St. Lucia, 154

Anse Duquerry, Guadeloupe, 139, 140, 145

Anse Rouge, Haiti, 78

anthropomorph, 10, 11, 14, 19, 20, 27, 29, 38, 49, 51, 55, 80, 83, 90, 95, 96, 98, 101, 110, 119, 125, 126, 128–132, 138–144, 148–151, 155, 166, 167, 177–184, 195, 196, 211, 214, 217, 218, 220, 221, 226, 227, 231, 237, 238; mixed type, 55, 95, 150, 211, 227; on rock sculptures, 11; South American, 14

Antigua, 2, 205

Antilles, 14, 18, 20, 39, 41, 69, 183, 219, 229, 237, 238; rock art of, 14, 41, 109, 183–184, 198, 211, 232–233, 237–239. *See also* Greater Antilles; Lesser Antilles

archaeo-anthropological framework, Cuba, 25, 38, 39

Archaic age, *7, 8,* 9, 78, 90, 97, 102, 109, 111–112, 125, 162, 171, 214, 218, 229–233

areyto, 10, 39, 98, 129, 132, 230. *See also* ceremony

Arikok National Park, Aruba, 178, 185

arm, design, 69, 72, 73, 83, 96, 119, 139, 150, 178

Aruba, 11–12, 109, 111–112, 161, 171; geography, 5, 6, 175; legal framework, 184–185; rock art conservation, 185–187; rock art dating, 176–177; rock art history, 175; rock art images, 175–176, 205, 209–211, 214; rock art interpretation, 178–180, 182–184; rock art sites, 175–177, 182, 205, 207. *See also* Netherlands Antilles

astronomy: observations, 2, 24, 36, 116, 170; ethno-astronomy, 230

Ayo, Aruba, 177, 185

Bahamas, 12–13; cultures, 13–14; geography, 5, 13; rock art, 14; rock art dating, 14, 217, 233; rock art execution techniques, 15; rock art future research, 20–21; rock art images, 14, 205; rock art interpretation, 15–18, 20; rock art site descriptions, 15–20; rock art sites, 14–15, 205, 207, 211

Bahamian archipelago, 3, 6, 14, 15; geography, 5, 13. *See also* Bahamas; Turks and Caicos

ball court, 45, 73, 128, 132, 136, 158, 207, 219, 238; characterization of, 10, 118; rock art of, 40, 42, 79, 116–118, 126–127, 139, 207, 220. *See also* plaza

Bananier River, Guadeloupe, 138, 139

Bassin Caraïbe, Guadeloupe, 139

Bassin Zim, Haiti, 44, 79, 82, 84

Beach Cave, Bahamas, 20

behique/shaman, 11, 17, 39, 48, 55, 57, 66, 67, 69–70, 72–74, 83, 97–98, 179, 186, 209, 221, 222, 226, 237

Belmont, Tortola, British Virgin Islands, 117, 122, 127, 132

body, design, 1, 14, 17, 49–50, 68, 70, 72–73, 84, 104, 119, 122–127, 130–132,

139, 141–142, 144, 149–150, 152, 154–155, 176, 178, 207, 218, 227, 231–232

Bohoc/Colladère, Haiti, 79, 84

Bonaire, 11–12, 111–112, 183; cultures, 162–163; geography, 5–6; rock art conservation, 172–174; rock art dating, 171, 214; rock art history, 161–162; rock art images, 163, 209, 214; rock art interpretation, 168–171, 183–184, 207; rock art site descriptions, 163–168; rock art sites, 163, 205, 207. *See also* Netherlands Antilles

Botany Bay, St. Thomas, U. S. Virgin Islands, 116, 117, 122, 127

boulder, rock art location, 26, 47, 58–62, 67, 70, 80, 84, 94, 110, 117–118, 126–128, 131, 139–142, 144, 148, 149, 152, 155–156, 165–166, 176–177, 188, 193, 207, 218, 220, 238

Bridge Cave, Dominican Republic, 98

British Virgin Islands, 117, 205; geography, 5, 117. *See also* Virgin Islands

Byndloss Mountain, Jamaica, 49

caciazgo. See chiefdom

cacique/chief, 10–11, 17, 54, 73, 79, 81, 84, 86, 92, 129–132

Caguana ball court/rock art site, Puerto Rico, 40, 116, 118, 126, 128–131, 136, 139, 158, 188, 190, 192–193, 195–197, 220, 238

Camp-Perrin, Haiti, 80

Canashito Cave, Aruba, 176, 177, 178, 180, 181

Canoe Valley caves, Jamaica, 43, 45, 49, 55

Capesterre-Belle-Eau, Guadeloupe, 138

Caribbean, 10, 112, 116–117, 162, 184, 229; cultures, 10, 55, 66–67, 74, 88, 106, 141, 228–231, 233, 238; geography, 3, 5–6; rock art, 1–3, 12, 20, 23, 32, 37, 41–42, 44, 70, 89, 98, 103, 110,

114, 161, 163, 174, 184, 188, 198–199, 205, 214, 217, 218, 220, 231–233, 236, 238–239

Caribbean Sea, 117, 162

Carpenter's Mountain, Jamaica, 55

carving, rock art, 2, 19, 23, 26, 37, 41, 45, 48–50, 64–65, 67, 69–70, 77, 93, 102, 109–110, 116, 126, 130, 137, 139–140, 142, 144, 158, 162, 169, 188, 192, 220

cave, rock art location, 14–24, 26–33, 35–37, 40, 42–51, 54–57, 59–60, 66–67, 70, 74, 78–88, 90–98, 100–111, 113–114, 117, 122–124, 126, 138, 144, 146, 163–164, 166–168, 172–173, 175–178, 180–185, 205, 207, 209, 211, 218–222, 226–227, 233, 236, 238; cave mouth, 15, 18, 32, 66, 104, 144, 226

Caverna de Patana, Cuba, 23, 35, 40, 54, 227, 228

Caves 1, 2, 3, and 4, Dominican Republic, 98

cemí/zemí, 18, 20, 23, 45, 54–56, 67, 73–75, 81, 92, 102, 124, 129–134, 141, 224, 227; characterization of, 10–11, 66–67; named, Attabeira, 11, 18, 20, 84, 224; Yúcahu Maórocoti, 11, 18, 20, 84, 227. See also ancestor; three-pointed object/three pointer

Central America, 3, 6, 112, 218

Ceramic Period/Cultures, 7, 8, 9, 23, 27, 60, 78–80, 105, 111–112, 118, 126, 145, 148, 151, 158, 162, 171, 175–177, 214, 218, 220, 228, 230, 233. See also Early Ceramic; Late Ceramic

ceremony, 10, 11, 21, 55, 85, 97, 99, 125, 129–130, 171, 175, 177, 179–180, 183, 186, 219. See also areyto

Ceroe Pungi/Cero Plat, Bonaire 161

Ceru Cachu Baca, Bonaire, 164

Chacuey Petroglyphs, Dominican Republic, 92

Chacuey Petroglyph Style, Dominican Republic, 95, 220

Chesterfield, Jamaica, 43

chiefdom, 10, 39–40, 132, 148, 221, 238

Chipaque, Bonaire, 171

chronicler, accounts by, 1, 10–11, 17, 23, 40, 46, 53, 65–67, 73, 90, 92, 99, 102, 105, 128–130, 132, 221, 229, 230

cohoba, 11, 39, 54, 66, 69, 72, 73, 83, 99, 102, 230; altered states, 11, 48, 54, 65–67, 72–74, 102, 103

colors, rock art, 23, 24, 28, 64, 96, 98, 107, 109, 119, 163, 167, 171–173, 177, 179, 180, 182, 184, 186, 214, 222; black, 19, 28–30, 84, 96–98, 107, 119, 163, 165, 167, 171, 214, 222, 226; brown, 163–167, 176, 181–182; gray, 28, 96, 107; ochre, 96–97, 109; orange, 96–97, 101, 119; red, 23, 28–29, 96–97, 108–109, 119, 163, 164, 166–168, 171–172, 177, 180, 182–184, 214, 222; sepia, 28; white, 96, 99–100, 119, 180, 184

color sources: animal grease, 96; bat guano, 119; carbon, 30, 32, 38, 96, 119, 124; chalk, 176; clay, 96; hematite, 96, 119, 163; iron oxide, 176; jaguar/bija, 96; kaolin, 43, 96, 99, 119; manganese, 38; mangrove tree, 96; monochrome, 96, 107, 176, 222; ochre, 38, 43; pigments, 43, 93, 101, 176; soot, 27, 32, 96; polychrome, 107, 176, 179–181, 184, 219, 221; tree resin, 163; vegetable, 30, 38, 43, 119, 163, 222

Columbus, Christopher, 14, 19, 66, 73, 74

Concentric Lines Style, Cuban, 214

Congo Cay, St. John, U.S. Virgin Islands, 116, 117, 122, 127

Contact Period, 10, 13, 17, 19, 40, 46, 83, 90–91, 102, 105, 126–129, 132, 199, 214, 220

cosmology/worldview, 42, 51, 83, 87, 128;

Caribbean, 11, 38, 40, 46, 52–53, 56, 65, 73–75, 81–82, 84, 92, 96, 103, 129, 130–132, 135, 204, 209, 221–222, 228, 230, 238

Cousinière Grosse Roche, Guadeloupe, 142

Coventry Cave, Jamaica, 49

Cuba, 1, 12–13; cultures, 6, 9, 106, 112, 125; geography, 3; rock art conservation, 34–35; rock art dating, 34, 109, 112, 214, 217–218, 233; rock art history, 22–26; rock art images, 27–28, 171, 184, 205, 227; rock art interpretive frameworks, 35–40, 80; rock art site descriptions, 32–34; rock art sites, 26–27, 54, 110, 205, 207, 211; rock art styles, 29–32, 109, 111

Cuckold Point, Jamaica, 55

Cueva Ambrosio, Cuba, 29, 35, 37, 40, 109

Cueva Ceremonial Nos. 1 and 2, Cuba, 34, 35

Cueva de Berna, Dominican Republic, 105, 108, 109, 111, 112, 114, 126, 214

Cueva de Berna Pictograph Style, Dominican Republic, 97, 103, 108, 109, 110

Cueva de Espinar, Mona Island, 105

Cueva de la Cachimba, Cuba, 32, 80

Cueva de la Cidra, Dominican Republic, 96–97, 99–100, 107, 233

Cueva de la Cidra Pictograph style, Dominican Republic, 97, 99

Cueva del Agua, Cuba, 34

Cueva de la Iguana, Cuba, 32

Cueva de la Línea, Haiti, 98, 101

Cueva de las Caritas, Mona Island, 105, 111, 112, 126, 214

Cueva de las Maravillas, Dominican Republic, 98, 103, 105, 113–114

Cueva de las Mercedes, Cuba, 35, 40

Cueva del Caballo, Puerto Rico, 123

Cueva del Ferrocarril, Dominican Republic, 114

Cueva del Indio, Puerto Rico, 122, 136

Cueva de los Balcones, Mona Island, 105

Cueva de los Bichos, Cuba, 23, 31. See also Caverna de Patana, Cuba

Cueva de los Indios, Puerto Rico, 136

Cueva de los Generales, Cuba, 34

Cueva de los Petroglifios, Cuba, 27, 32

Cueva de María Teresa, Cuba, 22, 29, 35

Cueva de Mora, Puerto Rico, 70, 119, 136, 211, 221–224, 226, 228, 238

Cueva de Waldo Mesa, Cuba, 24

Cueva el Cura, Cuba, 35

Cueva el Fustete, Cuba, 35

Cueva el Indio, Cuba, 35, 218

Cueva el Puente, Dominican Republic, 98

Cueva García Robiou, Cuba, 35

Cueva Hoyo de Sanabe, Dominican Republic, 97–98, 101, 106, 108, 114

Cueva Hoyo de Sanabe Pictograph Style, Dominican Republic, 97–98

Cueva José María, Dominican Republic, 96–98, 100, 103, 114

Cueva José María Pictograph School, Dominican Republic, 97–98, 103–105, 107, 110

Cueva Lucero, Puerto Rico, 107–108, 115, 122, 124, 125, 211, 221–222, 224, 228, 238

Cueva Matías, Cuba, 35

Cueva Mesa, Cuba, 35

Cueva Mural, Cuba, 29, 32–33

Cueva Negra, Mona Island, 105

Cueva No. 1, Cuba, 23

Cueva Paredones, Cuba, 35

Cueva Perla del Agua, Cuba, 35

Cueva Pichardo, Cuba, 35

Cueva Pluma, Cuba, 29

Cueva Ramos, Cuba, 40

Cueva Ventana, Puerto Rico, 123

Cueva la Catedral, Puerto Rico, 116, 211, 221–222, 227–228

Cueva la Colmena, Dominican Republic, 109

Cueva la Virgen, Cuba, 35

Cueva las Manos, Dominican Republic, 108

Cueva los Portales, Cuba, 35

Cuevas de Borbón, Dominican Republic, 93, 96, 101, 107–108, 113, 222, 237

Cuevas de Borbón Pictograph Style, Dominican Republic, 97–98, 103, 106–108, 110, 230

Cuevas Guácaras de Comedero Nos. 1–5, Dominican Republic, 106, 107

Cuevas las Abejas, Dominican Republic, 108

Cuevas los Musulmanes Nos. 1 and 2, Cuba, 35

Cuevas Nos. 1, 2, 3, and 4, Punta del Este, Cuba, 35

cultural-morphological framework, Cuba, 36, 38, 40

Curaçao, 11, 111–112; geography, 5–6; rock art of, 161, 163, 170–171, 183–184, 205, 207, 209, 214. *See also* Netherlands Antilles

dating, rock art, 46, 101, 110, 115, 125–128, 133, 140, 171, 198–199, 214, 220, 224, 232; AMS, 176–177; radiocarbon, 45–46, 97, 105, 109, 111, 112, 126, 150, 160, 171, 214, 231

deity/god, 11, 18, 20, 27, 55, 81, 84, 227. *See also cemí/zemí*

design, rock art, 48, 57, 165, 172, 189; Caribbean, 1, 2, 14, 17–20, 23, 27–30, 33–34, 37, 40, 49–52, 72, 80, 85, 90, 94–98, 101, 104, 107–111, 114, 119, 122–126, 130, 133, 139, 141, 148–149,

151, 155–156, 163–169, 172, 174, 176–178, 184, 186, 205, 214, 218, 228; element/layout, 14, 20, 24, 37, 95, 98, 119, 126–127, 147, 149–151, 154, 157–158, 178

digitized images/data, 12, 186, 188, 189, 193–195, 197

Dominica, 5, 199, 205

Dominican Republic, 1, 12; culture, 67–68, 70, 90; geography, 3; legal framework, 113–114; rock art conservation, 101, 114, 233; rock art dating, 94, 102, 110–112, 214; rock art history, 90–94; rock art images, 90, 94, 96, 109, 184, 226, 230; rock art interpretation, 97, 105–109, 111–112, 126; rock art sites, 90, 94, 96–97, 102, 109, 205; rock art styles/schools, 94–101, 103–112, 220, 228

drawing, rock art: designs, 116, 161–168, 173, 182, 185, 222, 228; drawings of, 1, 36, 84, 116, 203–204

Dryland, Jamaica, 41, 44, 47

Dubedou, Haiti, 79

Duff House, Jamaica, 45

Duquesne Bay, Grenada, 156

ear, design, 17, 50, 67, 70, 96, 119, 123, 130, 131, 138, 142, 144, 150, 220

Early Ceramic, 7, *8,* 9, 10, 90, 145, 150, 151, 154, 156, 171, 217, 219, 230, 237

El Bronce ball court/rock art site, Puerto Rico, 126

El Dolmen de Taguasco, Cuba, 26

El Palo, Puerto Rico, 119

Ensenada, Puerto Rico, 118

engraving, rock art, 49, 61, 80, 138–143, 147; areas of, 63–64

eye, design, 16–19, 37, 50, 67, 70, 72, 75, 80, 81, 96, 110, 119, 127, 133, 138–140, 144, 149, 150, 156, 178, 183, 227, 228

face, designs, 14, 16, 18, 19, 20, 55, 64, 72, 95, 119, 124–125, 127–128, 130, 132–134, 138–140, 142–144, 154, 218, 220, 223–227, 231, 233, 237–238; complex faces, 50, 80–81, 119, 124, 141, 149, 156; developed faces, 50, 119, 146, 156; face mask, 130; facial designs, 17, 19, 20, 50, 67, 82, 98, 110, 119, 122–124, 127, 130–132, 149, 150, 155, 157, 178, 183, 214, 220; jaw, 67–68, 72; simple faces, 16, 20, 50, 80–81, 109, 111, 119, 122, 127, 130, 139, 141–142, 144, 148–149, 155–156, 158, 214, 218, 220, 221

Farquhar's Beach, Jamaica, 50

figure, rock art, 16, 19–20, 22–24, 29–30, 33, 39–40, 47, 54, 74, 82–83, 85, 91, 93–98, 101, 104–105, 107, 109–110, 116–117, 122, 124, 126–132, 139–141, 144, 148–152, 154–158, 168, 170, 173, 176–178, 186, 188, 193, 197, 203–204, 214, 221, 226–227, 232; abstract, 29, 181; anthropomorphic, 14, 17, 19, 80, 83, 96, 98, 101, 107, 110, 119, 125–126, 129–130, 140, 149–150, 152, 154–155, 166, 178, 183, 221, 232; anthrozoomorphic, 227; definition of, 2; geometric, 100, 156; zoomorphic, 19, 95, 98, 99, 107, 119, 125, 150, 181, 224–225

Fine-Line Incised Petroglyph Style, Dominican Republic, 96

Fontein, Aruba, 175, 178, 180, 182, 185; Bonaire 161–162, 164–166, 170, 172–173

Galion, Martinique, 156

Gato, Dominican Republic, 96

geometric, design, 14, 17, 20, 27, 29, 31, 49–51, 72, 94, 96–97, 100–101, 109–110, 118–119, 124, 138, 144, 148–149, 151, 155–156, 177, 179–180, 182–184, 211, 214, 218, 227, 233; circles, 29, 94–95, 101, 109–110, 119, 139, 154, 164–167, 184; circular, 16–18, 50, 95, 139, 144, 150–151, 176, 179; concentric circles, 16, 29, 97, 110, 156, 165, 167, 169, 184, 218, 231; concentric lines, 218; cross, historic, 19; cross, prehistoric, 94, 101, 110, 119, 138, 164–169, 184; curves, 19, 30; curvilinear lines 125, 224; dashes, 119; dots, 30, 164–167, 214; fret, 95; heart-shaped, 126–127, 130, 133, 150, 224, 226–227; hexagonal, 177; oval, 16, 18, 50, 126, 150; rectangles, 29, 119, 176; rectilinear lines/designs, 27, 30; round/rounded, 14, 19, 67, 70, 110, 126–127; spherical, 84, 177; spirals, 51, 80–81, 94, 97, 109–110, 119, 150; stars, 51; triangular, 14, 17, 29, 70, 101, 150, 157, 227; wave forms, 80

Geometric-Figurative Pictograph Style, Cuban, 29

Goat Cave, Bahamas, 19

God's Well, Jamaica, 49

Grand Carbet River, Guadeloupe, 138, 139

Grande Grotte, Haiti, 80

Greater Antilles, 5, 6, 8–11, 13–14, 18, 20–21, 111–112, 117, 125, 139, 148, 157–158, 231–232, 237; geography, 3; rock art, 157, 199, 204–205, 207, 209, 211, 232, 237

Grenada, 5, 148, 155, 156, 158, 214, 218, 228

Grita Cabaai, Bonaire, 161, 163, 164

Grotte aux Indes, Haiti, 80

Grotte Dufour, Haiti, 79

Grotte du Morne Rita, Guadeloupe, 138, 144, 146

Grotte nan Baryè, Haiti, 80

Guadeloupe, 12, 44; geography, 5, 137; legal framework, 140, 146; rock art dating, 144–146, 217; rock art history, 137; rock art images, 110, 138, 144, 205; rock art interpretation, 138, 146, 238; rock art site descriptions, 138–144; rock art sites, 2, 137–138, 199

Guayabal, Dominican Republic, 110

Guiana, 9, 14, 65, 231, 232, 237

Gut River #1, Jamaica, 45

hair, design, 19, 50, 127, 224

Haiti, 12, 97, 106, 108; geography, 3, 5; cultures, 78–79; legal framework, 87–88; rock art images, 84–85, 108; rock art interpretation, 85–87; rock art research 88–89, 220, 233; rock art sites, 44, 79–84, 109, 205, 217

Hamilton Cave, Bahamas, 19

hand, design, 63, 69, 70, 72, 81, 92, 167, 169, 178, 183, 218

handprint, design, 96, 108, 164–167, 171, 178

Hartford Cave, Bahamas, 15, 16, 20

Hato, Curaçao, 170

head, design, 17, 19, 54, 70, 72, 80, 81, 84, 97, 119, 125–127, 130, 139, 150, 157, 178, 223–228

headgear, 50, 96, 119, 123, 124, 127, 131, 132, 150, 220; crowns, 19, 127

Hispaniola, 6, 13, 85, 86, 90, 91, 102, 105, 125, 126, 222, 238; geography, 3, 6, 105; cultures; 6, 7, 9, 103, 105, 112, 230, 238; rock art dating; 111, 229, 230; rock art history; 219; rock art site locations, 66, 109, 114, 205; rock art site types, 207, 211, 220, 237, 238

historic rock art, 217; Aruba, 176; Bahamas, 19, 215; Bonaire, 163; Cuba, 34, 219; Dominican Republic, 99; Haiti, 79; Puerto Rico, 116–117, 126

Hull Cave, Jamaica, 51, 55–56

human, 42, 52, 54–56, 69, 72, 93–94, 97, 103, 107, 109, 123, 131, 174, 186, 188, 233, 237, 238; rock art, 19, 49, 55, 67–70, 80, 84, 98, 108, 118, 144, 179, 220

humanlike, 16, 18–20, 50, 95, 96, 98, 107, 109–111, 119, 122, 125, 128, 139, 142, 178, 183, 214, 220, 237

iconography, 32, 40–42, 57, 103, 114, 116, 128, 147, 148, 158, 169, 188, 193, 203, 220, 221, 230, 238; designs, 10

ideology, 14, 40–41, 42, 51, 57, 219

igneous rock, 13. See also volcanic rock

image: definition of, 2. See also carving, rock art; design, rock art; drawing, rock art; engraving, rock art; figure, rock art; motif; painting, rock art

imagery, rock art, 39, 41–42, 48, 57, 70, 75, 107, 132–134, 141, 225

Interconnected Lines Pictograph Style, Cuba, 29–30

Jacuana, Puerto Rico, ball court/rock art site, 220

Jackson Bay caves/Jackson Bay Cave-1, Jamaica, 44–45, 47

Jamaica,. 3–4, 6, 12, 41–42; 105; geography, 3, 5, 43–44, 74; conservation, 60–63, 65, 75–77; cultures, 44–46, 60; rock art dating, 44–46; rock art image locations, 47–48, 64–65, 73–74; rock art images, 41, 49–51, 205; rock art interpretation, 51–57, 65–75, 107; rock art sites, 41, 42–47, 58–60, 68–69, 110, 205; rock art techniques, 63–64

Kasimati/Kaomati, Bonaire, 161–162

Kelly Cave, Bahamas, 18–19

Kempshot, Jamaica, 48

La Loma de la Chicharra, Cuba, 26

landscape, 42, 44, 57, 74, 182, 185, 237–239; sacred, 41, 57

La Piedra del Indio, Dominican Republic, 109

La Piedra Escrita, Puerto Rico, 119, 136

Las Casas, Fray Bartolomé de, 65, 66, 72, 86

laser scanning, 12, 189–191, 193, 196–197, 204

Late Ceramic, 7, 8, 9, 11, 17, 21, 60, 118, 123–124, 126–128, 145, 150–151, 157, 160, 188, 214, 217, 219, 232; characterization of, 9–12, 148; cultures, 10, 44, 46, 133, 157

Leeward Islands, 6, 11, 205, 209, 231, 238; geography of, 5. See also Lesser Antilles

leg, design, 63, 69, 70–72, 96, 119, 130, 139, 150

Lesser Antilles, 3, 6, 11–12, 116–117, 148, 151, 155, 158, 199, 219, 221, 231, 238; geography, 5; rock art, 1, 137, 139, 147, 162, 169, 199, 204, 207, 214, 217, 218, 228, 232. See also Leeward Islands; Windward Islands

lighting conditions, caves, 15, 29–30, 32, 46, 61–62, 70, 95, 97–98, 100–101, 104, 107, 109, 122, 124, 176, 182–183, 222, 225, 227

limestone rocks: formation, 5–6, 13, 15, 18–19, 43–44, 58–59, 74, 122, 163–164, 177, 182, 221–222; islands, 13, 105, 137; karst, 26, 74, 167; karst regions, 80, 90, 94, 137, 143; surfaces and rock art, 15, 32, 43, 47, 61, 64, 108, 120, 165, 171–172, 176, 182

linear designs: prehistoric, 18–19, 23, 27, 29, 30, 32, 51, 67, 71, 94–98, 119, 125, 154, 164–169, 177, 214, 218; prehistoric elements, 139, 144, 209, 221, 227; modern graffiti, 61, 63, 164–165

Lithic Age, 6–7, 8, 9, 78, 105, 230; characterization of, 6–7; populations, 6, 9

Little Miller's Cave, Jamaica, 55

Maffo Petroglyph, Cuba, 26

Maisbel, Puerto Rico, 118, 126

Marie Galante, Guadeloupe, 138, 144, 209

Martinique, 148, 150, 155–156, 217

Mártir de Anglería, Pedro, 92, 102

McKay Cave/John Winter Cave, Bahamas, 18–20

metamorphic rocks, 5, 13

migration, 6, 12–14, 112, 162, 170, 183, 219, 228–229, 231–233

Milk River, Jamaica, 51

Mixed Type Style, Petroglyph, Dominican Republic, 95–96, 126

Mona Island, 105, 111–112, 126, 204–205, 207, 211, 214, 238

Mora Style, Puerto Rico, 221–222, 228

Morne Deux-Têtes, Haiti, 79–80

motif, 2, 20, 24, 37, 42–43, 48–49, 51–52, 56–57, 60–61, 63–65, 67–68, 72, 74, 76–77, 101, 127, 134, 147, 149, 166, 169–170, 172–173, 182–183, 186, 217–218, 228, 231–233; specific, 14, 18–19, 29, 50–51, 55, 63, 67–68, 70–74, 80, 94, 96, 104, 110–111, 119, 130–132, 139, 144, 149, 163–167, 169, 176–179, 181–184, 214, 228, 231, 233

Mountain River Cave, Jamaica, 45, 48, 50–51, 55, 57, 107

Mount Rich, Grenada, 155

mouth: cave, 15, 18, 32, 66, 104, 144, 226; rock art design, 16, 18, 50, 67–68, 70, 110, 119, 127, 139, 144, 149, 224

narrow/wide-mouth flank-margin caves, 15, 18–20. See also solution cave

Netherlands Antilles, 5, 161, 168. *See also* Aruba; Bonaire; Curaçao

New No. 1 Cave, East Caicos Island, 19

New World, 11, 14, 17, 23, 232

Non-Concentric Line Style, Cuban, 214

nose, design, 17, 50, 127, 132, 144, 150

Old Colonial Bridge, Guadeloupe, 139

Old Harbour Bay, Jamaica, 45

Onima, Bonaire, 161, 162, 164–165, 167, 170, 171, 173

open-air sites, 26, 45, 92, 94, 95, 97, 207

oral tradition/mythology, 52, 115, 168, 172, 174; South American, 130, 146, 207; Taíno/native, 17, 40, 52–54, 57, 73, 81, 84, 131, 139, 220–222, 225, 228, 230, 237–238

Orinoco, 9, 112, 161, 162, 169, 170, 183, 184

Ortoiroid series, Archaic Age, 7, 8, 9, 112, 230

Ostionoid, ceramic period, 7, 8; cultures of, 10, 14, 44–46, 80, 219, 232–233, 238; material culture, 45–46, 60, 79, 123–124, 127, 218, 229–233

paint, 43, 60–64, 103, 124, 144, 163–167, 171, 172, 176, 182, 183, 220, 233; acrylic, 34, 61, 62, 63; latex, 163, 166–168, 172

painting, rock art, 9, 23, 26, 37, 49, 94, 97–98, 102–104, 107–108, 110–111, 114, 116, 126, 161–163, 167–172, 174–177, 179, 181–186, 214, 238; definition of, 2; false/modern, 164, 174; South America, 162–163, 170, 174

Palo Hincado, ball court/rock art site, Puerto Rico, 136

Pané, Fray Ramón, 40, 53–55, 65, 67, 72–74, 90–92, 102, 228, 230

Pantrepant East, Jamaica, 44–45, 47, 49

Parc Archéologique des Roche Gravées, Guadeloupe, 139–140, 146

Patana petroglyph style, Cuba, 31

Petit Carbet River, Guadeloupe, 139, 140, 146

petroglyphs, 14–21, 23, 27–28, 31–33, 35, 38, 40–41, 43, 44–45, 47, 49–50, 53–55, 57–58, 60–61, 63–65, 70–71, 74, 76–77, 80, 82–84, 92–97, 104–105, 108–112, 116–134, 136–141, 143–144, 146–149, 156–158, 169, 176, 188, 205, 209, 211, 214, 217–222, 224, 227–228, 232–233, 237–238; definition, 2; production of, 12, 25, 188, 190, 192–197, 204; sites, 23, 26–27, 41, 45, 49, 55, 80–81, 90, 110, 121, 137–138, 148–152, 156, 158, 160, 162, 211; South American, 169–171; styles of, 29, 31, 94–96, 110–111, 220

photography, 25, 36, 64, 107, 116, 122, 149, 161, 185–186, 188, 192, 195–197, 203–204

pictographs, 14–15, 18–19, 21–24, 27–28, 32–33, 35, 37–38, 40–41, 44–45, 47–48, 53, 55, 84, 90, 93–101, 103–105, 107–112, 114, 116–121, 124–126, 144, 161–169, 171–172, 174–177, 179–180, 182–186, 205, 209, 211, 214, 217–219, 221–222, 226–230, 232–233, 237–238; definition, 2; production of, 25, 36, 193; South American, 162–163, 169; sites, 26, 37, 41, 45–46, 51, 109–110, 161–163, 167, 169–170, 175, 177–178, 182, 185, 211; styles, 24, 29, 33, 97–99, 103, 106–108, 110, 114, 220

pitted, design, 119, 139–141

plaza, 118, 126, 128–129, 131, 158, 188; characterization of, 10. *See also* ball court

Plessis River sites, Guadeloupe, 138, 141–142, 146

Pont Bourbeyre, Guadeloupe, 138, 139

Port-Salut Moreau Cave, Haiti, 80

Pos Calbas site, Bonaire, 161–162, 164

Potoo Hole petroglyphs/caves, Jamaica, 41, 44, 46, 48, 51, 53, 57, 107

Preceramic Period/Cultures, 6, 105, 108–112, 126, 175–177, 214, 218, 220, 230

pre-Columbian, 2, 17, 24–25, 31, 39–40, 80, 87, 90, 93–94, 97, 103, 132

pre-Hispanic, 1, 10, 22, 34, 103, 117, 124, 137, 176, 182–184, 236, 238

Propriété Derussy, Guadeloupe, 139, 140, 145

Puerto Rico, 2, 6, 12, 79, 105–106, 112, 204–205, 229–230; geography, 3, 5, 117; legal framework, 134–136; rock art dating, 125–128, 214, 217–219; rock art documentation, 122; rock art history, 115–117; rock art images, 118–119, 121–122, 139, 205; rock art interpretation, 128–132, 231–232, 238; rock art production techniques, 119–120; rock art site descriptions, 122–125; rock art sites, 70, 109, 117–118, 158, 188, 205, 207, 211; rock art styles, 107, 220, 222, 228

Punta del Este cave system, Cuba, 23–24, 35–36, 109, 171

Quadirikiri cave, Aruba, 109, 178, 180–183

Quebrada Maracuto, Puerto Rico, 136

Ramoncito cave, Dominican Republic, 98

rays, 14, 18, 20, 50, 64, 127, 218, 223–225, 227, 231–233; lunated crest, 14

recording techniques, 58, 60, 63, 77, 147–149, 188–189, 190–193, 195–196, 199, 204

Reef Bay, St. John, U.S. Virgin Islands, 44, 116–117, 122, 127, 132–134, 141

relief, in petroglyphs, 84, 85, 94, 96, 104

religion, 102, 219. See also Taíno, religion

religious specialists, 11, 66, 133. See also behique/shaman cacique/chief

ritual, 10, 11, 39, 46, 48, 51, 53–54, 56–57, 65, 77, 83–85, 91, 93, 97, 99, 103–104, 114, 132, 177, 179, 186, 230, 233. See also cohoba

river, rock art location, 23, 26, 42, 44, 47, 79–80, 82, 94–95, 109–110, 116–118, 138–142, 207; river mouths, 138–140

Robin Bay, St. Croix, U.S. Virgin Islands, 116, 117, 122, 127

Roche à l'Inde, Haiti, 79, 80

Roche Tampeé, Haiti, 79, 80

rock art: definition of, 2. See also carving, rock art; design, rock art; drawing, rock art; engraving, rock art; figure, rock art; motif; painting, rock art

rock art conservation, 2, 34, 35, 58, 60, 61, 65, 76, 87, 88, 93, 114, 116, 149, 185–187, 198, 199, 233; conservation issues, algae, 15, 61–64; dust, 61, 62, 76; graffiti, 34, 58, 60–64, 77, 88, 124, 136, 144, 167, 173, 174; natural deterioration, 34, 77, 233; natural elements, 166, 188–189; preservation, 71, 101, 155; spray paint, 124, 173; state of, 71, 155; strategies and issues, 65, 75–76, 88–89, 94, 101, 115, 134–136, 189, 233; vandalism, 34, 77, 101, 172, 174, 186;

rock art locations: beach rock, 117, 126, 207; cave entrance, 48, 97, 100, 101, 167; cave exterior, 97; ocean-edge/coastal, 18, 33, 42–44, 117, 118, 122, 151, 154, 156, 158, 170, 176–178, 181–182, 207; outcrops, 58, 109, 117; overhangs, 19, 47, 143, 165; ravines, 207; rock formations, 110, 117, 177–178, 180, 207; rock ledge, 47; rockshelters,

46, 94, 117, 138, 148–149, 163, 164–
165, 167; valley, 43–44, 138, 207
rock art production techniques: abrad-
ing, 27, 32, 120, 150, 152; application
devices, 15, 32, 96, 98, 105, 120, 164–
166, 168; carved, 2, 47, 48, 64, 76, 80,
84–85, 94, 110, 117–118, 122, 125–
127, 131, 134, 140, 142, 144, 152, 156,
158, 188, 192–193; engraved, 32, 63,
64, 122, 138–140, 144; etched, 15; ex-
cised, 71; ground, 2, 94; incised, 27, 32,
50, 67, 76, 95, 96, 152, 227; pecked,
1, 2, 27, 31, 63, 76, 84, 94, 111, 120,
150–152, 154–156; percussion, 120;
scratched, 144
rock art reproduction, 122, 149, 188, 194,
196, 203–204; plastic, 63, 64, 149, 204;
tracings, 25, 58, 63–64, 76, 149, 188,
192, 196, 204, 222–223
rock art sculptures, Caribbean, 2, 11
rock art surfaces: ceiling, 27–28, 48, 97,
108–109, 164, 167, 176, 182–183, 222;
gallery/chamber, 19–20, 27, 32–34,
47, 82, 104, 122–125, 144, 176, 182–
183, 221–222, 227; mural, 29, 34,
94, 96, 110, 125, 226–227; rock face,
47–48, 63, 72, 84, 95, 149, 151; rock
panel, 33, 61–65, 67–72, 76, 95–98,
104, 105, 107, 109, 141, 155; roof, 32,
182; stalactites, 32, 47, 57, 60, 64, 117,
144, 225; stalagmites, 23, 32, 47–48,
57, 60–62, 64, 67, 82, 84–85, 110, 117,
144, 225, 227; wall, 16, 18–19, 22,
27–30, 32, 48, 84, 94, 122, 125, 144,
164, 168, 176, 182–183, 214, 222
Roshikiri, Bonaire, 166, 170, 173

Saint-Suzanne, Haiti, 79, 80–81, 85
Saladoid, 7, 9, 57, 125, 140, 142, 143, 145,
156, 158, 218, 219, 229, 230, 231, 232,
237. See also Early Ceramic

Salt Pond, Bahamas, 19
Salt River, St. Croix, U.S. Virgin Islands,
116, 117, 122, 127, 132
sedimentary rocks, 5, 13, 198
shaman. See behique/shaman
Sierra Prieta mural, Dominican Republic,
110
smudge/smear, 164, 168
South America, 3, 5–6, 14, 148, 169; rock
art of, 1, 3, 7, 169, 174, 183–184, 211,
218, 220; cultures of, 6, 9, 11–12, 39,
65, 111, 128, 130, 146, 158, 199, 207,
219, 228–229, 231, 237–238
solution cave, 15, 222. See also narrow/
wide-mouth flank-margin caves
solution hole, 13, 15, 19
Spelonk, Bonaire, 161–163, 166–167,
170–173
spirit/spirit world, 10–11, 18, 39, 46–48,
54–56, 58, 66, 70–74, 76, 83, 102–103,
130–131, 133–134, 158, 182, 221, 237
Spot Valley, Jamaica, 46, 57
St. Croix, U.S. Virgin Islands, 44, 116,
122, 132, 205
St. Francique, Haiti, 79, 84
St. John, U. S. Virgin Islands, 116, 122,
132, 205
St. Lucia, 148, 150, 151, 154, 209, 228
St. Thomas, U.S. Virgin Islands, 116, 122,
205
style/school, 3, 29–31, 33, 94–99, 103–
111, 114, 168, 214, 220–222, 228, 230,
238; definition of 2. See also individu-
ally named styles
Suriname, 163, 232, 237

Taíno, 10, 11, 14, 17, 21, 23, 44, 47, 57,
65, 67–68, 72–73, 79, 85, 86, 105, 126,
128, 132, 139, 148, 157, 214, 218–219,
221–222, 224, 227, 229, 230, 233, 238;
religion (spiritual beliefs/oral tradi-

tion), 10–11, 14, 17–18, 20, 32, 41, 46–48, 51–58, 65–66, 69–70, 72–77, 81, 83–84, 91–92, 97–98, 102, 111, 128–129, 131–132, 134, 138, 147, 150, 158, 170, 175, 186, 221, 224–225, 227–228, 230

teeth, design, 17, 20, 149, 224

theme, rock art, 48, 57; Caribbean, 31, 48–49, 51–53, 93, 97, 100, 103, 106, 114, 124–125, 224, 227

three-dimensional/3-D: reproduction technique, 12, 64, 188–194, 196–197, 204; rock art design, 48, 67

three-pointed object/three pointer, 10–11, 157, 227

Tibes ball court/rock art site, Puerto Rico, 136, 220

Tobago, 3, 5, 6, 11, 205

Tortuga Island, Haiti, 79, 88

tradition, rock art, 101, 106, 109, 150–151, 160, 183–184, 214, 218; definition of, 2–3

Tradition A, Petroglyph Characteristics, Lesser Antilles, 151, 152

Tradition B, Petroglyph Characteristics, Lesser Antilles, 152, 154

Tradition C, Petroglyph Characteristics, Lesser Antilles, 155, 156

Tradition D, Petroglyph Characteristics, Lesser Antilles, 156, 157, 158

Trinidad, 1, 3, 5, 6, 8, 11, 137, 199, 205, 207, 209, 232

Trois-Rivières, Guadeloupe, 138, 139, 146

Turks and Caicos, 5, 13. See also Bahamian archipelago

Two Sister's Cave, Jamaica, 45

Unconnected Line Style, Cuba, 214

United States Virgin Islands, 2, 12, 116, 127, 132, 135, 136, 141, 205. See also Virgin Islands

Venezuela, 3, 5, 9, 109, 112, 162–163, 169–171, 183–184, 231

Virgin Islands, 2, 12, 106, 115, 231, 238; culture, 6, 125–126; geography, 3, 5, 117; legal framework, 134–136; rock art dating, 125–128, 214, 217, 219, 231–232, 238; rock art history, 116, 117; rock art images, 119, 121–122, 205, 209; rock art interpretations, 128, 132–134; rock art site documentation, 199, 203; rock art sites, 117, 141, 205, 207. See also British Virgin Islands; United States Virgin Islands

volcanic rock, 5–6, 140

Voûte a Minguet (Minguet Vault), Haiti, 79, 81–82, 86

Warminster/Genus, Jamaica, 46–50, 55, 58, 60, 67, 70, 72, 74, 75, 77, 110, 237

water sources and rock art, 20, 32, 42, 44–45, 57, 131, 134, 138, 140–141, 144, 146, 150, 164, 166–168, 170–171, 207, 209

West Indian Archipelago/West Indies, 3, 137, 169

White Marl Burial Cave, Jamaica, 45

Windsor Great Cave, Jamaica, 48, 49, 57

Windward Islands, 5, 6, 11, 12, 147, 148, 150, 158, 228, 238

Worthy Park # 2, Jamaica, 45

wrapped/enclosed motif, 14, 17, 18, 20, 119, 122–124, 127, 131, 141, 150, 152, 207, 209, 214, 221, 227, 232

Yambou Valley, Lesser Antilles, 232

zoomorph, 10, 19, 29, 38, 49–51, 55, 80, 90, 95–96, 98–99, 118–119, 129, 132, 138–139, 144, 148–149, 155–156, 167, 177, 180–184, 211, 214; animal, 43, 49–51, 55, 57, 72, 84, 97, 99, 106, 119,

124–125, 181, 237; bat, 57, 69, 119, 124, 132–133, 226–227; beak, 71–72; birds, 38, 43, 50–51, 53–55, 98, 107, 119, 124–125, 130–131, 139, 181, 184, 190, 192, 226, 237; claws, 72; crocodiles, 43, 51; ducks, 51; egrets, 51; feathers, 19; feline, 169; fish, 51, 68, 84, 98, 107, 124–125, 130–131, 181;

frogs, 43, 51, 53, 57, 84, 124, 127, 130, 169, 224–225, 231; iguana, 181; lizards, 81, 124; manatee, 99, 138, 181; owl, 50, 55, 63, 67–74, 80, 100, 131, 224–225; serpent, 55, 125; sharks, 99, 181, 220; snake, 50, 68, 72–73, 84, 100, 166, 167, 225; spiders, 51, 124; turtle, 51, 84, 99, 119, 124, 181